ALSO BY NICHOLAS FOX WEBER

Mondrian: His Life, His Art, His Quest for the Absolute
The Bauhaus Group: Six Masters of Modernism
Anni and Josef Albers
iBauhaus
Wayne Thiebaud
Freud's Trip to Orvieto
Le Corbusier
The Clarks of Cooperstown
Marc Klionsky
Balthus
Cleve Gray
Patron Saints
The Art of Babar
Warren Brandt
Leland Bell
Louisa Matthiasdottir
The Drawings of Josef Albers

THE ART OF TENNIS

THE ART OF TENNIS

NICHOLAS FOX WEBER

Godine • *Boston*

Published in 2025 by
GODINE
Boston, Massachusetts
www.godine.com

Copyright © 2025 by Nicholas Fox Weber

ALL RIGHTS RESERVED.

No part of this book may be used or reproduced in any manner whatsoever without written permission from the publisher, except in the case of brief quotations embodied in critical articles and reviews. For more information, please visit godine.com.

LIBRARY OF CONGRESS CATALOGING-IN-PUBLICATION DATA
Names: Weber, Nicholas Fox, 1947- author.
Title: The art of tennis / Nicholas Fox Weber.
Description: Boston, Massachusetts : David R. Godine, Publisher, 2025. |
Identifiers: LCCN 2024060026 (print) | LCCN 2024060027 (ebook) | ISBN 9781567928310 (hardcover) | ISBN 9781567928327 (epub)
Subjects: LCSH: Tennis.
Classification: LCC GV995 .W414 2025 (print) | LCC GV995 (ebook) | DDC 796.342—dc23/eng/20250417
LC record available at https://lccn.loc.gov/2024060026
LC ebook record available at https://lccn.loc.gov/2024060027

FIRST PRINTING, 2025
Printed in the United States of America

For Lucy

CONTENTS

PROLOGUE 〉 The Tennis Court Is Home — XI

CHAPTER ONE 〉 Charisma — 1

CHAPTER TWO 〉 Tennis in the Art of Bonnard and Vuillard — 17

CHAPTER THREE 〉 The Curious Case of Claude Anet — 23

CHAPTER FOUR 〉 Alice Marble — 43

CHAPTER FIVE 〉 Bill Tilden — 59

CHAPTER SIX 〉 Dressed to Win: Katharine Hepburn and René Lacoste — 79

CHAPTER SEVEN 〉 Suzanne Lenglen — 91

CHAPTER EIGHT 〉 Pierre — 103

CHAPTER NINE 〉 The Song and Dance of Tennis — 121

CHAPTER TEN 〉 "Green or Yellow?" — 135

CHAPTER ELEVEN 〉 Helen Wills — 141

CHAPTER TWELVE 〉 Vladimir Nabokov — 159

CHAPTER THIRTEEN 〉 Tennis Chic: Jean Patou — 177

CHAPTER FOURTEEN 〉 Althea Gibson — 185

CHAPTER FIFTEEN ⟩	Tennis in the Work of Eadweard Muybridge	197
CHAPTER SIXTEEN ⟩	Bunny Austin	205
CHAPTER SEVENTEEN ⟩	A Fabergé Tennis Trophy	221
CHAPTER EIGHTEEN ⟩	Anyone for Tennis?	229
CHAPTER NINETEEN ⟩	Guillermo Vilas	241
CHAPTER TWENTY ⟩	Oleg Cassini	247
CHAPTER TWENTY-ONE ⟩	Henry McBride	259
CHAPTER TWENTY-TWO ⟩	Caravaggio	265
CHAPTER TWENTY-THREE ⟩	Mantua	271
CHAPTER TWENTY-FOUR ⟩	Henry V	285
CHAPTER TWENTY-FIVE ⟩	Nick Ohly	289
EPILOGUE ⟩	The Magic of It All	299
NOTES ⟩		305
CREDITS ⟩		315
ACKNOWLEDGMENTS ⟩		321

PROLOGUE

The Tennis Court Is Home

When my wife and I were in Guangzhou, in 2006, as soon as I saw public tennis courts I resolved to see if I could drum up a game. Although I spoke not a word of Cantonese, I managed to borrow a racquet and make it clear that I hoped one of the people standing around would play with me.

Soon enough, I found myself on the court with a stranger who indicated, after I pointed to myself and said "Nick," that his name was Pang.

Our common language was tennis. I quickly realized that Pang was more than your everyday player. It's not that he was a champion, but he played with panache. He could retrieve the ball from the ground by tapping the face of his racquet on it and making it ascend as if guided by a wand. He hit his groundstrokes deftly, with a stylish follow-through that resembled the bow of a gondola. Pang served with the energy of a turbine engine. Trim and pleasant-looking, he exuded charm.

When we changed sides, Pang hopped over the net with a scissor kick—making the acrobatic act look effortless. When he was receiving serve, he was in perfect position with the engagement of a gladiator, as present and concentrated as Rafa Nadal. During a break between sets, he casually juggled four balls. He lit up at everything he did. His energy was one hundred percent, and his congenial personality was such that when he lost a point, he applauded my winning shot by clapping his free

hand against the racquet strings and smiling broadly. Although we had met just half an hour earlier, he was happy for me.

We communicated as needed despite the language barrier. We knew the score although we announced it differently. There were a couple of long rallies that exceeded our expectations and we showed our excitement. We shared the enjoyment of a good game, surprisingly equal for players who had met by chance. Tennis is understood by all who play it. It releases endorphins and inspires stories, reflections, and artistic expression, well beyond the confines of the court.

I HAD gone down the hill to that court in Guangzhou without any trepidation. For me, the tennis court is home. It both cossets me and enables me, securely and happily, to spread my wings. But I knew I was fortunate to encounter someone as companionable as Pang, and as quietly magnetic.

Playing with him enhanced an experience that is already for me one of life's glories. The court provides reassurance and memory, the ideal essence of what "home" should be. The moment I set foot on one, I'm on familiar territory, a place to which I've always gravitated. And because I'm lucky, it's where I encounter fine people I'd never otherwise meet.

The stage never changes, wherever I am in the world. The layout is invariable: The length is seventy-eight feet, the width is thirty-six. If you look for a precise system, however—everything divisible by two, for example, or one dimension being exactly twice the other—you won't find it. Yes, the width and length are even numbers, but the twenty-one feet from net to service line and the thirty-nine from net to baseline are both odd numbers. Those measurements impart a sense of inevitability but also an essential element of variety.

It is all heartening and comforting: the way the court is what it is, whether it is surfaced in clay, grass, asphalt, or Astroturf. The scheme is a mirror image, the net its divider. This exactitude is part of what makes you know yourself whenever and wherever you are, whether it is an autumn day in Norway, when your fingers are so cold that you can barely grip the racquet, or a sweltering afternoon in Dakar, when you

are so soaked with sweat that you wonder how you will ever get your shirt off afterward.

It is always the same: a reduction of straight verticals and horizontals and impeccable right angles. Diagonals belong only to the action that lies ahead. You can hardly wait to angle those shots, to lace a crosscourt backhand at a sharp trajectory, to vary the destination of your serves unpredictably from one back corner to the other, but when you set foot on the court, you start with the calm and sense of inner balance that come because of the flawless grid.

It's a home to which I can always return, knowing that everything is as I remember it—and, moreover, it will always remain that way.

At any location and under any conditions, even if I am thousands of miles from where I live, I imagine the voice of my Cameroonian friend Pierre Otolo urging me not to stop the stroke before a full follow-through—"Laisse partir, Nicholas!" We all have our own albums of memories that come back whenever we stand on the court. When I play, wherever it is, days when the air is cool and crisp take me back to afternoons at Tamarack Tennis Camp, the haven in a mountain valley where I worked every summer during my college years. We maintained the nine red clay courts, rolling them, spreading calcium, sweeping them with the large, yoked broom unique to tennis, cleaning the lines. The campers and counselors wore whites; it was all very 1960s. I can picture Mrs. Whitehouse Walker, the grandmother of one of the campers, arriving in her Ford Mustang, wearing a flowered dress, saying, with impeccable British diction, "The air is so pure you could drink it!"

How trustworthy those 2,808 square feet are! In Quito—when I was fifteen, on a summer trip that started with a coup d'état, when we were told that if we were still in the city after sunset, we risked being shot at—the court from which we could see volcanoes was a comfort. It took awhile to get used to the ball bouncing so much higher at Quito's elevation than it did at sea level, and the sprint to net initially left me more breathless than I was used to, but still, the court was a safe harbor.

The memory of Guangzhou, however, looms largest. In one way, everything was foreign—the pagoda shapes, the rickshaws, the appearance of most of the people I saw. Pang's skin and hair and eyes differ from mine, but those are surface characteristics. What was striking was

that in character and personality, he had qualities that made it feel as if we were members of the same family.

THE THRILL of the *thwack* of ball against the racquet and the perpetual state of suspense about what is coming next appeals to individuals from every walk of life. Tennis has been the basis of ballets and symphonies, the stuff of poetry and inner flights of fantasy. The game—its setting, the unique movements it demands, the clothing, the miracle of the ball itself—has inspired players and artists for centuries. It has prompted the creation of sublime architecture and moved composers in wonderful new directions; it has been the foundation for literature and been the source of hilarious cartoons. It has also, in fabulous ways, enabled human beings to demonstrate some of their most admirable qualities: courage, tenacity, generosity of heart. It has made it possible for people to alter their lives dramatically, to move from what could seem a confining milieu to a sort of global citizenship. It has brought out compassion and spawned humor and dreams.

The purpose of this book is to present some examples of the reach of this remarkable sport. In it, I show tennis as the manifestation of the elusive quality we call charisma, and how it opens our eyes to the ways that the sport has been the inspiration for world-class painting, literature, music, dance, and photography. It considers the impact of the sport on human style, in both appearance and behavior, and provides a sense of tennis as a source of transformation. It also portrays tennis as an art form.

Tennis can be central to one's existence or it can be peripheral; in either case, it provides constancy and continuity. The perfect functioning of the racquet, the aptness of the scoring system and the shifts from "deuce" to "advantage," have been a springboard for individual pleasures as well as cultural masterpieces. Tennis takes us on a rich journey that is diverse in its scope. The sport is a catalyst for some very different manifestations of human greatness. The chapters that follow celebrate them.

THE ART OF TENNIS

1

CHARISMA

THE OSCAR winner, the Nobel laureate: We like to focus our sights on the champion who vanquishes everyone else in the field. Who is the ne plus ultra in the history of tennis?

Novak Djokovic—the thirty-seven-year-old player who, as of June 2024, was ranked the world's No. 1 for a record-breaking 438 weeks—has been called the best tennis player of all time. Many current experts are in agreement, but the same thing was said of Bill Tilden, who held top ranking in 1920–26 and was the first American to win Wimbledon.

How do we measure who was better? Are we to assume Djokovic, because the equipment is more effective and because he has tuned his body to a level of fitness such that his serve and groundstrokes are harder and placed with greater accuracy than Tilden's? Or should we consider the possibility that a champion of a century ago was every bit as good as, perhaps better than, one who plays now?

Maybe there is a computer program or a form of AI that can set up a match between Tilden and Djokovic and determine how Djokovic would have returned Tilden's famous cannonball serve. Or re-create what Tilden would have done with Djokovic's lacing groundstrokes. But how about Tilden's unique sense of strategy? Would that have enabled him to defeat Djokovic, despite the Serb's incredible fitness? Tilden could plot and anticipate. He could hit the ball crosscourt and deep to his opponent's backhand knowing the return would then

enable him to deliver a deft dropshot to the forehand, which, if it did not win him the point, would elicit a shot he would receive midcourt from where he could next hit a winner. His control and ability to summon surprises might have gotten the better of even the tennis machine that is Djokovic.

René Lacoste, an established tennis champion well before his name became associated with polo shirts, wrote about Tilden playing an exhibition match against "a wonderful Spanish player" named Manuel Alonso in the mid-1920s:

> Seemingly, in two steps Tilden covers the whole of the court; without any effort he executes the most various and extraordinary strokes. He seems capable of returning any shot when he likes, to put the ball out of the reach of his opponent when he thinks the moment has come to do so. Sometimes he gives the ball prodigious velocity, sometimes he caresses it and guides it to a corner of the court whither nobody but himself would have thought of directing it.[1]

Could Djokovic have trounced Alonso as easily as Tilden did? What would Tilden and Lacoste himself—as well as such greats as Jean Borotra and Jack Kramer and Rod Laver and Pancho Gonzales—have been like if they had the nutritional and training advantages of the hot players of today? Before the current era, tournament players were largely on their own. Now the superstars have an entourage supporting them. Each seems to have a primary coach, a trainer for strength and another for conditioning, a sports psychologist, a massage therapist specializing in the back and buttocks and another who works on the legs, arms, and shoulders, a strategist, a nutritionist, and even a wardrobe master. There are first-class hairdressers next to the locker rooms. Would it have mattered to our greats from the past if they had had all that backup?

And then there is the equipment. The racquets of today, with their high-tech materials and perfectly calibrated stringing, are of a different breed from the old wooden racquets strung with sheep gut. Champions' shoes have inner soles designed by specialist doctors who have studied how the human foot is used in racquet sports. The clothing facilitates movement and flexibility. The technology of the new balls makes them

more effective ammunition than the old ones were. So if we were to compare, say, Helen Wills and Serena Williams—two amazing players, both winners of the same major tournaments but almost a century apart—do we factor in the difference in racquets or should we mentally equip Wills with the most tensile graphite?

There is one characteristic, however, that cannot determine the issue of who might win or lose, for which there is no issue of "better" or "best."

At Wimbledon at the end of the nineteenth century, at Roland Garros in the 1920s, behind the scenes of Forest Hills in the aftermath of World War II, on a public court in Guangzhou or a leased one in Yaoundé, the tennis players in this book, some current and some from the past, have cast their spells. They may not beat the "No. 1's," but they have or had that something extra, that inexplicable force for which there is no measure: charisma.

The quality we call "charisma" is tough to define. The synonyms provided by the thesaurus are just stabs in the dark. These are approximations, absent the oomph of the real deal. *Allure* seems superficial. *Glamour* is too close to *bling*, which is too conspicuous. *Fascination* is too mild, *dazzle* too opulent, *flash* is just obnoxious. *Witchcraft* and *witchery* are, even if Roget mentions them, out of the question. The vaguer ones, such as *something* and *it*, are getting closer; *drawing power* may be closer still. The quality we call "charisma" is really a combination of the most apt of these—that is, attracting attention in a positive way.

A friend has pointed out that the concept is both as rich and as amorphous as *love*. Charisma is that elevating characteristic you cannot quite put your finger on and which endows a few individuals with star quality. It is beyond excellence, deeper than mojo, and exhilarating to witness. Those who possess it have a certain spirit. Their smiles come from deep within. Their body language is different from other people's; they seem to celebrate their own aliveness.

The impact on others is an essential element of this characteristic. Charismatic people have a magnetism that is revealed during an encounter, whether with another person or a large audience; their intensity boosts our endorphins. We thrill to it; we behold a grace that makes us happy although we are not sure why. Even if we cannot name its constituents, we know it when we feel that frisson.

The philosopher Max Weber writes, "The term 'charisma' will be applied to a certain quality of an individual personality by virtue of which he is set apart from ordinary men and treated as endowed with supernatural, superhuman, or at least specifically exceptional powers or qualities. These as such are not accessible to the ordinary person but are regarded as of divine origin or as exemplary, and on the basis of them the individual concerned is treated as a 'leader.'"[2] The concept of charisma derives from the Greek χάρισμα (*chárisma*), which means "favor freely given" or "gift of grace." In Christian theology, the giver of the extraordinary endowment that was "charism" is identified specifically as "Holy Spirit." Whatever its source, charisma is a form of charm that, as Weber explains, has "a mysterious, elusive quality."

Some tennis players, from the moment they walk onto the court, evince it. It is not just a question of skill. We can watch and admire perfectly executed groundstrokes, a lightning serve, and nimble footwork, but it requires some extra magic for us to be blown away. The players who win every championship warrant respect, but that is not the same thing as saying they slay us. What gives one or two of those athletes charisma, whereas others are simply extremely talented?

I ASKED friends whom they would name as the most charismatic tennis player of the current era; their answers were all over the place.

"Frances Tiafoe; he just has it."

"Maria Sharapova, the ultimate."

"Martina Navratilova, but no way for poor Sharapova."

"Federer, no question."

"Nadal; definitely not Federer."

"Go, Coco! Gauff is radiant."

Charisma is in the eye of the beholder.

You no doubt have your own notions of who makes the grade; it has to do with you and your own wiring. And although I am convinced of who is charismatic and who is not, I do not expect you to agree with my selection—at least not one hundred percent. All the websites that claim

to be certain of "the ten best-looking..." or "the hundred most talented...." fail to recognize how subjective the evaluations are; this is even more the case with charisma. Human qualities cannot be measured. It is how we perceive other people that matters more than some absolute criterion. There is no explanation for what happens inside us when those athletes have their racquets in their hands, yet with some we enter a realm of delight. The expression "to knock your socks off" is worth summoning; it suggests an impact that equates to someone managing to remove your socks without first pulling them down.

For me, Nadal has the energy and concentration of a blazing sun; he perpetually regenerates himself for every single point. He has that mysterious *je ne sais quoi* of, say, Don Quixote as painted by El Greco. In 2005, on his nineteenth birthday, Nadal beat Roger Federer in the semifinals at Roland Garros (the stadium where the French Open is played) and two days later, after dropping the first set, he beat Mariano Puerta in the finals. It is rare for a teenager to display such mettle.

Nadal is both a dancer and a boxer. How can he combine unbelievable force with an aura of sweetness? Although he has supernatural concentration, he is humble. When Nadal signs autographs, he puts his fans at ease. The lack of narcissism alongside the allure, the vulnerability despite his strength: These are among the components of the magic with which he induces such sympathy in his audience.

I know a surgeon at the Mayo Clinic who says Nadal's court performance is his guiding light during an operation. What motivates this doctor is not simply that Nadal gives his all once the ball is in play; it is also the relaxation the tennis player displays between points. To be totally on, someone requires the capacity to turn it off, too. The surgeon says he learned long ago that if he allowed hectoring administrators or residents with irritating questions to get to him, he could not master his craft. In idle moments, he needs to unwind rather than become even more tightly coiled. Nadal is the model: Breathe deeply and calmly, with no intrusions, during those intervals when you do not have to be present to the nth degree. Relaxation will give you fortitude; you will be strong when you need to summon your strength. Jack and Jackie Kennedy, each of whom notably exuded charisma, had a no-pressure easiness in undemanding moments that enabled them, when

the situation was urgent, to act with steel and vigor. Occasional insouciance begets fiery engagement when it is needed.

I asked Maurice Moore, a friend who is an excellent athlete and great observer of the human comedy, whom he considers the most charismatic players alive. "Federer and Gabriela Sabatini," he replied immediately. Sabatini is the first tennis player to have a rose named for her. Its orange-red petals suit this vivacious athlete, who wrote a book about motivation. She has been ranked No. 3 worldwide and has daunting tennis strokes, but just as important, she is composed under pressure. Her fortitude has enabled her to come back repeatedly after serious injury and soar to victory on sheer stamina. Sabatini also embodies the empathy and altruism that are common in people with charisma. She has received awards for her work on behalf of the Special Olympics and was a United Nations Goodwill Ambassador, helping victims of Chernobyl. Heart is essential to those imbued with magic.

There are pundits who are adamant that Djokovic lacks magic, regardless of his enormous skill; others would describe him as charismatic. It has been written that Venus Williams has charisma, apparent in her humor, whereas her sister Serena, a warrior, does not ("Charismatic people are never petulant," said one friend). Other commentators cite Serena Williams as the essence of charisma.

A few current players are always on the charisma list—Gael Monfils and Emma Raducanu, for example; Andy Murray doesn't make it. Poor Pete Sampras is invariably off: "a cold fish, and arrogant to boot," according to one aficionado. Verdicts have been emphatic on both sides of the Billy Jean King debate. When we were drinking wine one evening, I asked a group of friends which tennis players they felt had charisma: There was unanimity that Ilya Nastase had it but controversy concerning Bjorn Borg. Martina Navratilova was deemed to have lacked it at the start but to have developed it over time. One friend, with an authoritative Etonian accent, shouted out his answer the moment I asked the question: Goran Ivanišević. There was consensus when he said, "The BBC loved him. If you can instigate a laugh in the crowd in that high-pressure situation, you have charisma." After people reflected for a moment, our hostess said, "Ons Jabour; how can you even ask?" The Swiss wife of the Etonian agreed: "She has a serenity about her.

She comes across as very confident." The host, a brilliant doctor whose calm demeanor belies the harrowing cases with which he is always dealing, said, "Jabour's development would eventually mean so much to everybody. She was far behind and then she came out."

When I asked my son-in-law, Robbie Smith, to name his candidate, his face lit up. "For me, there is no question: Agassi. It was about much more than tennis. He brought the whole world in. You would see the Lycra tights underneath his tennis shorts, and then the question was, 'What will he wear at Wimbledon?'" Robbie felt adulation, which is just what charisma brings on.

In the 2023 US Open, I was swept away by Carlos Alcaraz. In his close semifinals match, his opponent, Daniil Medvedev, played superbly and won, but Alcaraz, only twenty years old, had the magic. Between sets, when he twirled his racquet the way a drum majorette manipulates a baton—as well with his left hand as with his right—he made the crowd smile. The guy can do anything. He hits balls after they seem to have passed him at a hundred miles an hour and are already well behind him; this ability fits Max Weber's definition of godly power. But it isn't only a level of coordination that puts him in the same class as Nureyev and Fonteyn: His lightness of foot even if he is as solid as a wrestler gives him his wow factor. He is possessed by some supernatural energy that he wears easily. He is proof that you can be young and innocent and still be charismatic; his imperfections only make him that much more compelling to watch. The grace with which he lost his battle is an example of the extra something that is difficult to describe but elates us when we observe it.

What a magnificent quality that is: to know and enjoy who you are. In charismatic people, I now realize, the sense of self is absent all conceit, simply a matter of fact. That is one of the elements that separates Carlos Alcaraz from some of the players who have lower rankings than he does but are still well known. I once spotted one of those players in an Air France lounge in Paris. This fellow lacked both Alcaraz's confidence and his modesty. Even at the airport, without the pressures of a match, he had, as he does on the court, a look of bewilderment, even defeat. Having been ranked among the top ten players in the world, he was certainly recognized as a celebrity, but seemed

uncomfortable albeit pleased with himself. He is a handsome fellow and had a certain "I'm famous" bearing, but none of this equates to charisma. Of course, these impressions are superficial, but that's how it is with charisma; it is either there immediately or it is not. In May 2023, I saw Coco Gauff in the queue for a flight we were taking, from Rome to Paris, just after the Italian Open and before Roland Garros. I asked her if she was heading to France for the tournament. The agreeable "I am not too important to be friendly" tone of her reply, the smile, were remarkable. Gauff made me feel as if she was just another traveler. This was before she won the US Open, but I assume that she has not changed. Her modesty, even as she exults in her own talent and success, contributes to her charisma.

Suzanne Lenglen and Bunny Austin, tennis stars from long ago, had it to an even greater extent. They made an impact on us, their audience. Both could lace their forehands and power their volleys, but they had something beyond their prowess. In her body language, the tilt of her head, her warm smile, her chic clothing, and the flair of her words and gestures, Lenglen radiated a charismatic confidence. Austin, always jaunty, was possessed of the humanism that made him, in the 1930s, one of the few athletes to speak out against the Nazi ban on Jewish players in the Davis Cup. That same willingness to go against the tide guided him to be the first player at Wimbledon to wear shorts, which he did with such class that his temerity won over even the naysayers. He had a mix of intelligence and verve: charisma in spades.

These individuals had an extra something. They had drive, but were givers rather than takers. They had generous souls; fans in the stands or listening to the radio sensed their goodwill.

Such rare athletes, of yesterday and today, go the limit without flaunting their talent. It shows in their serves. These men and women start the point with all their might, but do not seem to exert effort beyond their capacity; it is as if the straight and high toss, the full extension of the racquet, and the perfect curve of the downward swing are innate. They have no conceit; they give the impression that they are smiling within and unconscious of their charm. They are innately competent. All they do, their perpetual celebration of being alive, comes to them naturally. With sparkling eyes, they exude confidence. These are the people Robert

Browning had in mind when he wrote that "a man's reach must exceed his grasp, or what's a heaven for?" The beauty is in the striving.

◆

ADMIRATION FOR charismatic athletes generally begins in childhood. It is accompanied by the sense that you might emulate your superstars and eventually ascend to the heights you are witnessing. Our heroes become role models, our fantasies of who we could become.

When I was growing up, in the 1950s, my friends' heroes were either Mickey Mantle or Ty Cobb. The first is easy to understand. Mantle was a superlative first baseman and center fielder but also a brilliant switch hitter (that is, ambidextrous). He triumphed despite suffering from the after-effects of osteomyelitis and stayed humble when he was considered the best player in baseball. He welcomed rookies and didn't showboat: This is the stuff of greatness. But the adulation of Ty Cobb feels almost perverse. Although his number of runs batted in and strong play in the outfield made him a superior athlete, his reputation was based on his cursing, slugging other players on and off the field, and throwing temper tantrums. An attraction to those explosions of belligerence seems peculiar.

Cobb claimed that the source of his ferocity was his need to win to impress his father, who was killed by Cobb's mother with a pistol he gave her. Cobb said he felt that his dead parent was watching him. It gave him an odd sense of justification, and certainly his skill was prodigious. But how some of my childhood friends could swagger around our elementary school playground imitating that infamous poor sport and exalting him is baffling. Still, both Mantle and Cobb exuded charisma, the hero and the antihero.

Whereas my friends considered the baseball diamond to be the stage for greatness, for me the tennis court was like the gladiators' ring in the Coliseum. My god was a player: John Newcombe was swift of foot, light in spirit, classically handsome, and possessed of perfect behavior. This Australian was the player I loved to watch and wanted to be.

He had company in my pantheon of greats. James Bond was there, too, the other deity whose charisma I dreamed of making my own. Bond,

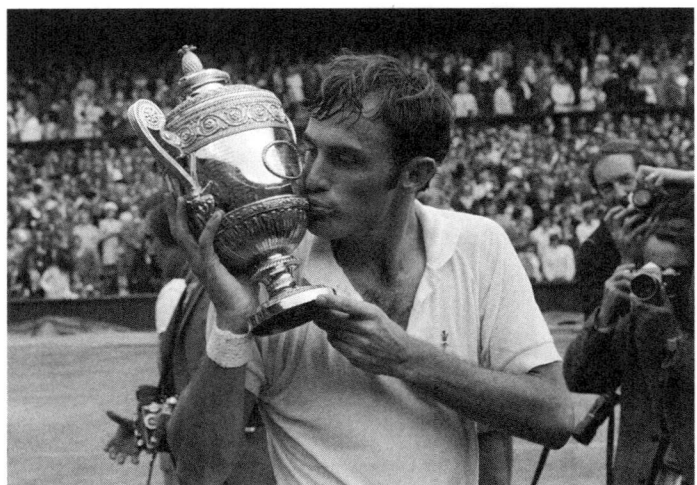

John Newcombe savored victory with the same joy
he put into his tennis game.

however, left nothing to the imagination. You'd see it all—not just the ability to vanquish every rival and escape every danger, but also the romantic conquests, the fast cars, the suavity with which he downed those shaken-not-stirred martinis. With Newcombe, I only saw him *playing tennis*, but that was all it took: This guy epitomized life lived to the highest degree, unfathomable skill, and charisma radiating from every pore.

I wish I had seen him in the finals of the Australian Open in 1975. He had agreed to be in the draw only after he was certain that Jimmy Connors, a young American player as petulant as he was gifted, would be competing in it. This was at a time when "Newc" had not been playing a lot of tennis, so he prepared himself by running a three-mile loop with a very steep hill at the end. Reminiscing about this fifty years later, he said, "I called it Connors Hill, and I ran it in the middle of the day when it was like ninety degrees Fahrenheit. I'd get to the top of the hill and I'd do like a Rocky jog at the top."[3] He had to work himself with extraordinary willpower and focused tenacity to get to the finals. The quarter finals went to a fifth set, which he finally won 10–8, but he had to rush to the physiotherapist afterward. Seeded No. 2, he then played in the semifinals against No. 3 seed Tony Roche. On at least two occasions it was match point against him, but Newc held on until he was victorious

at 11–9 in the fifth set. "From 5–2 there was about 45 minutes more of the match that I have no memory of," he said. "I'd never been in that state before where I was so physically exhausted. It was like an out-of-world experience. But I knew that I had to win because I had to get to the finals against Jimmy."[4] That's the sort of determination inherent in people who exude charisma.

Without gloating, Newcombe, in his recent recollection of the event, clearly took pleasure in his own power. "The whole of Australia was listening either on TV or on the radio," he said. "The people at the beaches all had their radios tuned to the match. It had developed such a hype with this brash American taking on the older Aussie whom everyone liked." After winning the fourth set 7–6 in a tiebreaker, he jumped over the net. But there was none of the lying on the ground and cheering oneself with which major matches end today. He simply shook Connors's hand. That night, he had "a quiet dinner with friends" and went to sleep early.[5] Confident but never boastful, a superb athlete who never grandstanded, he embodied charisma.

As a kid, I had seen Newcombe when I was in the stands at Forest Hills and close up on our behemoth of a TV. But the clincher came when I stood courtside as he practiced for an indoor tournament in Hartford, Connecticut. I was older, and knew there was no chance of my becoming a serious competitive tennis player; still, seeing Newcombe put me in a state of little-boy admiration. Every forehand was a masterpiece, executed as if by a stone carver manipulating his chisel in and out of a marble block with millimeter-perfect measurements. Every backhand made complexity seem simple—the way a leap by a great ballet dancer gives the illusion of effortlessness, whereas in truth it is the by-product of intense training. And that serve! Most tall people seem to stoop a tiny bit, but not Newcombe. He rose onto his toes and extended his arm to the maximum altitude, the racquet meeting the skyscraper of a toss at the right moment to send the ball soaring to its precise target on the other side of the net. His volleys, lobs, and overheads were textbook-perfect. He moved like a gazelle. But that wasn't it: It was the something extra, the aliveness, the constituents of charisma.

I'll always remember Newcombe's reaction when his opponent laced a driving forehand to the far back corner of the court so that he couldn't

possibly reach it. First, he smiled in admiration. Then he put down his racquet to have both hands free to applaud. It was more than class. Yes, I make comparisons to President Kennedy; these are people who injected life with a grace that had an indelible impact during my teenage years.

No one calls Newcombe the best player ever. He once won Wimbledon, and garnered his share of major trophies, but he was not up there with his colleagues Laver and Rosewall. That's part of what made him likable. What he didn't have in hardware (my term for sports trophies), he made up for in charm. Look at that smile! See those crow's feet—they showed life really lived. The guy sparkled. And it wasn't just his gleaming teeth beneath the dapper mustache; it was more; it was panache.

Facts about our heroes can be quite surprising. Newcombe was born in 1944 and stood six feet tall. So now I know that the guy who seemed like a nimble giant, the epitome of maturity and savoir faire to the teenage me worshipping him at courtside, was only three years older and just three inches taller.

Statistically, the only time Newcombe was "best in show" was for his second serve. It was an ace more than the usual number of times. Maybe that detail sums it all up. Just when you thought he couldn't do it, he pulled out the miracle. How James Bond! To be down after missing the first serve, which is like having not just to escape, but also to vanquish the rival who had you at knifepoint, with a clean, can't-even-touch-it victory. The guy was more than a good tennis player; he was a magician.

Newcombe was my hero and my wannabe, but until recently I never knew why. Then I found a firsthand account of him playing at Wimbledon in 1967, written by the longtime *Sports Illustrated* writer Frank Deford, whom *The New York Times* dubbed "a literary storyteller of sport." It opens with a flourish: "At 23, John Newcombe is handsome, attractive, popular, quick, confident, and—as winner at Wimbledon in July—champion of the amateur tennis world." Deford is patently enchanted: "Newcombe plays the net with his own special daring—on top of it, challenging like a third baseman moving in close, defying a potential bunter to hit away. And his on-court peculiarities—shirttail out, tousled towhead, a large inurbane grunt that he dispenses with

each serve—can become crowd-pleasing characteristics. The considerable charm of the private Newcombe is unlikely to remain hidden within the public one."[6]

Newcombe lost in the finals of the US Championships that same year, but a contemporaneous report of the match makes it obvious that he was hardly a shirker:

> He roared away to a terrific start, serving like a bomb and volleying with tremendous confidence. Few players look quite so thoroughly aggressive and out-for-the-kill on the court as Newcombe. With his huge springy stride, square shoulders, and handsome features that contort and grimace with every mighty effort he makes, he seems to be hellbent on landing the knockout punch before the referee stops the fight.[7]

Newcombe won at Wimbledon again in 1970 and 1971. In an article about the finals, the sportswriter Walter Bingham called him "a big, strong, good-looking 26-year-old with a crashing serve and volley and the stamina to run all day." But Bingham also captures him at a moment in which he is beguilingly self-effacing: "Newcombe admitted his back was better than last year, when he had been forced to sleep on the floor of his London hotel room. 'Bit embarrassing, you know,' he said, 'looking up at the wife to say goodnight.'"[8] But nothing made him quite as sympathetic as his remarks following a loss to Rod Laver in a five-set match at Madison Square Garden in 1971. "'He never ceases to amaze me,' said Newcombe . . . 'When I make a truly great shot, I look up and thank God. Rod takes his for granted.'"[9] Modesty is an essential component of charisma.

The first female athlete I noticed with that inexplicable extra something was Virginia Wade. This is not simply because, like Newcombe—they are almost the same age—she garnered an impressive number of Grand Slam titles. Nor is her particular radiance the result of her having won Wimbledon in 1977, which was the year of the Queen's Silver Jubilee as well as the hundredth anniversary of the tournament. For those are facts, and facts are not the point. What made Wade exceptional was her intelligence. I am sure she has that still, but I

use the past tense because I am thinking of her in the epoch when she was a public figure.

Virginia Wade projected wisdom. It helps that at the height of her tennis power, she resembled Virginia Woolf—not just because they were both Virginia W's, but because of the intense thoughtfulness. The dark hair, black before it was salt and pepper, and those strong blue eyes imbued her with real stature. Beyond that, she had an exciting edginess that distinguished her from other players. The daughter of an archdeacon and a mathematics teacher, brought up in vicarages, Wade was high-strung and volatile and did not conceal it. She was deemed haughty by other players because she spoke like the educated person she was. Her mix of class and the fire within was irresistible to me.

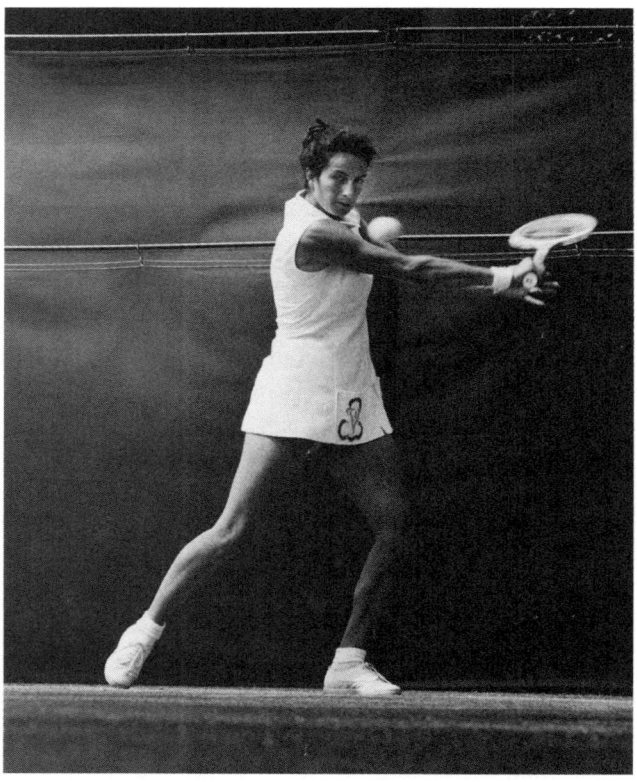

Wade had an intensity in everything she did.

Others deemed her uncouth and aggressive; I thrilled to the nervous energy that infused her damaging forehands and merciless backhands. The way she was triumphant manifested charisma.

I became enchanted by Wade when I learned that to relax between matches, she read Henry James. That in itself is not charisma, but in my eyes Wade was the tennis equivalent of some of James's most intrepid female characters. She had something that set her apart from the others, a sort of restlessness as well as an independence. She had a staggering talent that meant she could have had minions waiting on her, but she chose to be private and solitary. She never groaned; she never showed off. She embodied quality. She never tried to be anything she was not.

The sportswriter Herbert Warren Wind wrote about the first US Open, in 1968, when both pros and amateurs were allowed to play. It was played on grass at Forest Hills, and Arthur Ashe won the men's finals against Tom Okker; if ever two tennis players had exceptional grace and class, this was the occasion. Meanwhile, in the women's singles finals, Virginia Wade "outclassed Billy Jean King, the defending champion, 6–4, 6–2, hitting out all the way and never losing her nerve or her purpose."[10]

Such steel is a beautiful quality. But that was what distinguished Virginia Wade: She had the concentration of a master musician or a ballerina, the totality of engagement that is the reason certain tennis players may be considered artists. In 1975, in the important Virginia Slims tournament, Wade beat a highly ranked California-born player named Julie Heldman in attire people would never forget. *Sports Illustrated* reported, "The fashion parade was led by England's Virginia Wade, who actually won a match wearing a dress of frosted turquoise lamé with a Marie Antoinette diamond-necklace neckline (rhinestones, really). When she strolled on court she looked as though she had chopped a few feet off a slinky evening gown before picking up her rackets."[11] Heldman went on to write an essay in which she likens Wade to "a Lioness, albeit only a cub." Heldman, who was America's No. 2 player but lost a lot of important matches against Wade, goes far with the analogy:

> The lion is distinguished by his pride, his roar, his courage and his killer instinct; our heroine is just as famous for these very same qualities. The lion is King of the Jungle; our protagonist is Queen

of the British Courts. She becomes frustrated when her right paw does not connect correctly with fleeting victory and then we are treated to the roar of pain of the wounded cub who goes off to the corner to lick her wounds.... Virginia is the most educated lioness in captivity, having earned a high degree in mathematics at Sussex University. Her assets are a bright and disciplined mind, great athletic ability and an indomitable desire to **succeed**.[12]

Heldman, herself no slacker in the major matches they played against each other, captures Wade's intensity, the fire that can be the essence of charisma. "When she is ahead, she stalks about the court with deadly efficiency, slashing balls at all conceivable angles, but when the foe begins to look unconquerable, her discouragement becomes evident to the onlookers. If unhappiness could be measured in decibels, Virginia's vociferousness would probably be counted second only to my own hearty screams."

But the anger is mostly at herself. Exigence is a key to charisma. Virginia Wade had it in spades.

2

TENNIS IN THE ART OF BONNARD AND VUILLARD

THE ALLURE that comes when one dons tennis whites and takes the racquet in hand inspired the artist Pierre Bonnard to a rare evocation of human agility. In one painting of a group of people luxuriating in summer sunshine, he immortalized that moment unique to the tennis serve when players contort their bodies to rise like a gazelle and put the ball in play. His friend the artist Édouard Vuillard also captured the sport on canvas, undertaking commissions for one of the most charismatic tennis players of the 1890s. The sense of well-being that comes with tennis infused the art of these pioneering painters in surprising ways.

Bonnard and Vuillard were two of the most inventive artists in France in that fertile period when revolutionary new styles of painting were emerging all at once. While the Cubists were expanding all notions of perception and the Fauves were heightening colors to extremes, Bonnard and Vuillard took a new approach to rendering everyday life: Their art is a celebration of sunlight illuminating ordinary existence. They give us the corners of gardens and the presence of people—sitting with coffee cups in hand, or emerging from the bath, or holding their tennis racquets—in paintings that were a bridge between Impressionism and abstraction.

Both evoked the world as shimmering surfaces with spatial depth receding in the background. In their work, light renders mass

weightless, and in a vast woven tissue, people and their accoutrements merge, the brioche on a breakfast table having the same value as the bland-featured woman who may soon eat it. They were certainly distinct from one another—we have no trouble differentiating Vuillard's muted and atmospheric colors from Bonnard's sundrenched ones—but joined in their creation of a new artistic style in which representation was secondary to the expression of emotion.

There are libraries devoted to Bonnard and Vuillard—there are books of their letters that give us details of their friendship—and their work, ranging from small sketches to canvases that occupy entire walls, can be seen in museums all over the world. Here I focus on their art specifically associated with tennis.

From Bonnard, we have a sketch of a player in three positions, and a large painting of a paradisiacal summer scene, all a light lavender-purple and vibrant orange, where the same player from the sketch is shown at the right edge of the canvas. This painting, *The Terrace at Vernonnet*, belongs to a series of the artist's large compositions illustrating groups of people luxuriating in the sunshine (see Color Plate 1). The position of the tennis player is not easy to discern, but in this painting she is in the back scratch position of the serve. This is that moment when the stronger arm (for most people, the right, as is the case in Bonnard's tennis player) is bent backwards, the elbow thrust upward, the racquet dropped to the small of the back. The left hand has been lowered near to the ground and is about to be raised to the fullest height for the toss. We see only the handle of the racquet, but in the pencil sketch, we see most of the racquet head as well. The player, in her striped blouse and her straight skirt puffed out by her stretching motion, looks deep in concentration within this combination of motions that is possibly the most difficult feat in all of tennis. Few players can do it right: get the racquet down far enough and relate the movement of the two arms so precisely that the tossed ball will be high above when the racquet hits it. By then, the arm that was crooked will be stretched upward, so that the ball can be struck with maximum force to arrive in the opponent's service court with speed and power that will make it daunting—ideally, impossible—to return. Bonnard had an astute understanding of the technique of the serve.

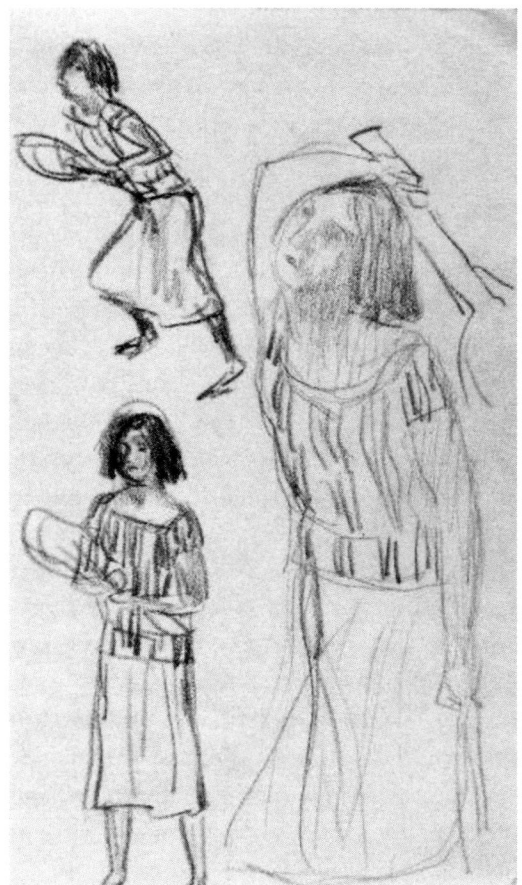

This Bonnard drawing is a marvelous evocation
of three different positions mastered by
a competent tennis player.

In this pencil sketch, there are two other images of the same player. Her neat pageboy and determined look suggest that she is quite serious about her sport. In one image she is in the "ready position" and in the other at a moment of waiting. At the upper-left part of the sheet, she is primed to receive the ball in perfect form. Bonnard portrays her with her weight on the balls of her feet, her heels lifted; in that position, she is ready to move as soon as she knows where the shot will land. She holds her racquet in both hands waist-high, so she can respond quickly

with either a backhand or a forehand, depending on what's appropriate. At bottom left, she stands still in a sort of rest position—maybe she is playing doubles and her partner is soon to serve, perhaps the opposition is getting ready for action. In all three images, Bonnard's technique is superb, his pencil stokes lightning-fast, suggesting the speed of the tennis in play. There is animation; Bonnard tells us a lot with only a few lines and renders a face, the fingers on one hand, such that nothing is detailed, yet everything is plausible.

Art lovers who see *The Terrace at Vernonnet*—begun in 1920 and completed in 1939—will probably not appreciate the exceedingly odd position of the character primed to serve a tennis ball. In oil paint, she is less easy to read than in the pencil sketch, which we presume to have been a study for the painted version. The woman with the racquet halfway down her back is unrelated to the rest of the scene and to the two women standing with their large bowls of fruit at the center of the canvas. The tennis player is behind a park bench, standing on a patch of grass; the material on the ground in the rest of the scene is the stone of the terrace. The canvas is, rather than a single synchronized scene, a generalized image of summer life, no one person's activities obviously connected to another's. On the far left, a couple talk in the sunlight. On the white tablecloth, the bottle of wine and paniers of fruit are luxuriant; the large tree trunk is imposing and almost harsh. There seem to be fields and a mountain in the background, but nothing is certain except that the mélange of elements is beautiful.

Two Vuillard works that feature tennis as a marvel of summertime depict a woman seated at courtside. One is a study, the other the final version of the painting, made in 1907 at Castle Guernon Ranville. They are relatively obscure in his body of work and present tennis not so much as a sport as a requisite of opulent country living. We see almost the entire tennis court behind the woman, who, dressed in white, will presumably play, although at the moment she is sitting in a garden chair. It captures a delightful moment of repose.

Here tennis in the summer sun, the fenced-in court with its shimmering white lines, the man smoking a cigarette in a straw hat and dark suit, and the woman impeccably coiffed as well as elegantly dressed, all evoke well-being. Tennis is one of the expected pleasures of country life

for people of means who make their home in a chateau, and Vuillard's fluid brushwork, the apparent ease with which he conjures a complex scene, the movement from the sitter to the court behind her, provide a sense of plenitude. Sport, we must never forget, is one of the greatest pastimes known to humankind.

But equally art—in the form of paintings, ceramics, and literature—can be central to the existence of tennis players. One champion—Jean Schopfer, largely forgotten today but once the winner of winners—commissioned art of the highest order. What Vuillard did in return is the surprise that follows.

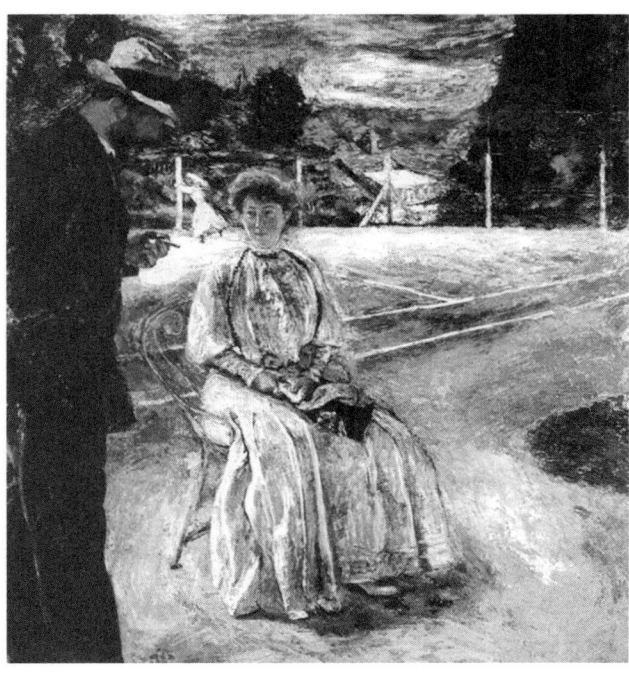

Vuillard's subject, seated in front of a lovely tennis court in the countryside, is dressed perfectly for her game.

3

THE CURIOUS CASE OF CLAUDE ANET

My discovery of Claude Anet began with a porcelain plate that the painter Édouard Vuillard decorated with an image of a woman frolicking in a diaphanous, polka-dot blouse and a white skirt that has a flowing blue hem. This delicate object is now in the Musée d'Orsay, in Paris. The plate, its label tells us, was commissioned in 1895 by Jean Schopfer, "connu comme champion de tennis sous le nom de Claude Anet, à l'occasion de son mariage en 1895 avec Mrs Alice Nye Wetherbee."

A tennis champ who used a pseudonym based on a character in the writing of Jean-Jacques Rousseau, the Swiss-born philosopher whose innovative thinking helped give birth to the notion of the French Enlightenment? A bon vivant who asked Vuillard to make this and other white china plates painted sumptuously with this animated image of a stylish, fun-loving young woman? The bridegroom who married a woman with that name which could come from an Edith Wharton novel?

This is someone about whom we want to know more. That identification of an object in one of the easily overlooked side galleries in this noted Parisian museum warranted investigation.

A bit of sleuthing unearthed more surprises. From 1898 to 1900, the tennis star commissioned two pairs of large panels by Vuillard. In 1908, Schopfer wrote a book called *L'Amour*, for which Bonnard would

The tennis champion Jean Schopfer took the name of Claude Anet, who in the eighteenth century had been the lover of the woman with whom Jean Jacques Rousseau lost his virginity. Schopfer/Anet assumed many different identities under both names.

contribute illustrations fourteen years later, in 1922. In 1910, his second wife had her portrait painted by Bonnard; in 1930 Bonnard would do two portraits of Schopfer's daughter. In between his practice sessions on the best grass and red clay in Paris, Schopfer excelled as an art critic and owned a gallery. After arriving in St. Petersburg, in 1914, at the beginning of the war, he wrote four books comprising a firsthand account of the Russian Revolution. Calling himself Claude Anet, he penned novels that were turned into films we still watch today and wrote the first biography of the French tennis star Suzanne Lenglen.[13] He used two different names, but he had more than two distinct identities, managing to flourish in most of them.

What sort of tennis player was this aesthete? A consequential one: In 1892, he was the winner of the second French Championships, which had begun the previous year. This was because he had won the title of the very first International French Open, which would eventually become the tournament known as Roland Garros. And what kind of writer? One whose novel *Ariane, jeune fille russe* would become the basis of the Billy Wilder film *Love in the Afternoon*, in which Audrey Hepburn, as the cellist daughter of a private eye (Maurice Chevalier) whose specialty is uncovering the liaisons involving the wives of wealthy businessmen, prevents a

man (Gary Cooper) from being shot dead by a jealous husband. To save him, she barges into a suite at the Ritz in Paris, where Gypsy music and room service meals are part of Cooper's seduction routine. Anet's historical novel *Mayerling* spawned three film versions and a ballet.

The more we investigate the life of this star athlete/arts patron/novelist, the more we find him to have been colorful, talented, and warm-hearted. Jean Schopfer was handsome, he was rich (at least most of the time), and whatever he did he did with panache. Overall, he led a charmed existence. He could write with the force and elegance with which he hit a tennis ball. Why did he get lost to history? Stumbling on the label for a porcelain plate decorated by Vuillard and learning that the person who commissioned it was none other than a champion tennis player was a stroke of luck. For with his extraordinary aliveness, Schopfer emerged as a person of charisma.

◆

JEAN SCHOPFER was born in Morges, in the French-speaking region of Switzerland, in 1868. His family, mostly French Protestants, had been exiled there for two centuries. His father was a wealthy banker. His mother, Emily Barton, who was English, was the quintessential banker's wife of the era: She hosted a sort of salon, where among the guests were Jules Renard, a French naturalist well known as a writer and playwright, and other cultural leaders. Schopfer's youth was spent in elegant settings, with devoted parents, lots of tennis, and ample opportunities for younger men and older women to succumb to one another's appeal.

In his 1909 *Adolescence*, his debut novel, Schopfer, for the first time using the name Claude Anet, described aspects of this privileged childhood. He and his mother, just the two of them on a luxurious Oedipal holiday, were in a grand hotel together. Anet danced and played tennis with abandon.

"When I was with my mother, I continually missed the comfort and delightful calm of our home and complained incessantly about the comings and goings at the large hotel in which we lived, where being alone was utterly impossible. Yet, there was something

uniquely charming about rubbing elbows and exchanging glances with so many strangers, something appealing about the communal lifestyle, intermingling our enjoyment and activities, about meals at the restaurant, dancing in the evening... I had proclaimed I wanted to live like a savage. I had not been at X... more than 48 hours and I was already in on every game of lawn tennis and dancing each night away. I did everything with a sense of urgency. To feel numb, to forget. Forget what?[14]

It is not long before the speaker finds himself obsessed with an older woman, La Comtesse de Francheret, who is already known to him from the society pages. Deeming himself "a young provincial," he feels that she is from a superior social class. Her aristocratic name is one of the many things about her that excite him.

It is on the tennis court that their relationship advances, from distant observation to exchanges of glances. In the reader's imagination, the man is a powerful tennis player. His competence comes through in his writing voice; there is no chance that this is a player who just loops the ball over the net. He is, in fact, good enough to attract an audience along the court. Romance sparks: "Two or three times, I felt her penetrating gaze on me. In the afternoon, she would come by the tennis court where I played. There was always a crowd, and she kept her distance. Still, whenever I looked up, I rarely failed to catch her looking back at me."[15]

A couple of days pass. The adolescent would like to approach the countess but does not know how. Then he has a stroke of good fortune. One day, as dusk falls, just as he is getting off the tennis court and going for a shower, Madame de Francheret drops her scarf. He hands it to her and they start to chat as if they are old friends.

The detail of being on his way to the showers is brilliant, subtly encouraging the reader to picture the athletic young man nude, standing tall as water cascades down his body.

The relationship between the strapping teenage hero and the beguiling countess grows. They see each other every day; she often comments on how young he is. Then, one afternoon, he visits her in her apartment. Again, she tells him how young he is, adding "How lovely!"

He feels the warmth of her breath; she puts her arms around his neck; and then comes a one-line paragraph: "When I left her room one hour later, I had become a man."[16]

It is an elegant way for the reader to understand that this athletic teenager has lost his virginity. Longer accounts of their relationship follow; they are no more graphic than that, but they don't have to be, because Anet knows how to evoke ecstasy without describing it. The young man explains quite simply that he has come to spend his afternoons in the apartment of Madame de Francheret, playing tennis only at the end of the day, and that even then he finds himself practicing with lassitude. Other pleasures take over the young man's life, but we still see him as fit, quick, and thoughtful. The way he plays tennis is the way he lives: with verve.

WHEN JEAN Schopfer was eighteen years old, his parents sent him to Paris to study literature at the Sorbonne. Equally interested in the visual arts, he quickly registered in the École du Louvre as well. In 1897 he earned his degree; his thesis, on medieval manuscripts, was so good that it was published three years later.

While he was learning about literature and art history, Schopfer practiced his tennis—hard and diligently. Presumably there were more women like Madame de Francheret in his life, but he now made the sport a priority. In 1892, when he became the champion of France by winning the singles finals of the French Championships, the twenty-four-year-old Schopfer beat an American player, Francis Louis Fassett. Nine years older than Schopfer, Fassett, born in Philadelphia but educated in Lausanne, played the international circuit; like Schopfer, he was a highly gifted amateur whose family's comfortable circumstances had enabled him to work on his game without the need to make a living. In this sport, mostly the enclave of upper-class gentlemen, Schopfer again made it to the finals, in 1893. This time he lost—to a Frenchman, Laurent Riboulet. Riboulet, twenty-three years old, born in Lille, was another of these gentleman athletes who achieved a level of excellence. Although he never won a championship again, he got to the finals of the

French Championships two more times. He is one of many characters in Schopfer's world who was a minor star and forgotten today.

Besides practicing forehands and backhands and attending classes, Schopfer was spending time at the Lycée Condorcet, a meeting place for some of the most adventurous artists and writers of the era. The playwright Pierre Veber, a habitué of the Condorcet, who called Schopfer "un garçon merveilleux,"[17] introduced him to Vuillard and Thadée Natanson. Natanson, who was the same age as Schopfer, and his brother Alexandre founded, in 1891, *La Revue Blanche*, an avant-garde magazine devoted to art, music, and literature. Schopfer immediately began to write for the publication, specializing in the decorative arts.

La Revue Blanche, writes the art critic John Russell, "was for eleven years the best periodical of its kind that has ever been published."[18] Schopfer's articles appeared in it regularly from the start. While honing the tennis skills that would enable him to be the French national champion, he was spending a lot time in the company of intellectuals. His colleagues at the magazine were a different lot from his fellow athletes. In the same pages where Schopfer regularly published articles on art and design, Debussy reviewed a performance of the Berlin Philharmonic in Paris, Mallarmé's poem "Tennyson" appeared for the first time, Tolstoy and Nietzsche were printed in translation, the young André Gide contributed a story, and the futurist artist Filippo Marinetti reported from La Scala. The range of subjects went beyond the arts: There were pieces about antisemitism in central Europe, endurance training for bicyclists, and the significance of Bismarck's birthday. Léon Blum, who would become prime minister of France, was a regular contributor, and Vuillard and Bonnard provided art for the covers.

Schopfer considered himself an intellectual peer but a social superior to his colleagues at the magazine. His close pals Thadée and Misia Natanson—she would, after marrying the painter José-Marie Sert, become renowned as a friend of Serge Diaghilev's and Coco Chanel's—were fashionable enough for most people, but apparently not Schopfer. On one occasion, when everyone else at the Natansons' was dressed in "black tie," Schopfer showed up in tails. He explained proudly that he would be calling on Princess Morat later that evening, adding that of

course the rest of them could never expect to have the same entrée. His condescension became part of his reputation.

Meanwhile, Schopfer cultivated connections with some of the greatest young French artists of the period. The relationship with Vuillard, who had his first solo exhibition, in 1891, in the offices of *La Revue Blanche*, began to grow, thanks in part to Thadée Natanson, who often wrote letters to Vuillard in which he mentioned Schopfer. Natanson regularly attended a salon that Schopfer and his brother, Louis, a pianist who had gone to Paris with him, had in their apartment on the Quai Voltaire, and Natanson liked Schopfer's companionship for going to art shows. In April 1895, Natanson and Schopfer went to an exhibition of designs for windows to be executed in America in stained glass by Louis Comfort Tiffany. Vuillard's ravishing study of chestnut trees in the snow, intended as a motif for a window, inspired Schopfer to ask Vuillard to undertake a commission for a porcelain table service. The idea of a project that would give him a role in the burgeoning decorative arts movement appealed to Vuillard, and for Schopfer, recently engaged, it was an ideal wedding present for his bride-to-be.

THE CEREMONY was scheduled to take place in New York City on October 23, 1895, at the Church of the Heavenly Rest on upper Fifth Avenue. Alice Nye Weatherbee's father, Gardner Weatherbee, owned luxury hotels; it was sure to be a stylish event. The dinner service hand-painted by Vuillard would make a gift that matched the splendor of the occasion. Alice was, according to *The New York Times*, "an unusually attractive and highly accomplished young woman." A sculptor, she also fenced and rode horses. A gift with Vuillard's artistry and élan was sure to please her. And it was an added delight that Vuillard's main subject was contemporary women in stylish clothes. Every mention of Alice Weatherbee in the newspapers called attention to her good looks, and she enjoyed seeing women of the same description.

In May 1895, Schopfer asked Vuillard to give him "an hour or two on a day that will suit you"[19] to discuss the china service. Subsequently,

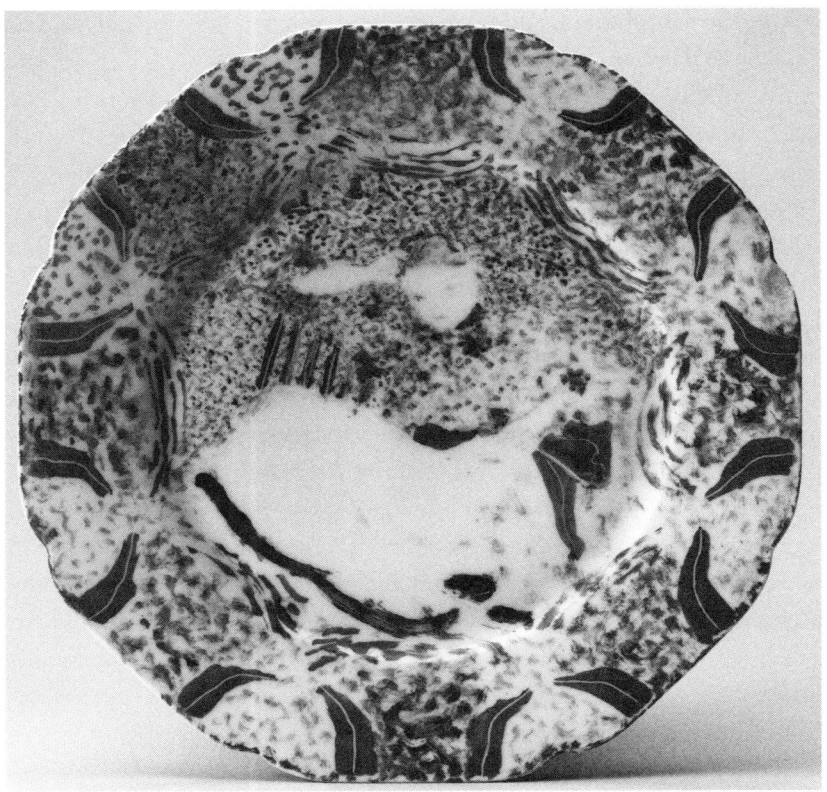

At first the figures in Vuillard's dinner service are difficult to discern, but then they and their surroundings become seductive.

Schopfer provided Vuillard with what are called "blanks"—unglazed porcelain ready to be decorated. He picked a standard wedding model of Limoges white porcelain. Called the Pompadour Service, it was available in a large shop on the rue Drouot. Schopfer bought dinner and dessert service for twelve: that is, per person, a seven-piece place setting with a soup bowl, five round plates of different sizes for fish, vegetables, meat, potatoes, and salad, and a concave "coupe plate." In addition, there were eight serving pieces.

Schopfer's daughter from his second marriage remembered 144 pieces, which is no doubt an exaggeration of the reality; the place settings and serving pieces would have added up to under a hundred. Nonetheless,

her memories of the splendor of the dining room table set with the hand-painted dinnerware were surely accurate.

Besides the plate with the woman in a "petit pois" blouse and blue-bordered skirt at the Musée d'Orsay there is a second one in the d'Orsay. It depicts a woman in a feathered hat, a blouse with puffed sleeves, and a skirt with a pattern of squares. All but nine of the pieces Vuillard painted on commission, however, have disappeared (seven are in a private Swiss collection). Yet although so little remains, at least to the best of our knowledge, a remarkable chapter of history has opened to us by following events in the life of a French tennis champion. None other than Pierre Bonnard wrote to Vuillard about the Schopfer set of porcelain dishes, commending the project in a letter of September 17, 1895. After lamenting his inability to change his travel plans so that he might be in Paris for the opening of a Vuillard show on September 28, Bonnard writes, "I wish you every success with your coffer. What a lovely thing it is to decorate a service set. And with so many different pieces, there is no harm in getting started straight away."[20]

Vuillard's sole examples of decorated objects, the dinner service is, besides these enchanting pieces in Paris, known mainly from photos that appeared in an article Schopfer wrote for the January–March 1897 issue of the *Architectural Record*. Even without the originals, we can imagine the plenitude and the excitement of the variations. Vuillard painted seven closely related pieces for each of the dozen different place settings. This meant that all of the diners had their own unique Vuillard series, with its design transformed as the soup bowl was replaced by the fish plate, the fish by the meat, and so on.

Each set of china has a fashionable woman at the center. Bold, decorative scrollwork surrounds her, the ornamental lines working in harmony with the shape of the plate. To achieve the sumptuous effect, Vuillard used what are called "overglaze" paints. He would apply a light coat to the white porcelain, after which the piece was fired. Then he would add more paint and fire it again, with further painting and firing if he was not yet satisfied. He worked with a limited palette of oxides: cobalt blue, copper green, and iron, the latter a reddish brown. He left some passages unpainted or removed some of the paint after applying it, which accounts for the ethereal feeling of the results. The method

was similar to the way Vuillard made lithographs. Now he showed substantial amounts of white porcelain in the same way that he left whole areas of white paper. The large passages of pure background add a feeling of weightlessness. The china has a breeziness that defies the solidity of the porcelain; the blue and green strokes of paint, feathery light, have the same elegance as the women's clothing.

Painting all that porcelain in a single month required intense concentration, and the dishes exude Vuillard's energetic engagement. The goal had been to make functional, everyday objects as visually enticing as they could be, and Vuillard succeeded.

The main motifs reveal how much Vuillard cared about what was fashionable. The women's spotted sleeves, silk blouses, low bodices, large bows and ribbons, and feathered hats belong to what Schopfer calls "all the frivolous and charming side of feminine life of the present day." As with Vuillard's paintings, one could focus on the details or succumb to the overall impression.

FOLLOWING THEIR marriage, in 1895, the Schopfers settled into a luxurious way of life, facilitated by Alice's family money and Jean's income from tennis. Alice sculpted and Jean wrote when he wasn't on the court. Jean maintained his close connection with Vuillard; in 1896, he asked the artist for work to use as illustrations for *La Revue Franco-Americaine*, and in 1897 Schopfer and Vuillard went to Florence and Venice together with the painter Maurice Denis.

That March, the Schopfers moved into a deluxe apartment on the Avenue Victor Hugo, in the middle of Paris's posh sixteenth arrondissement. The location could hardly have been better, in one of the most fashionable neighborhoods of the Right Bank and a short carriage ride or agreeable walk to the tennis courts in the Bois de Boulogne.

The Schopfers lived well, enjoying trips to America, where, at the Metropolitan Museum, a short walk from his in-laws' apartment, Jean gave lectures. He also enjoyed large audiences at Columbia, Yale, and Princeton. And he began to write books. At least eighteen titles would

appear under one of his two names; the first, *Voyage ideal en Italie*, came out in 1899 and the second, *Petite Villa*, in 1901. Some were novels, but there were also historical chronicles, biographies, and books on travel. Jean would start going to Persia and often write about it, producing the titles *Les Roses d'Ispahan: La Perse en automobile, à travers la Russie et le Caucase* (1906), *Feuilles Persanes* (1924), and *La Perse et l'esprit Persan* (1925); he also translated Omar Khayyám. There would be four volumes about the Russian Revolution, a book about love, and novels of sufficient quality to be translated into English.

In France, meanwhile, the Schopfers had access to such agreeable country houses that they did not yet need to have one of their own. The dashing tennis player and his pretty American wife commissioned Vuillard to paint a pair of canvases that evoked the paradise they enjoyed at the home of friends, a redbrick mansion near Dijon, surrounded by vineyards that produced some of the finest Burgundy grapes. The paintings—each 214 cm high and 161 cm wide—hung side by side. The left shows an idyllic scene in front of a dwelling, with its ivy-covered brick and its large windows shuttered against the midday heat. Bonnard, lean and bearded, his legs in wide-cut vertically striped trousers, is playing with a small dog; Marthe Méligny, whom he would soon marry, is reading a fashion magazine. The style of painting suggests a certain languor; Marthe in her flowered blouse and voluminous red skirt is not so much seated as hovering in front of a classic outdoor bench. The impression of physical weightlessness—the sense that all is floating, yet firmly positioned in space—adds to the atmosphere of this canvas, in which air and matter are both convincing. Could life be more agreeable? And could it more successfully evoke the grace and lightness of a game of tennis well played? The characters are ethereal; sunlight has the effect of dematerializing everything; even the large and hefty trunk of an old tree is splashed in white so that it shimmers. The paintings are oxygenated. Relationships are in harmony.

To fund a further sumptuous canvas by Vuillard, Schopfer had organized a tennis tournament in Divonne-les-Bains, a spa town in the French Jura, near Geneva, that was very much like the setting in his writing about his adolescence. How the tennis tournament proved lucrative is still a question, but it enabled him to pay for Vuillard's

masterpiece. It was presented at a party for the collectors' friends on December 18, 1901.

It was a cold evening when the guests first saw the additional depiction of summer in the capacious apartment on the Avenue Victor Hugo. We can imagine the pleasure of drinking champagne in a well-appointed room where this idyllic scene gave them a feeling that all was well in the world. At that event, a week before Christmas, what a treat it was to feast on this large canvas where sunlight shimmers in lush foliage and in wildflowers blanketing the ground. The smiling exchange of the characters in the painting, and the style with which they live, make everything luxurious.

Jean Schopfer is beaming in the middle of the background. He is the height of summer elegance with his straw boater, neatly tied black bow tie and crisp white shirt, and the hint of a white handkerchief in the breast pocket of his dark green suit jacket, probably of fine linen. In the foreground, Alice Schopfer, in a white dress, is the dominant figure. She is talking to Bonnard. Standing with his legs slightly splayed, almost as if he is about to begin dancing in his shiny black pumps, he wears a white suit and foulard and holds his straw hat jauntily as he looks at Alice. Their white clothing suggests that it is the tennis season.

John Russell summed up the world revealed here:

> Everyone was free to talk or not . . . and clever men and pretty women were completely at ease with one another. Nobody had to show off, nobody deferred unduly to anyone else, no one was in a hurry to leave.[21] . . . If many of the paintings of the 1890s have unearthly overtones for us, it is because Vuillard's sense of tone at that time was uniquely persuasive. A sense of celestial security comes over as he re-creates the world, touch by touch, in such a way that everything in it harmonizes with every other thing. What in other hands would be a jungle of discordant patterns comes out as paradise on earth: the world is at one with itself. . . . Space does not retreat before us; we can caress it.[22]

Not everyone had these impressions, though. In 1905, André Gide, in an article about Vuillard in the *Gazette des Beaux Arts*, wrote about "the

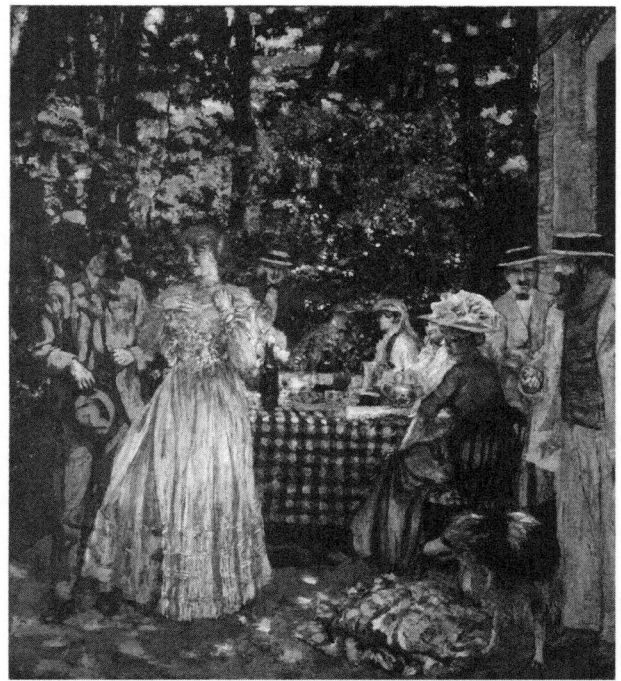

Every character in these sumptuous scenes could be part of the Schopfers' orbit.

discreet melancholy which pervades his work. Its dress is that of everyday. It is tender and caressing; and if it were not for the mastery that already marks it, I should call it timid. For all his success, I can sense in Vuillard the charm of anxiety and doubt."[23]

If some of us feel that the world immortalized by Vuillard at Jean Schopfer's behest represents the peak of moneyed leisure, with the sun shining and people seeming to have not a care, Gide considered their hold on life somewhat tenuous.

It may be possible to see the paintings firsthand: They are now owned by the National Gallery, in London. They are not always on view, but when they are, they are ravishing. To most of us, they are without melancholy or doubt. The paintings commissioned by a self-assured tennis player exude only confidence, and the dexterity and technical skills necessary for the expression of joy.

◆

IN JANUARY 1903, the Schopfers ended their marriage. There was no scandal; it was simply a case of differences "relative to their civil interests," according to the divorce papers. Alice moved back to America, heading to California with the couple's young daughter. Before she left Paris, she gave or sold the first two Vuillard paintings to the brothers Emmanuel and Antoine Bibesco, Romanian princes. Jean got to keep the large *The Luncheon at Vasouy*. He was entitled to it in the divorce settlement by organizing a tennis tournament in Divonne-Les-Bains, which proved to be a profitable venture. A gay divorcée with a full social life, Alice married the Count Festetics de Tolna in February 1908.

In about 1904, Jean Schopfer was—albeit briefly—expelled from paradise. His father died and left large debts. Suddenly Schopfer was close to broke. He wrote to Vuillard because he was moving to a smaller apartment and wanted the artist to store the paintings somewhere safe. At least he did not have to sell them, but he could no longer afford a big enough living space to have them on view. In those days, even the greatest tennis players had no income from the sport unless they gave lessons; there was no prize money from tournaments back then. Without funding from either his parents or his wife, he had to find another income.

Soon enough, the first French national tennis champion came back to life—with a new name. This was when, with the publication of *Les Bergeries*, he became Claude Anet.

It was a provocative sobriquet, both erudite and mischievous to those in the know. The original Claude Anet was the lover of La Baronne de Warens. Madame Warens, twelve years older than Jean-Jacques Rousseau, was the person who gave Rousseau his sexual education. By then Anet, a serious young man who was midway between Rousseau and Madame de Warens in age and was her amanuensis, had for some time also been her sexual intimate. Schopfer had chosen to name himself after the least-known member of a celebrated ménage à trois.

In his new existence, in addition to enjoying success as a novelist and continuing to prove his prowess on the tennis court even if no longer engaging in national competitions, he opened a gallery of Persian art.

After taking an apartment at 63, rue de Chaillot, in the chic neighborhood between Trocadéro and the Place des États-Unis, he retrieved *Luncheon at Vasouy* from Vuillard and installed it over a leather sofa that was almost the same green as the foliage in the Vuillard canvases. On an upswing, Schopfer/Anet remarried, again advantageously. He and his second wife moved to the Left Bank, to 109, rue du Bac. In that apartment in a bustling neighborhood in the Faubourg Saint-Germain, he had a wall built between the dining and living rooms just for these two paintings. Plates from Vuillard's dinner service hung on a wall in the dining room, even if he had commissioned them for a different wife. Happy to be back in a grand apartment, he installed panels by Xavier Roussel, a Bonnard nude, and a portrait Bonnard made of his current wife.

In that image of the woman who was referred to as both Clarisse Schopfer and Mrs. Claude Anet, Bonnard rendered a stolid person soberly. It is not as spirited as were, for example, Bonnard's many portraits of Misia Natanson. Clarisse is wearing a single strand of pearls, which, along with her filmy white dress, is one of the few sources of light in an otherwise dark canvas. Misia Sert wrote in her diary about Vuillard's response to the painting. Visiting the Schopfers, Vuillard said that "seeing his own work alongside Roussel's and Bonnard's, he was struck by his own ignorance of drawing."[24] It was a remarkable tribute from an artist discussing the work of his closest colleague.

AGAIN USING the name Claude Anet, our subject's firsthand account of the Russian Revolution is still a historical resource. In 1917, he published *Through the Russian Revolution: Notes of an Eye-witness from 12th March–30th May*. He wrote it in what was then called Petrograd (formerly St. Petersburg, eventually Leningrad, and now St. Petersburg again) as daily dispatches he sent to Paris for publication in a newspaper; the book came out in an English translation later that year. For now, he has absented himself from the tennis court, immersing himself in difficult circumstances abroad.

Anet describes Cossacks attacking crowds. He had to use the same craft with which he played tennis to manage to send telegraphs to Paris.

He provides an hour-by-hour account in which Rasputin's appointees face death, governments fall, and the tsar's whereabouts are closely monitored. He uses chutzpah to negotiate the transmission of his dispatches: "I had to explain . . . the necessity of allowing me to telegraph to my journal. The German wireless, I said, was announcing the Revolution to the whole world. Would the friends of Russia succeed in making their voices heard in France?"[25]

The empress and heir to the throne are imprisoned and it is declared that the emperor will abdicate. The news changes by the day. A different government is established. Kerensky makes "superhuman efforts to bring about an agreement"[26] between warring factions as "the New Russia" emerges.[27] Schopfer takes us to a moment "at 4:20 a.m. on 14 March"[28] when the emperor's Imperial train is stopped in its tracks. Schopfer is on the scene for all of it, providing a vivid account of Nicholas II at this crucial moment. "The Emperor, always so calm, master of himself to such a degree that all the witnesses who saw him during the last days of his reign and in the midst of his crisis, declared that he appeared as if stricken by a kind of stupor and insensible to the frightful blows of destiny, made an

When he traveled to Russia, Schopfer resembled a high-ranking diplomat.

angry gesture, the only one that was noticed in the whole course of the Revolution."²⁹ Schopfer understands and evokes the nuances of human behavior as he had learned them on the tennis court, where the need to control a show of emotions is of paramount importance.

Schopfer penned his words with the same courage with which he rushed net. He writes with wit and confidence of Nicholas II as a reformer and discusses issues ranging from indigenous alcoholism to the "inexhaustible kindness of the Russian heart."³⁰ He provides a short but gripping portrait of Kerensky: "He is quite a young man, with a long, bloodless face, and eyes extraordinary blue and clear, which have a habit of blinking. His features bear the marks of unutterable fatigue."³¹ He interviews Kerensky about the abolition of the death penalty (which Kerensky had just achieved), the future of the Imperial family, and women's voting rights. Jean Schopfer was as a writer the way he was when winning at Roland Garros: energetic, confident, and bold.

In 1920, again under the name Claude Anet, our subject wrote *Ariane, jeune fille russe*. This was the novel that become the movie *Love in the Afternoon*: the name of the book in its English translation. Anet set it in Russia and gave his characters names that could be in a play by Chekhov play or a Turgenev novel; Ariane Nicolaevna and Léon Davidovich are good examples. Even if he was back in Paris with his Bonnards and his Vuillards, the writer was still in the thrall of "the Russian soul"—at least on the surface.

It is not a great book. Its characters lack depth, and how they felt about their quirky behavior is anybody's guess. But the plot has twists and a lighthearted amorality that give it a certain allure and explain why it became the basis of more than one movie. The lovely seventeen-year-old Ariane Nicolaevna, pursued by countless young men, all of whom she resists, falls for an older playboy, Constantin Michel. To taunt him, she invents a slew of earlier lovers. It is known that Constantin Michel has had no shortage of ladies in his past, and Ariane Nicolaevna hopes that her amorous history will incite him to prove himself in competition with those other men. But Ariane's ploy fails. Constantin has a double standard and leaves Ariane when he believes her when she says she was not a virgin when they met. Even her confession, that her previous love life was imaginary, fails to sway him. He despises her; they are finished.

That is, at least, until the closing scene, which is quite a melodrama. Constantin Michel is about to leave Ariane Nicolaevna forever. She has accompanied him to the train station. We hear three bells ringing and then a whistle. "The train quivered with pain. Ariane was fighting not to faint."[32] Constantin Michel is on the steps of the train, Ariana on the platform. "Suddenly, hooking himself by one hand on the rail of the coach, he leaned forward, encircled the girl with his other arm, lifted her to him, carried her in the compartment. He slammed the door and fell with her on the seat.... And he covered her face with silent kisses."[33]

For a book published in 1920, the happy ending for characters whose actions could be considered sinful, was scandalous. The adulterous Anna in *Anna Karenina*, after all, was forced to commit suicide. The code of romantic behavior did not condone relationships with such a disparity of age and in which one partner had multiple lovers and the other was a liar. Traditionally, characters who acted like Ariane Nicolaevna and Constantin Michel were supposed to end up tragically. Claude Anet had yet again taken risks.

Perhaps because of its radical permissiveness, the story had a following. In his 1930 novel, *The Eye*, Vladimir Nabokov writes that two of his female characters are reading *Ariane, jeune fille russe*; it is his means of showing their attraction to scandal. In 1931, a German movie based on *Ariane* was made, with the great actress Elisabeth Bergner in the title role. It was directed by Paul Czinner, who followed it with versions in French and English. The Legion of Decency in each country condemned it, making it more exciting to a public that clamored to see it.

In the 1950s, Billy Wilder decided to adapt the story—the new title would be *Love in the Afternoon*—and set it in the heart of Paris rather than in a Russian village. With I. A. L. Diamond, the same writer with whom he would work on *Some Like It Hot* and *The Apartment*, Wilder revamped the plot. Ariane is now the daughter of a widowed detective who specializes in investigating adulterous affairs. A cellist, she overhears an outraged husband who says he will kill his wife's lover once the detective identifies the scoundrel for him. Ariane leaves a concert rehearsal to go to the lover's suite at the Ritz to warn him, and when the husband storms the room, gun in hand, she pretends to be the roué's mistress. Seeing Ariane instead of his wife, he concludes that his wife is innocent, that it was a case of mistaken identity. Thus, the adulterous

wife (and the lover) is saved by a young woman's intervention, and all is fine—except that the young woman falls for the playboy.

The performances by Maurice Chevalier as Ariane's father, Audrey Hepburn as Ariane, and Gary Cooper as the wealthy playboy make it a superb movie. The American public, however, objected to its morals, and the film was deemed indecent. It has amazing dialogue—Hepburn: "I'm too thin and my ears stick out and my teeth are crooked and my neck's much too long"; Cooper: "Maybe so, but I love the way it all hangs together"—but the lovers' age difference and the behavior the story condoned made *Love in the Afternoon* unacceptable.

Today, however, it is a cinema classic, although few people realize that its author was the French national tennis champion.

◆

HAVING HAD Bonnard paint his wife in 1909, Anet got the artist to make a portrait of his only daughter in 1930. Madeleine Leila Schopfer, born in 1912, was so good at tennis that in 1932 she was ranked No. 6 in France. Not only did she carry on her father's legacy in the sport, but she also maintained his tradition of different names, eventually calling herself Leila Claude Anet. Bonnard did two versions of her portrait, one close up and absent details of the setting, the other, an oil on canvas more than four feet high, appearing to be almost a classic society portrait. But the angles, the sumptuous colors, the mixture of abstraction and verisimilitude, all give it the luminosity and visual wealth unique to Bonnard's work. Although not dressed for tennis, Leila Claude's sweater and skirt, bright white, conjure the sport. So does the sunlight bathing her face. The sitter's power and elegance in the sunshine endow her with the qualities of a good tennis match.

◆

CLAUDE ANET wrote eighteen books in all. They ranged from volumes about Persia to one provocatively called *L'Amour en Russie*.

Mayerling, the last book Anet wrote before he died, age sixty-three, in 1934, is generally considered his best. It is a fictionalized biography of Archduke Rodolphe, slated to lead the Austro-Hungarian monarchy.

Like all of Anet's other love stories, it has a complex plot. Rodolphe falls in love with a young baroness, Marie Vetsura, deemed the most beautiful woman in Vienna. Rodolphe's parents have a tragic, loveless marriage, and Rodolphe is expected to follow their example. Rather than marrying his baroness, he is forced, in order to uphold the Hapsburg dynasty, to wed Princess Stéphanie of Belgium, whom he loathes. Nontheless, for eight months—from May 1888 to January 1889—the illicit union of Rodolphe and Marie Vetsura, at age sixteen, is in some ways idyllic. But then the conclusion of their romance is a heartbreaking mutual suicide in the woods near the Royal Hunting pavilion. Anet poses this question: "Is death really the only refuge for unhappy lovers, but for eternity?"

There would be three film versions of *Mayerling*. In 1936, Anatole Litvak directed the first, with Charles Boyer as the Archduke and Danielle Darrieux as the baroness. He directed a television version, in 1957, with Mel Ferrer and Audrey Hepburn. A third, written and directed by Terence Young in 1968, stars Omar Sharif, Catherine Deneuve, James Mason, and Ava Gardner. Sharif's good looks do not compensate for the ridiculousness of him cavorting in his red bow tie, but as a period piece, it is entertaining.

The best was yet to come. In 1978, Kenneth MacMillan choreographed *Mayerling* for the Royal Ballet. Performed to music by Franz Liszt, it premiered at the Royal Opera House. It is one of MacMillan's greatest works, and would eventually be performed by, among other companies, the Houston Ballet, the Stuttgart Ballet, and the Paris Opera Ballet. In October 1992, Kenneth MacMillan died of a heart attack backstage at Covent Garden at a revival of *Mayerling*. But his ballet lives on, and it is to dance what Bonnard and Vuillard are to painting: a testament to excellence, imagination, and lightness.

The legacy of France's first national tennis champion is a treasure chest. His larger-than-large personality infused everything he did, on and off the court. While he continued to play tennis at a high level, he showed the courage and panache of his performance holding a racquet when it was a pen in his hand. His confidence and bravura made him a perpetual winner.

4

ALICE MARBLE

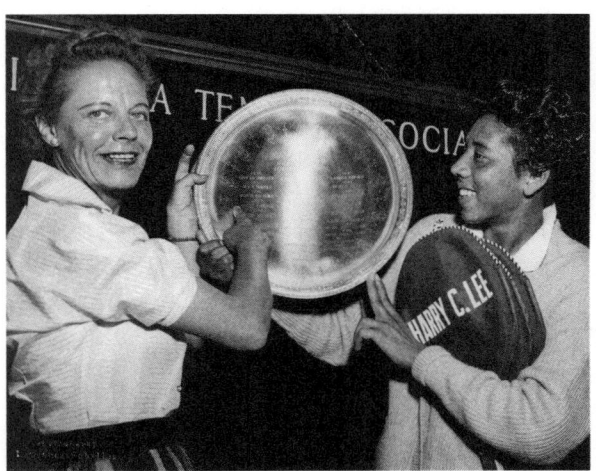

It was thanks to Alice Marble that Althea Gibson was
allowed to play in the US Open.

FROM THE start, she had the advantage of her name. Alice Marble would live up to it: strong, solid, polished, and able to roll with the punches. She was beautiful and her character was noble.

In 1947, when Althea Gibson, a talented Black athlete, was kept out of the US National Tennis Championships at Forest Hills, Alice Marble was the doyenne of women's tennis. And it was Marble's activism that changed history. What happened on the tennis courts and in the struggle for everyone to be allowed onto them is more proof that tennis is not only about the game but also about some of the most central issues of human existence. Marble had elegance in her behavior as well as her appearance: beauty inside and out.

Racial discrimination was prohibited by law, but to qualify for the Nationals, players had to win a certain number of sanctioned tournaments, which were held at all-white private clubs. In 1947, Gibson in theory would be allowed at Forest Hills, but only if she had already won tournaments you could only enter if invited; and of course these tournaments would not invite a Black person.

Alice Marble published an editorial in the July 1950 issue of *American Lawn Tennis*, which Gibson reprinted in her lovely autobiography, *I Always Wanted to Be Somebody*. In the editorial, Marble reports that a committee member of the United States Lawn Tennis Association did not think it adequate that Gibson had been a finalist in the National Indoors. She would have to play in the tournaments in Orange, East Hampton, and Essex. But they were invitationals. Marble explains:

> If she is not invited to participate in them, as my committee member freely predicted, then she obviously will be unable to prove anything at all, and it will be the reluctant duty of the committee to reject her entry at Forest Hills. We can accept the evasions, ignore the fact that no one will be honest enough to shoulder the responsibility for Althea Gibson's possible exclusion from the Nationals. We can just "not think about it." Or we can face the issue squarely and honestly ... It so happens that I tan very easily in the summer—but I doubt that anyone ever questioned my right to play in the Nationals because of it.[34]

Just after the editorial appeared, Gibson tried to enter the New Jersey State Championships at the Maplewood Country Club, but was refused on the basis that there was "not enough information." Alice Marble's article, however, had an impact. American Tennis Association officials were so moved by its eloquence that they joined the battle for Gibson's admission to Forest Hills by making sure that the Orange Lawn Tennis Club, in South Orange, New Jersey, allowed her to play in an important championship. "The dam broke," Gibson would write. At age twenty-three, she was invited into the Nationals and became the first Black player, female or male, to participate in the tournament. An article in *The Daily Worker* reported, "No Negro player, man or woman, has ever

set foot on one of these courts. In many ways, it is even a tougher personal Jim Crow–busting assignment than was Jackie Robinson's when he first stepped out of the Brooklyn Dodgers dugout."[35] Alice Marble paved the way for Gibson to change history.

◆

MARBLE, TOO, had known obstacles, but of a very different sort. In 1933, at age twenty and on her rise as a tennis champion, she became ill from anemia and pleurisy, which her doctors initially failed to diagnose. Having won the California State Championship, Marble was then ranked third in the nation among all female players. Despite her standing, she had to qualify to make it onto the Wightman Cup Team. Suffering from myriad symptoms without knowing their cause, she despaired at having to play four sequential matches on a brutally hot day in a tournament held at the elitist Maidstone Club in East Hampton, Long Island.

The first was the semifinals in singles in three sets. She won the match, but would write, "The pounding in my temples reverberated through my body, painfully in my joints and turning my stomach into a queasy knot."[36] She had to go on to a doubles match, and it was getting hotter. Marble's partner, Helen Wills Moody, was suffering from back pain, so Marble was obliged to hit all the overhead slams, exhausting herself. She then had an hour off at lunchtime before going on to the singles final.

It was 104 degrees and humid. Marble gave the singles her all, despite having eaten very little during the lunch break, and won the first set 7 to 5. Her opponent pulverized her in the second. During the two-minute break, Marble's body stiffened. In the third set, her muscles were so tight that she could hardly move. It took just ten minutes for her to lose. Still, she had to go on to play in the doubles final—her fourth match of the day. "Neither my muscles nor my brain cared to function,"[37] she wrote later. Marble and Moody lost quickly. Playing eleven sets in the debilitating heat, Marble had lost fourteen pounds in a single day.[38] After she got off the court, she collapsed. At first, Marble's suffering was attributed to a tough day on the courts. Neither she nor anyone else thought there was anything wrong beyond sunstroke.

Marble continued to compete, trying to get used to the idea that she felt perpetually tired and weak. She took time off that winter, and by spring she thought she had regained her strength. In the summer of 1934, she headed to Paris to compete at Roland Garros. She embarked on the trip with hopes of a Grand Slam trophy, and did not allow herself to be deterred when her weakness and sleeplessness led her to more doctors, who discovered her low blood count and diagnosed her with anemia.

She played in the tournament anyway. But in the middle of a match on a hot June afternoon, her knees gave way, and she could no longer hold on to the racquet. After collapsing on the court, Marble was whisked off to the American Hospital in Neuilly. She was told she had tuberculosis and would never play tennis again. She returned to the United States in a wheelchair, and the prognosis was repeated in New York.

Marble was unpersuaded. The TB diagnosis proved to be incorrect, and with treatment in a sanatorium and the loving care of friends, she eventually recovered from the anemia and pleurisy that were the real problems. She played again with extraordinary physical strength—as well as grace and good humor.

In 1936, she won the US Championships at Forest Hills, and Albert Gillis Laney, whose byline was "Al Laney," wrote about it. A thirty-year-old journalist who worked for the *Paris Herald*—the European edition of *The New York Herald*—and *The New York Herald Tribune*, Laney regularly covered Wimbledon as well as other tennis and golf tournaments and boxing matches:

> They had told Miss Marble soon after her collapse that she had anemia, pleurisy, and even tuberculosis, and now she was champion two years later. The people loved it and her. There never was a more attractive woman athlete than this tall, graceful girl with fair curly hair, large eyes, and a wide smile. It was great fun watching her play, and I saw every stroke she made in that 1936 Championship.[39]

Thanks to her resilience, Alice Marble's skill at tennis and her charming personality eventually brought her into a world of glamour.

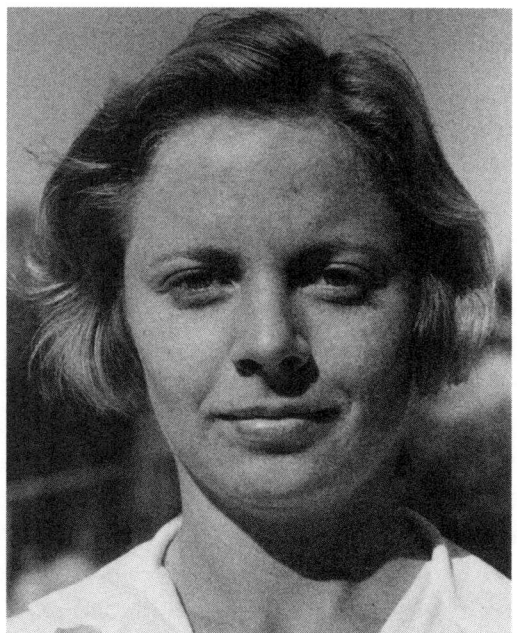

Marble was often compared to Greta Garbo.

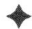

TENACITY AND bravery were in Alice Marble's genes. She grew up in Northern California, where her father, a lumberjack, routinely topped gigantic trees. After he died, when Alice was seven, her mother had to raise their five children on her own. Alice's brothers, aged eleven and thirteen, quit school "to work six days a week laying hardwood floors."[40] Alice was endowed with a photographic memory and rare athletic prowess, but experienced difficult obstacles. A year after her father's death, she witnessed, at age eight, the death of her best friend when they were roller skating and, while racing her, he tripped on streetcar tracks and was killed by a trolley. (His was the last funeral Alice Marble would attend until thirty-two years later. When the tennis great Bill Tilden died, in near destitution, she went to his funeral as a public statement when almost all other well-known tennis players boycotted it because of the scandals that had resulted from his having made sexual advances toward underage boys.)

A crackerjack baseball player, Marble took up tennis and improved meteorically. And she developed poise at a young age. Marble was only nineteen when she was playing a tournament in Los Angeles where she had to muster the courage to perform her best in front of some of her idols. The dashing Robert Montgomery introduced Marble and her opponents to the audience for the finals match, which was attended by some of her favorite movie stars. "Loretta Young, Errol Flynn, Marlene Dietrich, Charlie Chaplin, Bette Davis, Myrna Loy, Norma Shearer, Kay Francis, Claudette Colbert, Robert Taylor" were, she would recall, among those who watched her win. Her photographic memory enabled her to reel off the names sixty years later in a memoir and to recall her emotions: "They were all handsome. I have never seen so many beautiful people in my life. It's a wonder I managed to play tennis at all."[41]

Whereas tennis was still a rich person's sport and Marble had come from the other side of the tracks, she had a sense of herself that drew people to her. Her start in baseball—and boxing and basketball—made her tough: Billie Jean King would call her "a picture of unrestrained athleticism . . . remembered as one of the greatest women to play the game because of her pioneering style in power tennis."[42] She was fast on her feet and exceptionally strong. It was said that she played like a man. Her lacing serve, adept volleying, and winning smashes pulverized most of her opponents. But even if she was known as "the Queen of Swat" and wore shorts when most women players wore tennis dresses or skirts, it was always with elegance..

Al Laney provides vivid descriptions of the particularities of Marble's game, and in so doing equates her game to that of a man's:

> I have no reluctance and no hesitancy in saying that she owned an array of strokes never surpassed in quality by any woman player. On several occasions she played briefly a brand of tennis I never saw excelled by any player of her sex. . . . The Marble first service often was as hard as a man's, the second a "twist" with plenty of pace and kick that many men would envy. Tilden served that way too, and Miss Marble's was just as effective against her opponents as Big Bill's had been against his. Miss Wills had a good hard serve hit to a length with her body lithe in the delivery. It was nearly always certain.

> The Marble forehand, taken by her so easily, could be hit with fine pace to the base line or angled.... The Marble backhand was a highly individual shot, a peculiar stroke delivered with a slack wrist. It was well produced, and though it seemed of equal quality with her forehand, it was slower, less certain.[43]

In these ways, Laney assures us, she outdid her best-known female competitors, Helen Wills and Suzanne Lenglen, and was the equal of the top male players of the era.

◆

ALICE MARBLE'S prowess at tennis and her allure took her to the upper echelons of American society. Not long after she performed in front of all those movies stars, she was invited by William Randolph Hearst to go with her coach, "Teach" Tennant, to play at San Simeon, the mogul's castle. The experience was dreamlike. The mansion sat on two hundred and forty thousand hilly acres at the edge of the sea. Marble and Tennant entered on a winding, narrow dirt road with kangaroos, giraffes, zebras, camels, and llamas peering at them. Once they were inside, they were stunned; the dining room, its walls covered with Renaissance tapestries, was twenty-four feet high.

Marion Davies—the actress who had been crowned "Queen of the Screen" in the 1920s and was Hearst's girlfriend—greeted them. She presented them to the "tall and heavy-set" Hearst with that "famous high squeaky voice of his."[44] Marble was then introduced to some of the biggest names in Hollywood—among them, Jean Harlow, Charlie Chaplin, Paulette Goddard, and Bing Crosby. They all said they had seen her play, assuring her of how esteemed they thought her.

There was a lot to take in at San Simeon. Marble noted the rules concerning alcohol: wine only and in the right place at the right time. "Guests drinking in their rooms found their bags packed and waiting for them at the front door."[45] The fifty-foot-long dining room table was covered with rare condiments as well as "common catsup and mustard bottles scattered among the exotic ones."[46] That mixture of ordinariness and opulence was also evident in the paper napkins at dinner when

fresh truffles were served. The house seemed like a fantasy, with thirty-eight bedrooms, each with its own bathroom. The two tennis courts were on top of the indoor Roman swimming pool; they were unlike any others that have ever existed. The idea that people were swimming underneath you in a setting out of the realm of the Caesars was mind-boggling.

Marble had Hearst as her partner in doubles against Tennant and Charlie Chaplin. All the guests gathered to watch. "Chaplin was cheating, calling balls out when they were in," Marble recalled. She became so angry that she tried to hit him with the ball. Then, when the score reached five all, Marion Davies signaled to Marble to come to the side of the court to have a word. Davies urged Marble to let Chaplin and Tennant win. Marble would not consider it. She had no idea that Davies wanted a quick end to the match because she was worried about Hearst's health if he overexerted himself. Marble played her hardest rather than throw the match.

Victory!

"We won 10–8. Perspiring, the big man gave me a bear hug and said, 'Alice, you're the best partner I've ever had!'"[47] Davies's fears had been unfounded, and Marble had been right in thinking that the best thing for the portly publisher would be to win rather than to succumb in letting Chaplin get away with his false calls.

Not only had they had the splendid experience of a 10–8 victory, but Hearst had also come to realize a solution to Charlie Chaplin's cheating. From then on, Hearst saw to it that Chaplin was always given Alice Marble as a partner so that she could make the line calls. Marble would simply correct his lies in a calm voice. She saw a fair bit of Chaplin at San Simeon and was so impressed by the way he played his left-handed violin that she forgave his unrepentant cheating.

◆

ALICE MARBLE's success was not just because of her proficiency. She had panache and savoir-faire. Humble enough not to count on her own judgment about her appearance, Marble took advice so that she could shine in the extraordinary milieu of San Simeon. Told she had to look just right for an evening where there would be "a surprise," she allowed other women to steer her:

> [Marion Davies] chose a dress that matched the blue of my eyes, with a low back. While she did my hair, Jean Harlow applied my makeup. Harlow was a truly beautiful woman, with eyes that mesmerized and a warm, sexy smile. "Alice, you're going to make the men wild," she told me, dabbing rouge on my tanned cheekbones.

To get made up by Jean Harlow and told what an effect she would have was unusual enough, but there was more. Marble's manicurist for the evening was the silent film star Bebe Daniels. She was groomed by the best.

At the actual party, when David Niven showed up, Marble wondered if he was the surprise. While she was speculating, an unfamiliar voice behind her said, "Young lady, I admire the moles on your back."[48] Turning around, she recognized George Bernard Shaw. That unusual opening line was not their only conversation. Hearst, knowing that Marble had

written her college thesis on the Irish playwright, had seated her next to him at dinner. "I knew the names and characters of every one of his plays, so I talked about his work and he talked about himself,"[49] Marble recalled.

Arthur Brisbane, one of the most famous editors in the country, whose blaring headlines were fundamental to the success of Hearst newspapers, was among the guests that evening. When he started calling Marble "Venus," she had no idea that he was writing about her in a story that would appear in every Hearst paper the following day and thus inform the nation of her new sobriquet. Her already glossy reputation now reached new heights:

> What a girl Alice Marble is, with everything the Venus de Milo has, plus two muscular, bare, sunburned arms marvelously efficient. Her legs are like two columns of polished mahogany, bare to the knees, her figure perfect. Frederick MacMonnies should do a statue of her. And she should marry the most intelligent man in America, and be the perfect mother with twelve children, not merely the world's best tennis player, which she probably will be.[50]

That she should be portrayed by the best-known expatriate American sculptor in Europe, a Beaux Arts giant, was mighty praise. Marble's mother, however, reacted with puritanical rage, writing her "a terse note telling me to come home right away"[51]—which is what Alice Marble obediently did. For her glamour to be so public was unseemly for someone of such a modest background.

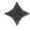

MARBLE'S HEALTH troubles were not over. Following her days at San Simeon, she learned that she had scarred lungs. She required ongoing medical care and had to toe the line about diet and lifestyle. The person who encouraged her the most was Carole Lombard, a film star known for her spirited performances in screwball comedies. Thanks to Lombard's care and generous financial aid during rough patches, following the idyll at San Simeon, Marble got her blood count back up so that she was again fit to pick up a racquet.

Marble was always in the company of Tennant, and many people presumed they were lovers. When Tennant, one of the finest tennis teachers of the era, landed an important job at a Palm Springs club, Marble accompanied her. Marble often watched while Tennant coached Marlene Dietrich, Robert Taylor, George Brent, Jeannette MacDonald, and Joan Crawford. Marble would never forget Crawford shouting, "Get the hell out of here!"[52] when Marble watched a lesson, or needing to comply when six-year-old Shirley Temple challenged her to "play tennis and ride a bike at the same time."[53]

In Palm Springs, Tennant and Marble met Gilbert Kahn, son of the banker Otto Kahn. Again, Marble's skill took them to "lodgings" that defy the imagination. While she played in the Nationals in Forest Hills, she and Tennant stayed in Kahn's "fifty-room stone grey mansion" with "excellent tennis courts (inside and out), an eighteen-hole golf course, a marina, several swimming pools, greenhouses and formal gardens overlooking Long Island Sound." From these digs, Marble arrived at Forest Hills each day in "a long silver limousine."[54]

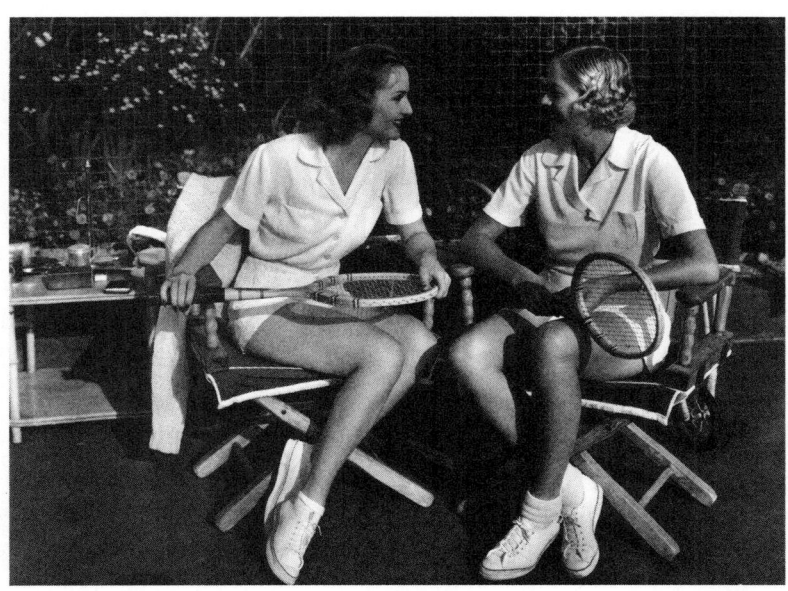

Carole Lombard became a good friend.

After two weeks of matches during which she was living amid such splendor, the former invalid earned the large silver bowl that was the trophy for the winner. The photographers crowded her, Marble recalled fondly: "Their flashes melded into one bright blur of light. It was one of the happiest moments in my life, and much more than a tennis victory. I had been counted down and out, but I didn't stay down, and I certainly wasn't out."[55]

That night, she was celebrated back at the Kahn estate with a sit-down dinner for forty-nine, followed by a party for five hundred guests who enjoyed "a lavish garden buffet and dancing to the Emil Coleman orchestra in the ballroom." Marble sang "Pennies from Heaven" and two other songs with the orchestra.

The following morning, Tennant, the toughest of trainers, allowed her to sleep in. Then a late breakfast tray was brought in, festooned with flowers and telegrams, including one from Carole Lombard saying, "You're the best." The setting could have been in *The Great Gatsby*, but whereas Fitzgerald's characters are world-weary and laconic, Alice Marble glowed with the joy of triumph over adversity.

◆

HER VERVE as a player combined with her looks—she resembled Greta Garbo—became Marble's passport not only to movie star partners, but also to royal ones. In Monte Carlo, when she was warming up for Wimbledon, she played with King Gustav of Sweden against two French players who had not been warned that the king despised losing. The king and Marble were vanquished. Following their defeat, Tennant told Marble that the king "'blamed his loss on you. He told everybody you were off your game because you had your period.'"[56] The infuriating remark only made both women burst into laughter. And Marble fared better when the former Edward VIII, following his abdication, was her partner.

In New York, Marble "prepared a speech on the will to win." Coached by Eleanor Roosevelt's speechwriter, she ended up rehearsing it in front of the first lady and Katherine Cornell—then one of the most famous theater actresses in America. Shortly thereafter, she received a

phone call from President Roosevelt himself. He asked her "to co-chair a physical fitness program for the Office of Civilian Defense with Jack Kelly"—a world-class rower and the father of Grace.

Marble had moxie. She was unfazed to have Clark Gable, Carole Lombard, and Barbara Stanwyck in the audience when she and Don Budge played doubles against Bill Tilden and Mary Hare. Bob Hope and Bing Crosby introduced them. But Alice Marble was not so jaded by fame and glamour as to keep a blind eye to human cruelty. She was miserable that "Budge was condescending to Tilden" because of his "high voice and effeminate way of walking and standing with his hand on his hip."[57]

It was common to compare men's and women's tennis. Bill Tilden believed that the male players, even at the second level, were intrinsically better than the top females. By attributing male traits to Marble, whom he considered "the champ of champs, the greatest woman star America ever produced,"[58] he thought he was paying her the greatest compliment.

> It's an astounding and quite unique game that Alice plays. As I've said, she is the only girl I have ever seen who plays tennis man-wise. Suzanne Lenglen, Helen Wills and Helen Jacobs, great as they were, played woman's tennis. During her tournament years Alice Marble hit, ran and thought like a man. She served and followed in on service to volley and smash with the same ease that a boy does. She covered court with none of the effort always noticeable in Helen Wills. She had every shot in the game, and a keen brain to direct their use.
>
> One might think from this description that Alice lacks attractiveness. Far from it. She is wholly feminine, and lovely to look upon; so much so that she has made her mark in show business. She has grace and charm in abundance, and a great sense of fun. She has admirers by the thousands all over the world.[59]

When Bill Tilden wrote about Alice Marble, it was in the memoir he published shortly after being released from a two-year prison term. He had been incarcerated because of his sexual advances toward a teenage boy.

It is no surprise that Tilden felt such adulation for Alice Marble. He had talked openly to her about how much his homosexuality tortured him. Almost all of his colleagues on the tennis circuit had dropped him since the scandal; he was not allowed in tournaments, banned from teaching, and shunned by almost everyone he knew. But just as she had gone to bat for Althea Gibson, Marble stuck up for Tilden. Demonstrating both her loyalty and her courage, she publicly remained his friend and tennis partner. For Bill Tilden, she was "still the best woman player in the world. And—just between you and me, this is much more important in my eyes—she's my friend."[60]

When Tilden compared Marble's game to a man's and when King Gustav made the remark about her having her period, they probably did not know about a match she had played in Ireland in July 1939. In Dublin to compete in the Irish championship, she had played an exhibition match at Fitzwilliams, a private tennis club, against Cyril Kemp, the twenty-four-year-old club champion. Tennis matches between men and women were rare events. In 1888, in England, Ernest Renshaw had defeated Lottie Dodd in one such contest. More recently, in 1928, Bill Johnston had beaten Helen Wills in a match that required a third set. When Alice Marble beat Cyril Kemp 9–7, 8–6, that close contest was the first of these high-caliber matches to be won by a woman. *The Irish Times* reported,

> The controversy as to whether the world's best woman player could beat a good man has raged since the days of Mlle. [Suzanne] Lenglen's primacy, when it was first realized that a woman could challenge a man and have a hope of winning. . . . It was delightful tennis to watch. Both players kept a superb length, and there was no question of Miss Marble being on the defensive—she did just as much attacking as her opponent did, and the manner in which she returned Kemp's heavily sliced backhand was mastery. . . . In one respect Miss Marble must surpass any other woman in the history of tennis—the power of her service. . . . It was a really grand match, played in the most sporting spirit imaginable, and Miss Marble is to be congratulated on a truly wonderful display. . . . Tribute must also be paid to Kemp.[61]

Tilden would surely have been proud of the one woman he played whose game he said had the strength of a man's. Theirs was an exceptional friendship. After Tilden died, a broken man at age sixty, Marble "died a little, too, when I heard that no one from the tennis community planned to go to his funeral. I called all the players I knew and shamed them into going."

Alice Marble had not gone to a funeral since the one for her friend who was killed by a trolley, but this was one she would not miss.

As when she wrote the editorial that resulted in Althea Gibson becoming the first Black person to get onto the court at Forest Hills, Alice Marble proved that tennis can be a showcase for what is most noble in human behavior.

5

BILL TILDEN

WHEN IN 1922 the future King of England summoned Bill Tilden for tennis at Buckingham Palace, following his second victory at Wimbledon, Tilden did not seem like someone who would eventually be imprisoned for sexually abusing teenage boys. For now, he was a knight in shining armor, a man who elevated the sport so that it became a masterpiece to behold.

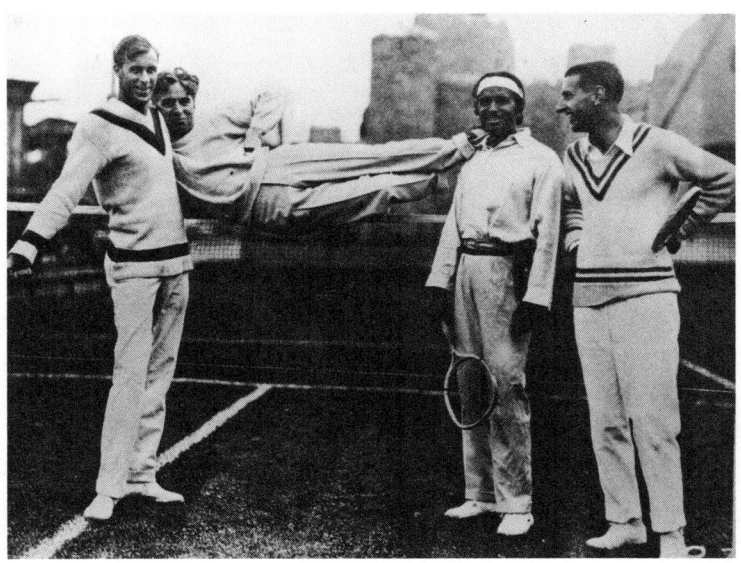

Hacking around: Bill Tilden, Charlie Chaplin, Manuel Alonso, and Douglas Fairbanks Sr. in 1923.

During his lifetime, the tall and handsome "Big Bill" was considered the greatest tennis player of all time. Others have now eclipsed him, having won more Grand Slam titles, but from 1920 to 1925 he was ranked the World No. 1 Amateur, and from 1931 to 1933 as the No. 1 Pro. In 1920, when he won Wimbledon at age twenty-seven, he was the first American to do so, and he won it twice more after that. Of the 192 tournaments he played in, he won 138, with ten Grand Slam titles among them. (There are four annual tennis tournaments that comprise the category of "Grand Slam": in Tilden's time they were the Australian and French Championships, Wimbledon, and the US Nationals.)

Tilden's knowledge of strategy and his strokes were legendary; the journalist Stanley Wilson wrote in *The Sunday World* of "this wizard of the court" that "the overwhelming drama and color his personality and methods infuse into the game, make him quite the most magnificent champion of tennis history."[62] His magnetism, too, was legendary. He gave lessons to Hollywood stars; crowds clamored to watch him play. But at the end of his life, his circumstances were harshly reduced. Al Laney tells us,

> Big Bill, living in a furnished room, wrote to the president of Dunlop, his sponsor, "Winnie, could you please send me a couple of dozen balls and a racket or two? If I had them I think I could get some lessons to give. I need the money badly." But the greatest tennis player the world has seen was dead when the packet arrived. He had less than five dollars in his pocket and there was no one to care.[63]

Part of what made this so surprising is that Tilden was known for comebacks. Laney writes:

> Tilden scored more important victories after seeming to be beaten than any other champion. He won these matches with super tennis, but I do not think it compatible with Tilden's greatness to hold, as many did, that he deliberately toyed with an opponent for the pleasure of snatching victory from his grasp. Against outclassed opponents he did not always use the full force of his game, since there was no need to, but I decline to believe that he let up against first-class players to tantalize and finally crush them. The fact that

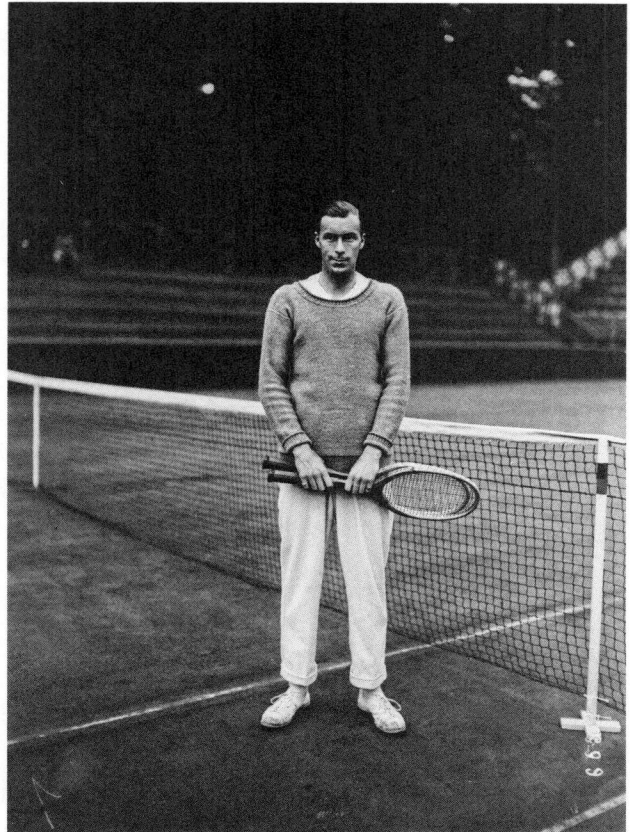

Tall and dapper, Tilden was considered the
best male player of his era.

this occurred so often probably was part of the peculiar genius of the man. It may have been part of his feeling for showmanship, his real desire to give the crowd a full value and put on a proper show.[64]

Tilden's fame above all was for being at the brink of defeat, often at match point against him, and managing to pull out the win. Stanley Wilson analyzed his will to emerge from behind as being intrinsic to Tilden's nature: "This unconscionable relish of his for the prolonged battle and deferred rush to victory, is not volitional but belongs to the temperament and the peculiar genius of the man."[65]

Tilden fascinated people. A "mercurial, irascible" man who was "easily upset and sent into rages," he achieved "world supremacy"[66] because of his remarkable ability to prevail against the odds.

> Tilden could not accept defeat. If on occasion he lacked the natural spark to ignite his game, he crowded on the temperament. He could tap a vein of something like divine frenzy by pulling out all the stops in that often deplorable but priceless temperament. Tilden could play superlative tennis while boiling with anger against an opponent.[67]

At the highpoint of his run of tournament victories, Tilden developed an infection in his right hand that made doctors amputate most of his middle finger. The loss required serious adjustment to how he held the racquet, and few people thought he could regain his prowess. He came back more triumphant than ever.

◆

EVEN IF he had grown up in luxury, William Tatem Tilden Jr. never had it easy. He was born to considerable wealth but in a household that was predominantly sad. Before his birth, his parents had seen three of their children die in a three-week span, all succumbing to diphtheria. His mother was a gifted pianist but became confined to a wheelchair in Tilden's adolescence and died when he was eighteen. His father was too preoccupied trying to become mayor of Philadelphia to spend time at home. Even though the family mansion had an ample number of servants for life to continue pretty much as it had before his mother's death, Bill was dispatched to the house of a maiden aunt. Then, when he was twenty-two, by which time he had dropped out of the University of Pennsylvania, his father died, as did an older brother, his sole remaining sibling. He fell into a severe depression. The saving grace was that his aunt encouraged him to play tennis to help combat his grief.

Tilden had played tennis since he was six years old and had started strong. If his late-life autobiography can be believed, when he was seven years old, in 1901, he won a fifteen-and-under Junior Boys Championship at the tony private club where his family were members. But by most

accounts, he was hitting on a desultory level in high school and college, and his abilities became apparent only when he began to rise from the doldrums by hitting against a backboard for long hours every day. From then on, the successes piled up. He had a powerful serve—his height was an asset—but the key to his victories was his canniness.

If you watch old clips of him playing, you will see to what extent he elevated the art of the game. His position on the court was a feat of choreography, and each stroke was selected from a grab bag of possibilities. He was an exceptionally thoughtful player, a strategist as much as a titan. With the flair of a clever tactician, he mixed up his shots to be unpredictable, alternating strong groundstrokes with lobs and slices. One of his greatest skills was his execution of drop shots, which left his opponent no chance of getting near the ball; you could never predict when it was coming.

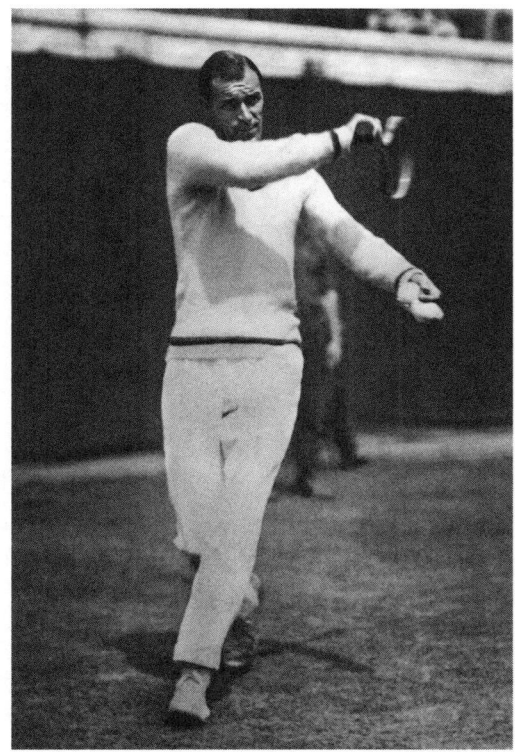

Tilden could place his forehands with pinpoint accuracy.

There is an excellent, balanced biography of Tilden called *American Colossus*. The author, Allen M. Hornblum, formerly a "criminal justice administrator" who wrote a book on travesties committed against prisoners, presumably became interested in Tilden because of his legal issues, but he does a fine job of describing Tilden's skill at tennis. Hornblum writes about the early development of Tilden's game; by the time he was in his mid-twenties, Tilden brought the sport to an apogee, with unique strategies and impeccable control in how he stroked and placed each shot:

> He could pulverize the ball and blast opponents off the court or tap delicate drop shots that left adversaries stunned and in a state of paralysis. His knowledge and use of spin were unprecedented. Chop shots, slices, topspins, sidespins, and underspins flew back at opponents in a barrage of dizzying trajectories and speeds that underscored his incredible racquet control and impressive armory of court weaponry. Add to his myriad ground strokes an arsenal of heavy artillery—his serves—including the most feared weapon in the game, his "cannonball" that shot by amazed players like a bullet.[68]

For Al Laney, it was when Tilden developed a flat backhand that he became unbeatable: "It was a shot that made it impossible to keep Tilden on the defensive for long or break down that defense. It was one stroke that put him above the class of his contemporaries, and there is some ground for believing it the finest single stroke ever developed in tennis."[69]

TILDEN STAGGERED the three greatest French champions of the era. Said Jean Borotra, "Tilden has everything. His best serve has no answer. His volleys take your breath away. He gives you no rest. He has no equal."[70]

René Lacoste was in awe. He marveled at Tilden's court coverage and the dexterity of his hitting: "He seems capable of returning any shot when he likes, to put the ball out of reach of his opponent when he thinks the moment has come to do so. Sometimes he gives the ball

prodigious velocity, sometimes he caresses it." Lacoste said Tilden would place the ball in spots no one else would have considered.[71]

And Henri Cochet deemed Tilden the inventor of modern tennis.

The amiable British player Bunny Austin, a lesser-known contemporary, noted a deficiency in Tilden's net game, but still saw him as a sort of god: "I believe that Tilden, by his superb play, by the force of his personality, by his love of the game and his unselfish interest in other players, has done more than any other single individual towards making lawn tennis the world's most popular game."

Austin was among those who considered Tilden to be the greatest player of all time. What brought him to this conclusion was Tilden's cannonball serve, the variety of his groundstrokes, and his ability to cut and slice. Austin also noted that Tilden hit his backhand "with his thumb around rather than up the handle." It's likely that this unusual grip compensated for the part of Tilden's finger that was missing, but Austin, like most other people, was probably unaware of the disability. Austin provides a vivid image of Tilden's lumbering body:

> In physique he is by no means perfectly proportioned. He is tall, has huge shoulders and long limbs. But though lacking the compactness of Cochet and Borotra, he could last the longest matches in the great heat of the New York sun."[72]

Still, there was something about Bill Tilden that left his contemporaries off-balance. Both Bunny Austin and Al Laney struggled with what seem to have been two sides of Tilden's persona. He was a nasty guy; he was a great guy. Austin writes about his angry looks to linesmen and his complaints when he did not agree that one of his serves had skimmed the net.

Laney depicts "the champion of champions" as haughty and priggish.

> The lantern jaw and wide straight mouth above the long neck were familiar from pictures. They suggested great determination and it was a face on which no expression of humility seemed possible. It was lit with enthusiasm when I first saw it, and there seemed to be a conscious feeling of superiority.

I thought as I watched, though, that I never had seen such arrogance and such distasteful mannerisms.[73]

Yet Laney also sees Tilden as a mass of contradictions, alternating contempt with kindness, demanding praise but also complimenting opponents.

And Laney, one of the greatest tennis pundits of all time, was, even if sometimes repelled by him, dumbfounded by his skill. Laney describes Tilden's backhand as a magic act:

> The backhand was the shot that made it impossible to keep Tilden on the defensive for long or break down that defense. It was the one stroke that put him above the class of his contemporaries, and there is some ground for believing it the finest single stroke ever developed in tennis.
>
> Tilden's backhand was absolutely free and flexible. He could give it as much speed as he wanted from almost any position in the court, swinging it across court or down the line with undiminished pace as he pleased.[74]

Laney marveled at Tilden's versatility. He could appear to be hitting the ball flat while putting a lot of spin on it; he could seem to hit a spin while keeping the ball flat. Whatever temper he showed, however quirky he was, he had powers above those of mere mortals.

Tilden's personal style was on a par with his tennis. For the finals of the US National Singles Championship in 1920, he walked onto the court wearing a camel hair coat. His array of cable-knit tennis sweaters had differently colored V-necks, combinations of blue and red, dark and light blue, or navy blue alongside emerald green. He was a box-office favorite at demonstration matches, where audiences admired his taste in fashion as well as his athletic skill.

Still, Tilden was credited with elevating tennis from the status of a gentleman's pastime to a tough sport. Before Tilden, the general

perception of a tennis player was of a dandy in white flannels and boater asking, "Anyone for tennis?" Hornblum's assertions to the contrary sound like a propaganda campaign to combat gossip about Tilden's homosexuality, but they paint a vivid picture:

> Tilden's impact was transformative; he almost single-handedly revolutionized the Victorian game from its effeminate image as a sissy activity for the wealthy at sedate garden parties to a real man's game that appealed to masculine, red-blooded Americans. No one who witnesses the tall Philadelphian rip off howitzer-like forehands and backhands—one almost imagined the whiff of gunpowder in the air—could think anything other than this was no longer a placid outdoor distraction for genteel aristocrats.
>
> Adding to the macho image was Tilden's size and athleticism. At six-foot-two and 155 pounds, he was taller than most, with a raven-like wingspan and a few turf-gulping strides. His cheetah-like speed was augmented by unlimited stamina. Blessed with grace, power, and endurance, to a thoroughly overmatched opponent Tilden could well have been reimagined as a lethal avatar packing the punch of Jack Dempsey, the intricate footwork of Vaslav Nijinsky, and the longevity of a California redwood.[75]

The writing is over the top, but there was something about Bill Tilden that was so beyond the norm that people were at a loss to explain it without a bit of purple prose.

IN RESPONSE to a questionnaire sent to top-caliber male tennis players asking where their female partner should stand during mixed doubles, Tilden replied, of what he called "the weaker sex," that she should position herself "wherever she's least in the way."[76] He was adamant on the subject that "men's tennis and women's tennis are simply not the same game.... There are always at least a hundred men in the United States certain to defeat the female champion of the moment."[77] He went on to compare male and female physiques and levels of strength as the reason.

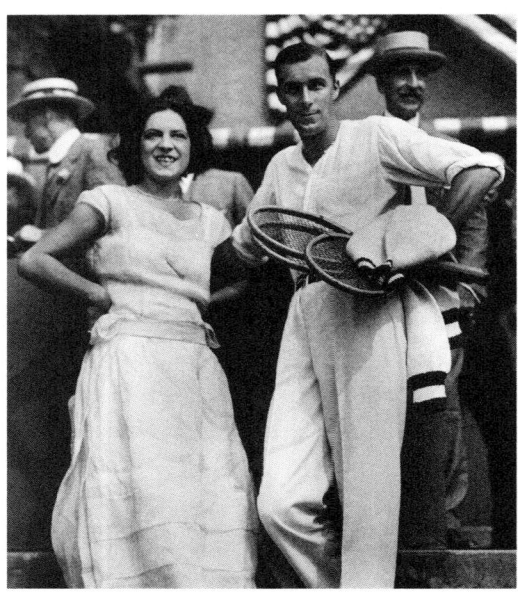

Suzanne Lenglen and Bill Tilden exude confidence.

Tilden decided to demonstrate the truth of his claims about women tennis players with none other than the French champion Suzanne Lenglen as his opponent. He knew she was a famously bad loser but that "for sheer genius and perfect technique Lenglen was the greatest woman star of all time."[78] A lot about Lenglen applied to Tilden as well.

> Suzanne had a gift of showmanship, a great sense of the theatre. Heaven knows no one could call her beautiful. But she had the French flair for wearing clothes, coupled with a peculiar panther-like grace that from a little distance gave the illusion of beauty. Her unpredictable temper always lent tension and suspense to her matches.[79]

Tilden knew there were people who maintained that Lenglen was the equal of top male players. One day, when he and Lenglen and others were practicing on red clay in St. Cloud, near Paris, he writes, "[T]he thought came to me that if I looked off my game, Suzanne might ask me to play her."[80] To trap Lenglen into a match, "I proceeded to be really lousy"; the bait worked, and she asked him to play a set.

Once on the other side of the net from Lenglen, Tilden played a very different level of tennis than what she had just witnessed. "With deliberate intent and quite mercilessly I ran six straight games to win 6–0. . . . It seemed the only way to settle once and for all the relative ability of top men and top women."[81]

The matter, however, was not settled with Bill Tilden's specious victory. The issue of male vs. female tennis players inspired one of the most significant events in tennis history. The general public did not know about Alice Marble's victory at the private club in Dublin in 1939, a match that had demonstrated that a top-notch female could beat a first-rate male player and that the inter-sex competition could make for a spellbinding experience.

In 1973, Bobby Riggs—who, like Tilden, had been ranked No. 1 in the world, although for only a short period—had, at fifty-five, taken to saying that even a man his age could easily win against any of the top female players because of women's innate inferiority in the arena of sports. He seemed to prove his point by handily beating Margaret Court, a splendid player. Billie Jean King, one of the best female tennis players in the world, decided she had to challenge Riggs.

The match was quickly dubbed "the Battle of the Sexes" and was scheduled for one of the largest public venues anywhere, the Houston Astrodome, usually reserved for football games. More than thirty thousand people flooded the stands. It was estimated that ninety million people, all over the world, watched it on television.

King arrived seated on a gold throne that was carried in by five bare-chested men clad in togas. Riggs came in next, in a rickshaw pulled by six women who looked like Playboy bunnies. Whereas at Grand Slam events women's singles finals were best of three sets, as had been the case when Alice Marble beat a club champion, Riggs and King followed the model of men's finals by making it best of five. In a match that lasted just over two hours, King won in straight sets, with Riggs losing the first set six to one and only getting to three in each of the following sets.

King made a statement following the match: "I thought it would set us back fifty years if I didn't win the match. It would ruin the women's tour and affect all women's self-esteem. To beat a fifty-five-year-old guy was no thrill for me. The thrill was exposing a lot of people to tennis."

Billie Jean King was a class act. She did not gloat over Riggs's loss. Rather, she made her victory a step forward for tennis everywhere—for men as well as women.

There would be a movie. In 2017, Emma Stone played Billie Jean King and Steve Carrell was Bobby Riggs in *Battle of the Sexes*. I wish Bill Tilden had lived to see the match (and then the film, which is superb.) And if Tilden had competed against King, the charisma coming from both sides of the net would have been off the charts.

BILL TILDEN considered himself a writer and an actor. To some degree, he succeeded in both professions, but hardly on the same level as his tennis. In 1922, at the peak of his tennis, when he was the world's No. 1 player, he published a volume of short stories titled *It's All in the Game*. The central character is an athletic sixteen-year-old boy who has a bad temper on the court until he starts to imitate a role model, an older player of calm demeanor, who advises him, "All tennis players take what comes in a match, boy. It's all in the game."[82] One might have thought Tilden based the older player himself, but as Allen M. Hornblum observes, "Any serious follower of Tilden's career knew that he was not the model for this story. . . . His menacing glares and angry comments to umpires, linesmen, and ballboys were well known."[83]

Over the years, Tilden published twelve books. Some were strictly instructional guides for amateurs to improve their game, but otherwise, whether fiction or nonfiction, the central character is consistently someone with decent intentions who makes significant mistakes in life. That was, we may assume, how he saw himself.

Tilden wrote in flowery style, but he could be compelling. That dichotomy is apparent in the opening of *My Story*, the memoir he wrote in 1948 after his arrests and imprisonment for charges stemming from sexual advances to young men. Nonetheless, his emotions are heart-wrenching.

> Life is like a spring day. Clouds and sunshine alternately fill the restless skies, one succeeding the other with disconcerting abruptness. Sometimes it seems that there will be no break in either, but the end

of both always comes. Just now I am under a cloud, but I know that somewhere ahead shines the sun. Fighting toward it, already I glimpse a beam tinting the gloom and I take hope. For all through my career I have loved the brightness, and I long for it again.[84]

He tried hard to be successful not just as a writer but also as an actor. In the 1920s, Tilden kept a suite at New York City's Algonquin Hotel. Among the denizens of its Round Table were F. Scott Fitzgerald, Dorothy Parker, and Ernest Hemingway, and luminaries of the theater were also on the scene. Tilden had deliberately positioned himself in the hotel so that he could meet them, in the hope of being offered roles in their plays. He had the looks to be a leading man on the stage, and his name had cachet.

He started with amateur theatricals. At the same time he was accumulating Grand Slam titles, he had a part in a play called *Wedding Bells*, by Edward Salisbury Field, a popular American playwright and novelist whose best-known comedies were *Twin Beds* and *Life of the Party*. It was performed in the ballroom of the Germantown Cricket Club; Tilden got the part largely because he was so well known on its tennis court. He went from there to Broadway, with a part in *Don Q Jr.*, then a leading role in *The Kid Himself*. The New York Times review damned him with faint praise: "Certainly many worse ones are acting away for dear life in sundry theatres up and down the avenue. . . . There is no reason why Mr. Tilden should not enjoy a successful stage career, although it is unlikely that he will ever mean to the stage what he means to the courts."[85] *Variety* followed suit, saying Tilden was "not the champion on the stage that he is on the tennis courts," and added that "with a little more rehearsing," he might have some success as an actor.[86] Still, he was determined, and when the play folded after two weeks, he used his own funds to have it continue at a different theater. He arranged to have his tennis matches start an hour later than usually scheduled so he could perform in matinees and still be on the court on time.

Acting and writing plays interested him almost as much as tennis did. He often produced the work he wrote and starred in, losing substantial amounts of money. People laughed at his performances, but he seemed impervious to their disapproval. Al Laney was aghast:

I felt ashamed for him, almost humiliated. Tilden himself, of course, never knew how incredibly bad he was as an actor. In admitting that he had perhaps been foolish to waste so much money in that way, he attributed it only to bad luck, never to lack of talent.[87]

Bill Tilden's confidence was both his greatest strength and a major shortcoming.

◆

TILDEN LIKED famous people. His skill was his entrée into their worlds and he had the diplomacy to get along well with them. In 1921, two days after he won at Wimbledon, he was invited to Buckingham Palace to play tennis with the future king George VI. He determined that, while he had to beat his royal host—as a Wimbledon champion, it would be too fishy if he lost—he would go easy so as not to win by too much. "I decided to beat him but to be decent about it and see that he played well."[88] He was astonished that he had to play at his normal competitive level to win 6–3, 6–3. He had an equally good match with King Gustav of Sweden at the Royal Tennis Club in Stockholm.

After Tilden moved to Hollywood, in the 1930s, he played tennis with, among others, Clark Gable, Judy Garland, Barbara Stanwyck, Gary Cooper, Lauren Bacall, and Humphrey Bogart. One of his closest friends was Charlie Chaplin, to whom Douglas Fairbanks had introduced him. Tilden considered Chaplin "the greatest genius of the screen and the most brilliant comedy brain in the world."[89] We know from Alice Marble's experience that Chaplin cheated on line calls, but the actor's desperate efforts to win did not put off Tilden or other Hollywood players. Chaplin gave tennis parties on his private court, where Tilden's partners included Olivia de Havilland, Spencer Tracy, Montgomery Cliff, and Errol Flynn.

Clifton Webb, who also had a court, introduced Tilden to Katharine Hepburn, Tallulah Bankhead, and Greta Garbo, all of whom he coached. At one point, Katharine Hepburn and he were playing tennis every day. With his notion of male superiority, he made up rules obliging him to cover the entire doubles court while hitting against her on the singles

court—and Hepburn managed to beat him. Nonetheless, he made sure, in reporting it in *My Story*, that his readers knew he was playing with a self-imposed handicap and that he won the following day:

> Believe it or not, she beat me one day—playing really amazing tennis; she threatened to send out a special announcement and then retire from the game, but hurried back the next afternoon to make sure I didn't take her threat seriously. Where she gets the power from I can't imagine. But she hits a harder forehand than any girl I've seen on a court—including Alice Marble! It's just as well she hadn't too much control of that wallop or I might have died chasing it.[90]

In his memoir, Tilden would periodically mention being in love with various female stars. "Twice in my life I even considered marrying. Both women were famous, and both of the stage."[91] The first was the glamorous Peggy Wood, an actress with a fine singing voice who got major roles in Noël Coward plays and was part of the Algonquin set. His second "bout with romance" was with Marjorie Daw, who starred in *Haunted Hands*, a film in which Tilden appeared. And then there was the Polish-born Pola Negri, who had become a sex symbol in silent films:

> I had another infatuation—shorter and more violent, this time—when I met Pola Negri in 1923. There was a gal! She was on the rebound from her affair with Charlie Chaplin, and at the moment footloose and fancy free.[92]

It only ended, he claimed, because he was forced to leave Los Angeles on the tennis tour. Beyond those flings with actresses he mentions in the memoir he wrote after being incarcerated, he boasted of romances with four female tennis players—while making clear that none turned into a full-fledged love affair.

People liked to gossip about him. His body odor was legendary. He was both pathologically shy and way out there. He was famous for never stripping in the locker room or being seen heading to the showers, but he was so public in the attention he gave to ballboys that after one Wimbledon match Vladimir Nabokov purportedly said, "Looks

like Tilden's got himself a harem of ballboys." Nabokov was sufficiently intrigued that he gave the name "Ned Litam" to Lolita's tennis teacher. The name is "Ma Tilden" spelled backwards.

◆

TILDEN MADE films that teach tennis. Lanky, his hair brushed back, wearing an unusual sweater that joins a strong diamond pattern with images of camels, he coaches wisely, speaking with a patrician voice and accent that resemble Franklin Delano Roosevelt's. The only problem with the films is that some of them show him with a good-looking teenage boy. Tilden, in a manner perfectly normal for a tennis pro, often has his arms around the boy as he guides him through the strokes. In hindsight, maybe the "perfectly normal" was not quite that.

In November 1946, when he was fifty-seven years old, Tilden was arrested on Sunset Boulevard by Beverly Hills police. He had been discovered with a fourteen-year-old boy whom he had first encountered at the Los Angeles Tennis Club, and was found guilty of "contributing to the delinquency of a minor."[93] The sentence was a year in prison, of which he served seven and a half months, followed by five years of parole with conditions that meant he was not allowed to give private lessons. The man who had grown up wealthy and earned a lot of money as a tennis pro, who played with the stars and taught millionaires, no longer had a clear way to make a living.

Bill Tilden tells his version of the event in *My Story*. He explains that when the second annual World's Hard Court Championship would be held at the Los Angeles Tennis Club, he worked "with the youngsters" in his spare time during the days before the tournament.

> I am one of those who believe that it is up to the older players to do all they can for the kids; besides, like many people, I find in youth a constant source of stimulus and incentive. I met one lad on the courts who showed unusual promise. I had known him casually for some time. He was keen to learn, and I wanted to help him.
>
> He and I . . . became good friends. Somehow we drifted into a foolishly schoolboy-ish relationship which I should have prevented.

> My nervous strain was such that at the time I seemed to lack will; I seemed dissociated, and beyond control of my own actions.[94]

One evening, Tilden reports, they went to the movies together and then he allowed the boy, who did not yet have his license, to drive his car. "We were fooling around, indulging in horseplay." They were stopped by the police. He took "full responsibility" in order "to save the youngster."

Tilden then tries to defend himself: He writes that all athletics "throw the same sex together constantly and intimately." It is as if that explains what happened. But then he shows self-consciousness in writing this: Because of "admiration for physical perfection, an attraction may arise almost like that of love. The result is . . . relationships somewhat away from the normal."[95]

From there, Tilden provides a discourse on such relationships historically. He explains that they have nothing to do with tennis in particular, and says they call "more for psychiatric than legal or punitive measures. . . . It is, if anything, an illness; in most cases a psychological illness."[96]

In court, the judge chastised him. "You have been the hero of youngsters all over the world. . . . It is a great shock that you are involved in an incident like this." According to an article with the headline "Bill Tilden Gets 9 Months in Jail for Sex Offense," in *The Philadelphia Inquirer* on January 17, 1947, the reporter wrote that Tilden said his trouble began "when I was very young and stupid many years ago."[97] Saying twice that this was "an object lesson," the judge added to his prison sentence the stipulation "that on release, Tilden should obtain psychiatric treatment and not associate with juveniles except in the presence of responsible adults."[98]

WHEN HE wrote *My Story*, Tilden voiced profound remorse. He writes that prison "gave me a wonderful opportunity to undergo rehabilitation and I took full advantage of it."[99] On the last page of the book, he says his fame had no impact on his treatment during incarceration, and that he considered himself on a new path:

I was just one more guy in jail, which was what I deserved to be, and what I wanted to be.

Now all that is past! All that I ask is the chance to prove that I have learned my lesson, that I have paid my debt, and that I am intent on resuming life as an honorable member of society....

I hope to carry on my tennis career... I hope to be able to play for worthy charities, for the entertainment of our Veterans in hospitals, and to do it knowing I am welcomed. I trust that whatever of good I have done in this world will be set against my mistake and found to outweigh it in the final balance.

... What the end of this, my story, will be, the years ahead will tell. I can only try to give it a happy ending.[100]

BUT HE could not contain himself. On January 28, 1949, about a year after his release from prison, the police arrested Tilden at home following charges from a high school student "that the tennis champion made improper advances last Friday morning, after he allegedly had picked up the youth in his automobile in Westwood."[101] There was "a juvenile" present when the police entered Tilden's apartment in Westwood Village. Tilden reportedly did not argue when the police said they were arresting him.

The presence of a youth in Tilden's apartment was already a violation of his parole terms, and newspapers named the boy, who gave Tilden's license plate number. Nonetheless, Errol Flynn advised Tilden to get a lawyer, who proposed Tilden plead not guilty. The plea would necessitate a jury trial in which the boy would be required to testify. Flynn anticipated that the boy's parents, eager to keep their son from appearing in court, would not agree to this, so there would have to be a settlement in Tilden's favor. But Tilden would not go along with the scheme. He was sentenced to a one-year prison term, of which he served ten months.

People turned their backs on him. When he was no longer behind bars, Bill Tilden was ostracized. He was banned from most tournaments and tennis clubs. His name was removed from the alumni files at the

University of Pennsylvania. The Germantown Cricket Club revoked his membership, and his picture was taken off the wall there, as it was at the West Side Tennis Club in Forest Hills. He was no longer allowed at the Los Angeles Tennis Club.

But a few people were still there for him. David O. Selznick, Joseph Cotten, and Charlie Chaplin continued to allow him to use their tennis courts. Errol Flynn wrote to him: "You're just one set down with plenty of games to play."[102] When the sporting goods company Dunlop stopped sponsoring him and providing him with tennis gear, another company, Bancroft, took over. Pancho Gonzales still played with him on the pro tour—at the few places where he was allowed to play.

He was a broken man, however. He could no longer make money teaching and had to sell his trophies. He died at age sixty on June 5, 1953, alone in his apartment, of a heart attack. There was less than a hundred dollars in his bank account. Still, Pancho Segura, Gussie Moran, Nancy Davis (the future Mrs. Ronald Reagan), and Alice Marble were at his funeral. Tilden's body lay in state in a new sweater bought for the occasion by Joseph Cotten. He was buried in style.

6

DRESSED TO WIN: KATHARINE HEPBURN AND RENÉ LACOSTE

A<small>N EARLY</small> picture of René Lacoste—yes, there was a man with that name before there were shirts and jackets and boutiques—shows him racquet in hand at the age of eighteen. A foulard puffed like meringue flows between the lapels of his blazer. The get-up suggests the same sense of enjoyment with which Lacoste played tennis. This bold neck covering is a declaration that tennis is not just about fitness, tactics, skill, or coordination; it is also about *style*. It demands the temerity to go to the outer limits of what is possible. Perhaps the term "ascot," or even "scarf," would be more apt for this item Lacoste has knotted so lavishly, but "foulard" is the one of choice because it conjures a material that is light and flexible. Its weightlessness and movement in the air are the quintessence of a beautiful serve or of an effective rush to the net.

Once upon a time, a certain elegance was the norm in tennis clothes. The outfits worn in sixteenth-century England by the noblemen who played the French game *jeu de paume* at Hampton Court conveyed an impression of courtiers jousting. I would say the word *swashbuckling* is appropriate. With their long hair, worn pageboy-style, in their skintight jackets with white ruffles billowing out from the collars, around the shoulders, at the elbows, and around the cinched waists, these sportsmen oozed confidence. These fellows wore their finery with self-possession. They carried off not just the fitted tops but also the tight breeches,

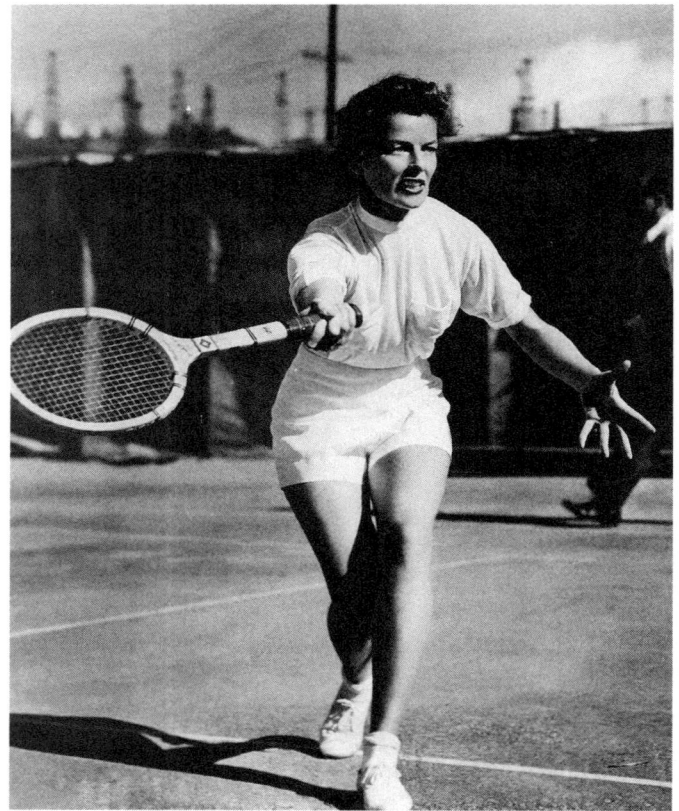

Katharine Hepburn was not known for timidity.

possibly suede, rolled up just over their knees, so a sport that requires great skill no matter what its players wear was most entertaining. Women were not yet playing tennis, but the men were fashion plates.

Walter Clopton Wingfield, the Welsh army officer said to have invented lawn tennis, wore incredible outfits. What gives them distinction is that they were dashing without being the least bit foppish. Wingfield favored doublets, snug and without sleeves, of thick fabric with a complicated weave, fastened with embroidered buttons. He would roll the sleeves of his loose-fitting cotton shirt above the elbows, his bulging forearms on view, thus demonstrating that he was an aristocrat and a tough guy, who followed the rules of style but was also strong and relaxed. He

wore his beret at a jaunty angle, tied his neck scarf in military style, and kept his handlebar mustache and pointed beard in trim. At the same time, he had the body of an American football halfback. That combination of worldliness and imposing physique surely intimidated any opponent.

Women back then wore long flowing dresses and floppy hats, until Helen Wills, a star of the 1920s, donned pleated skirts and gamine tops. She had the joie de vivre of a flapper in an F. Scott Fitzgerald novel. We picture her playing with that same sense of fun as someone sipping champagne at sunset on the Riviera. But the style most irresistible among the well-known female players was Althea Gibson's, some three decades later. This Black American athlete who broke the color barriers, in both tennis and golf, wore skirts and tops that imply a simple life. Her clothing was as natural as her smile.

There is a photograph of Gibson taken at the 1957 Wimbledon Women's Single Championships as Queen Elizabeth II presents her with the Venus Rosewater Dish. The queen, smiling, wears a soft summer hat, two strands of pearls, pearl earrings, a flowered dress showing just as much cleavage as her position allowed (maybe a tiny bit more), and white gloves to her elbows. A tall, lean Black woman dressed to win the game, Gibson is as consummately who she is as the queen is a monarch.

In men's tennis of the modern era, René Lacoste set the style with garments like that foulard. He cut an elegant figure on and off the court well before he developed the eponymous shirt, with its reptile logo symbolizing power and cool.

Clothes do not in fact make the man, but if someone has flair to begin with, dressing with panache can contribute to the overall impact, and Lacoste—who, among other things, was one of the best tennis players of the day—was a marvel.

With straight black hair and a nose that is brazenly *there*, he was, by European standards, exotic. He emphasized his Byronic appearance with clothing that has pizazz. The blazer he sports in the picture with the foulard is unique. Whereas today's players would be wearing warm-up jackets made of synthetic fabric, what Lacoste has on to keep his muscles from getting cold and tightening is a masterpiece of haberdashery. It manages to be simultaneously tailored to his body and loose enough for

comfort. The terms used for menswear—"English fit," "unstructured," "formal," "casual"—all apply. They are contradictory, as is the way the blazer buttons function, making the jacket seem both double-breasted—which the French call "crossover"—and single-breasted. How perfect for a player who could hit his groundstrokes flat, sliced, or with topspin—always unpredictably. To have it all in your bag of tricks is the essence of good tennis, and perhaps, too, of stylish dressing.

Lacoste had developed not just those groundstrokes, but also a first-rate serve and volley, by the time he posed for this photo. For the native Frenchman, born in 1904, it all began in England. When he was fifteen, he accompanied his father on a trip there and picked up a racquet for the first time. He was a quick learner, playing at Wimbledon a mere

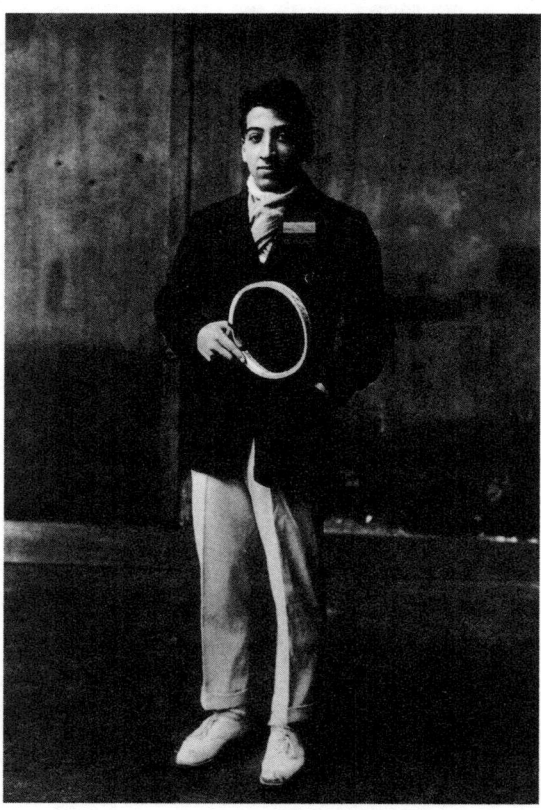

René Lacoste always dressed to the nines.

three years later, the year he was portrayed as so dapper. The racquet is here simply a symbol, held at the throat rather than on the grip, with his left hand in his pocket in the fashion of a country gentleman. He wears immaculate white tennis shoes and long, cuffed, somewhat baggy white pants—short by Savile Row standards but ideal for tennis. If it was premature for him to look so much like a potentate—Lacoste lost in his first round that year—in the following year he made it to fourth at Wimbledon, which gave him a berth at the US Championships. At nineteen, he was in the upper echelon of the sport.

From there, victory followed victory. In 1925, Lacoste triumphed at both the French championship and Wimbledon, garnering singles titles as he would continue to do, on and off, for years. He beat Bill Tilden in the finals of both the French and US Championships. His conquests included the legendary players Jean Borotra and Bill Johnston. He did his country proud in the Davis Cup. People called him "the tennis machine." He generally stayed on the baseline, hit his groundstrokes deep with pinpoint accuracy, and was so methodical that he kept a notebook in which to record his opponents' weaknesses.

As he began to pile up the trophies, Lacoste, already interested in clothes, wanted to redesign what men wore on the court. Ranked No. 1 in the world in 1926 and 1927, winning Grand Slams, he wondered why he had to wear long-sleeved shirts as well as neckties and long trousers in all the important competitions. The requisite shirts were cut pretty much like the ones men wore with suits, except that for tennis they were button-down to keep the collar tips from flying outward as the players ran. Lacoste noticed a friend in a social match wearing a polo shirt. His friend, the Marquis de Cholmondeley, had a name and social position that made the way he did things instantly acceptable, so Lacoste felt comfortable following his example. The polo, which could be pulled on and off over the head, was more practical than shirts that required opening and closing a long row of buttons. Its short sleeves made sense, as they left the elbows and forearms unencumbered. It stayed closer to the body than did dress shirts, with their loose material.

Lacoste decided to have polo-style shirts made, just the right way, by his English tailor. Some were in cotton and others in wool, both

materials "breathable." What mattered most to Lacoste was to be able to run more easily, and these shirts were the answer.

Shirts worn in India by British polo players in the Victorian era had been fabricated in America ever since John Brooks, grandson of the founder of Brooks Brothers, had seen them worn by polo players in England at the end of the nineteenth century. Its attributes were many. The tail was supposed to keep the shirt tucked in at the back while the shorter hem in front let in a bit of air, invisibly. The tailor in London had done a good job executing Lacoste's design, but America was the place to try producing these shirts in volume. In the days when Brooks Brothers had just a couple of stores—large ones in New York and Boston—whatever it carried had style and a pedigree. The painter Winslow Homer rarely left his studio in Maine except for the two times a year when he went to Boston to update his wardrobe at Brooks; what the store sold was socially acceptable, well made, and aesthetically appealing. René Lacoste first wore a Brooks Brothers polo shirt on the court at the 1927 US Open.

Lacoste married a golf champion, had children, and, when his health took him out of tennis competition, went into business with those shirts as the principal product. His company began to manufacture and market the shirts independently. The quality was impeccable, the style dashing. The success of the shirts, and of a range of related items, has been consistent since then.

◆

ALLIGATOR OR crocodile? Which is the animal on Lacoste products?

This is a hotly debated subject. Most people are sure they have the right answer—whichever of the two reptiles they name.

On a trip to Boston in 1923 with his Davis Cup team, René Lacoste saw a suitcase made of crocodile. "If you win the match, I'll get one for you," his trainer, Alan Muhr, said ironically before the game. That anecdote gave birth to the name "The Alligator" that appeared for the first time ever in a newspaper article in the *Boston Evening Transcript*, and that became the symbol of the brand.

Is it a crocodile or an alligator?

So it was crocodile as suitcase that begat the nickname "the alligator." Adding to the confusion, whereas René Lacoste was called "the alligator" in Boston, he became "le crocodile" in France. In his obituary, his son explained that a friend of Lacoste's embroidered a crocodile onto a blazer Lacoste wore over his tennis clothes in honor of his name. Yet some of the company's advertisements, in English, use the slogan "See you later..." to set up the rhyme with *alligator*.

There is nothing in the actual image of the animal on the logo that clearly establishes it as one or the other.

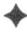

"YOU-AH SHORTAH than he is, and he is tallah than you-ah, so you two change seats. Move to wheah he is, and then *I* will be able to see—at least slightly bettah."

She did not say "please." And it is impossible to capture her accent phonetically, because no one else except for her sister—Marion Ellsworth, whom I once heard ordering a half pound of Dover sole in Kaye's Fish Market in West Hartford, Connecticut, where their family was like royalty, and whose intonation made me expect the man behind the counter to be Spencer Tracy—spoke in that mix of upper-class

London and New England Yankee, and with that deep voice and unflinching authority.

I did not have to turn around to know that the woman instructing us was Katharine Hepburn. And my wife, another Katharine, and I did exactly as commanded. The curtain would soon be going up at the Goodspeed Opera House—an ornate Victorian building with wedding-cake architecture on the Connecticut River—and it made sense that the great nonagenarian actress was there, as she summered in Fenwick, an exclusive coastal enclave nearby. Still, as the heavy red velvet curtain rose to reveal the stage, I was gobsmacked when the Katharine behind us placed her two small feet in white tennis socks on each of my Katharine's shoulders. She planted her heels firmly with her toes pointing up.

So there I sat, Katharine Hepburn's left foot on Katharine Weber's left shoulder, so close that I could be certain it was odorless. I could pay no attention whatsoever to the first act of the musical comedy; I kept thinking that those were the feet that went down the river with Humphrey Bogart in *African Queen*. Then there was an intermission, and my wife felt she had earned the right to speak to the woman who had used her shoulders as a footrest. She thanked her first for her generosity to Planned Parenthood, causing the infamous Kate to bellow, "The problem is the goddamn Catholic Church!" Then Katharine Weber explained that when making sure people spelled her name correctly, she referred to Miss Hepburn. The actress asked, "Were you named for me, deah?" My wife replied that she was named for her grandmother, the composer who was professionally Kay Swift but whose real name was Katharine Faulkner Swift. This information did not interest the gal who broke barriers with her tennis clothes.

That style of socks had once been a detail in a major fashion statement. Katharine Hepburn had, in the 1952 movie *Pat and Mike*, changed forever the way socialites could dress for tennis. The cushioned socks that went up the ankle just a couple of inches were intrinsic to the look. They were a declaration of the need for functionality, with their roughness and toughness. The socks, though, were a minor detail. The trendsetter was the shorts.

◆

Pat and Mike, directed by George Cukor, was written by Garson Kanin and Ruth Gordon, friends of both Hepburn and Spencer Tracy. It was created specifically to showcase Hepburn's skills at tennis and golf. As Pat Pemberton, the actress plays both sports superbly, and what she wears is equally superb. Women like Hepburn's mother wore long white skirts they had to hold up so as not to trip on the hems when running around the court. Until Hepburn wore shorts in *Pat and Mike*, female players were always in tennis dresses, albeit shorter than in earlier years and easier to play in than those outfits that looked like ball gowns.

And what shorts Hepburn wears! They are high-waisted and, well, short. Just as when she laced her forehand drive crosscourt, Katharine Hepburn was not timid.

Her blouse in *Pat and Mike* has a high crew neck that gives the modest impression of a religious habit. But its useless pockets with a button over each of her breasts are provocative. Hepburn's clothes are as audacious as she is. Designed so a woman could really play the game at

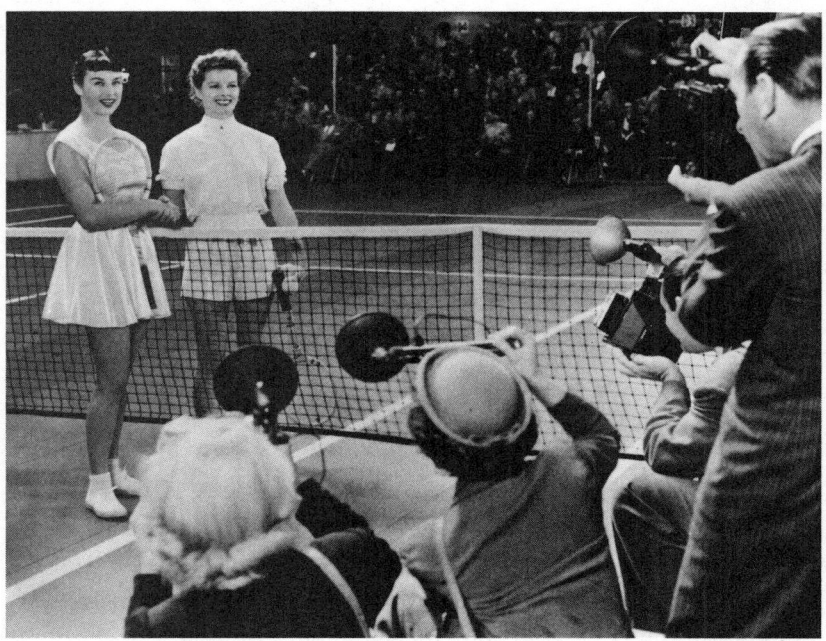

Hepburn was dignified however short her shorts.

her best, they reveal determination and athleticism in lieu of the "girly-girly" style of many of her contemporaries.

Pat Pemberton's skill at sports combined with her mischievousness make her utterly charming. Her straitlaced fiancé gets on her nerves whenever she is competing, because he hopes she will quit the game, marry him, and settle down. Meanwhile, a colorful sports reporter, Mike Conovan—played by Spencer Tracy, Hepburn's love in real life—falls for Pat. Those tennis shorts with their waistband hiked above her midriff and the interesting top are part of what makes Pat exactly the sort of rebellious woman this ruffian finds irresistible. The cameo roles of Gussie Moran, Don Budge, and Alice Marble—tennis greats of the epoch, dressed more traditionally—add to the "wow" factor. The tennis scenes were shot at the Cow Palace, in California, just right for the actress/athlete to do her stuff.

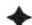

WOMEN'S TENNIS clothing had come a long way since women started playing the sport in 1873, and Katharine Hepburn donning those shorts and being seen bare-legged was a vital step in that evolutionary process. At first, female players had covered their entire bodies except for their heads and hands. Underneath their high-necked long-sleeved blouses and their long bustle skirts, they bound their bodies in tight, hard corsets. The undergarments constrained them, but comfort and ease were beside the point; you would not violate the dress code or show flab any more than you would grunt the way players do today. Whatever the heat and humidity, flannel and serge were the norm, sometimes with fur. Most of the outfits included neckties, perhaps because they were de rigueur for men as well. And skimmer hats were essential—these being straw boaters with very wide brims, often with colorful bands.

At first, the flowing wool of these outfits was in muted but lush blues, mauves, and golds. That changed only in 1884. At the Wimbledon Ladies' Lawn Tennis Championship that year, Maud Wilson won the event wearing solid white. Her bustled two-piece dress, so long that it swept along the grass as she ran, looked as pure as snow. It was discovered that white did not show sweat stains the way that colors did, and so

it became de rigueur. When Katharine Hepburn donned those shorts in regulation white, she did so with grace and quiet confidence. And no one argued with her. She had the same power and radiant charm as when she instructed the young couple at the theatre to switch seats; resistance was out of the question.

Katharine Hepburn helped pave the way for that comfortable outfit Althea Gibson wore in the presence of the queen. At last, clothes gave female players the physical freedom that enabled them to play their best. And René Lacoste's stylishness was a mark of liberation in another way. A male athlete could be dapper without being a fop. These two great sportspeople dressed as they played: with bravura. They and Althea Gibson, the three of them exuding personal forcefulness, became models for generations to come.

7

SUZANNE LENGLEN

Today, most tennis aficionados think of "Suzanne Lenglen" as the smaller of the two stadium courts at Roland Garros, at the edge of Paris's Bois de Boulogne, where annually, starting in late May, the French Open is played. Important matches take place on Suzanne Lenglen, and many people prefer being here than at Philippe Chatrier—the "championship court" on which the finals are played—because the stands are smaller, and a fan is never too far from the scene of the action.

But if you ask those who go to Roland Garros or see the courts there on television who Suzanne Lenglen was, very few would know the answer. Nor, for that matter, would they be likely to tell you that Roland Garros was a French fighter pilot in World War I who had been the first to shoot down a German aircraft and had been rumored to have shot down a Zeppelin before being killed himself at the end of the war.

A little investigating makes clear why Suzanne Lenglen was worthy of having a court named for her. We discover not only that she demonstrated consummate artistry in the way she played her sport, but also that she inspired a marvelous ballet, breakthroughs in fashion design, and splendid prose.

Lenglen was born in Paris in 1899. In 1921, when ranking was inaugurated, she was the first No. 1 female singles champion, a position she held until 1926. She won the French championships year after year and

Wimbledon six times. At one point, she was victorious in some one hundred and eighty consecutive matches. She was known as "the Goddess," mainly because she comported herself like one. She was by no means a classical beauty, but she had spark, as was evident in the dress designed by the couturier Jean Patou for what was called the battle of the century. This was a tennis match played at Cannes in February 1926. If ever tennis was theater, this was the occasion. It even had a surprise second

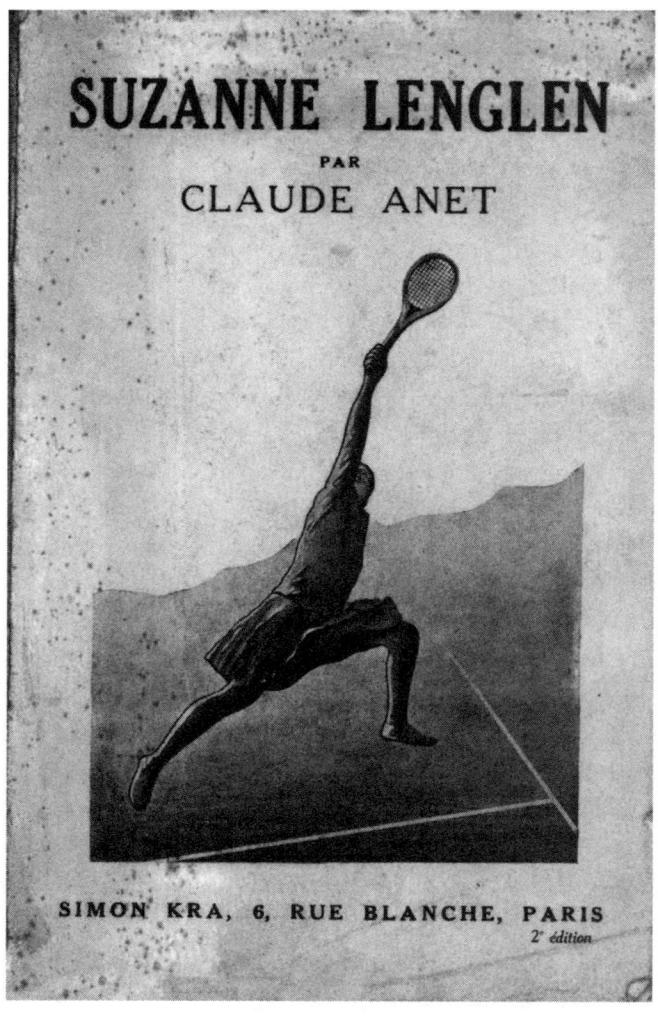

This biography has been all but forgotten.

ending, one that caused the spectators to return to their seats just after abandoning them.

That match between Lenglen and the American Helen Wills Moody was thrilling from the start, but it was in the all-important seventh game of the first set when the scene on court became spellbinding. For many players, this game has mythic importance. If it begins with the score at 5–1, the seventh game can determine the winner of the set. If it starts at 4–2, it ends either with one player far ahead and the other far behind at 5–2, or at the much tighter 4–3. And if the seventh starts at 3–3, its winner will have taken the lead at a vital moment close to the end of the set. Wills was the server of this crucial game and needed it desperately, as she was down 2–4. None other than Claude Anet, who as Jean Schopfer had won the French Championships two years before she had, wrote about it:

> Seventh game. Yet, they are harshly battling it out. Every point won is a struggle. Helen Wills' serves swish across the court. She is hitting

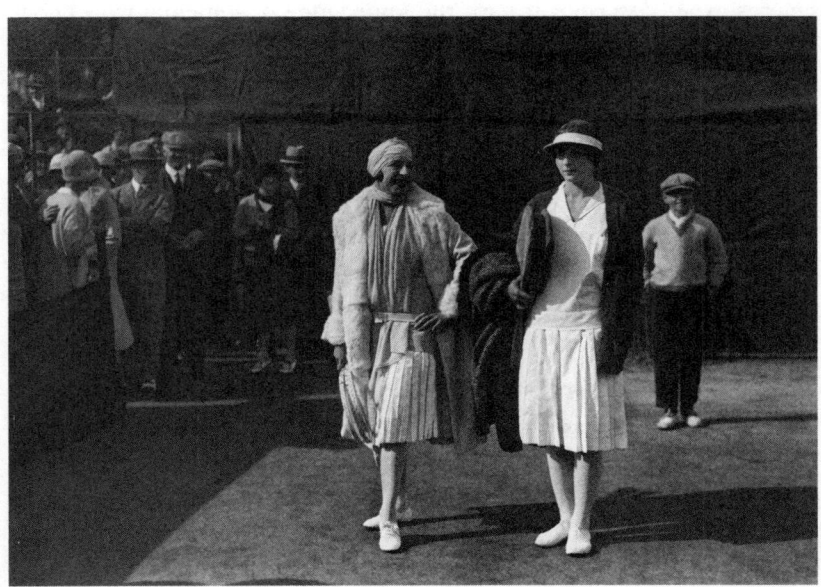

Before "the battle of the century," Helen Wills and Suzanne Lenglen presented very different personas walking onto the court.

with all her might, as per W. T. Tilden's recommendations. But is any ball really capable of getting past Suzanne Lenglen? Any she could possibly miss? She flies across the court with her signature grace, lightness of foot and seeming lack of effort. The ball heads back over the net—not so quickly today, just enough to keep her adversary on her toes. All the same, every stroke requires preparation and a calculated move to score. After a lengthy rally, Helen Wills positions herself admirably and lands her first serve. The two that follow come fast—Suzanne sends them right into the net. Forty for Wills. Then Suzanne tricks her rival with a ball she cannot reach in time. But Wills takes the game with a magnificent volley that wrong-foots Suzanne. Four games to three, with Suzanne in the lead.

Despite that pivotal loss, Lenglen wins the first set, after which she drinks some cognac out of a silver flask handed to her by her mother. There is no sign that the alcohol has hampered Lenglen's athleticism and tenacity: quite the opposite. By the fifth game of the second set, even though she is losing the set and is noticeably exhausted, she perseveres. Anet describes it with the knowledge of someone who knows the game inside out:

> She runs no risk, coolly calculating serves that draw her opponent toward the net and others that send her to the back of the court. From crossed backhand, to open, or a double bounce ball that catches her opponent off guard . . . We all watch in admiring awe, even though —alas—these beautiful moves are all happening rather slowly. With just a hair more speed, the serves would be positively lethal.

The coup de foudre is within the narrative of this ultimately decisive set. The pace has quickened, and just when we think the energy level might have decreased, the two players come on full force, without showing a hint of lassitude or even seeming to catch their breath. Anet compares it to

> A fight to the death, that will only end when one of these heroic girls falls, lifeless, at our feet. The emotions ripping through us are akin

to those the Romans felt during a fight between gladiators. It is no longer a thing of pleasure or of joy. An undefinable sense of anxiety has us glued to our seats, panting right along with the two women fighting it out in the ring.[103]

Until now, Lenglen had been secure on her throne as the queen of tennis. But Wills goes after her with flawless strokes and lightning speed. Lenglen's reaction, although she is visibly weak and exhausted, is to summon some inner force. Just as she appears to be failing, at the point of collapse, she bulldozes her way to victory.

Or so it seemed. A minute or so after Lenglen is declared the winner, the announcement is countermanded by a tardy line call. The umpire has learned from the line judge that the call of the shot with which Wills was thought to have lost the match was "in," not "out" as the umpire erroneously assumed. A moment after everyone thought the match was history,

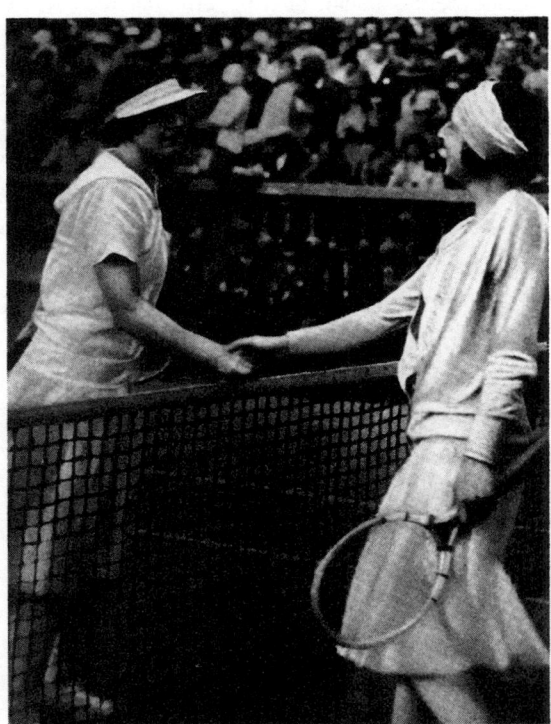

An ecstatic victor; a gracious loser.

the audience becomes rapt with attention in this unexpected encore until Lenglen is declared victor yet again, this time accurately.

◆

MANY PEOPLE would write about the match, but it is Claude Anet who makes us feel as if we are at courtside. Anet keeps us at the edge of our seats in suspense as first one player leads, then another, and then back and forth again. We watch some of the points shot by shot and can imagine the sounds of balls whizzing by and the *thwacks* of the racquets striking them.

"Un match historique: Suzanne Lenglen contre Helen Wills" is about as obscure as anything once in print could be. It is almost impossible to find a copy of the 1927 *Revue de France*, which is where Anet's account of the match appeared. It is only because the Bibliothèque Nationale, in Paris, provided, during the time when COVID restrictions made it impossible to see original documents, a scan of this gem that we can read it today. For the sake of anyone who would love a phenomenal courtside report of one of the greatest tennis matches ever, it should not only be reprinted in the original French but also translated into multiple languages. It enables us to see the fire and panache that made Suzanne Lenglen a unique force.

Anet subsequently published a text devoted to Lenglen on her own in *La Nouvelle Revue de France*. This is more than "tennis writing"; it is a portrait in the tradition of Janet Flanner, Lytton Strachey, and other masters of brief biography. Lenglen's fiery nature and her theatricality emerge. Anet also emphasizes her sense of style and concern for elegance and fashion on the tennis court—all the more remarkable in the era before tournament players were raking in huge sums of money in prizes and sponsorships.

Anet's interest in appearance may infuriate some readers even while it enchants others. What matters to the writer are the qualities that cause the star athlete to resemble one of Vuillard's high-style ladies:

> Miss Lenglen is surprisingly feminine. I imagined her as a bronze statue but she's frankly more wax up close. It feels like stepping barefoot on to a marble slab only to discover it is an Oriental rug.
>
> Instant photography (come to think of it, is posed photography more realistic?) gives us an incomplete impression of people. They

are warped by sunlight and shadow and the color of their eyes escapes us. Miss Lenglen's irises contain grayish-green and twinkling blue. Her eyelids, which reach back toward her temples like those of a nocturnal bird of prey, make her face ever so charming. No instant photograph in the world is capable of reproducing that sort of beauty. Those eyes must hone in on the ball's trajectory like an eagle hones in on a wood pigeon in flight...

Miss Lenglen is much more at ease speaking of dresses and the pleasures of Parisian life than she is about her sport. She shakes nervously. She wants to talk; doesn't anymore. Someone is waiting for her. Her girlfriends giggle about the so-called gigolos who squire her, crowd around her at the dance hall, at the tearoom, all across Paris . . . They are proud of her, and she is quite content to count them. It is a welcome distraction from her anxiety, a sort of neurasthenia; from her desire to be elsewhere and to achieve something that she cannot identify. Something that *is* without *being* and causes her to leave where she is and go somewhere else. Miss Lenglen is not an athlete at heart.

In those days, it was not the norm for tennis players to make money or for them to be associated with a designer's name. The public pairing of a recognized athlete with a particular make of clothing was forbidden. Whereas today there can be a full-page image in *The New York Times* of Jannick Sinner with a monogramed Gucci bag over his shoulder, with this flashy advertisement for the brand typical of the way consumers are guided to associate what they might buy with the prowess and charm of great athletes, it was out of the question a hundred years ago. Claude Anet points this out: "The Federation will not so much as allow Miss Lenglen to grant a dressmaker who may have made her a dress at a bit of a discount, to publish a picture of her with her name on it!"

◆

JUST AS the account of the Lenglen–Wills match has been all but lost, it is almost impossible today to find a copy of Anet's full-length biography of Suzanne Lenglen, which came out in 1927, subsequent to the article.[104] Even in Paris where it was published, the book, of which there were

only three hundred and twenty copies, all numbered, is unavailable. It is noteworthy for being the first biography ever devoted to a single tennis player—all the more unusual for being about a woman while written by a man. Its scarcity is unfortunate, because it tells a fascinating story.

Lenglen was trained by her father, who would place a handkerchief on the side of the court opposite from where she was hitting so she could use it as a target. She developed into not only a player with deadly accuracy, but also an ambitious, worldly woman, keenly aware of her own effect. Anet evokes sorceress-like charms in his description of a Wimbledon match held on July 5, 1919. Calling his subject "Suzanne" and her opponent "Mrs. Lambert-Chambers," he contrasts them in a way that evokes a tennis game as a two-person costume play:

> How different they are! Mrs. Lambert-Charles is tall, thin—skinny, even. No frills from head to toe, nothing recognizably female upon which the eye might enjoy lingering. She has one of those asexual bodies England insists on making into athletes. That said, hers is an impressive fighting machine, without the slightest bit of fat. She is all nerve and muscle, letting nothing distract her, certainly not in an attempt to please anyone. All her efforts and willpower are aimed at one thing: winning.
>
> Across from her, a girl who has just turned 20, with a feminine body in its prime. She is agile, graceful, barely skimming the ground as she walks, her arms long and lean with attractive muscle play. Her runner's lungs have all the space they need behind her ample bust. Wide hips support her slim waist. Her legs are appropriately vigorous. Her head is small, with a high forehead, a large nose, and light-colored eyes—green with yellow speckles, reminiscent of a panther—adorned with attractive eyebrows.
>
> The first time I laid eyes on her, she brought to mind a young version of Racine's Athalie. I had a queen before me. Though there is nothing conventional or rigid about her. It is almost as if her young body is trembling with the kind of excessive life force that drives foals bouncing across prairies. In this case, however, her confidence and self-control are keeping it carefully restrained. She

is delightfully dressed in a short, white dress that flatters her legs, with a slightly plunging neckline. Her arms are bare.

Mrs. Lambert-Chambers is stuffed in a large skirt that is a bit too long and a high-collared blouse with elbow-length sleeves.

She has a clear, quick mind and a sharp, immediate view of what move should be made in any given circumstance. She weighs her opponents up instantly, ascertaining their strengths and weaknesses. She knows how to break down a game, how to neutralize an attack and exactly when to play defense or offense.[105]

In the course of the match, Lenglen demonstrated that rather than defend herself with her game, she would attack. After a shot to the back of Mrs. Lambert-Chambers's side of the court, she would rush net, and when the ball came back far to her left, Lenglen would somehow manage to hit it with the wood of her racquet more than the strings and put it away. Time and again she would head to the net and win points decisively from that daring position. Because of her sterling tactics, she dominated the tennis world and became one of the most popular of all female athletes. Her name appeared in a vast number of newspaper articles and she was photographed profusely. The filmmaker Alain Gerbault made a scene of himself landing on a remote island in the Galápagos and encountering a man who fled Europe years earlier to live as a sort of savage. The man has one question of his unexpected visitor from France: "Is Suzanne Lenglan still a champion?" Indeed she was.

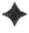

CLAUDE ANET cites a British journalist: "[I]n spite of her athletic prowess, Suzanne Lenglen remains supremely feminine." She stood on her toes like a dancer. Beyond that, she played tennis with exceptional intelligence. Anet writes:

She has a clear, quick mind and a sharp, immediate view of what move should be made in any given circumstance. She weighs her opponents up instantly, ascertaining their strengths and weaknesses.

She knows how to break down a game, how to neutralize an attack and exactly when to play defense or offense.[106]

It seems she resembled a panther.

◆

ON JUNE 30, 1924, a character representing Suzanne Lenglen, clad in stunning white tennis garb created for her by Coco Chanel, glided gracefully across the stage of the Théâtre des Champs-Élysées to the strains of Darius Milhaud's playful arpeggios. Simulating forehands, backhands, volleys, serves, and overhead slams, at one moment she assumed a correct "ready position," her racquet properly held in front of her so she could opt for the desired groundstroke once the ball was coming. She moved around the stage in what is both ballet and a series of well-executed shots. Then she did a splendid duet with a male bather who had just emerged from his cabana in his tight, brief swim trunks. The real Lenglen epitomized agility on the tennis court, and always had fun, and her rendition of a gallivanting dancer is a delight.

This ballet with Suzanne Lenglen as its central character, called *Le Train Bleu*, was performed by Serge Diaghilev's Ballets Russes to music by Milhaud. The *Train Bleu* epitomized derring-do. The libretto, by Jean Cocteau, had a lot of flirting in it. The choreography, which was by Vaslav Nijinsky's sister, Bronislava Nijinska, was gracefully athletic; Nijinska had done her research well by looking at newsreels of Lenglen playing. The manifestation of creative genius was hard to beat. Henri Laurens painted the sets, in an accessible cubist style where the forms had sculptural depth. And Pablo Picasso designed the curtain, its spirit carefree, its classical force instantly arresting. Nijinska herself danced the role of Lenglen, and not only did this lively character who swings a tennis racquet onstage wear Chanel, but so did the other performers. In the case of one of the leading men, this meant sporting trim-cut swim trunks and nothing else.

Le Théâtre des Champs-Élysées was an ideal setting for this ballet, in which tennis was presented as a chic pastime. It had a bold white marble façade that was streamlined compared to the ornate fronts of the

Diaghilev's *Le Train Bleu* put
tennis center stage.

Opera Garnier, the Comédie Française, and the other larger theater in town. The geometry of this theater, just off the Avenue des Champs-Élysées, its revolutionary clarity and sense of lightness, suited a ballet based on modern sports.

When a theatergoer entered for this ballet, Picasso's curtain of oversized women running on the beach awaited. In a style not unlike the drawings circling a Greek vase, it celebrated the wonders of the human body and the marvel of any living being moving through air. Legs were stretched; arms lifted. Once that curtain was raised, the "danced operetta" that unfolded was essentially a burlesque that parodied the frivolity and hedonism of the epoch. The ballet was named for the luxurious and fashionable train taken by chic people traveling between Paris and the cushy resorts on the Côte d'Azur, and the action occurred on a beach where people are waiting for it to arrive and deliver their sporty friends. Not only was Suzanne Lenglen present, but so was a golfer based on the Prince of Wales. There was a choir of "poules"—which roughly translates as "chicks" in the slang sense of the term—and gigolos. They cavorted

and flirted, performing cartwheels and leaps and back falls in concord with the energy and playfulness of Milhaud's marvelous music.

A lot was about presentation and illusion. There was no sand on the beach. Nor did the train ever come. The viewer was counted on to be imaginative, even as the tennis racquet was real.

Following the tennis scene, a professional golfer appeared—dressed in plus-fours according to the fashion of the time—and then a woman in a bathing suit danced with the male swimmer. A weightlifter entered; an assembly of bathers danced with beach balls; and, toward the end, both the Suzanne Lenglen character and the golfer reappeared. A dancer mischievously snatched the tennis racquet from Lenglen's grip, and the ballet moved toward a finale that makes us think that if there is a single artwork that brought together the style, the wit, the freedom, the inventiveness, and the sheer fun of the 1920s, this is it.

In almost everything she did, Suzanne Lenglen had the spirit and élan of Nijinska's rendition of her. "Whether she was drinking brandy on a changeover during matches, crying on the court, or simply showing off by unnecessarily jumping high into the air to her signature flying ground strokes,"[107] she was alive to the hilt. She was as swift of foot as any tennis player of the era; in 1926, she would, at the French Championships, break a world record for the speed with which she won the championship final, triumphing against Mary Browne, an American who was the No. 6 seed, in twenty-seven minutes during which Browne won only one game in two sets. It's no surprise that she was known as "the Goddess."

8

PIERRE

ALL PEOPLE who play tennis have certain things in common. We coerce our bodies to perform as well as possible. Even for the greatest pros, there is occasionally a gap between the desire for a shot and its execution; perfection, though elusive, beckons us. We experience, at whatever level we play, alternating satisfaction and disappointment. Body type, strength, coordination: Of course they make a difference, but all people who wield racquets have a link. We want to play a sport as best we can. Not only that, but we are engaged in the desire to validate Robert Browning's statement (in his poem about the Renaissance painter Andrea del Sarto) that "a man's reach must exceed his grasp."

And so, a hulky, powerfully athletic man born to poverty in Cameroon and an over-privileged, overeducated American aesthete thirty years his senior developed, more than twenty years ago, a friendship that only strengthens with time. From the day we met, it was clear that Pierre Otolo and I shared passions essential to our lifeblood: the delight in tennis as tennis—the sheer pleasures of the game—and the belief in tennis as a vehicle for human greatness. In the way he played and taught the sport, he demonstrated a resilience and a determination that were a life lesson.

Pierre is one of those individuals for whom it is essential to give a leg up to people born in less fortunate circumstances. That generosity

of spirit, I have discovered, often pertains to tennis players. It is as if the nature of the sport, the grace and the requisite adherence to a code of behavior and the release of endorphins, transforms many of its practitioners into givers more than takers. Having endured setbacks and overcome obstacles beyond the norm, Pierre is generous to the core. Tennis is his means of helping the world.

◆

SOME OF us perpetually need a next goal in life. I had gone past the age of fifty and was ready for a sabbatical. I was starting to write the biography of the architect Le Corbusier, whose papers are in an archive in Paris, and the French capital seemed the perfect place for my sixteen-year-old daughter to spend her junior year of high school. And would not Paris be the ideal meeting point for the rest of the family to welcome the new century as 1999 ended and 2000 arrived with the lights on the Eiffel Tower performing as never before? Still, I needed more objectives. I decided I would improve my French and would work to progress beyond the plateau my tennis game had been on for decades. Now or never.

I found a sublet for my family on the Boulevard Raspail. In Paris, if you live in the fifth, sixth, or seventh arrondissement, you might assume that the tennis courts in the Luxembourg Gardens will be yours to use. They are a splendid public amenity in this park, once the gardens of a royal palace, and they beckon with a look of egalitarianism. The only problem was that to get half an hour playing time on them was harder than it would have been for someone who was not white and Protestant to be admitted to the West Side Tennis Club in Forest Hills in the 1950s. Technically, courts could be reserved via the internet, but it did not work out that way. Most of the time, no courts were available because of a mysterious system by which a group of insiders always managed to take all the courts. Once or twice, I managed to snag a half hour at 8 a.m. on a drizzly day, but otherwise those wonderfully positioned courts remained an exotic kingdom that should have been signposted ONLY FOR MEMBERS.

For two years, I pretty much gave up on the idea of tennis in Paris. But then I went to the resource on which people depended in the pre-

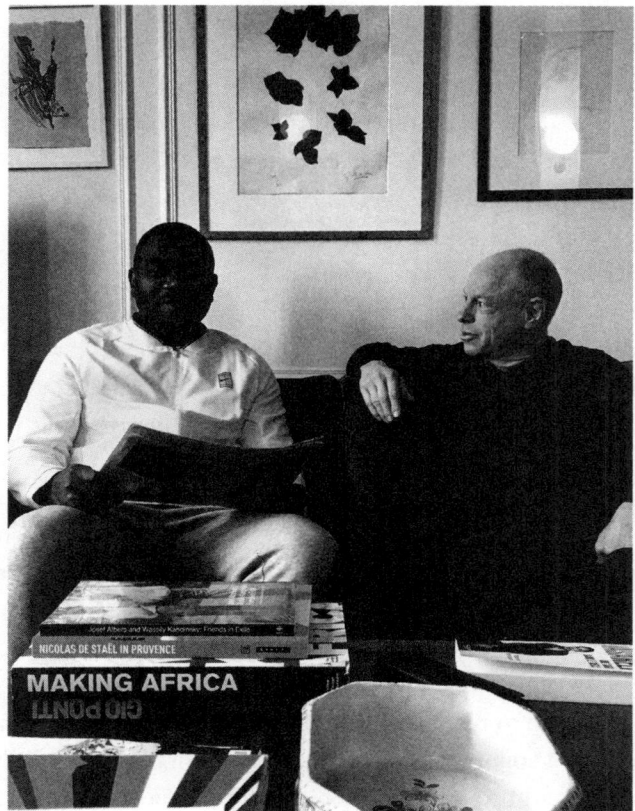

A wonderful friendship.

Google era: "les pages jaunes"—the yellow pages—of the phone book. The listings for "tennis" took me to an enchanting territory I did not previously know existed. Few people realize that almost on top of the Gare de Montparnasse, a bustling train station, there is an urban plaza that looks like one of the cityscapes of the Italian artist Giorgio de Chirico. There you find a bunch of nice courts, set pleasantly amid trees, at a place called Tennis Atlantique. *And* you can book them. I phoned, initially to ask if there was anyone who either would be a partner for someone new in town or who might give me a lesson. Pierre was working at the reception desk that day and answered the phone. "Il n'y a pas de souci"—no problem. We scheduled a lesson for the following day.

Pierre still remembers the details vividly. He came out with a basket of balls. "I did not give him any special treatment just because he was older. Most of my students were. I taught him just as I would a fifteen-year-old. He came to play, take a class. Though it was hot out, I did not do him any favors and worked him quite hard. I certainly didn't say as much but he managed to last an hour, even in 30-degree heat."

In trying to improve my tennis at more than fifty years of age, I did not simply want greater athletic skills. I was vaguely hoping for some sort of eye-opening change in my life. I had not, however, anticipated tennis as my introduction to sub-Saharan Africa in a way that has changed my life's priorities. This was not just because I had to tough out the heat during an unusually hot Parisian summer. Coping with high temperatures was not new to me, and I had been brought up never to complain about the weather. When I was a kid, if I said it was hot on the tennis court, my mother told me to appreciate how lucky I was not to be a postman or traffic cop in uniform out in the sun on steamy pavement all day long. But through Pierre I would be introduced to a knowledge of the endurance required to survive financial poverty and atrocious jail conditions. What Pierre told me about his experiences in Cameroon was my first exposure to realities I would soon discover in Senegal and that led me to start a nonprofit organization to work in the fields of education, medicine, and culture to make life better for people who grew up in circumstances I first came to know directly through my tennis teacher. Le Korsa (the word in Pulaar means "love with respect"), now a flourishing charity with fantastic Senegalese staff and offices in the United States and France and Tambacounda, had some of its roots in a tennis lesson.

That is the power of tennis: It can alter you to the core. It can happen if you are born in a world of material luxury where the nearby club with its lovely striped awnings is at your beck and call, and then, miraculously, you discover the meaning of this sport in milieus where others do not even know that this game exists. It helps, to be sure, if your guide has the charisma to electrify you.

◆

PIERRE WAS born in Yaoundé. In a country where French and English are both official languages, depending on who colonized a particular region, they speak of "le tennis" or "tennis." But there is no equivalent term in the local Betie, Pierre's maternal language, one of the eighty dialects spoken in Cameroon. As is true in Wolof and Serer and Pulaar, the other major languages of West Africa, there is no word for "tennis" or its ancillary vocabulary because there is no need. Pierre discovered that tennis existed when he was fourteen years old.

On the first day of class in a new school, everyone was supposed to assemble in the courtyard to sing the national anthem. Pierre and two friends had not heard the announcement that they were expected to stop talking and join the gathering. It was not what we would call a criminal offense, just some normal teenage clowning around. Still, Pierre and his two friends each received "twenty lashes in front of all three hundred other pupils"—a mighty price for not lining up and being silent. "That night I went home and told my father I didn't want to go to school anymore."

To Pierre's surprise, his father, a policeman, who was invariably strict with his eight daughters and two sons, sided with him about what had happened that day and decided to help him find an alternative to remaining in school with such an unjust teacher. Now that his father is no longer alive, Pierre will never know what prompted him to take the action he took, but in effect his father exemplified the will to solve problems that is inbred in Pierre. The day following Pierre's humiliation, his father took him, not by accident, to meet a friend who lived two hundred meters from their house. The neighbor, the uncle of the renowned tennis pro Yannick Noah, was an avid tennis player and immersed in the local tennis scene. Pierre's father had the idea that introducing his wounded teenage son to a person in the world of tennis would help him. Pierre, though amiable and responsible, was not a good student, and it was clear that if he was to flourish, it would not be in school, and that he required an alternative. Noah's uncle discerned that the athletic lad could do what was asked of him and made him a "ramasseur de balles"—a ball boy.

Pierre had been brought up in a household where his father got up at four in the morning and the children cleaned the house and fetched

wood for the fire before walking five kilometers to school, so he was used to doing as he was told. He immediately became a nimble, alert ball boy at a small private club where all the members were white. And in chasing those balls and throwing them precisely to the player who needed them or to another of the ball boys who was part of the relay, he yearned to try the game those people with the racquets in their hands were playing.

◆

YAOUNDÉ IS a bustling city, the second largest in Cameroon. Most of its population of two and a half million are too poor even to consider the idea of organized recreation. The people playing tennis in that small private club where Pierre worked as a ball boy were expats. They were all white, many of them diplomats, mostly French, Canadian, American, and English. They considered the midday heat intolerable for tennis, and the courts were always empty starting at noon.

When the club members were cooling off in the pool or lingering over their lunches of seafood platters or chef's salads, the ball boys were able to use the tennis courts. Cameroonian food is among the best in Africa, but club menus are the same everywhere, and specialties like the indigenous *ndolè*, *nkui*, *tchap*, *eru*, and *nfiang owonda* were not the choice of expats, even if taro and cassava made their way onto the table. On the culinary and economic levels, two entirely different worlds existed in the same place. Nonetheless, the desire to play tennis pervaded everyone. Pierre did not have shoes with which to go onto the courts and was too poor to buy a pair, so he played with bare feet. It did not occur to him to be bothered by the effects on his soles as he ran all over the surface made of "le quick," a synthetic that was hot enough to fry an egg in the noonday sun.

Pierre got "a tiny bit of cash" for his hours of service. The pay enabled him to eat and to dress correctly for his work at the club. For the first few months, he continued to attend school—at night—but mainly he was exalted by the chance to play the new game. Eventually, a white player gave him a pair of tennis shoes he was about to chuck into the garbage can. They were cracked, and their soles had holes in

them, but footwear is almost as important a piece of tennis equipment as the racquet, and those crumbling shoes enabled Pierre to progress at this sport he was growing to love. He played for as long as possible during the midday sessions in the brutal sun, until the club members returned to the courts, when temperatures began to cool. Pierre played well. "I was very good at it from the start." Pierre says this matter-of-factly, not boastfully, as if was just something that happened to him.

In little time, "a gentleman from Washington"—Joseph Ingram—asked him to play. Pierre would never forget the name, but did not know exactly what "Mr. Ingram" did, except that it had to do with finances and diplomacy. Ingram admired Pierre's seriousness of purpose and affable manner as well as his top-notch tennis strokes. When he was leaving Cameroon and going back to the United States, he gave Pierre a racquet. It was not a discard, but a brand-new one, of good quality: Pierre's first. By the time he was sixteen, the boy who had started the sport only two years earlier was playing tournaments.

HAVING HEARD the name "Joseph Ingram" from Pierre for years, I tried to get in touch with the man, but had no success. I discovered, however, that he is a lucid, insightful writer for "iPolitics," a Canadian online publication, and that he worked for the World Bank for thirty years. For some of that time, he was director of the bank's office in Cameroon. He has also served as special representative to the United Nations.

It was no surprise to me that Pierre's benefactor held positions of global significance. It is nice to think that such people have power in the world. Joseph Ingram's acquisition of that brand-new racquet for Pierre exemplifies the form of human action celebrated by William Wordsworth in his 1798 "Tintern Abbey" as revealing "that best portion of a good man's life, his little, nameless, unremembered acts of kindness and of love." Joseph Ingram must have gone to a pro shop or sporting goods store in Yaoundé to buy that racquet for Pierre. It was well suited to a player with powerful groundstrokes and a lacing serve.

Pierre has never forgotten the generosity of the gift and the style with which it was given. It had not occurred to him that he would have the joys of a new racquet, its grip still wrapped in tight plastic, one that was his alone.

◆

PIERRE'S SUCCESS in tournaments was rapid. The father of Yannick Noah, brother of Pierre's family's neighbor, was in charge of a junior team comprised of Black youth. Pierre became number two on the team, and they played all over Cameroon. The eight talented young players were sponsored by the Fédération Camerounaise de Tennis. For the first time in his life, Pierre took an airplane—to play in a tournament in Côte d'Ivoire. He advanced to the semifinals, a major achievement for someone whose name was unknown on the circuit. He and the team went on to play in Benin, Mali, and Burkina Faso as well.

While Pierre began to flourish as a young tennis player, any thought of further traditional education went down the drain. He has never continued his academic studies or received a diploma. He is not pleased about this, yet when he goes back to Cameroon and encounters friends who went the traditional educational route and are nonetheless unable to get jobs, Pierre marvels at his own good fortune. He is also grateful that when he was in Yaoundé as part of the junior team, Yannick Noah would come and give all the kids racquets, clothes, and shoes. He rallied with all of them. Noah's material and psychological support felt like a lifeline to a new world.

Gilbert Kadji, the owner of a chain of brasseries as well as the breweries that made one of Cameroon's most popular beers, sponsored Pierre and another of the young players for a three-month internship in Paris. Pierre managed to have his renewed. When he returned to Cameroon, after six months, he hoped Kadji would sponsor his going back to Paris. Kadji, however, had turned his sights more to football. This is often the case—that for sponsors and fans, football takes precedence over tennis. Pierre managed to save up enough money to return to Paris under his own steam and optimistically submitted his visa application and all the requisite papers at the consulate at Doula.

A week later, when he returned to the consulate to pick up the visa, he learned that it was refused. It made no difference that he had a round-trip air ticket and had set aside money as a deposit; he was told he would have to wait for three months before he could consider reapplying. The rejection stung.

A week after that setback, when Pierre, dispirited, was staying inside on a rainy afternoon, he decided to go out for a walk. A white woman parking her car looked oddly familiar. Then Pierre realized she was the person at the consulate who had told him in no uncertain turns that his visa application had been turned down. She was going into the hairdresser's.

Pierre could not decide whether to speak to her. It was one of those moments of indecision when what we determine, in a flash, can change our lives forever. "Bonsoir, Madame," Pierre offered as she headed into the coiffeur's. She looked at him without recognition. He explained that he was Monsieur Otolo, and that she had denied him a visa.

This woman whose name he did not know asked him a few questions, and he answered in a way that he thought would strengthen his image in her eyes. Before rushing into her appointment, she told him to get a letter from Gilbert Kadji and then return to the consulate. She said he should forget her stern advice that he not even consider reapplying for three months and must disregard her insistence that doing so sooner would cost him dearly. Five days later, Pierre got his visa to go to France.

IN PARIS, Pierre found meager digs in an apartment owned by a fellow Cameroonian. The neighborhood was nice, and he was near a tennis club where he could play—and therefore could enter tournaments in France—but the living conditions were miserable, even for someone who had grown up in modest surroundings. Pierre's rent money only allowed him a mattress on the floor in a corridor of the crowded apartment. Whenever one of the residents failed to pay his rent, the landlord changed the lock on the door. The entire lot of young people were forced to stay out in the cold because of a single individual not paying.

The landlord also locked everyone out if one of the residents failed to cover the cost of hot water he had used for the shower; the consumption per shower was recorded on the meter of the heater.

As a young African man alone in Paris, Pierre was perpetually asked for his papers by the police. Then he realized that if he went everywhere in jogging clothes, always carrying his tennis racquet, he would be left alone. Perceived as an athlete, he was trusted. His life improved and he wanted to stay on. When the time permitted on his visa ran out, he remained on although he no longer had the requisite papers. Six months after arriving from Cameroon, he got his job at Tennis Atlantique.

For nine months, he worked at the desk of the tennis club, gave lessons when he could, and played in French tournaments. The club management had him sleep on the office floor as a sort of nightwatchman, and he was allowed to use the players' showers. But the park was technically closed at night. Pierre had to turn off the lights before the police did their rounds; he should not have been there overnight, and he still did not have viable papers to be in France.

Regardless, his kind boss declared him an employee. He got his *carte vitale*, a wallet-sized plastic card that served as identification and entitled him to get free medical care. Concerning the difficulties of living in the office—"It didn't bother me."

This was 2002. It was in this period that I had telephoned to inquire about lessons, and Pierre had become my teacher. I had no idea about how he lived except that when I arrived for my regular lesson at eight in the morning, Pierre was sometimes folding up the blanket on which he had slept on the office floor.

ON THE surface, Pierre and I could hardly be less alike, and not just because of our skin colors. He is built like an American football player, heavyset without being fat. When we met, he had dreadlocks and often wore a wool stocking cap—even on days when to me it seemed hot out. I am quite bald, relatively trim, blue-eyed, my pale skin always reddened by the sun. He sports brightly colored tennis clothes you might expect on a basketball player. I am inclined to wear traditional

tennis whites—since I still have so many of them left from the years when I played in places where they were required. I am a quarter of a century older. Some people say I look slightly like Tom Okker, and when I had a mop of curls in the 1970s, I was mistaken (off the court) for John McEnroe, but I play tennis no better than your average advanced intermediate, addicted to the game but not especially good at it. He, of course, is a superlative player.

When Pierre first agreed to give me those lessons, back in 2002, we tried to do an hour twice a week. American pros compliment you on everything. If you miss the ball completely, they may suggest that you watch more closely, but then they assure you that your grip and swing are exactly right. If your toss hardly goes over your head, they gently allow that you should aim to make it higher, but "Wow, the way you arch your back and the fit of your Sergio Tacchini shirt are glorious sights to behold." In places like Palm Beach and in bucolic resort hotels, you hear the pros acting as if, above all else, they are being paid to make their clients feel good about themselves.

Pierre was, from the start, gentle in manner, but he never looked satisfied with the way I executed his spare but apt suggestions. I needed to hit the ball more in front of me. I had to follow through more consistently. I should speed up my footwork. If I rushed net, I had better volley with a real punch and not a swing. It was only after three months of tough training, with no consideration that I might be tiring during any of those intense lessons, no suggestion that I had done anything well, that he let out two words of praise. I had hit more than a hundred successive forehands. This garnered me a "Pas mal, Nicholas." [Not bad, Nicholas.] He said it taciturnly, but it was like winning a shining trophy. Some of us never outgrow the need for approval, and Pierre's pleasure in my performance meant the world to me, the intellectual who always wanted to be a jock, the person with an impressive curriculum vitae but for whom nothing equals the sense of athletic accomplishment. Pierre is a great teacher, dedicated to his students' success, and because he gives 100 percent of himself, you do not want to let him down. The man has the courage of a Titan and the ability to transform situations that would kill most people into just another challenge he will overcome; how can you not want to do your best in front of him?

◆

EARLY ON, Pierre's and my personal connection strengthened over a sadness that pertained to both of us. One day, not long after we met, he told me that his beloved grandmother had died back in Cameroon.

Here I cannot dissemble about the money factor. It became clear that Pierre, who was essentially alone in Paris, still sleeping on the floor of the tennis office, lacked the funds either to buy an air ticket or to pay for a funeral that no one else would cover. My father had died at the end of 2001, and I had a small bit of money left from my modest inheritance. Dad, successful in business, had started life penniless, passionate about golf, caddying thirty-six holes a day so that, as sunset approached, he could afford the greens fees to play nine himself; he would have approved of Pierre's mettle. Dad and I, extremely close, had gone together to buy, first, my mother's casket—she died in 1990, at seventy—and, subsequently, his mother's. (Nana died in 1992, at ninety-four. My father never told his own mother that Caroline, my mother, had died: "I did not want her to have the victory.") It seemed fitting that money from Dad should enable Pierre to get to his grandmother's funeral in Cameroon and pay for her casket and whatever else was needed so that she could have a decent burial of the sort my father had organized for a wife he adored and a mother he liked far less.

After Pierre returned to France, our routine began again. Whenever I was in Paris, and weather permitted, he gave me a lesson. He was the best sort of teacher—his words few but entirely apt, his example stalwart—and anything he taught got reinforced with drilling, then more drilling, then more drilling. The lessons invariably ended with a set where this tournament champion could have reduced me to mincemeat but played me at just the right level so that, if I were at the top of my game, I could win some points, even a game or two, but never a set. I found myself playing better tennis than I had before I met Pierre. Approaching the age of sixty did not have to feel like a downward slide. Despite the realities of those funerals of people we loved, it was as if tennis could forestall death.

◆

FROM THE start, Pierre and I also had in common that fatherhood was the most important thing in our lives. He knew that my two daughters were the focal point of my existence. Similarly, he had a son in Cameroon who was like a magnet to him. He would often return to visit Chris, and when Pierre was in Paris, they were in touch by telephone all the time. Pierre regularly showed me superb pictures of the smiling, happy boy as he was growing up. And he met my daughters, both in their twenties, when they visited me in Paris, and relished our incredible connection.

In 2014, when Chris reached the age of fifteen, he developed a mysterious illness. Pierre rushed to be at his son's side in Africa, and when the doctors in Cameroon were unable to get him better, he brought him back to Paris.

Three weeks later, Chris died.

This time, the grief-stricken Pierre had not only to organize and fund a funeral, but to take his son's body back to Cameroon as well. It was nice to be able to relieve some of the financial burden; while Le Korsa functions mainly in Senegal, it often pitches in with emergency economic support for people in need. But nothing alleviates the pain of a parent who has lost a child.

The day after Chris's funeral, the boy's maternal grandmother showed up at Pierre's brother's house, where he was staying. The police were with her. They arrested Pierre for having taken Chris out of Cameroon and for being responsible for his death in France.

The insult and prison itself were more than most human beings could have survived. Even in his anguish, however, Pierre kept his street smarts. When he was stripped of all his possessions, he still managed to hold on to fifteen euros and his mobile phone. He then used the money to bribe a prison guard to allow him to keep the phone.

Pierre was packed into a prison cell so tightly with fifty other men that they had to sleep standing up. There were no toilets; all human functions had to be dealt with in public. But the cell phone enabled Pierre to call his lawyer and to call me. A flurry of action ensued.

Pierre's brother visited in prison and brought him a baguette, which he shared. It was the beginning of his efforts to improve the lot of his cellmates. By the time a lot of phone calls and wire transfers had succeeded in getting Pierre released from prison, he had become such a hero to the other prisoners in uplifting their spirits that they cried when he left.

Pierre's resilience, his ability to find a solution even when the odds were against him, reflect the same resolve demanded of a tournament tennis player when he manages to fight his way through match points against him and emerge victorious when other people would crumble. If you have ever seen the strength and unwavering concentration with which Rafa Nadal manages to emerge from tough situations, you know what I mean.

A couple of years following his incarceration, when Pierre was on one of his return trips to Yaoundé, Chris's grandmother arrived from her village, a substantial distance away. She explained: "I made this long trip because I heard you were in Cameroon. I have come to ask pardon. I was badly advised." She told him she could not forgive herself for his ten days in prison or, even worse, for the cruelty of having accused him of being responsible for his son's death.

"There is no problem," he assured the remorseful woman, who was in tears. Even before she came in, just knowing she would be arriving, he had mentally forgiven her.

The visitor cried all the harder. Pierre assured her that she could always count on him. In his resolute, cheerful voice, he said simply that they were still in the same family.

SHORTLY AFTER Chris died, Pierre fell in love with one of his tennis students, Axelle Dupontreue, a white Frenchwoman from the Paris suburbs. Two years later, Pierre and Axelle had a daughter, and five years after came a second child. Axelle's parents were a great source of support, and Pierre's life was on the up and up.

Then Pierre got word from Cameroon that his older brother, a soldier, and his sister, a teacher, had been murdered by Boko Haram in the north of the country. He rushed back to Cameroon. Shortly thereafter,

he returned to Paris with his brother's son, Little Pierre, and his sister's daughter, Gloria. Axelle's parents took in the children while Pierre raised money for their winter clothes and school lunches. Little Pierre and Gloria quickly adjusted to their very different way of life in France.

Then Little Pierre was hit and killed by an automobile when he left school. Anguish beyond anguish. Gloria was now even more on her own. In the course of this, Pierre developed a mysterious illness, debilitating and impossible to diagnose. He ended up in long-term hospitalization, until it was determined that he required stomach surgery. Subsequently, he contracted diabetes, which forced him to lose a lot of weight and to learn to give himself constant blood tests while he took heavy doses of medicine. There was a time when he looked so unwell that I wondered if he would make it.

But Pierre clung to his love for his family and his passion for sport. Sticking to the diet and exercise regimens, he became healthy and vigorous again. He decided that he wanted to render service to the world. "I made a decision. I was on vacation in Cameroon." He saw children sleeping in the street back in Yaoundé. "What's going on? What are they doing here?" He became determined to do something.

Pierre is the most patient of teachers.

Since then, Pierre has managed to have a life-changing impact, through tennis, on hundreds of people. "Whatever you do in life, you must apply yourself," Pierre explains matter-of-factly. He does not have a hint of sanctimoniousness. He is who he is and does what he does, and that is that. "Now, my duty is to help those in need." He founded an association not just for teaching children tennis, but also for providing them with food, a roof over their heads, and emotional support.

He started with seven homeless children whose only way to buy something to eat was by collecting and selling empty bottles. Pierre introduced the children to tennis, fed them, and found a place where they could play the sport three times a week. "Resources or not, we can always find a solution," he explained. But while the children were happy to go play tennis and have a meal, Pierre had no idea where they spent the night, except that it was basically in the gutter.

A man Pierre taught in Yaoundé who had a private tennis court let Pierre use it for teaching the children. But then the man died. He left the property to his son, who, noticing that the children had new racquets and balls, decided to charge Pierre for their time on the court. Pierre managed to pay for court usage for two hours every Monday, Wednesday, and Friday, but they needed more time. Fortunately, the new owner of the court softened, and, recognizing that these were street kids, allowed Pierre to take a long-term lease for the court at a low price.

With each step of his realizing his project, Pierre approached Le Korsa for funding, which we provided. He always presents cogent explanations and provides all the necessary paperwork and receipts that demonstrate his capacity to get good value for every expenditure.

Once Pierre had the lease, the children, who sometimes walked four miles to get to the court, were now able to play even more, and to hang out around the court the rest of the time. But Pierre decided he had to find a way to take even better care of them. He was with them from eight in the morning to seven at night, and they flourished when they had structure, but except for two girls who still lived at home, the children had to sleep wherever they could. Most of those Pierre was training at tennis did not have living parents, or did not know where their parents were. Their lives were so precarious that Pierre rented them living space. So he could return to Axelle and their daughters in Paris,

Through tennis, boys and girls in Yaoundé are gaining confidence in many aspects of their lives.

with the plan that he could visit Cameroon every six months, he hired a director to run the program. It was complicated to keep the program going from a distance, but he was determined.

Pierre had to battle to make everything work. His diabetes was out of control. In Cameroon, it was a struggle to get the tennis academy—as he called it—accepted as an official organization. He juggled a life with two small children, an illness that required periodic hospitalization, and the need to travel to Cameroon to meet with the authorities. He depended above all on his own willpower: "I'm the resource. It doesn't take money, it takes drive." Finally the organization achieved official status in Cameroon. We constructed a dormitory that can house up to twenty of these homeless children who are learning tennis, while another twenty live at home with their families. There are students there who walked forty miles to escape Boka Haram. An excellent staff takes care of these boys and girls

in Yaoundé, and all of them have square meals and places to stay. Pierre is quick to point out that they do not have to be champions of the world, but they need to develop the will to improve. When he learned tennis at age fourteen, he never imagined that he would end up in France; tennis changed his life, and he hopes this will be true for these children who grew up in such perilous circumstances.

Not that life is simple. When one fourteen-year-old girl in his care became pregnant and the father of the future child was killed in a street attack, the staff in Yaoundé asked Pierre what to do. His reply was the usual: "Nothing to worry about. No problem." Any child in Pierre's care is like a member of the family.

Pierre has added a number of handicapped people to his roster of tennis students, enabling men and women confined to wheelchairs to know the joys of tennis. Most recently, in April 2023, his tennis academy hosted a tournament for players in wheelchairs, and fifty people entered, coming from all over Cameroon either to compete or to watch and realize the possibilities of what they might do despite their handicaps.

Pierre Otolo lives his life the way he rushes net. He is all there! He summons his energy when others would drop. And if once his purpose was to win tournament matches, now it is to give a mix of impoverished children and handicapped adults food and shelter and a chance to learn a sport. For Pierre, tennis is hope.

Thanks to Pierre, children who were sleeping in the streets now have a safe haven.

9

THE SONG AND DANCE OF TENNIS

WHEN *Le Train Bleu* was performed at the Théâtre des Champs Élysées, the presence of tennis was not new on its stage. The game warranted rendering in concert form as the embodiment of energy and subtle spirit. On May 15, 1913, more than a decade before *Le Train Bleu* enchanted its audience, *Jeux*, a ballet with music by Claude Debussy, had been performed at the Champs Élysées with Pierre Monteux conducting the orchestra. A tennis ball is thrown across the stage as the opening gambit, and then, since it is lost, three dancers, one male and two female, look for it. Vaslav Nijinsky had originally conceived of the ballet as a homosexual encounter among three men. For the version that was performed, however, he had changed it to an encounter of a single man, played by Nijinsky himself, with two women. Not only had the great dancer/choreographer dropped the gay theme, but he also abandoned his plan to dance the part in women's ballet shoes and to do so "en pointe." Rather, he played the lead in a more manly guise.

When *Jeux* was presented, the audience had good reason to expect the unexpected. The theater, which had only opened recently, specialized in extraordinary cultural events. On May 10, the only opera composed by Gabriel Fauré was performed there two days before Fauré celebrated his sixty-eighth birthday. On May 29, Stravinsky's *Rite of Spring*, also choreographed by Nijinsky, had its premiere there. That

event prompted Carl Van Vechten to report in *The New York Sun* that "the unruly audience became as much a part of the performance as the dancers and musicians."[108] Their shouts were so loud that management felt obliged to turn on all the lights so they could control the mob, whose noise dominated the performance even after the loudest protestors had been forced outside. Debussy's "poème dansé," with tennis as its theme, while it caused less of a sensation when it was performed two weeks earlier, is now, in retrospect, considered by cognoscenti to have been as revolutionary a cultural occurrence as *Rite of Spring*. Its humor and sportiness were a more radical break from tradition than was the drama of the Stravinsky. And it belongs in the annals of tennis history for its unique revelation of the way a representation of the sport, when executed adroitly, produces energetic leaps of the body that elevate the soul.

After Debussy wrote a quick draft of the music, in the summer of 1912, he said that it required an orchestra "without feet." In the seventeen minutes of the ballet, there are some sixty different tempos, so that the pace and directions of the music seem to change every two measures. A recent article describes its airiness:

> *Jeux* is understated and suffused with light. It's chromatic, yet never harsh; rhythmically complex, yet fleet-footed and graceful. Analysing it is like trying to capture wisps of mist.[109]

Other composers would come to praise it. Stockhausen and Ligeti said it influenced their sense of "moment form"; Pierre Boulez wrote, "The general organization of *Jeux* is as changeable instant by instant as it is homogeneous in development."[110] Boulez went on to describe the ballet as "*The Afternoon of a Faun* in sports clothes".[111] It was high praise.

When Diaghilev initially proposed *Jeux* with Nijinsky's choreography, Debussy refused, declaring the subject itself "idiotic." The composer recanted after Nijinsky agreed to scrap the idea of a plane crash in the ballet and offered to pay twice as much as he had previously proposed for the creation of the music. The year before, Nijinsky's choreography for Debussy's *Afternoon* had ended with the faun masturbating with a scarf left behind by a nymph. Debussy, displeased with Nijinsky's

literal translation of the explicit rendering of the Malarmé poem on which *Afternoon* was based, wanted to avoid a repeated scandal.

Leon Bakst set the action in four large circular flower beds in front of a white building. There were trees in full summer bloom. He dressed the dancers in the white requisite of tennis garb. After the ball is thrown on stage, a young man in tennis clothes leaps about holding his racquet on the top of his serve; two girls appear; other characters run in, on and off the stage. There are furtive kisses. The characters quarrel, reconcile, flirt, and generally cavort. The man sometimes holds his racquet with a correct grip, but more often not. The racquet is mainly a prop—more than a piece of sports equipment. Tennis is clearly the theme, but the result succeeds neither as an analogy with the sport nor as a convincing representation of it.

Debussy knew tennis well. He played—competitively—with Maurice Ravel. The sequence of staccato in the music was true to the bouncing and hitting in a tennis game. Debussy was unhappy that the ballet's choreography, however, did justice neither to the music nor to the sport.

Debussy's friend Erik Satie would review the performance. Satie felt that Nijinsky's choreography for the 1913 ballet that purported to be about tennis betrayed a lack of knowledge of the sport and thus did an injustice to the music by Debussy; Satie preferred the music on its own. Nijinsky's interpretation of tennis when represented in dance seemed so much like football that Satie had decided it needed a different name—"Russian tennis"—which, claimed Satie, would be "all the rage." He emphasized that this was an unusual form of tennis—played at night under electrically lit baskets of flowers. It had three players, no net, and for most of the performance a large soccer ball instead of a tennis ball.

Debussy also hated Nijinsky's score, remarking that Nijinsky "with his cruel and barbarous choreography . . . trampled my poor rhythms underfoot like weed." By deprecating Nijinsky's choreography, in a review he wrote for a popular magazine, Satie was thus echoing Debussy's own views of it.

Even though *Jeux* was not what Debussy hoped for, given how well he knew the actual game, it was a marvel overall. It had lightness and a jaunty pace, and a sense of its players using their racquets as magic

wands. *Jeux* did not satisfy everybody, but it combined the movements of tennis and ballet with panache.

✦

Jeux WOULD prompt Erik Satie to compose his own small gem of music that in his and Debussy's eyes captured tennis with greater fealty. As such, it was the seed of a masterpiece. Satie's musical version of tennis, essentially a riff on Nijinsky's presentation of the sport, would be short, but in its forty seconds, this mischievous work for piano and voice would render the sport tantalizing and erotic.

It was nothing new for Erik Satie to have his own approach to things; he was irreverent about everything that was part of the Establishment. Born in 1866, in Normandy, to an English Protestant mother and a French Catholic father, he got his musical start at age eight when he took organ lessons and developed a fondness for Gregorian chants. When he was thirteen, he was sent to the Paris Conservatoire, which he compared to a "district prison"[112] and where, in 1880, when he took his first exams as a pianist, he was called "gifted but indolent." The following year, his piano teacher, Émile Decombes—who had the impressive credential of having studied with Chopin—declared him "the laziest student in the Conservatoire"; Satie was subsequently expelled. He was readmitted, but by his own account was "worthless ... cannot sight-read properly"[113] and he joined the military service, only to dislike it as much as he had the conservatory. As a soldier, he stood outside bare-chested on a winter night with the goal of contracting bronchitis sufficiently severe to get him thrown out. Moving to the ninth arrondissement of Paris and landing himself a job as a pianist in a cabaret, Satie became very much a long-haired bohemian, developing an eccentric personal style he would always maintain. At age twenty-two, he wrote the experimental piano music he called *Gymnopedies*, three spare but melodic pieces based on young, naked Greek athletes. The following year, Debussy, already a friend, orchestrated two of them, and Satie's future as someone with the ability to link sport and music was assured.

Satie cultivated his originality and became known for his rebellious lifestyle; at one point he dressed as a priest and subsequently bought

seven identical brown velvet suits, often wearing them with a bowler hat. He lived alone—although in 1893 he had a brief affair with the painter Suzanne Valadon—and was a radical socialist. He made money performing in nightclubs. But Satie was always composing, and his fortunes improved in 1911, when Maurice Ravel performed his work and he was embraced as a pioneer of new music.

In 1914, the publisher Lucien Vogel had the idea that Satie and the illustrator Charles Martin should produce a luxurious volume called *Sports et Divertissements*—the title an expression used by the most fashionable resorts in France to describe the offerings with which to tempt their wealthy clientele.

Lucien Vogel wanted *Sports et Divertissements* to be fun to read and listen to. The publisher of *Gazette du bon ton*—a popular French fashion magazine—he was married to Cosette de Brunhoff, the first female editor of *Vogue France*; they shared a fondness for highly stylish forms of entertainment. Vogel eventually would encourage his wife's brother, Jean de Brunhoff, to publish the children's story that Jean's wife had invented and for which Jean had done the marvelous illustrations, about an elephant named Babar who develops a taste for well-tailored clothes and spiffy motorcars. Vogel was instrumental in the publication of all of Jean de Brunhoff's *Babar* books; in its light-hearted way, *Sports et Divertissements* forecast those books in which the text and illustrations have such élan.

Vogel had initially approached Stravinsky to do the music for his publication, but Stravinsky said the amount of money he was offered was not enough. For Satie, meanwhile, the three thousand francs he received was a blessing considering his impecuniousness. Two years earlier, he had sold a piano suite for fifty francs; Stravinsky may have been able to sniff at the amount of money, but Satie could not afford to. Recognizing that he was at risk as a big spender, to pace himself he took a third of his fee each time he delivered seven pieces, with the payment per piece just under a hundred and fifty francs.

Sports et Divertissements became one of the most original and charming artist's books of the modern era. Its copperplate etchings showed wealthy people, fashionably dressed, enjoying their leisure activities and for each amusement there was a composition of solo piano music by Satie on which he had drawn, in calligraphic style, a surreal poem. The

Lucien Vogel's publications were all the height of style.

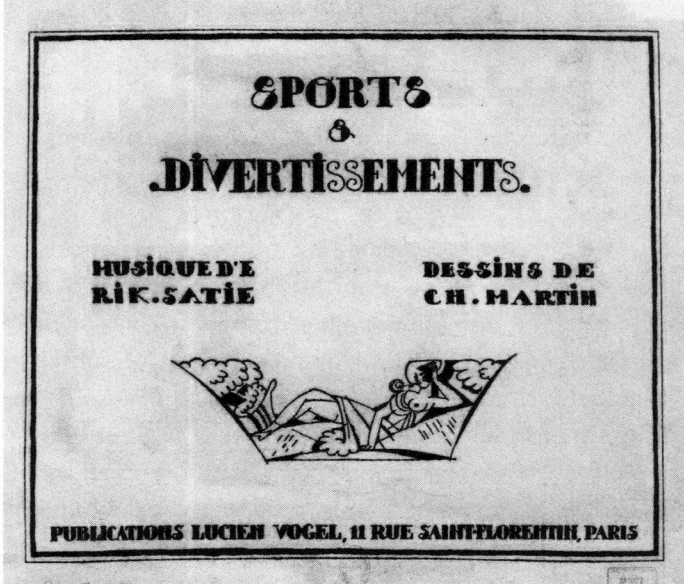

Even the program's lettering is playful.

music, the words, and the presentation all adhered to Satie's mandate, "Keep it short," with one page per composition.

The opening of *Sports et Divertissements* is called "Unappetizing chorale," with the musical directives being "Seriously. Surly and cantankerous. Hypocritically. More slowly." Satie wrote—with his remarkable handwriting—a "Preface" that appears on the same page as the music. It loses a little in translation, but it guides us to understand his intention with "Tennis" as well as with his other sports and divertissements: "My advice is to leaf through the book with a kindly and smiling finger, for it is a work of imagination. Don't look for anything else in it." As for the "unappetizing chorale," Satie says that it is "for the Shriveled Up and the Stupefied." He calls it "a sort of bitter preamble, a kind of austere and unfrivolous introduction." This is a warning about what happens if we are not sufficiently light-hearted and take everything too seriously: "I have put into it all that I know about Boredom. I dedicate this chorale to those who don't like me."

The twenty amusements include "Hunting," "Blind Man's Bluff," "Fishing," "Yachting," "Sea bathing," "Golf," "Horse racing," "The perpetual tango," "Flirting"—for which the directing was "agitated"—and "Tennis." Satie did two versions for this last one: The second was the one he approved for publication, but the first was also a delightful musical sketch.

"Tennis" opens at a moment when the players have just finished warming up, debating whether they are ready to begin the game. At the start, some staccato piano notes clearly evoke the ball being bounced; we anticipate the beginning of play and wonder for how long we will have to wait. A descending third follows. It is audibly a serve—a dramatic one, powerful and decisive—and is followed by the sound of praise.

Whereas "Tennis" is most often performed on the piano alone, the original intention was for the words Satie had written in lovely calligraphic India ink to be said out loud. The opening bounces were accompanied by "Play?"—in English—followed by "Yes!"—also in English. Then, during the serve, we hear "le bon serveur." What comes next is a mockery of many things at once: the beefy rather than tennis types in Nijinsky's staging of *Jeux*, the seductiveness of certain tennis players. "Comme il a de belles jambes," the speaker says as the music

achieves muscularity. And then, with the music markedly lighter, the speaker again praises the good looks of one of the tennis players: "Il a un beau nez." This is followed by something very different. It is best described by the musicologist Anthony Bateman in his fascinating book *Sporting Sounds*. Bateman writes that "Tennis" concludes "with a sporting detail: the musical rendition of a slice serve which finally brings about the match point. Unlike the previous service, this 'service coupé,' in which the descending third A–F# is woven into a scale-like passage, now begins forte, going—to remain with the language of tennis—right down the line, and no longer able to be returned."

"Tennis" ends quite simply with "Game!"—again in English (Satie would certainly have wanted to avoid the French word for "game," which is *jeu*," and sounds exactly like *jeux*, the name of the ballet he is spoofing). Yet the match is not over, only the game is, for the music has a tentative sound to it, as if there is something still to happen. And so Satie has ended *Sports et Divertissements* with a sense that the fun is still going on; there is an implicit continuation rather than a conclusion.

Charles Martin's illustration of the sport features a man dressed as "Pierrot"—the classic French clown of the type we see in Watteau's paintings—and a woman who has a stylish coif and wears a low-cut dress. Seated at a small table on a balcony, they are aghast and hold their hands up in the air because they have just had the rude experience of a tennis ball landing on the table and knocking over a cup of tea, which spills onto the man's trousers. The balcony overlooks a tennis court where we see, on one side of the net, a woman in a skirt and sunhat, and, on the other, hitting a backhand, a man with a beautiful nose and long legs, whose partner, only partially visible, wears a dress with puffed sleeves and a full skirt. Part of the charm of tennis is that its players are so decorative.

Satie's *Sports et Divertissements* was first performed in France only after World War I. During wartime, "military censorship" was in effect, and Lucien Vogel's fashionable magazines suspended publication, and he dissolved his company. He sold the rights to the Satie work. But then Vogel repurchased the work when he started a new company in 1922. Charles Martin was again commissioned to do illustrations for it, in quite a different style from his original etchings. The new edition was distributed, and the Satie work became popular in the United States after its premiere

at the Klaw Theatre, in New York, in February 1923, sponsored by Edgard Varese. George Gershwin attended and saved the program. In the 1950s, Virgil Thomson would perform it as a work for narrator and piano. Only forty seconds long, Satie's "Tennis" is a winner.

◆

DMITRI SHOSTAKOVICH'S "tennis ballet" is part of *The Golden Age*—also called "the propaganda ballet"—written in 1930 to portray the virtues of Soviet ways in contrast to the decadence of Western life. Like Satie with "Tennis," Shostakovich makes the sport seem like an irresistible indulgence. This is another occasion when, interpreted musically, tennis has a quality of exuberance.

There is an irony in tennis seeming so appealing in its rendition here. Shostakovich allegedly intended the sport to represent a way of life that was to be supplanted with revolutionary values. Shostakovich

Satie's writing and musical notations have energy and wit.

had been indoctrinated with Soviet ideas from the time he was a teenager. Born in 1906 in St. Petersburg, he was only eleven years old at the time of the Russian Revolution. A musical prodigy, he demonstrated his loyalty to the Soviet system in his earliest work. His highly successful second symphony, composed in 1927, was created specifically to celebrate the tenth anniversary of the Bolsheviks' rise to power. With its libretto by Alexander Ivanovsky, once *The Golden Age* had its premiere at the Kirov Theatre, in October 1930, its eighteen performances served the purpose of pitting the virtues of the new-style Russians against what was deemed the ridiculous frivolity of the pleasures pursued in places like Italy, France, and England.

The Golden Age was initially censored because it had an excess of Western-style dance in it, and although it was subsequently performed in public, we can see what must have been a problem for the Soviet officials. Its presentation of European habits—the frolicking associated with, say, a lovely afternoon game of mixed doubles played on a pristine clay court in the South of France—shows that Shostakovich was, at the least, ambivalent about what he was supposed to be decrying. Although there is no record of the dance performed with it, the music of the tennis ballet has splendid melodic leaps and a tone of playfulness; it demonstrates the unusual capacity of music to be ribald. Even if to the Soviets the very concept of tennis was the mark of the bourgeoisie and their evil ways, there is, with Shostakovich, a lot of merit to the game.

At the start of *The Golden Age*, a Soviet soccer team makes its initial appearance on the stage at the Golden Age of Industry Exhibition, which takes place in an unidentifiable capitalist country. The Soviet sportsmen who attend the exhibition are heroic—good, healthy people—as opposed to the denizens of the country they are visiting. Various forms of enemies of the Soviet ideal are presented: "a Diva," "a Negro," "an advertising agent," "fascists." The encounters of the athletic Soviets, including an early one with tennis players, are the substance of most of *The Golden Age*, until the evil bourgeoisie in the host country throw the entire soccer team into prison. But then the good adherents to Communism are freed from jail with a workers' revolt against their capitalist employers. The ballet concludes with "the Bourgeoisie in a panic" and, finally, a "dance of solidarity," as the athletes join forces with the workers.

The music is performed by a range of percussion instruments—among them a woodblock, a tambourine, cymbals, snare drums, and a xylophone; horns, including two bassoons and three clarinets; and the usual string instruments with the addition of a banjo. The tennis scene, which comes near the start of Act I, is a bit more than four minutes long. It begins with the clapping of cymbals and continues with music during which we easily picture a lively rally. There is a wonderful relationship of strings and horns that is high in energy. We feel the summertime spirit of the music, and revel in the lively pace of the nonstop motion. We have a sense of long rallies in which we picture different shots being played and someone rushing net, all with a general sense of spectacular footwork. Throughout these musical peregrinations, the entire piece has the playfulness and spirit and melodic richness that always mark Shostakovich. At one moment, the shots are strong, thanks to the power of the horns and drums. Then they are played with a light touch and a sense of carefulness, thanks to the wonderful interplay of the flute and clarinet and strings. Next come the heavier moments of suspense, building toward the end. Conflict is in the air; we sense a challenge. A point is well played. The shots get more powerful. Then comes the victory, one of the players clearly triumphant. We feel the allure of tennis played with fullest energy. What was intended to represent a certain decadence has become charming and irresistible.

◆

THE MAGNETISM inherent in tennis became infectious in a totally different way in a Broadway production written by one of the great composers of that particularly American artistic form, the musical comedy. The application of tennis to one-on-one romance was yet another example of the meaning that the sport could have when a gifted artist uses it as a basis for entertainment in another medium. It functions as such in one of the last creations of the underappreciated Cy Coleman.

Coleman, a songwriter and composer responsible for many great Broadway musicals, was born in 1929—his real name was Seymour Kaufman—in New York. Starting when he was six years old, he was giving classical piano recitals at Carnegie Hall, Town Hall, and Steinway

Hall. Before long, he was performing jazz and composing musical comedies. He eventually worked with various collaborators, one of the best known being Neil Simon, and his works include *Wildcat*, which had in it the song "Hey Look me Over"; *Sweet Charity;* and *City of Angels*, for which he composed the music in 1989 to a book by Larry Gelbart and lyrics by David Zippel.

City of Angels takes place in the film world and revolves around a writer trying to make his way in it. "The Tennis Song," which is performed midpoint in the first act, uses the language of tennis as the basis of love song lyrics that are as much about sex as about sport.

THE TENNIS SONG

(STONE) *You seem at home on the court*
(ALAURA) *Let's say that I've played around*
(STONE) *Well you don't look like the sort*
(ALAURA) *My hidden talents abound*
(STONE) *A competitor hasn't been found to defeat me*
(ALAURA) *I bet you're a real good sport*
(ALAURA) *Shall we say the ball is in your court?*
(STONE) *I bet you like to play rough*
(ALAURA) *I like to work up a sweat*
(STONE) *And you just can't get enough*
(ALAURA) *I'm good for more than one set*
(ALAURA) *But I promise I'll show no regret if you beat me*
(STONE) *My backhand is clearly my forte*
(BOTH) *Shall we say the ball is in your court?*
(ALAURA) *No one ever plays with me*
(STONE) *I thought your next of kin did*
(ALAURA) *My husband never plays with me, he's too easily winded*
(STONE) *You leave me breathless too*
(ALAURA) *Wait 'till our match is through*
(STONE) *I may lack form and finesse but I warm up in a jiff*
(ALAURA) *It's not exciting unless the competition is stiff*
(STONE) *I think I understand your racket, I'm not in your league*
(ALAURA) *But you can back it*
(STONE) *This game commences with love*

(ALAURA) *Well, I think love is a bore*
(STONE) *Let's give the tempo a shove*
(ALAURA) *And raise the stakes a bit more*
(BOTH) *One thing I'm positive of, it's time for someone to score*
(STONE) *Tell me how you like to play*
(ALAURA) *On grass or clay and every day*
(STONE) *They're both okay*
(ALAURA) *But time is running short*
(ALAURA) *Darling let's don't dilly dally*
(STONE) *Ready for a rousing rally*
(BOTH) *Shall we say the ball is in your court?*

The music suits the flirtatiousness of the lyrics. Coleman's melodies are in perfect service of the narrative, with its erotically laden trysting between a woman and a man. It's no surprise; for Cy Coleman, tennis and sex had long been inextricable. Starting in 1960, he had written music for Hugh Hefner's television show *Playboy's Penthouse*. The basis of the series was the idea of parties at Hefner's house in which *Playboy* playmates would perform with celebrities such as Jerry Lewis, Sammy Davis Jr., James Brown, and, famously, the Grateful Dead. His "Tennis Bum Blues"—from the music he wrote for *Playboy's Penthouse*—conjures a wastrel in the form of a not-quite-pro player who gets through life playing tennis with seductive movements he hopes will help him to pick up women. To play tennis well is to be a superior lover.

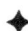

THE QUALITIES of tennis clearly provided fertile material for those colorful works of music, and for others as well. There is a rhythmic beat inherent in every rally, with the opportunity for a staccato emerging when a player assumes a position at net and executes a deft volley. The grace and continuity are very different from the stop-and-go action of baseball or American football, and the successful application of tennis to various forms of musical entertainment is somehow no surprise. The racquet itself is like a musical instrument—the means by which the atmosphere becomes charged with excitement—and the ball a note that flies through the air.

10

"GREEN OR YELLOW?"

"They are green."
"They are yellow."
People are as certain about the color of tennis balls as they are about whether it is a crocodile or an alligator on the Lacoste shirt. Few are ambivalent; most everyone *knows* the answer definitively. You, reading this, have presumably come down firmly on one side of the Great Tennis Ball Color Divide, wondering how anyone could possibly think otherwise.

Roger Federer says "Yellow." (Some of you will react to that information with "But of course"; others will think an incredulous "Whaaaat?")

The debate begins. And so does the perpetual conundrum of applying words to colors, in that there is no way of being sure that when two people say "red," they are picturing the same hue.

The Inuit have more than fifty words for "white," and anyone who has ever chosen the paint color for a wall knows that the range from cool bluish snow tones to warm creamy vanillas is infinite. Oral (and written) language is a great thing, but it only provides vagaries next to the undefinable miracles of *seeing*.

◆

ONE OF the most significant art movements of the last century is known as "kinetic art." It consists of work falling under the general

rubric of "sculpture," where the viewer perceives active motion of the parts and where physical change is an essential element of what we see. Among the best-known practitioners are Alexander Calder and Jean Tinguely. For the art of the first, you need the blowing of a fan or a gust of wind to initiate the movement; for the second, you press a button or turn a switch to set the machinery in motion. The viewer's experience consists of seeing small shapes—some roughly resembling leaves, others being armlike—that go this way and that, first in one direction and then in another, with a more stable and fixed immobile element going nowhere.

There are few better examples of kinetic art than a game of tennis—whether seen from within by the players or from the sidelines by observers. The canvas, so to speak, is fixed. The background color is either that marvelous terra-cotta of the clay court, the dusty dark green of a grass court, or the brighter, flatter hue of a synthetic surface. The subdivisions, with their fixed geometry, are made with white lines of consistent width. This perfectly charted structure of horizontals and verticals—creating long, narrow alleys for doubles and precisely delineating service courts—is pretty much always the same color whether it is laid with tapes, rolled with lime, or painted. This is not the bright glistening color of tooth-whitening ads; while clear and distinct, it is slightly matte. There is no nonsense about it, but still, this white, on analysis, might show just a soupçon of a tint, ever-so-slightly toning it down.

The parts of this kinetic masterpiece that move are, in their colors, something else altogether. The balls, the swinging racquets, the players: The neon dance begins. Snowy white clothes or dayglow outfits, human skin and hair of every hue, racquets that in the old days were the elegant color of varnished wood but that today are, like modern skis, an insistent amalgam of pulsating reds and yellows with the occasional glistening silver or gold: All are in a constant start-stop action. And there is one small, bright element that moves farther and more rapidly than any other, over the net and back again, always the same size and always the same bright color: the ball. But: Is it yellow or green?

Does it matter? Isn't language secondary to the action and the experience? Why this insistence on labeling?

THE REASON the current color came into use for tennis balls has to do with simple issues of visibility. Tennis balls were formerly white. That was until David Attenborough, the naturalist and television presenter, was controller for BBC Two. In 1967, Sir David obtained permission for the channel to start broadcasting in color. The first time Wimbledon was televised in color rather than black and white, the white balls were difficult to see. There was less contrast in the white ball hitting the white lines when there was a panoply of colors in the surroundings, quite obvious when there was only black-and-white television. (The preeminent color theorist and artist Josef Albers would have found this fascinating. The idea that the change in the surrounding colors to the full spectrum from the white-gray-black scale made the white balls less visible was the sort of phenomenon that delighted him.) Sir David had the idea that something else should be tried. By 1972, colored tennis balls were approved by the International Tennis Federation.

And the name of the color, written boldly on the tins of balls made by the company Wilson, was . . .

Optic yellow.

The color, as specified by the ITF, derives that name from the Hex Color Code. The code was developed in the online Color Encyclopaedia called ColorHexa, in which the color of a tennis ball is ccff00. Another color-coding system, RGB, gives it the color RGB 223,255,79. The hex coding system uses letters and numbers that indicate the proportions of red, green, and blue in a color; the RGB code is a different way of calculating the same relative quantities in a mixture.

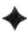

SO WHAT does that tell us? Color Hexa describes ccff00 as "Fluorescent yellow or Electric lime." In the RGB system, it is among the greens. "Electric lime"! How could that be the same as a yellow of any sort,

even fluorescent? The way we distinguish the fruit called a lime from a lemon is that one is green, the other yellow; they are by no means the same, even though limes preceded lemons, as lemons are a hybrid of citrons and limes. (Lemons grow in milder climates than the tropical and semitropical environments demanded by limes.) How can a single color be the equivalent of both limes and lemons, even with one made fluorescent and the other electric? Why can't there be a single answer to the question about tennis balls? What about the color of those citrus fruits you see in the supermarket that are shaped like small lemons or large limes, and that are mainly yellow with hints of what we call "green"? Does their taste echo the percentages of their colors, halfway between both types of fruit; do they have that high note that distinguishes a vodka gimlet or that rounder flavor that characterizes lemonade?

The solution is to accept the mystery, to recognize the limitations of words. Let's not even try to say what color a tennis ball is; the label, after all, followed the development of that particular hue. Language only comes afterward; the sun and fields were the colors they are long before there were names to identify them or to characterize their colors. The visual preceded the verbal, and with both we must accept the beauty of vagaries; to seek precision is to miss the boat.

For half a century, I have worked with Josef Albers's art, running a nonprofit foundation that he and his wife, Anni, the brilliant textile artist and printmaker, established. Josef was fascinated by the language as well as the function of color. He used to say that "color is the most relative medium in art." In his teaching, writing, and painting, he demonstrated, with utmost passion and pleasure, the way we see a color not so much on its own as in relation to its neighbors. What counts about the color of the tennis ball is what happens to it in contrast to the court surface, how it reacts to bright sunlight or to dusk, how it interacts with the multicolored background when it is flying through the sky. It—the color of the ball—is an absolute, but our experience of it is multidimensional.

Albers, who lived in Orange, Connecticut, reveled in the highway sign at the town border line that was painted the precise green requisite of such signs and declared, in bold white lettering, THIS IS ORANGE. Wherein lies the truth?

Let us look at the closest color to that of tennis balls in Albers's art. It becomes apparent that saying "yellow" or "green" does not mean much.

Albers was very aware that different manufacturers used the same name for colors that are very different. A Winsor & Newton Mars Yellow, for example, seems miles from a Grumbacher Mars Yellow. Adding to that, the way a color looks when reproduced is different from the way it looks on a painted canvas.

Test your color memory. Turn to Color Plates 12–16. Of these five Albers paintings, in which of these do you think the central color looks closest to that of a tennis ball?

These paintings belong to Albers's series called *Homages to the Square*, of which he painted more than two thousand between the time he turned sixty-two, in 1950, until his death, at age eighty-eight, in 1976. They gave Albers a chance to create a vast range of "color climates," and they incite a range of sensations of movement in colors that were factually inert.

The two central squares of Color Plates 13 and 15 are Cinnabar Green Light, made by the paint manufacturer Old Holland. The color does not seem to be identical, however, in the two instances; to most of us, it seems darker below. Its appearance changes according to its proportionate quantity in relation to the colors in the rest of the composition and depending on what other colors are adjacent to it. If you take a piece of white paper and fold it to size so that it blocks everything between these squares, you will see that, although they look dramatically different when their surroundings are visible, they are almost exactly the same. If they do not appear to be completely identical, it is only because we are dealing with photographic reproduction rather than the actual paintings, where those middle squares are made from the same paint.

Everything makes a difference with color; there are no absolutes. And in the case of the color of tennis balls, there is yet another element—beyond the distance from which we see the ball, the degree of sunlight or shadow, the color of the court that is its background, and the nature of our own eyesight—and that is the extent of our capacity to distinguish colors. The age and condition of the ball also has an effect.

In 2023, the artist Eddie Martinez pointed this out in *The New York Times*:

I have painted tennis balls for at least five years. I don't think I ever paint the color accurately. It's a funky color. There is a whole debate over the color of tennis balls. Are they yellow or are they green? I think that every tennis ball shifts between that range in the course of their life. They start off neon, like a toxic sludge, but once a ball starts to lose its fuzz and pick up the residue of whatever surface you're playing on, they get dull. I would say they start off neon green and go more toward yellow over time.

Maybe colors are like the word *color*, which is spelled differently in British English than in American English; there is no single law. Is the difference between lemons and limes a matter of flavour or flavor?

Exalt in what you cannot know! Yes, once upon a time the color of tennis balls was plain old coconut cake white (or angel food cake white, or a genoise; it depends on the state of the ball). Then, thanks to David Attenborough, it was made easier for the eye to perceive. But let the "green or yellow?" debate go to the side; throw it out of the court. You never know for sure who will win the match, and in this case the winner is the color itself, not its name.

Now look at the print at the bottom of the colorplate. Albers made it in 1969. Is this where the manufacturers of the new tennis balls got their idea? All we know for sure is that if we stare at the central color—*peu importe* the name—for long enough, and then look at the grays surrounding it (warm gray, cool gray, but gray nonetheless, or "grey" if you are so inclined), we begin to see slight afterimages of the middle color. Savour the thrill, or savor it; words are only words.

HELEN WILLS

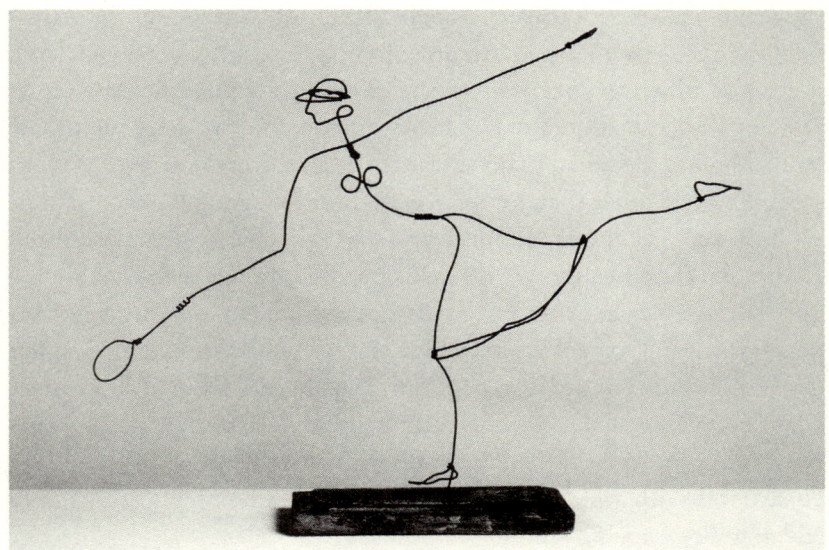

Alexander Calder's wire sculpture of Helen Wills is, like her strokes, an example of an economy of means for fantastic results. Every detail, including her trademark visor, is masterful.

H ELEN WILLS'S impact on artists evokes the notion of the face that launched a thousand ships. Some of the greatest painters and sculptors of the twentieth century portrayed her. The young Alexander Calder manipulated a single piece of sturdy wire with pliers, twisting it into a breezy image of the lithe athlete leaning into a forehand. Diego Rivera used her as a model for one of his greatest murals, her face several stories high, with a second image of her in

the nude in the ceiling above. Miguel Covarrubias painted a caricature of Wills—again with a lunging forehand—that had style and verve. Augustus John and Childe Hassam did traditional portraits.

But Wills was not satisfied merely to look like a goddess and be the model for artistic masterpieces. Nor was it enough for her that she glided to victory in Grand Slam tournaments with the aplomb of a prima ballerina. She needed artistry in every facet of her life. In 1927, the same year that this lithe twenty-one-year-old won Wimbledon for the first time, she designed splendid dress fabrics that were manufactured in silk. Tennis itself was her inspiration. One of her materials showed female tennis players sketched fancifully, extending their arms to the limits. Another had a motif of tennis courts interspersed with flowers in which the petals are made of tennis racquets. But the visual was not all that mattered to her. Her stories and poems were published. And although she failed to make the cut as an actress, she had a screen-test with none other than Joseph Kennedy as her agent.

It made sense for her to consider being in movies. She was admired for her dazzling beauty. Wills's face appeared on magazine covers not only because her lacerating groundstrokes made her a world-class tennis player, but also because both men and women wanted to look at her classically proportioned features. At the height of a national depression, when people needed to be cheered up and diverted, that visage made the world's top-ranking tennis player irresistible. And the Garbo-like elusiveness with which she exercised her sublime athletic skills only added to her drawing power.

After Wills died, the *Los Angeles Times* would report: "When Charlie Chaplin was asked to name the most beautiful thing he had ever seen, he responded: 'The movement of Helen Wills playing tennis.'"[114] The dashing British champion Bunny Austin wrote of Wills, "Both on the court and off the expression of her face, classical in its beauty, remains calm and dignified, and her bearing is always regal as befits the Queen of the Lawn Tennis world."[115]

Still, no one could quite get a handle on Helen Wills. There was no doubt that she embodied a form of excellence—for a six-year-long winning streak, no opponent could get so much as a set off her—but she was an enigma. What was she thinking, or concealing? The two

For one of her 1927 dress fabrics, Wills arranged the tennis racquets into flowers in bloom.

nicknames that reappeared constantly, when she was in her twenties and garnering her titles, were "Little Miss Poker Face" and "the Garbo of Tennis." Having risen to all those victories following her defeat to Suzanne Lenglen in 1926 at Cannes in "the match of the century," she proved her resilience, but she was impenetrable. She was not haughty, but she remained enigmatic. There were no chinks in her armor.

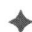

AT AGE fifteen, Helen Wills was the National Junior Women's Tennis Champion. Back then, she was the American Heidi. With her hair parted in the middle and in long braids, with her wide-set eyes, her small nose, and her big smile, she epitomized an American ideal. Wills resembled— it would be a well-known image—the cheerful country girl on the label

of the Vermont Maid maple syrup bottle. Could anyone with the grit to survive the competitive world of junior tennis really be that innocent? It had required something more than fortitude to challenge Lenglen at age twenty. She had gone to Europe ostensibly to continue her studies in art, which was her major at university. The media had thrilled to the idea of this young American tennis champion facing the world's best woman player. Lenglen was famously flamboyant, Wills reserved. She had not lost by much, but still, it was a defeat, and it took courage to carry on. It was her sense of resolve that enabled her to persevere to the point that she subsequently had the longest streak of tournament victories of any player in tennis history.

Wills and Lenglen had shown their different styles even before they were on the court. Lenglen had arrived at the clubhouse in a chauffeur-driven car, blowing kisses to the cheering crowd. Wills had appeared demurely with hardly anyone noticing that she was there. Then came their entrance in front of a crowd that, according to Al Laney, consisted of

> a great number of celebrities, including royalty in the person of ex-King Manuel, of Portugal, the Grand Duke Michael, Prince George, and a number of maharajas and titled persons whose names escape me. [They made] a nice picture for the battalion of photographers that immediately engulfed them. Suzanne came like a great actress making an entrance that stopped the show, with flashing smile, bowing, posing, blowing kisses, full of grace and ever gracious. Helen, walking beside the Queen and, as befits a lady in waiting, just a little to the rear, came in calm, impassive, and unruffled, looking nowhere but in front. She seemed sturdy and placidly unemotional.

Once play began, their differences were even clearer. Laney uses Lenglen's pizazz to accentuate Wills's reticence:

> Miss Wills had not Lenglen's ability to give you pleasure by the beauty of her method and the glitter of her personality, but she had a manlike speed of service and drive that gave her superiority over

her rivals. There was an immaculate quality about her play. Never much of a strategist, her progress through a tournament was seldom exciting, but the steady placidity of her play, unvaried against all opponents, never seemed to bore her. She never sought new ways of dealing with and defeating opponents as Lenglen did, but she never had to do so for a long time.[116]

Following the match and Wills's defeat, both women remained on the French Riviera. Wills apparently came out of her shell as she was besieged by the crowd of fashionistas and film people. She was quoted a couple of times as saying she was enjoying herself as never before. Even while she maintained a degree of seclusion, she slightly let down her guard.

She was newly at ease because Frank Moody, a wealthy young stockbroker from San Francisco, had recently become her constant consort. Laney writes: "Miss Wills was in great demand to attend parties and functions, and young Mr. Moody seemed to be her only cavalier."[117] The gossip columns reported his presence at receptions attended by the King of Sweden and the former king of Portugal. With his correct if unexciting demeanor, he could cut it with the fancy set, and if he was a bit of a square, his steady if boring manner perfectly suited Wills's need for discretion and stability. Moody and Wills soon married.

In 1927, the same year she made her fabric designs, the twenty-one-year-old Wills, after being the second American woman to win Wimbledon, landed a job doing illustrations and interviews for *The New York World*. She didn't stay on the staff for long—she needed time to practice her tennis—but she remained committed to writing and making art, which she had studied at the University of California at Berkeley. Meanwhile, she won one national championship after another: the American, at Forest Hills; the French, at Roland Garros; and then, in 1928, Wimbledon and Forest Hills again. She began not just to win matches but to take every single set as well, and to vanquish her opponents with record-breaking speed. In one tournament—the Kent Championships at Beckenham, in England—she won a match in eighteen minutes, and the following day triumphed over Molla Mallory, one of the best-known players, taking the first set in ten minutes and the second in thirteen. By 1933, Wills had won three

hundred and sixty sets in a row, all in major tournament matches. Not only had she triumphed six times at Wimbledon; she had done so in sixty-eight straight sets. None of those sets needed extra games, as she always won by 6–4 or better.

In those days, journalists did not hesitate to generalize about what was deemed masculine and what feminine. Of the first Wimbledon victory, where her opponent in the finals was Señorita Lili de Alvarez, a London newspaper reported:

> [T]his was tennis never seen on the Centre Court before. These were man-like strokes to which the perfect poise of feminine grace was added. They may not have had man-like tactics behind them; in speed and counter speed they were majestic, drawing riotous applause from an enraptured crowd.[118]

The male-female comparison informed everything that was said about the match. "Never, said Big Bill Tilden, had he seen a woman hit a ball as hard as did Miss Wills playing against the Spanish señorita in the finals."[119] She had to; Alvarez took the lead early in the match. Her winning maneuver was to drive the ball deep, force Wills to play from the back court, and then suddenly execute a drop shot with "a short, almost insolent flick." There is a craft to that way of playing—the extreme consciousness of precisely what she was doing—as there is to the writing that describes the hitting of a shallow ball as "insolent."

But then Wills figured out how to handle those volleys that Alvarez executed so contemptuously. She hit groundstrokes with a strength and a sense of placement that made it impossible for Alvarez to make her usual rush to the net. Following a rally in which each woman hit the ball twenty times with deft, muscular forehands and backhands, Alvarez cracked, not able to resist attempting one of her drop shots. Her backhand half-volley—one of the most difficult shots to execute in all of tennis—sent the ball out. From then on, Wills succeeded in mixing up her shots, alternating deep drives to the baseline with deadly little slices, with a mastery of changes in tempo worthy of a conductor the level of Toscanini in her alertness to the importance of every split second and her sense of nuance.

The September 9, 1928, *New York Times* reported on the king and queen watching this demonstration of virtuosity with rapt attention. Again, the comparison to men's tennis was invoked:

> This stalwart young American girl in short-sleeved middy blouse and skirt that allowed complete freedom of movement, hammered the ball with tremendous blows of her racquet such as were rarely seen even in men's play in the past.
>
> Not only does Miss Wills hit the ball harder than did the average men players of a generation ago. Even today there are not many men who wield a racquet so powerfully. Her forehand drive is deadly, a streak of lightning, and her backhand, which ordinarily is purely a defensive stroke with most women, and with most men, too, is also a strong attacking weapon.[120]

The wit of the subsequent repartee suited the quality of the tennis. Following the match, as Alvarez and Wills were leaving the court, Alvarez turned to Wills and gestured with a smile that Wills should precede her, saying, "Queens first."

WILLS OFTEN took on male opponents, and beat them. On one occasion, she was the solitary woman in a men's doubles tournament. Phil Neer staged an exhibition match in San Francisco. Neer, who was often Wills's mixed doubles partner, was ranked No. 8 nationally among male players. Wills won it handily, defeating Neer 6–3, 6–4. An anonymous article in the August 22, 1928, *New York Times Magazine* made much of the woman-versus-man theme:

> In spite of her success against these players Miss Wills would yet be far from a match for Tilden, and the reason is largely because of a man's greater speed in returning and delivering his strokes. A woman player is not able to start quickly enough or to move fast enough to get to many of a man's shots, whereas her strokes do not die as fast against him as would another man's. In Miss Wills' case

the disparity in the speed of stroke has been greatly reduced, but not enough to put her on par with men of equal skill.

The reason for her prowess was a combination of her remarkable physique and a perfect technique that had come only through intense practice. Helen Wills never let a day go by without practicing her strokes until they were executed with perfection, her sense of anticipation and her masterful footwork always assuring that she would be in the right place at the right time. Time magazine, which showed Wills on its cover twice, reported: "There was nothing frivolous about Little Miss Poker Face. She stood her ground like a tank, drilling out bullet serves and powerful baseline drives."[121]

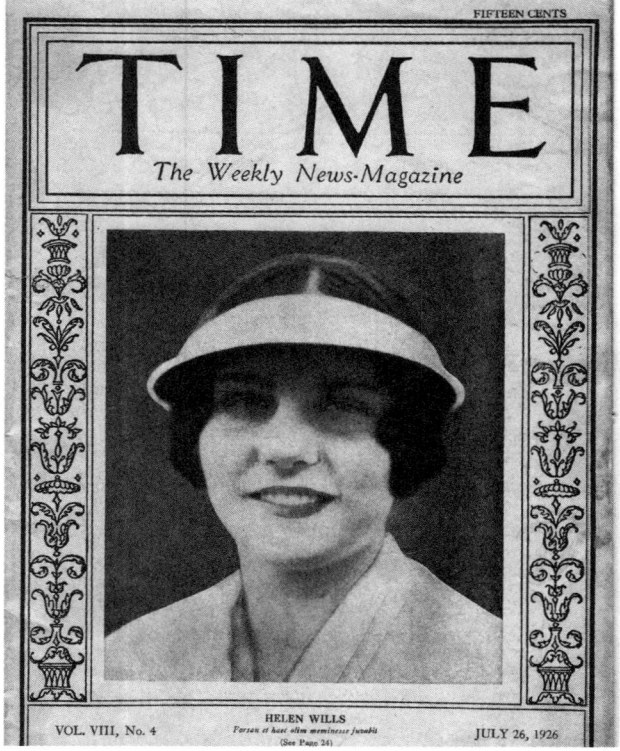

Wills was an American icon, known not just to the tennis cognoscenti but also to the entire country.

The same summer she won at Wimbledon, Wills was the subject of a profile in *The New Yorker*. Its writer, Helena Huntington Smith, opens this way:

> Atlantic City may bestow, to the delight of the rotogravure editors, the title of Miss America on any number of bathing beauties that it likes, but if the question were put to a popular vote, the real Miss America would probably turn out to be Miss Helen Wills. And Helen, it might be added, grows increasingly qualified to adorn the roto pages herself.
>
> "All the males of America from six to sixty," revealed an enthusiastic New York editorial writer as Miss Wills returned triumphant from Wimbledon last month, "are a little in love with her."...[122]

The tribute to Helen is the more remarkable for the reason that she is no siren of the stage, but a lady athlete. She is most closely identified with a class notoriously short on sex appeal.

Smith could not get over Wills's good looks and the traits that accompanied them. "Prettier every time she is snapped by photographers," Wills, it appears, perpetually outdid herself at every viewing. She continuously became more gracious yet remained exceptionally modest. She perpetually took her stylish dressing to new heights, choosing her clothes with a discerning eye and, thanks to her model-like carriage, wearing them in a way that accentuated her own beauty but as well as the perfection of her dresses and coats, each of which was perfectly suited to the occasion for which she wore it. The only surprise about Helen Wills was that she was "larger and taller" than one expected from her photos, but her size did not in any way hamper her beauty, as everything about her was proportioned impeccably. It seems that Mrs. Smith had seen Wills on an ocean crossing, because she reports on the tennis player being the most sought-after person on board the ship and dancing "divinely."

No one could get much of a handle on Helen Wills's personality, though. She was famously "the good child," born in Berkeley, California, into a life of ease. Her father, a physician, had taught her tennis. Her mother attended matches wherever she played; the family had the means

to travel. When Helen had to make sketches of a hockey game for *The World*, Mrs. Wills went with her to Madison Square Garden. Then, when Mrs. Wills said the game was "too much of a strain on [my] nerves" and that they had to leave once Helen had done a quick sketch, Helen said, "'Yes, mother dear,'"[123] and left compliantly. She was reticent in conversation and recalcitrant at press conferences, being known to say, "I'll let my racquet do the talking." Her virtuousness became part of her legend—she neither drank nor smoked and wore no makeup. This was the sort of thing that went down well in Middle America but was less palatable to the urbane and cosmopolitan readers of *The New Yorker*. Nor was her recalcitrance. Mrs. Smith reports that Mrs. Wills, approaching the age of

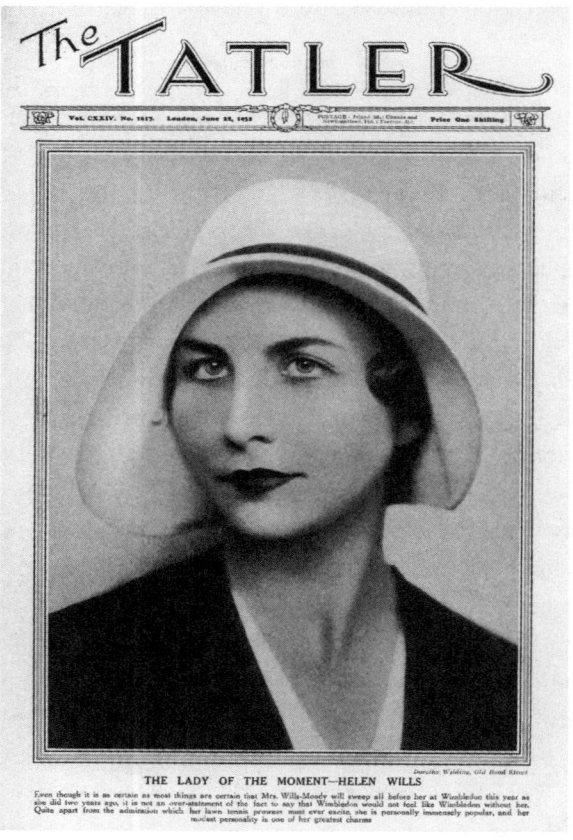

Wills was also well known in England.

twenty-two, was not just unusually silent: "It is dangerous for her to shake hands, for example, and she does so just as little as possible. She rarely, if ever, goes to the movies because the flicker is likely to injure her eyes." And then, having extolled Helen Wills's beauty beyond all heights, with the ironic twist intrinsic to the style of *The New Yorker*, the writer lets out a zinger. "Helen finds it difficult to say what she thinks, so much so that her friends have sometimes wondered whether she thinks at all. Undoubtedly she does. Undoubtedly she occasionally ponders on what lies beyond tennis."[124] In her memoirs, Helen Wills would provide an answer: "I had one thought and that was to put the ball across the net. I was simply myself, too deeply concentrated on the game for any extraneous thought." Still, the idea boggles the imagination. We wonder if and how such singularity of interests could really be the case.

◆

AFTER HELEN Wills died, in 1998, one obituary quoted Ted Schroeder, a former Wimbledon champion with whom Wills played mixed doubles: "'Never a hair out of place, the skirt extending precisely,'" Schroeder said Thursday from his home in La Jolla. 'She showed no emotion whatsoever. She never said a word. I don't think we ever spoke. But if you don't think she wanted to win, you're wrong. What a competitor. I don't think I ever played a better tennis match than I did that day with Helen, and that ought to tell you something.'"[125] Reading this, one gets the impression that the absence of visible emotions might have been off-putting.

We also become impatient with Wills's desire to prove herself in areas where she was pretty much a failure. The articles and stories that Wills wrote were, Helen Huntington Smith snidely remarks, "naïve enough to demonstrate that she really wrote them herself." And Wills's drawings were, according to *The New Yorker*, "pretty bad." While in *The World* she was given more space than any other illustrator,

> [t]he results were mediocre. Her sketches, it is said, are hardly original, nor are they of striking merit. Signed by Helen Wills, newspapers and magazines are glad to use them. Unsigned, she would be able to use very few of them.[126]

The New Yorker was belittling Helen Wills's art unjustly. Mockery rather than truthfulness—and with the mockery a certain sense of superiority—was, as was often the case with that magazine in its heyday, of paramount importance. For we come to our conclusions. And to my eyes Helen Wills's sketches, as they appeared both on silk fabrics and in newspaper illustrations, were remarkable. They betray a deftness at drawing and the capacity to evoke movement. Their light touch and lack of Sturm und Drang by no means makes them bad.

The effort to create a clear picture of Helen Wills is made cloudy by Helen Huntington Smith's rancor. She insists that there was something too good to be true about this tennis star who was considered "the normal American girl. But it is doubtful whether the normal type has ever been so sound in body and so untroubled in soul."

What do we, finally, make out of the quality of appearing placid despite what was clearly a tremendous drive to succeed? Smith quotes the French surgeon who had performed an appendectomy shortly before the French National championships:

> "She is a model for all young women!" Never, never he said, had he seen such a girl—such physical perfection, such poise! "Your Miss Wills is not only a wonderful athlete, she is undoubtably one of the calmest characters in the world!"

Whereas other women were styling themselves as flappers, Wills seemed to be cultivating the girlish image by "still wearing her hair down her back at an age when modern young ladies are supposed to be overcome by alcohol at nightclubs."[127] The question remains: Was the innocence authentic? Or was it a cover-up for something darker?

There is more than a hint of parody in the way that, in 1929, a journalist named Annie Laurie—this was the pen name for Winifred Black, who was one of the first female sports reporters in America—wrote about Wills in *The San Francisco Examiner*: "She just steps along through life as if she were just an ordinary everyday girl looking for a new hat in Paris and a new sport dress in London and going to see the Coliseum in Rome and then coming home to marry a plain American and settle down somewhere in a bungalow and have the Junior League in for tea." How white bread can you be?[128]

Her *New Yorker* profiler wrote, "It is the continued imperturbability of the girl that most baffles the public, a calm that still justifies the name of 'poker face' even though she has now flowered into a lovely woman." At a time when everyone else groused about Suzanne Lenglen's behavior on the court and her decision to become professional, Wills would only say, "'She is such a wonder! There is nobody like her!'" Was the tennis pro who gave the impression of being "Miss Merry Sunshine" a phony or, in fact, genuinely the rarity she appeared to be?

◆

JAMES PHELAN was an heir to a banking fortune. He had been the mayor of San Francisco, where he was from, and a US senator. He was enchanted by Helen Wills—her wholesomeness as well as the caliber of her tennis—and wanted to pave the way for what he assumed would be her stardom, either on stage or in films.

Wills had misgivings about the idea. Her father disapproved, and she worried that it would be bad for her reputation if she had a screen test and did poorly. Her decision was to let Phelan arrange a screen test, surreptitiously. If she did well, she would tell her father, but only then.

Phelan told Wills's father that she was busy writing and making art, while she was secretly preparing to show her capability as a film actress. Friends of Phelan's arranged for Joseph Kennedy, who at the time was running the Film Booking Offices, to be her agent. The film director Henry King agreed to do the screen test free of charge.

The test was done on September 30, 1927. A couple of months earlier, Wills had won at Wimbledon for the first time, and more recently she had won the US Nationals at Forest Hills. Kennedy and Phelan—and Wills herself—were eager for her next victory to be on the silver screen.

The results were disappointing. Joe Kennedy told Wills that she stood a better chance if she lost some weight. She said she would try to do so. Kennedy then dissuaded her. He knew she would best abandon the acting idea. Still, the following year she agreed to make a film for Herbert Hoover's presidential campaign. With two racquets in the crook of her left arm, she extolled the merits of her candidate. The epitome of American womanhood, she helped him convince the public he supported the family values she represented.

It was her unique allure that had made her the subject of Calder's wire sculpture. The year was 1929. Three intrepid young men, college undergraduates, had created the Harvard Society for Contemporary Art. They took on the costs themselves, although inexpensive memberships were available, and rented two rooms in which to show the best possible modern art. In advance of the creation of the Museum of Modern Art, they presented sculpture by Brancusi, paintings by Miró and Picasso, and the design work of the Bauhaus school, appalling conservative journalists but thrilling the handful of people receptive to these artistic adventures. They asked Calder, when he was thirty years old and almost broke, to show wire sculpture. He agreed to present seventeen pieces, but when Edward Warburg, the one of the three young men who owned a car, went on the day before the exhibition opening to meet Calder's train at South Station in Boston, Calder appeared with nothing but a large briefcase in hand. Warburg panicked and asked where the sculptures were; Calder assured him that he should not worry. Back in Warburg's room, he put on pajama bottoms in lieu of his trousers and took three spools of wire and a pair of pliers out of the briefcase. He looped a piece of wire around the large toe of his right foot and began to create human figures—some stereotypes (one was called "the debutante's mother") and others recognizable people, Josephine Baker among them. Soon Helen Wills emerged with Calder's toe keeping her earthbound. Her trademark visor is in place, her skirt flowing, as she lunges forward into that graceful forehand.

Calder was not the only sculptor to be inspired by her just as the various painters had been. The sculptor Haig Patigian did a large bust called *Helen of California*, of which he said she had a beauty that "rises from within"; a white marble version is in the collection of the Palace of the Legion of Honor. In 1930, Bryant Baker did two sculptures of her called *Pioneer Woman.*

The British fashion designer Ted Tinling, known for his tennis dresses, would write, "She had a flawless complexion with her facial bone structure and her finely chiseled features were reminiscent of a piece of serene classical sculpture. In dramatic contrast, she had the Marlene Dietrich technique of a conversation."[129] It was a reference to Dietrich as the seductive spy Mata Hari. Tinling certainly knew whereof he spoke; before making women's tennis clothes, he had been a spy for the British

army. But it was a reach to think that Wills's concealment covered up anything more than her shyness and not having a lot to say.

In the spring of 1929, when Wills was guest of honor at a festival in the town where Phelan had a vast country estate, he introduced her to the public with a speech in which he said that Wills, "the woman tennis champion of the world... represents California and the West and the fine spirit of achievement."[130] In 1930, shortly after she married Fred Moody, Diego Rivera was commissioned to do a mural for the San Francisco Stock Exchange Club and to be paid four thousand dollars. He had trouble securing a visa because of his politics, but influential people interceded, and he and Frida Kahlo, his wife, got visas and traveled to the United States so he could work on the thirty-foot-high mural.

Rivera was already well known for his large paintings, as well as for smaller paintings in which, with bold colors and a vivid narrative style, he celebrated the lives of ordinary Mexican people at work. To many, he was an unusual choice as the artist for a mural on a building that represented a height of capitalism. But Rivera had no problem with the idea or with the posh receptions at which San Francisco's financial royalty honored him. At one of those lavish social events, he met Helen Wills, who was there because her husband was a member of the stock exchange. Rivera was instantly enthralled.

Wills agreed to Rivera's request to go to his studio so he could sketch her. Soon the Mexican was obsessed. He began to make daily visits to the California Club to watch her practice tennis. The short, stocky Rivera would climb up into the umpire's chair and sketch her playing her extraordinary game. Fred Moody called him "a short, ugly little guy," but even if to some people Rivera was like a stalker, no one interfered.

Diego Rivera was quoted in a local newspaper: "I found in Mrs. Moody all that was beautiful in California womanhood. She represents my ideal of the perfect type."[131] He used her face and shoulders as the basis of an oversized image of a sort of earth mother, looming over scenes of people at work. The mural was dense with a profusion of scenes of industrial and agricultural labor, with a widened version of Helen Wills's face appearing in the middle of it.

There were protests once the work was complete. To most viewers, the woman who was supposed to be an allegorical figure was clearly

Helen Wills. People objected to the idea of a famous tennis player representing the state of California. Rivera responded by altering her features, but she was still recognizable as Wills, as was a second figure—of a nude on the ceiling, which was called "Helen flying."

Rivera went on the defensive, saying, "California is known abroad mainly because of Helen Wills Moody; that she seemed to represent California better than anyone I knew—she was intelligent, energetic, and beautiful." Rivera, who saw Wills Moody as a sort of goddess, explained, "On the ceiling above the wall, I painted a female nude in billowing clouds, symbolizing fertility of the earth as well as the natural interconnection of agriculture and industry."[132]

Helen Wills's prodigious skill at tennis, her marvelous face—and, very possibly, her elusiveness—made her a person people wanted to emulate. It was not just all those years of winning every set in all the

It is Wills who is flying naked in Diego Rivera's ceiling mural.

major tennis tournaments that made her a cult figure; the images of her by Calder, Rivera, and Covarrubias, and the proliferation of photos of her, gave her celebrity status of a type more common today than it was in the 1920s and '30s. Every day, she would receive a pile of mail from fans and others who sought advice on how to become like her. Crowds would form around her when she was out in public. There was no hiding; photographers would find her in obscure locations. Strangers would send flowers to this woman they idolized. She was modest, she was beautiful, she had magical athletic skill. What lay underneath the impeccable surface was impossible to know, but the mystery was part of her allure.

12

VLADIMIR NABOKOV

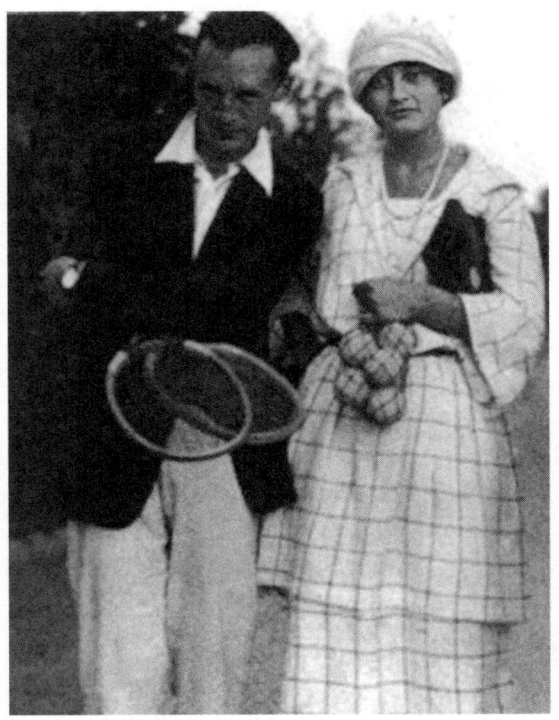

Vladimir Nabokov, who was an excellent tennis player, taught the sport as a young man and often referred to it in both his memoirs and his fiction.

IN *The University Poem*, a long narrative poem Vladimir Nabokov wrote in 1927, he carries on rapturously about Suzanne Lenglen. It was natural that Nabokov would include the great French tennis champion in this epic about his priorities of existence during his years

at Cambridge; he knew his tennis, and he liked audacity. Beyond that, he had a penchant for beguiling women.

He admired Lenglen not only for the excellence of her tennis but also for her audacity in appearing at Wimbledon in 1919 in a short dress. Until then, women had always played tennis in skirts or dresses that reached their ankles and encumbered their legs. Nabokov describes "the fleet-footed Lenglen" as being "like a chamois," and writes of this remarkable creature and of his feelings for her:

> *Oh, I confess I love, my friends*
> *At a full run the elastic stroke*
> *Of the goddess in her knee-length dress!*
> *To toss up the ball, to bend back,*
> *To turn around with lightning speed,*
> *And with the strung place from the shoulder*
> *To hit the crown of the ball,*
> *And, having advanced, to devastatingly volley*
> *The whistling return—*
> *On earth there is no sweeter pastime...*
> *In heaven we will play ball.*[133]

Nabokov played tennis well enough to know those components of an impeccable serve. His "strung place from the shoulder" refers to the ideal of having one's serving arm stretched straight upward, on a line with the racquet it is gripping to extend it to maximum height; his mention of "the crown of the ball" specifies the area on which to contact the ball to impart topspin. And he has evoked a perfect serve-and-volley game when Lenglen, having rushed net immediately after lacing that serve in, puts away the "whistling return." Only a true tennis aficionado could have depicted the sport so vividly.

Nabokov had tennis in his blood from early childhood. His first awareness of a tennis court, which predated his playing the sport, is an exquisite detail in *Speak, Memory*, his late-life autobiography.[134] Focused on his youth, this short book is written with considerable craft. By then, Nabokov had developed a marvelous style of writing in English although, when he learned it, it was his third language—

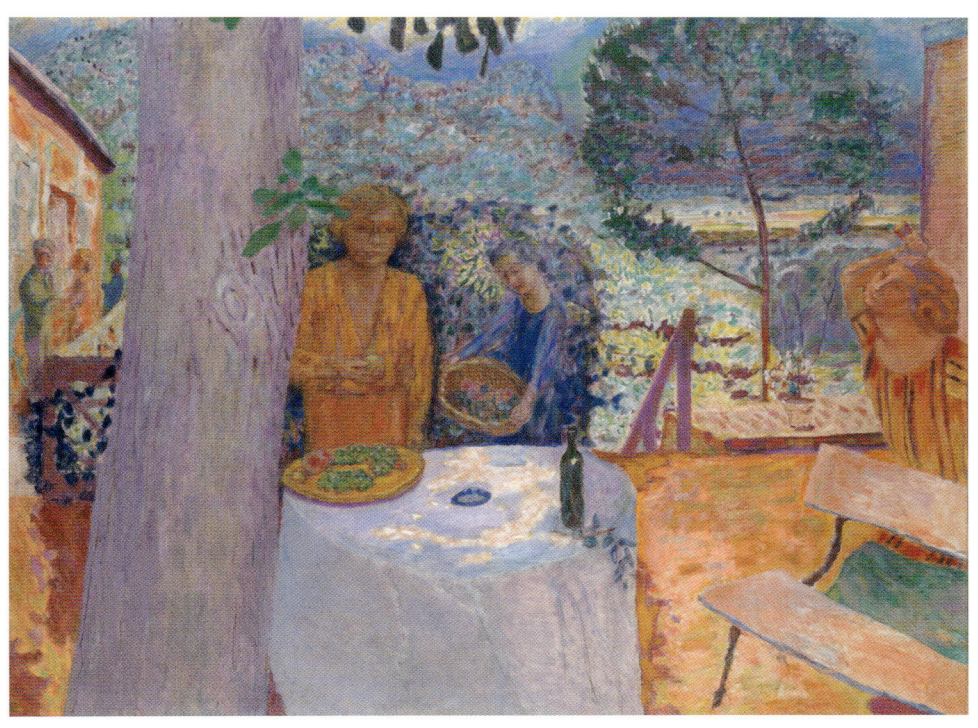

COLOR PLATE I: In the figure furthest to the right, Bonnard has perfectly evoked what is known as the backscratcher position of the serve.

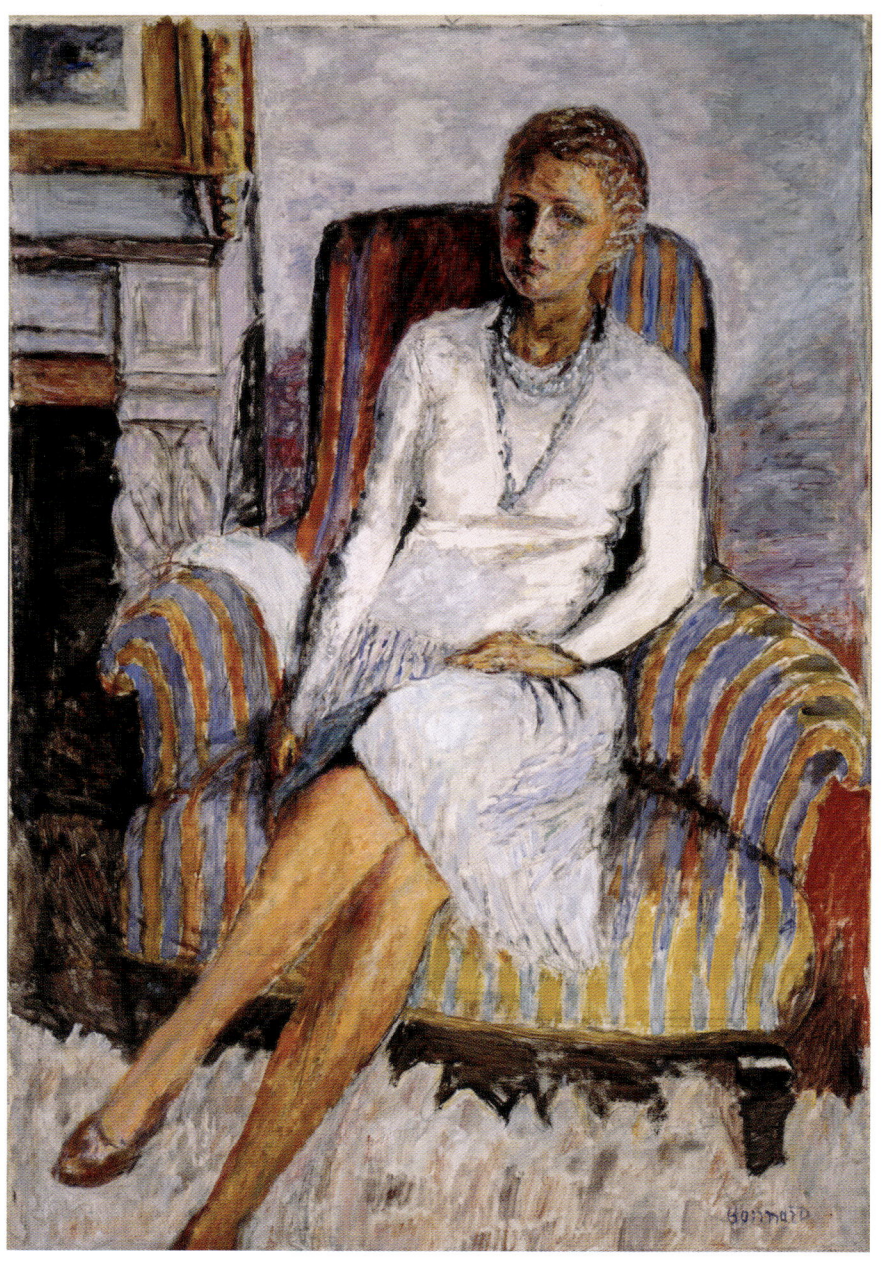

COLOR PLATE 2: Claude Anet's daughter, Leila Claude Anet, was an excellent tennis player. In Bonnard's portrait of her, she is at home but nonetheless wearing regulation white.

COLOR PLATE 3: A stained glass window, presumably from a 1920s clubhouse, found on the coast of Maine, echoes some of the leaps being made in modern painting.

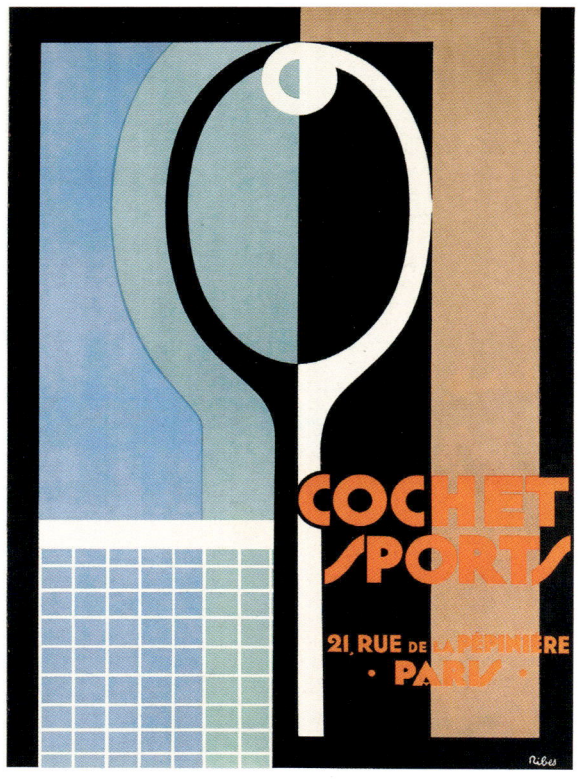

COLOR PLATE 4: This fantastic tennis poster from circa 1920 shows the strong impact of paintings by Léger and Le Corbusier.

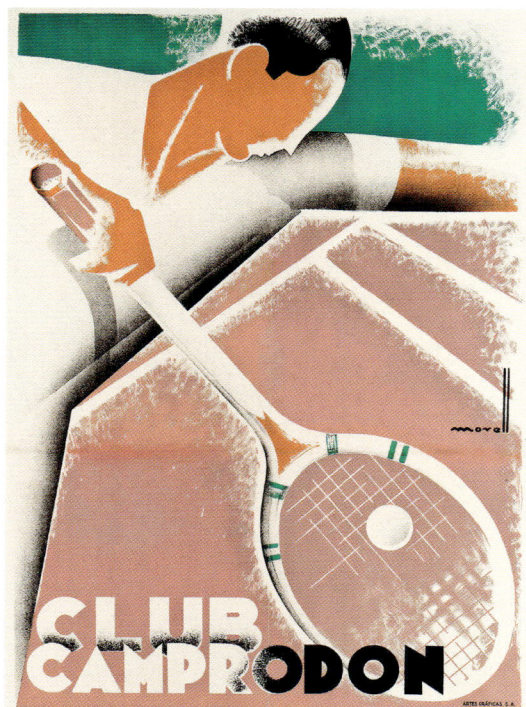

COLOR PLATE 5: This lively poster is by Jose Morell (1899–1949), one of Spain's foremost poster artists.

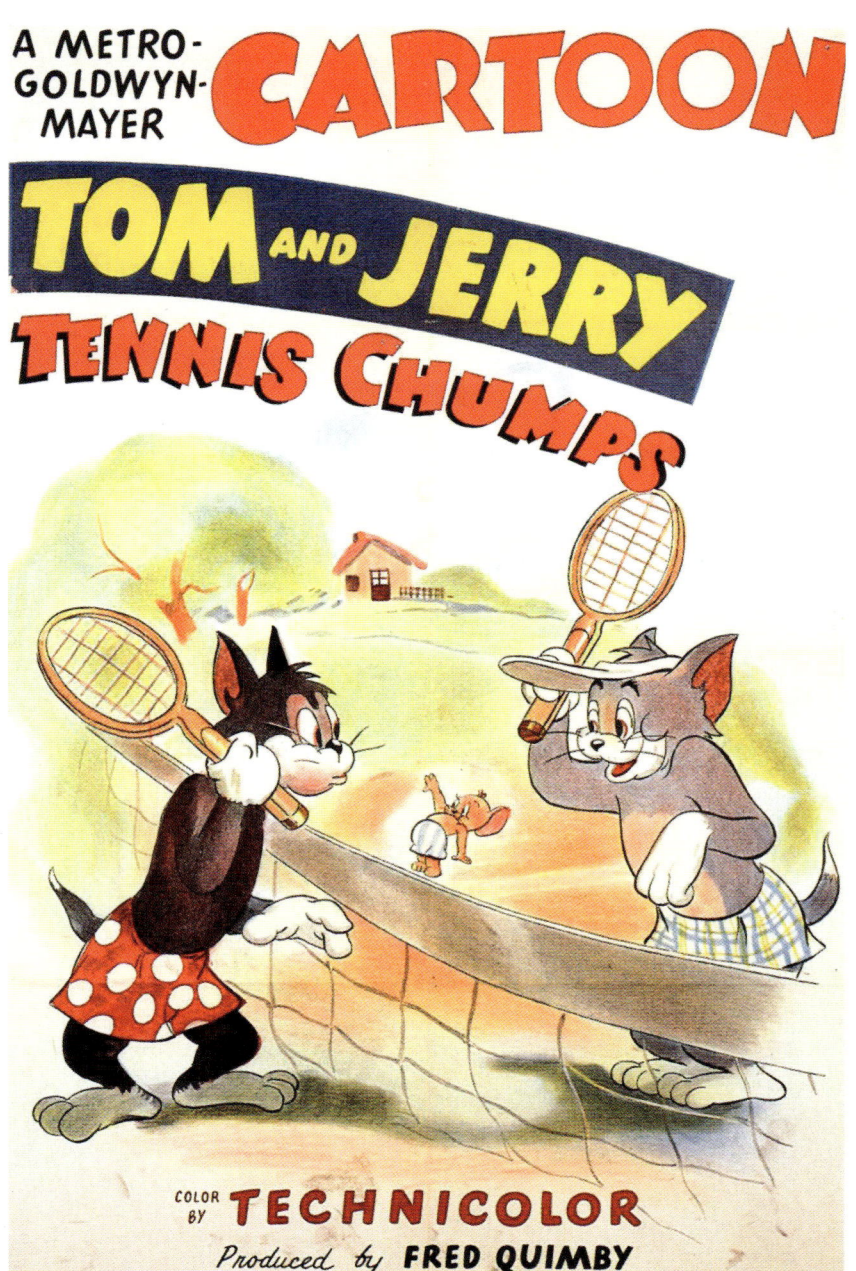

COLOR PLATE 6: Jerry has his thumbs down while Tom and another cat duke it out at net.

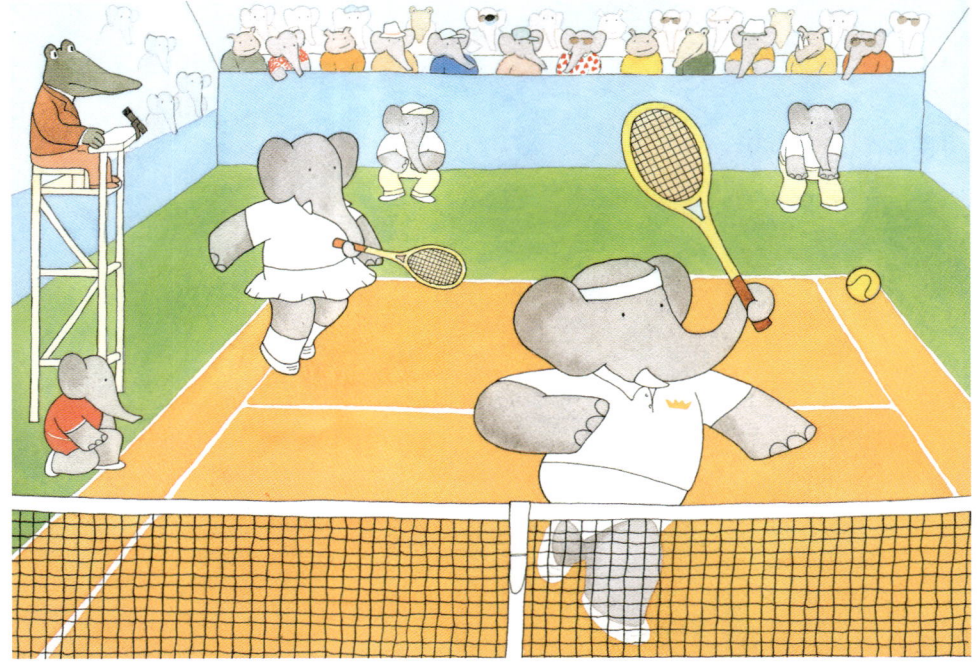

COLOR PLATE 7: The artist Laurent de Brunhoff marvelously depicted Babar and Celeste holding their racquets with their trunks and provided an extraordinary cast of characters for a tournament match complete with a crocodile and an umpire and elephants to call the lines.

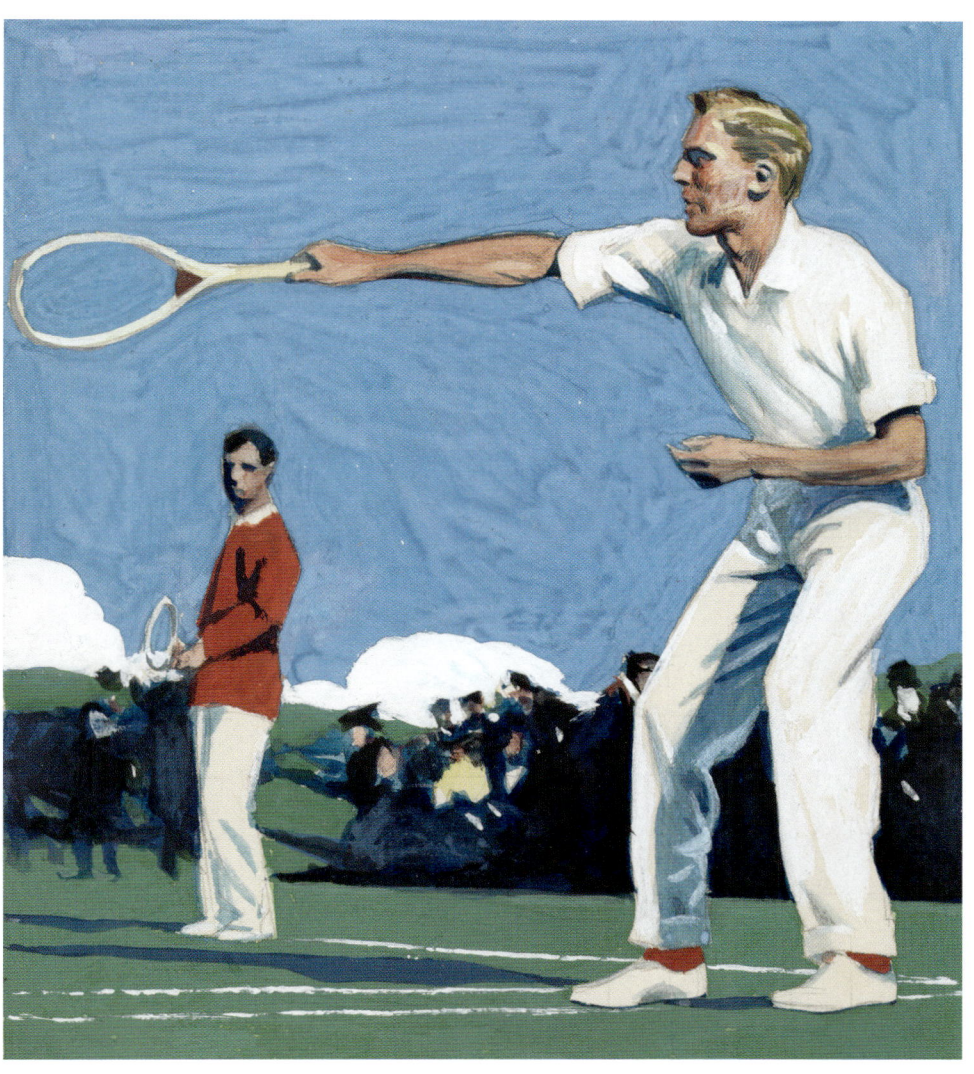

COLOR PLATE 8: The player who has just hit a forehand in Edward Hopper's painting of a game of doubles very much resembles Tilden.

COLOR PLATE 9: The contemporary artist François Olislaeger set up this imaginary tennis match between Piet Mondrian and Nicholas Fox Weber, who wrote Mondrian's biography.

COLOR PLATE 10: The cinched waist and bustle of this woman's dress must have made it difficult to breathe, let alone move. Painting by Sir John Lavery.

COLOR PLATE II: The tennis ball has sent a wine glass flying. Drawing by Charles Martin.

COLOR PLATE 12: Josef Albers, Color study for *Homage to the Square: Nowhere*, ca. 1964. Oil and gouache on cardboard, 13 ⅞ × 7 in. (35.3 × 18 cm).

COLOR PLATE 13: Josef Albers, *Study for Homage to the Square: New Pasture*, 1961. Oil on Masonite, 24 × 24 in. (60.9 × 60.9 cm).

COLOR PLATE 14: Josef Albers, *Study for Homage to the Square: Nowhere*, 1964. Oil on Masonite, 32 × 32 in. (81.3 × 81.3 cm).

COLOR PLATE 15: Josef Albers, *Study for Homage to the Square: Rare Diversion*, 1969. Oil on Masonite, 24 × 24 in. (60.9 × 60.9 cm).

COLOR PLATE 16: Josef Albers, *ADV*, 1969. Screenprint, 21 1/2 × 21 1/2 in. (54.6 × 54.6 cm).

COLOR PLATE 17: In one of her 1927 dress fabrics, Wills evoked the speed and grace of the game as she played it.

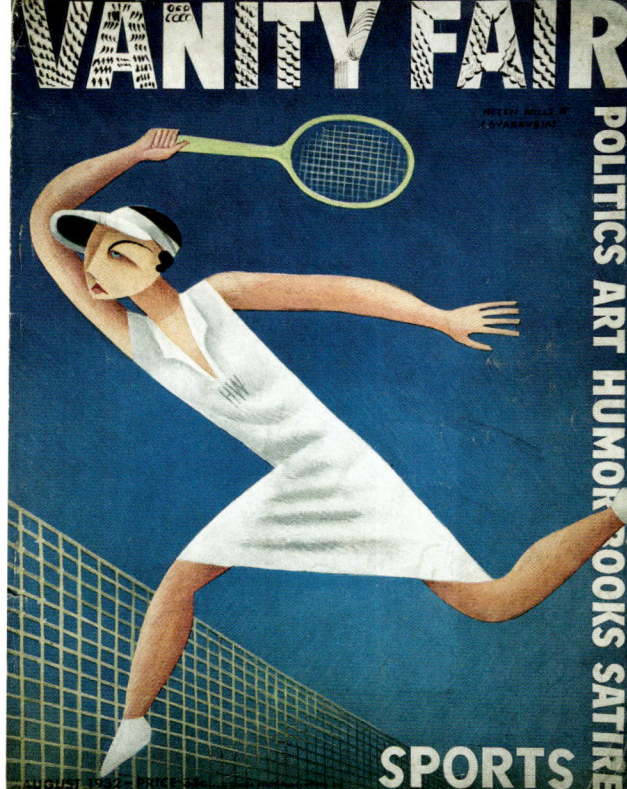

COLOR PLATE 18: Miguel Covarrubias's *Vanity Fair* cover of Helen Wills left no doubt as to her determination to win.

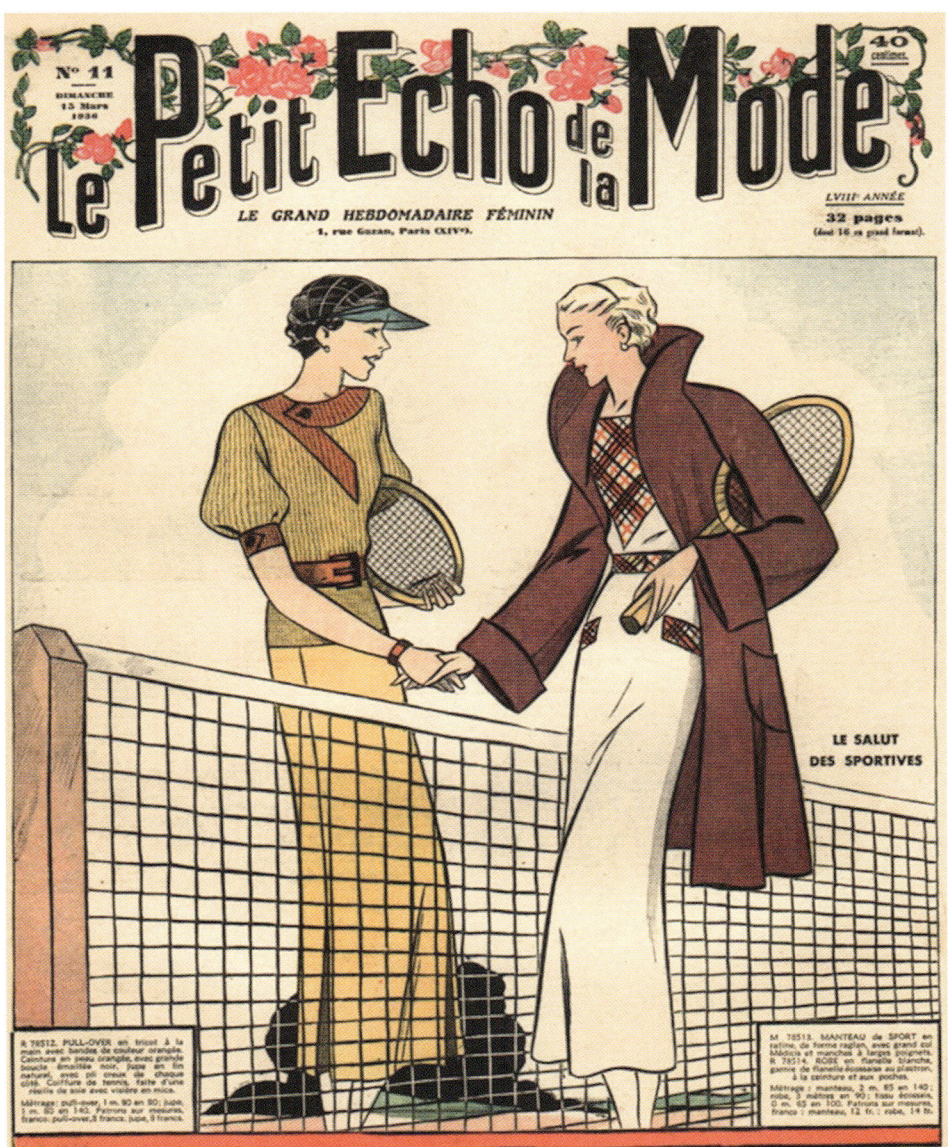

COLOR PLATE 19: Whether this moment was before or after the match, these players exemplified style in every sense.

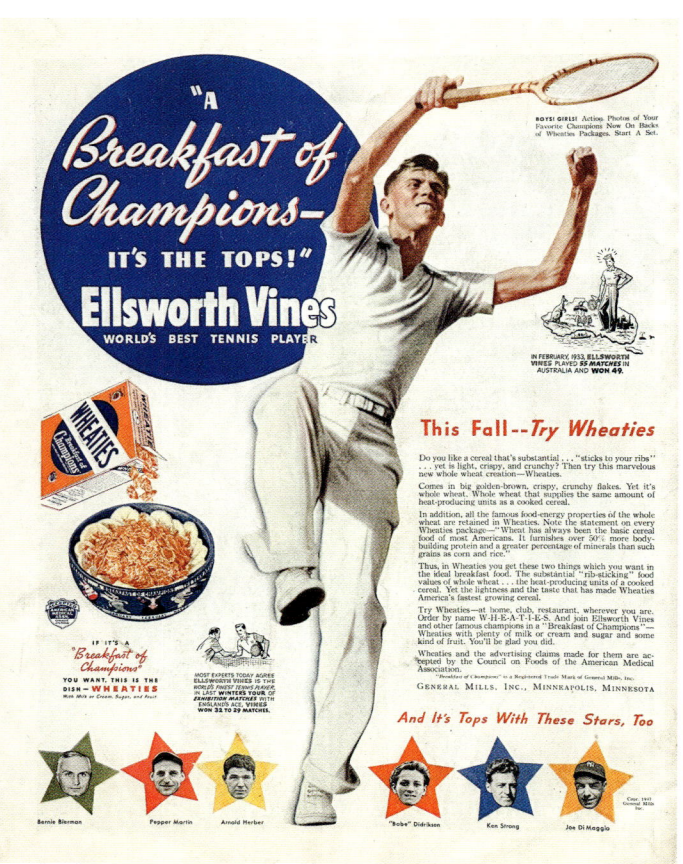

COLOR PLATE 20:
The man who defeated Austin ate his Wheaties.

COLOR PLATE 21:
With his seven racquets, this immodest fellow is ready to go.

COLOR PLATE 22: With the miniscule trophy in his delicate hand, the victor personifies the word *affected*.

COLOR PLATE 23: Florine Stettheimer's portrait of Henry McBride showed him as being both a knowing tennis umpire and discerning art critic.

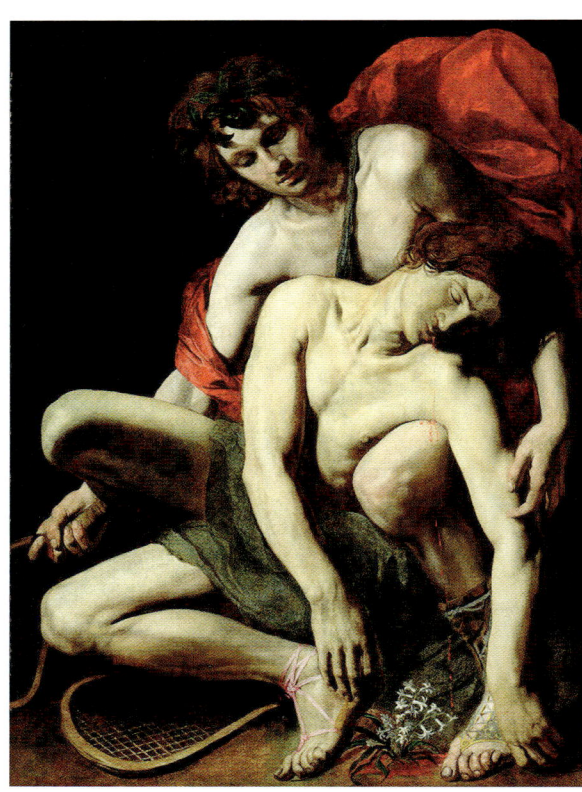

COLOR PLATE 24:
[Francesco Buoneri?],
The Death of Hyacinth, c.1622.
Oil on canvas. 51.9 × 35.9 in.
(132 × 91.2 cm). Musée Thomas
Henry, Cherbourg Octeville.

In both of these paintings, the tennis racquet is central to the story.

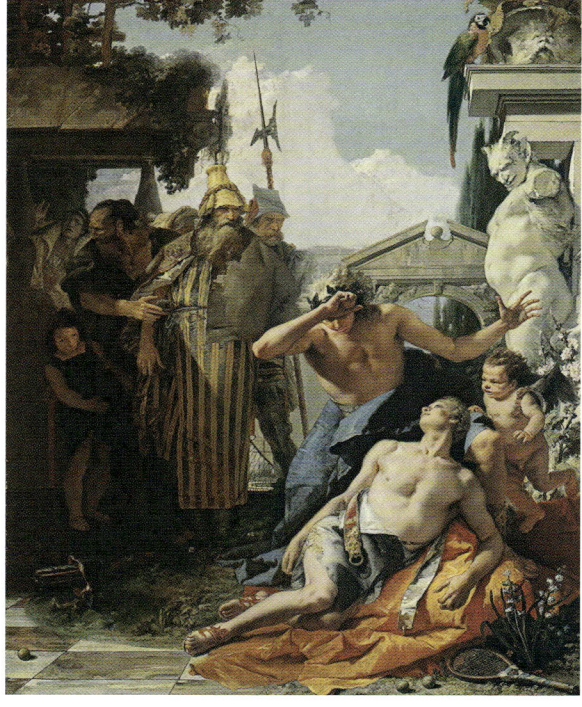

COLOR PLATE 25:
Giambattisto Tiepolo,
Death of Hyacinth, 1752–1753.
Oil on canvas. 112.9 × 91.3 in.
(287 × 232 cm). Thyssen-Bornemisza Museum, Madrid.

after Russian and French. His sensibility was sublime. He writes of his mother as she was in his childhood: "To love with all one's soul and leave the rest to fate, was the simple rule she heeded." The sweep of her love included sights experienced at their country house, Vyra. The family's luxurious existence in Russia before the Revolution was now in the distant past, but the sensations it induced were still alive. What his mother cherished included "a lark ascending the curds-and-whey sky of a dull spring day, heat lightning taking pictures of a distant line of trees in the night." Tennis courts, one old, one current, would belong to Nabokov's mother's sacred orbit: "As if feeling that in a few years the tangible part of her world would perish, she cultivated an extraordinary consciousness of the various time marks distributed throughout our country place." The recollection was what counted, felt with "retrospective fervor,"[135] he made those tennis courts seeable again. Like his mother, Nabokov relished the rich reprocessing of images of places that now existed only as memories. "Thus, in a way, I inherited an exquisite simulacrum—the beauty of intangible property, un-real estate—and this provided a splendid training for the endurance of later losses." Among the objects of delicious revery "there was, in the so-called 'old' park, the obsolete tennis court, now a region of moss, mole-heaps, and mushrooms, which had been the scene of gay rallies in the eighties and nineties (even her grim father would shed his coat and give the heaviest racket an appraising shake) but which, by the time I was ten, nature had effaced with the thoroughness of a felt eraser wiping out a geometrical problem."

In that single sentence, Nabokov presents the tennis court in its state of decay—conjured as the aftermath of what was once fertile and well maintained—and as a place where people had fun. It was a place where a single gesture, a personality (Nabokov's grandfather's), could reveal itself. And with the suggestion of the erased blackboard we get a simile for what happens when something complex is eradicated except as a mental echo.

But tennis withstands the ravages of time. Nostalgia for the old court has emerged because of the presence of the new one. Clay has replaced grass as the playing surface. As usual, Nabokov sees what is before his eyes with his mix of groundedness and imagination, his

capacity to convey an entire way of life through telling details, and his pitch-perfect characterizations of people who enter and exit the stage, however briefly. Precision accompanies his poetry:

> By then, an excellent modern court had been built at the end of the "new" part of the park by skilled workmen imported from Poland for that purpose. The wire mesh of an ample enclosure separated it from the flowery meadow that framed its clay. After a damp night the surface acquired a brownish gloss and the white lines would be repainted with liquid chalk from a green pail by Dmitri, the smallest and oldest of our gardeners, a meek, black-booted, red shirted dwarf slowly retreating, all hunched up, as his paintbrush went down the line....

This new court is the setting for family games described with novelistic sweep and depth:

> Our current tutor or my father, when he stayed with us in the country, invariably had my brother for partner in our temperamental family doubles. "Play!" my mother would cry in the old manner as she put her little foot forward and bent her white-hatted head to ladle out an assiduous but feeble serve. I got easily cross with her, and she, with the ballboys, two barefooted peasant lads (Dmitri's pug-nosed grandson and twin brother of pretty Polenka, the head coachman's daughter).... Wallis Myers' book on lawn tennis lies open on a bench, and after every exchange my father (a first-rate player, with a cannonball service of the Frank Riseley type and a beautiful "lifting drive") pedantically inquires of my brother and me whether the "follow-through," that state of grace, had descended upon us.[136]

The details belong to the upper echelons of the tennis world, which in Czarist Russia tended to be anglophile. Wallis Myers was an English sports journalist and one of the preeminent tennis authorities of the era; Frank Riseley was an English tennis champion who had twice won in doubles at Wimbledon and who played for Great Britain's Davis Cup

team. In a few lines Nabokov has used the setting of the tennis court not just to portray his mother and brother, but also to depict an entire milieu of society.

Yet the emotions brought on by "temperamental family doubles" can pertain to very different locations and epochs. A game in which parents and children go onto the court together can accentuate a myriad of issues, wherever the court is and whoever the people are. For some of us who have played family doubles, Nabokov's scene resonates. Decades after my own adolescence, a tennis match in which my mother and I were partners against my older sister and father would reemerge in my thoughts as I lay on a psychoanalyst's couch. It provided rich material for the good doctor and me to discuss.

My family hazarded this lethal combination when I was fifteen years old, still living at home. My sister Nancy, age twenty-one, a college student hellbent on an adventurous life as far away from the rest of us as possible, had returned to the nest for a rather fraught weekend. Nabokov evokes the tensions of the four of us on the court. Alas, there were no gardeners or imported workmen on a court at our own house. We were, rather, surrounded by my parents' fellow members at an expensive private club that for Nancy was the embodiment of "bourgeois hell"; the setting exacerbated the general feeling of discomfort. As for the matter of who played with whom against whom, the stories of Oedipus and Electra pertained. Mother and son in combination were monsters: better tennis players, intensely competitive, and formidable when we were allies on the same team. The father and daughter as usual were in another world with their little romance, more interested in their private jokes than in playing to win. The tensions evoked by Nabokov were redolent; the family dynamics were something of a nightmare. As is often the case with great literary descriptions, the feelings conjured are not only rich evocations of the writer's own experience but also the catalyst for the reader's own sequence of memories reflecting comparable anxiety in a very different world.

I was smug in my certainty that Mom and I would win. Yet even as we played to victory, she made one remark that puzzles me to this day: "Hit the ball harder, Nicky." This was the contrary of what we were taught at Tamarack Tennis Camp, where the emphasis was on control

and precision, not brute force, and we were often told to slow down and try to carry rather than smack the ball with the strings. Mom, of course, was giving me a message. In various ways, she brought me up to be a fighter. For better or for worse, she was determined that I not shy away from conflict. When I told her after the game that her advice was not well founded, that what counted more was steadiness and the ability to master direction, she was adamant that what she said had been spot on. Sixty years later, I think that she was right. Only a few weeks ago, Pierre urged me to attack the ball on my forehand, to meet it in front before it started to get by me. What sound counsel: to meet challenges head on before they get the better of you.

Vladimir had four siblings, and one of the players in family doubles was his brother Sergey. Sergey was ten and a half months younger. In writing about his past, Vladimir found it "inordinately hard"[137] to speak of Sergey: "His boyhood and mine seldom mingled.... I was the coddled one; he, the witness of coddling." Vladimir depicts himself as having been quite monstrous to Sergey, and the two having been very different from each other.

> We seldom played together, he was indifferent to most of the things I was fond of—toy trains, toy pistols, Red Indians, Red Admirables ... As a child, I was rowdy, adventurous and something of a bully. He was quiet and listless, and spent much more time with our mentors than I.

Sergey became interested in music and played the piano very seriously; Vladimir "would creep up behind and prod him in the ribs—a miserable memory."

But when the family moved to London—and then when Vladimir and Sergey both went on to Cambridge University—they became closer through a single shared source of enjoyment.

> The only game we both liked was tennis. We played a lot of it together, especially in England, on an erratic grass court in Kensington, on a good clay court in Cambridge. He was left-handed. He had a bad stammer that hampered discussion of doubtful points. Despite a

weak service and an absence of any real backhand, he was not easy to beat, being the kind of player who never double-faults, and returns everything with the consistency of a banging wall.[138]

Every detail reveals the brothers' essential differences as personality types. But tennis provided a rare camaraderie. The sport was an integral part of Nabokov's existence, not an adjunct but a vital element in human relationships. Even to the gentlest of souls, it is a battle dominated by the urge for victory.

◆

IN 1926, Nabokov wrote a short story that never appeared in print when he was alive but would eventually be translated and published by his son Dmitri. Called "La Veneziana," it is unique in Nabokov's writing because the behavior on the tennis court becomes the metaphor for all the character traits that are revealed in the rest of the story.

This marvelous tale opens in a setting described similarly to the grass court that was overgrown in *Speak, Memory*:

> In front of the red-hued castle, amid luxuriant elms, there was a vividly green grass court. Early that morning the gardener had smoothed it with a stone roller, extirpated a couple of daisies, redrawn the lines on the lawn with liquid chalk, and tightly strung a resilient new net between the posts. From a nearby village the butler had brought a carton within which reposed a dozen balls, white as snow, fuzzy to the touch, still light, still virgin, each wrapped like a precious fruit in its own sheet of transparent paper.[139]

Who but Nabokov could have given such romance to court maintenance or imparted such charm to a box of tennis balls—in that era when, like the lines on the court and the uniform for players, they were still a luxuriant white? This court had been readied and the balls had been brought for a social match later in the day. At about four in the afternoon, three men and one woman play doubles. The way one of the men plays, his movements and his bearing and even his grimaces, establishes his character.

Yet again, Nabokov reveals his deep understanding of the components of a good serve: the lowering of the racquet down one's back before stroking upward, the precise positioning of the toss, the connecting with the ball at the correct angle:

> Judging by the Colonel's blunt, stiff strokes, by the tense expression on his fleshy face that looked as if it had just spat out the massive gray mustache towering above his lip; by the fact that, in spite of the heat, he did not unbutton his shirt collar; and by the way he served, legs firmly planted apart like two white pokes, one might conclude, firstly, that he had never been a good player, and, secondly, that he was a staid, old-fashioned, stubborn man, subject to occasional outbursts of seething anger. In fact, having hit his ball into the rhododendrons, he would exhale a terse oath through his teeth, or goggle his fishlike eyes at his racquet as if he could not forgive it for such a humiliating miss.[140]

Nabokov uses body language to summon telling details. Depicting it with imaginative verbs and adjectives, he evokes the human comedy. The planted legs of the server are brilliant. Good servers begin with their legs apart, at a right angle to the service line. As they serve, they step forward gracefully with the leg that was behind and raise the heel of the other foot, pivoting on their toes. The leg that moves toward the service line belongs to the same side of the body as the arm that serves. The Colonel's "two white pokes" epitomize poor style and a physical recalcitrance, and give him the personality of a stick-in-the-mud.

The Colonel's partner, Simpson—"a skinny blond youth . . . trying to play as best he could"—is a friend of the Colonel's son, Frank. His playing is abysmal. His form suggests a weakness of character and an inability to concentrate. He misses every shot, generally hitting them not just out but off the court entirely. He violates the privilege of using a tennis racquet, about which Nabokov writes a brief ode, conjuring it as a beautifully effective tool before describing the travesty that occurs when it is misused. "Instead of an instrument of play, meticulously and ingeniously assembled out of resonant, amber catgut on a superbly calculated frame," the racquet, in our weak player's hands, has the impact

of "a clumsy dry log from which the ball would rebound with a painful crack." The opposition to this unfortunate pair consists of a young woman named Maureen, whose husband, a Mr. McGore, owns the court, and the Colonel's son, "the lightfooted, nimble Frank." They defeat "their perspiring opponents," soundly.

It is with their match that Nabokov sets up the story. With only a few hits and misses on the court, he establishes the personality traits of the central characters. To be good at tennis, however, does not assure one of a fine character. Nabokov's depiction of the winning pair is blistering. Seeing how they play tennis, we feel them as being competent enough at sports but too blithely contented with themselves, smug in their assumption of their innate superiority. "Just as handwriting can often fool a fortune-teller by its superficial simplicity, the game of this white-clad couple in truth revealed nothing more than that Maureen played weak, soft, listless, female tennis, while Frank tried not to whack the ball too hard, recalling that he was not in a university tournament but in his father's park." This is not a case of good manners; instead it shows a certain artifice that makes Frank untrustworthy. Frank is a gifted athlete and a good-looking guy, but he is one of those people whose natural gifts annoy us:

> He moved effortlessly toward the ball, and the long stroke gave a sense of physical fulfillment; every motion tends to describe a full circle, and even though, at its midpoint, it is transformed into the ball's linear flight, its invisible continuation is nevertheless instantaneously perceived by the hand and runs up the muscles all the way to the shoulder, and it is precisely this prolonged internal scintilla that makes the stroke fulfilling. With a phlegmatic smile on his clean-shaven, suntanned face, his bared flawless teeth flashing, Frank would rise on his toes and, without visible effort, swing his naked forearm. That ample arc contains an electric kind of force and the ball would rebound with a particularly taut and accurate ring from his racquet's strings.[141]

What a contrast between son and father: the younger one up on his toes while the older one stands with feet of lead, the son making his sterling

form seem effortless while the father is puffing with the strain of what he is trying but failing to do. And that is precisely what the dynamics will be between the two of them in the rest of the story, which has nothing to do with tennis.

Frank is, with his "phlegmatic smile" and effortless way, set up to be the victor in the subsequent battle concerning the true qualities of a painting—called *La Veneziana*—that is the crux of the story. "Frank and Maureen, having won five straight games, were about to win the sixth. Frank, who was serving, tossed the ball high with his left hand, leaned far back as if he were about to fall over, then immediately lunged forward with a broad arching motion, his glossy racquet giving a glancing blow to the ball, which shot across the net and bounced like white lightning past Simpson, who gave it a helpless sidewise look."[142]

Thus Nabokov, with a description of a serve that could only have been written by a tennis player who knows his stuff—the requirement of getting the racquet far down one's back before raising it in the upward stroke with which, at its apogee, it will strike the ball, which has been tossed impeccably into the invisible target high above—demonstrates Frank's extreme competence as well as his forcefulness of character.

As is often true in literature and in real life, tennis is a source of sexual allure. Simpson's mortification at his weak strokes is intensified because of "the extraordinary attraction he felt for Maureen." She is patently seductive with her "sidelong smile as she adjusted the strap on her bared shoulder." Tennis is also a vessel for competitiveness and proving one's superiority well beyond its own confines. The Colonel's response to his defeat is the epitome of fatherly braggadocio: "'We must have a game of singles,' remarked the Colonel, slapping his son on the back with gusto as the latter, baring his teeth, pulled on his white, crimson-striped club blazer with a violet emblem on one side." Even Somerset Maugham is not so sardonic in his depictions of the sporting set, of entitled upper-class types; Nabokov is the master of using gestures and appearance to paint his characters.

That is the last we will see of tennis in "La Veneziana," but all the personalities and relationships central to the rest of the story are captured in that opening scene on and around the court. And Nabokov has revealed his own taste—it would not be unfair to call it an obsession—

for a very particular style of tennis strokes. He likes the body to be stretched to the fullest and the swing to be long and circular, a sweeping arc. We will hear about sweeping, fully rounded groundstrokes and serves periodically through Nabokov's writing life.

◆

Nabokov was teaching tennis at a private club in Berlin at about the same time when he wrote "La Veneziana." Years later, after he moved to America, he told the philosopher Alfred Appel—author of the brilliant *The Art of Celebration* and *The Annotated Lolita*—that during that period when he was teaching he would on occasion want to play at the club where he taught but was not allowed onto the courts because he was not a member. He would sneak on to play, after watching from the woods nearby to find an opportune moment. His wife, Vera Nabokov, would say this was untrue, that it was an attempt of Nabokov's to portray himself as a sort of ruffian he was not. What is certain is that he wanted it known that his passion for tennis was fundamental to his identity.

Between 1930 and '32, Nabokov wrote a coming-of-age novel, its fictional hero clearly a sort of self-portrait. Called *Glory*, it was published in Paris and would be translated into English in 1971 by his son Dmitri. Nabokov named his autobiographical hero Martin Edelweiss. The setting of much of the book is a Swiss mountain resort where the edelweiss flourishes, and Martin is robust and healthy as befits his family name. We encounter Martin at an optimal moment in the life of a young man: "In the course of that summer Martin grew still sturdier, his shoulders broadened, and his voice acquired an even, deep tone."[143] His prowess at tennis only adds to the impact that this attractive young man has on girls:

> Bare-armed young ladies in white frocks, yelling and chasing off the horseflies with their rackets, would appear by the tennis court in front of the hotel, but, as soon as they started playing, how clumsy and helpless they became, particularly since Martin himself was an excellent player, beating to shreds any young Argentine from the hotel: at an early age he had assimilated the concord essential for the enjoyment of all the properties of the sphere, a coordination of

all the elements participating in the stroke dealt to the white ball, so that the momentum begun with an arching swing still continues after the loud twang of taut strings, passing as it does through the muscles of the arm all the way to the shoulder, as if closing the smooth circle out of which, just as smoothly, the next one is born.[144]

In that long Nabokovian sentence you feel the movement of a tennis stroke as executed with the writer's preferred form. But for all his excellence, and his ability to beat young Argentines, Martin, who is somewhat full of himself, gets his comeuppance. A professional from Nice turns up and challenges him. Spectators crowd around as Martin alternates between driving the ball the full length of the court and putting it away with volleys at net. He thinks himself to be heading toward victory:

His face was aflame, and he felt a maddening thirst. Serving, crashing down on the ball, and transforming at once the incline of his body into a dash netward, Martin was about to win the set. But the professional, a lanky coolheaded youth with glasses, whose game until then had resembled a lazy stroll, suddenly came awake and with five lightning shots evened the score. Martin began to feel weary and worried. He had the sun in his eyes. His shirt kept coming out from under his belt. If his opponent took this point that was the end of it. Kitson hit a lob from an uncomfortable corner position, and Martin, retreating in a kind of cakewalk, got ready to smash the ball. As he brought down his racket he had a fleeting vision of defeat and the malicious rejoicing of his habitual partners. Alas, the ball plumped limply into the net. "Bad luck," said Kitson jauntily, and Martin grinned back, heroically controlling his disappointment.[145]

This is about as good as sports writing can get. You feel the emotions while you see the action; you enjoy the word *netward*, so apt and logical that it is difficult to believe it did not exist before Nabokov coined it. Although in all probability you develop a dislike for Kitson—to begin with, his name works against him—even if he demonstrates no out-and-out deceitfulness, you have to face the truth that it is Martin's excessive self-confidence that costs him the match.

Any tennis player can identify with what happens next for Martin: "On the way home he mentally replayed every shot, transforming defeat into victory, and then shaking his head: how very, very hard it was to capture happiness!"[146] Tennis was that important to Nabokov; nothing less than happiness itself depends on victory on the court.

Martin never again plays tennis in the book, but there are lengthy scenes with him playing soccer and boxing. And Martin observes a tennis match where he displays his real knowledge of the sport. The character Gruzinov, watching "a rather lively game . . . between two young men," mocks the players—"Look at them—skipping like two goats," only to insist that a powerful blacksmith he knew "could belt a ball over the belfry or beyond the river—just like that. If we had him here, he would beat these lads hollow."[147]

Martin knows better. "Tennis is different," he counters. Gruzinov continues to hold out for the winning strength of the blacksmith, while Martin insists, quietly, on form, commending the "rather classy drive" of one of the players they are watching. The remark is seen to characterize Martin in general. "'You're a funny one,' said Gruzinov, and patted him on the shoulder."[148] Nabokov's stand-in, with a preference for style over brute force in tennis strokes, is not an ordinary type.

IN 1955, Nabokov wrote *Lolita*. When the obsessional character in whose voice the story is told—Humbert Humbert—first enters the rooming house where he will encounter the nymphet who will obsess him to distraction, he is appalled by the tackiness of his new digs and its tasteless contents. Confronted with the "Mexican trash in a corner cabinet" and the rest of Lolita's mother's clutter, he needs to steady himself, "to stare at something." The single reassuring object on which he can focus is "an old gray tennis ball that lay on an oak chest." The fuzzy sphere—in the 1950s, when this scene takes place, it would have been felt-covered rubber, white before it grayed—was the one thing in the house that was familiar to him and provided atavistic memories. Humbert, born in Paris to an English mother and a father of Swiss, French, and Austrian blood, had, as a boy, played tennis on the French Riviera, where his

father ran a fancy resort hotel, and attended an English day school. Back then, the ball would have had a nucleus of cork and been wrapped in wool, but still, the size and shape of the tennis ball in Lolita's mother's house was a comfort.

Further along in the book, once he and the teenage Lolita are lovers, Humbert, "a good player" in his prime, decides to teach her "to play tennis so that we might have more amusements in common." But he considers himself a "hopeless" teacher and so pays for "very expensive lessons with a famous coach, a husky, wrinkled old-timer, with a harem of ballboys." That "awful wreck" of a formerly great tennis player goes nameless, but Nabokov brings in another of his erudite tennis references in naming a player vanquished by him. Lolita's costly pro demonstrates how good his forehand once was. "He would put out as if it were an exquisite spring blossom of a stroke and twang the ball back to his pupil, that divine delicacy of absolute power made me recall that, thirty years before, I had seen *him* in Cannes demolish the great Gobbert!"[149] André Gobert is real, a splendid dose of actual history in a masterpiece of fiction. A Parisian, Gobert won the French Championships in 1911 and 1920 and several Olympic medals. Photographed in 1919, when he was the victor at the International Lawn Tennis Federation's World Covered Court Championships, he wears a boldly striped jacket and long white trousers, holds three wooden racquets, and faces the camera with a broad, toothy smile. His presence in *Lolita* is a great touch, linking the world of Nabokov's youth with the very American settings of the novel in a behind-the-scenes way, as it is unlikely that most readers would have any idea who Gobert was.

As Humbert travels around with Lolita, we see her play tennis in California, southern Arizona, and, ultimately, in a typical Nabokovian invention: a "Colorado resort between Snow and Elphinstone." This time the tennis scene is told as a memory, after Humbert's illicit girlfriend has freed herself from him forever. The images of the beguiling teenager playing tennis on the court the last time he saw her epitomizes Humbert's obsessions, both with Lolita and with tennis as a transformative, almost sacred series of acts, and with the tennis racquet as an object of magical power.

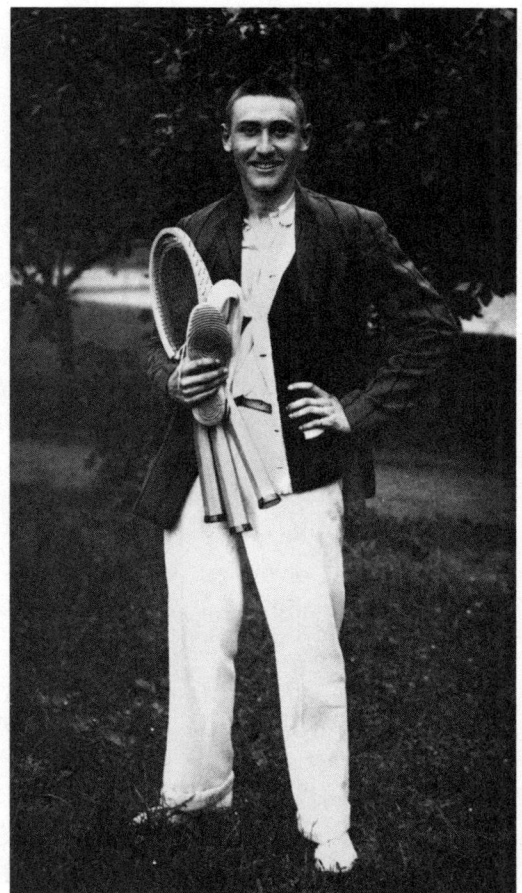

André Gobert, 1919.

She was more of a nymphet than ever, with her apricot-colored limbs, in her sub-teen tennis togs! . . . the white wide little-boy shorts, the slender waist, the apricot midriff, the white breast-kerchief whose ribbons went up and encircled her neck to end behind in a dangling knot leaving bare her gaspingly young and adorable apricot shoulder blades. . . . Her racket had cost me a small fortune!

But Lolita is more than an apricot-colored love object for him. She is someone who plays tennis in a manner that reveals her essential character.

> She would wait and relax for a bar or two of white-lined time before going into the act of serving, and often bounced the ball once or twice, or pawed the ground a little, always at ease, always rather vague about the score, always cheerful as she seldom was in the dark life she led at home. Her tennis was the highest point to which I can imagine a young creature bringing the art of make-believe...
>
> The exquisite clarity of her movements had its auditory counterpart in the pure ringing sound of her every stroke. The ball when it entered her aura of control became somehow whiter, its resilience somehow richer, and the instrument of precision she used upon it seemed inordinately prehensile and deliberate at the moment of clinging contact. Her form was, indeed, an absolutely perfect imitation of absolutely top-notch tennis...

Yet again, Nabokov reveals his deep understanding of the components of a good serve: the lowering of the racquet down one's back before stroking upward, the precise positioning of the toss, the connecting with the ball at the correct angle.

> My Lolita had a way of raising her bent left knee at the simple and springy start of the service cycles when there would develop and hang in the sun for a second a vital web of balance between toed foot, pristine armpit, burnished arm and far back-flung racket, as she smiled up with gleaming teeth at the small globe suspended so high in the zenith of the powerful and graceful cosmos she had created for the express purpose of falling upon it with a clean resounding crack of her golden whip.[150]

His young goddess has a serve that befits her rank. "It had, that serve of hers, beauty, directness, youth, a classical beauty of trajectory." We see its "spanking pace" and "its long elegant hop." He depicts her smash as the perfect echo of the serve without the necessity of a toss: "Her overhead volley was related to her service as the envoy is to the ballade, for she had been trained... to patter up at once to the net on her nimble, vivid, white-shod feet." Her groundstrokes are equally flawless and forceful: "There was nothing to choose between her forehand and

backhand drives; they were merely images of one another."

Of course, no backhand should really be the mirror image of a forehand—the grip should change; often the player's weaker hand should hold the throat of the racquet; the backswings are different even if the follow-throughs align—but what counts is that Lolita is patently so good at both that it is hard to know to which stroke to hit the ball to win the point. She is flawless at the two of them, as she is at the volley; the costly tennis pro in California had taught her a "short half volley" that was "one of the pearls" of her game. We picture the racquet being correctly angled upward at the moment of contact and the chopping stroke of between twelve and eighteen inches that is requisite if such a volley is to succeed in clearing the net and falling in the forecourt so that the opponent is unlikely to be able to get to it in time.

And Lolita runs like a gazelle. "She covers the one thousand and fifty-three square feet of her half of the court with wonderful ease, once she had entered into the rhythm of a rally and as long as she could direct the rhythm."[151]

That is, in fact, the accurate figure for the precise square footage of half a tennis court. The novel *Lolita* is, after all, like a game of tennis: a mixture of truths and flights of fancy.

13

TENNIS CHIC: JEAN PATOU

WHEN BILL Tilden remarked snarkily of Suzanne Lenglen, "Her costume struck me as a cross between a prima donna's and that of a street walker," he presumably had not seen her playing at Wimbledon in 1921. Because even if she had on one of her extravagant turbans, the rest of her outfit exemplified simplicity, dignity, and class. Her diaphanous tennis dress was designed by Jean Patou. And there could have been no greater mark of real stylishness and taste. Even though the Lenglen character in the ballet *Le Train Bleu* was clad in Chanel, the clothes by Patou that she wore on the court were better still. The knee-length pleated skirt and fitted sleeveless cardigan, of course in white, created a look that was called "la garçonne," and the mix of boyishness and femininity was beguiling. The understatement and cleanliness gave her a compelling elegance.

In 1919, following World War I, Patou opened a fashion house that had quickly became the favorite of many of the chicest women in the world. He made embroidered and beaded silk evening gowns for the doyennes of high society in France. His range of clothes went from Greek- and Roman-style white dresses to spectacular coats whose rich Persian textiles were bordered by copious fur collars, cuffs, and hems. He created a "Yacht Club" coat and made a hit with his "Fleurs du Mal" coat of caramel silk velvet with its back embroidered with flowers. When he wasn't austere as he was in his sportswear, he favored extravagance: Sequined

and embroidered chiffon over satin was a norm, as were dresses adorned with garlands of rose blossoms. There were few combinations he did not envision and then execute with the highest level of tailoring. He created velvet hats; he used silver lamé and paste beads.

Before he made clothing for tennis, Patou designed becoming golf clothing with sailor-style tops and pleated skirts; whether the women were blasting their drivers and three-irons or concentrating on their putting, what they wore showcased Patou's flair for dressing women in movement. When Suzanne Lenglen, already a client for some of her ordinary daywear, approached him about outfitting her for tennis, he took on the challenge with zeal. Lenglen had been drawn to the fashion and elegance of Patou's clothing—as well as the refinement and verve of the man himself—almost since Patou's beginnings. Both she and Patou wanted tennis clothes to be more suited to the sport than any had ever been.

It would be necessary to facilitate greater agility than the older styles of tennis clothing allowed. The wearer had to be able to rush net at full speed without having her short skirt get hiked up and reveal too much thigh, and to contort her body as she stretched upward for a slam without the material developing unsightly wrinkles. The idea that Patou and Lenglen nurtured together, of a dress just for tennis, was a challenge, but in the end it inspired the designer to make a sublime outfit. Wearing it, Lenglen was sure to be noticed even more than usual, and that was saying something.

Patou and Lenglen were already recognized as originals. For one thing, they took extravagance to new heights. One of Patou's formulations, Joy, was the single most expensive perfume on the market in the 1920s. It came in spectacular bottles; Patou liked everything to be the best of the best. He had an agreement with Cartier for a lipstick in a silver case that could be engraved with the client's initials. Like the most innovative architects of the era, he made designs that served their functions impeccably, but his also took the notion of luxury to a new extreme. How appropriate that the maker of Joy and his lavish dresses would be the couturier for the player who showed up at matches in limousines before sauntering over to the court in an ermine coat. Lenglen already sported diamonds on her banderol headscarves. Patou was also a maverick who knew how to make a splash; why not be clad by him

when she blew kisses to the crowd? Lenglen knew that the innovative designer had dispensed with the corset in a lot of his clothing. His style invited the sense of freedom she exhibited in her sweeping strokes and brazen shouting out. Patou was her man.

This was not the first time that Lenglen had people turn their heads at the sight of her. Even before she chose to work with Patou, the person often referred to as "a tennis diva" was in the habit of drawing attention to herself with her clothing. In 1919, when she had just turned twenty and there was a sense of liberation in London now that the world war had ended, she appeared at Wimbledon—it was her first time there—"in a low-cut dress and rolled-down stockings: an outfit the London press deemed 'indecent.'"[152]

Patou was as worldly as his clothes.

In 1921, when Patou outfitted Lenglen for Wimbledon, he shortened the usual length of the tennis dress so that its skirt stopped above the knees. Lenglen wore white stockings to maintain decorum; nonetheless, the exposure of just that little bit of upper leg shocked much of the staid British audience. But everything reduced encumbrances. The sleeveless dress and cardigan made it that much easier for Lenglen to move her arms. And the turban was aerodynamic: It kept her hair out of her eyes, lacked the awkwardness of a hat, and even served as a sweatband.

Lenglen also wore custom-made tennis shoes, made of white doeskin. The crêpe rubber soles helped her game. Everything about her was original: the lack of a corset and petticoats, the habit of sipping brandy between sets. She was a revolutionary, and so was Jean Patou.

Patou's use of pleats for one of Lenglen's tennis skirts would have far-reaching effects. Its accordion arrangement, which allowed for the sweep of her movements on court, had an impact on architecture. When, in 2024, a roof structure was added to the Court Suzanne Lenglen on the grounds of Roland Garros, home to the French National Open on the outskirts of Paris, alongside the Bois de Boulogne, its design was considered a reference to those very pleats. The newspaper *Le Monde* reported: "The pliability of the canvas, the elegance of its pleats, luminous lucence . . . The only thing more enchanting than witnessing it folding shut is when it retracts, and the blue sky reappears."

FOR THE great match between Suzanne Lenglen and Helen Wills in Cannes in February 1926, Jean Patou designed the clothing for both women.

By then, Lenglen was a devoted client. Not only had she worn Patou's fetching dress at Wimbledon in 1921; in 1925 she had bought a blue fox coat and a lamé cape from his fashion house. Wills, however, was new to Patou's client roster.

To dress these two different-looking women in the same style was like pairing High Baroque with the most refined classicism. With her

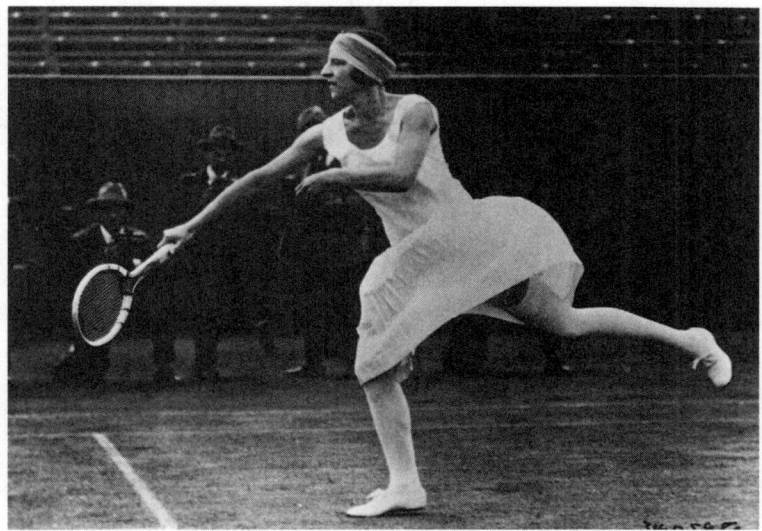

The hint of garter was a brilliant touch.

elaborate backswings and follow-throughs and her over-the-top comportment, Lenglen was all about flourishes. Wills, with her succinct strokes and impeccable conduct, evoked order and refinement. Putting Lenglen and Wills in almost identical outfits added to the theater of the occasion, one that was touted as the match of the century even before they walked onto the court. At the height of the season, with the chic set in attendance, Lenglen and Wills were considered the two most formidable women players in the world of tennis. The audience felt as if they were at the premiere of a masterpiece, and the nearly matching costumes enhanced the drama.

The uniform consisted of a white dress worn with a long cardigan that buttoned only toward the bottom. The cardigan had large pockets, long lapels, and a short collar.

By then, in an interview in *Tennis et Golf* magazine, Lenglen was quoted:

> What has not been said about my "chic"? I'm probably complimented more about my outfits than about my game; it's almost annoying! What's for sure is that Patou's success is no less than my own.[153]

One wonders about the "almost," but Lenglen had no reason to be surprised if people gave attention to her headgear—which was the main difference between Lenglen's and Wills's outfits in Cannes. Wills wore her trademark visor. Lenglen, however, had her hair wrapped in a turban. Patou made many for her. He made a public declaration about them:

> The turban of Mlle Lenglen is known all over the world, it is one of the effects which distinguished Suzanne from all other players of the courts. Yet few people can really say how her turban is made. In fact it is really a long silk band which is carefully woven around her head. I have made all of Mlle Lenglen's turbans, so I know how they are worn. They are always of 'crêpe georgette' and are of one color, of a delicate tint such as Nile green, canary yellow, sky blue, pale rose or any pastel shade. The turban is of a color slightly lighter than the sweater which she wears over her white silk court dress. A scarf of the same material and color generally always completed the ensemble.[154]

When we consider the colors of tennis clothes in the twenty-first century, the subtlety of those pastel shades bespeaks a very different sense of style. It was another sport back then—with wooden racquets and white tennis balls, and white the requisite color of what the players wore on the court. No one talked of product endorsements; no one shrieked when hitting the ball. What we now think of as an old-fashioned sense of elegance reigned.

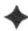

HELEN WILLS became a regular Jean Patou client off the court as well as on it. When she married the San Francisco stockbroker Frederick Moody, in 1929, she left her wedding in a dark blue wool day dress with white piqué trim, its skirt broadly pleated only in front, its top part a fascinating play on a jacket with lapels that is in fact part of the dress.

The style was lovely, but little engaged Jean Patou and brought out his genius as much as his sportswear. On the ground floor of his large fashion house in Paris, he had a space dedicated to it called "Le Coin

des Sports." Patou believed, "La silhouette sportive, c'est le chic absolu." The need for clothing to suit the movements of tennis was an inspiration for the great couturier. Its function as athletic wear determined his aesthetic; in 1928, he wrote a magazine article declaring that there was "nothing more ridiculous than a tennis dress with a lot of unnecessary trimmings."[155] As Ariele Elia, a fashion historian, has pointed out, "He carefully studied sports and built construction details into his garments designed to aid the athlete in her performance."[156] Tennis and modernism went hand in hand. In a good forehand as in the clothing worn for hitting it, the aesthetics of the International Style of architecture prevailed. Not only did form follow function, but it also did so beautifully.

That had certainly not always been the case with the clothes. But the excellence of the two intrepid and beguiling women competing in Cannes in one of the most celebrated tennis matches of all time and their relationship to the brilliant Jean Patou are examples of greatness inspiring greatness.

Lenglen in the December 1926 issue of Vogue made
tennis exceptionally elegant.

14

ALTHEA GIBSON

Carl Van Vechten's wonderful portrait conveys
Althea Gibson's confidence but also her youth.

IN 1959, one year after she had been ranked the world's No. 1 female tennis player, Althea Gibson played opposite John Wayne and William Holden in the movie *The Horse Soldiers*, directed by John Ford. Three years earlier, she had won the French Open, and in 1957 she had glided her way to the top with victories at Wimbledon, and

the US Championships. Yet her billing hardly showed up in any of the movie's publicity, even though she had a major role. Is it because she was considered a sportsperson more than an actress that, even though she was on screen longer than any other woman except Constance Tower, her name in the credits is the twenty-third? Was the reason the five-foot, eleven-inch thirty-two-year-old who played a slave in Ford's film was not given star treatment because great tennis players are not always great actors? Even if she had done what Suzanne Lenglen and Helen Wills had wanted to do but failed to do by making it onto the silver screen, was she accorded such bad treatment because she was not very good in front of a camera? Or was it because of the color of her skin?

When she won at Roland Garros, Gibson had been the first Black person, male or female, ever to win a tennis title in one of the four major championships that constituted the Grand Slam. Six years earlier, in 1950, she had, at age twenty-three, broken the color barrier of the American Lawn Tennis League by playing at the exclusive West Side Tennis Club in Forest Hills in the US National Tennis Championship. In 1951, she had been the first Black person to play at Wimbledon. None of it had come easily. She took the Wimbledon title six years later; after she was congratulated by Queen Elizabeth, she said, "Shaking hands with the Queen of England was a long way from being forced to sit in the colored section of the bus going into downtown Wilmington, North Carolina."

Gibson was born to sharecroppers who worked on a cotton farm in rural South Carolina. The Great Depression had an immediate impact on farmers, and in 1930 her parents moved to Harlem. The Police Athletic League operated a play area near the family's apartment on 143rd Street between Lenox and Seventh Avenues: Gibson, a natural athlete, participated in lots of sports there, and by age twelve she was the women's paddle tennis champion for all of New York City. Her father taught her boxing, which impacted both her athleticism and her attitude toward competition. Seeing how quick and agile she was, her neighbors made a collection for her to have tennis lessons, but she initially considered tennis a sport for weak people. She would later say that combat came so naturally to her that she would "fight the other player every time I started

to lose a match." When the kid who often engaged in "street fighting"—her description of it—played tennis, she played to win.

Soon, Gibson began not just to enter tournaments but also to end up the champion. She was discovered by Walter Johnson, a physician in Lynchburg, Virginia, who took young African American tennis players under his wing—Johnson would eventually mentor Arthur Ashe as he did Gibson—and he helped her to gain entry into tournaments that did not normally have Black competitors. She moved back to the South, to Wilmington, North Carolina, and her tennis was of such sterling quality that she got a full athletic scholarship to Florida A&M University.

But then she had her struggles to get into the US Championships at the West Side Tennis Club, in Forest Hills. An oasis of verdure and space in New York's borough of Queens, Forest Hills seemed like an English village in the middle of the metropolis, and the tennis club, with its half-timbered Tudor-style clubhouse and thirty-five tennis courts, was a bastion of America's white Protestant establishment. A large piece of real estate a short trip from midtown Manhattan, it represented great wealth; beyond that, its membership maintained a conspicuous exclusivity. The

In this Van Vechten portrait, Gibson is very much the performer—as she loved to be, off the court as well as on it.

founders and subsequent inner sanctum of the West Side Tennis Club had ideas on how to keep it the way they wanted. Like private schools, dancing classes, country clubs, and universities all over America's so-called integrated Northeast in the 1950s, there were unwritten rules concerning the eligibility of Blacks and Jews. Forest Hills Gardens was home to a number of Jewish refugees from Nazi Germany, but neither they nor Black people nor Asians were allowed onto its tennis courts.

That is why it had required Alice Marble to do battle on Gibson's behalf to be allowed to compete. Although the United States Lawn Tennis Association could not legally exclude Blacks from its tournaments, wherever they were housed, they had made it impossible for Gibson to qualify for the Open by requiring her to win a certain number of points preliminarily that could be earned only in matches at private clubs where Blacks were indeed barred. Marble, immensely respected, had written a public letter in the magazine *American Lawn Tennis* shaming the members of the USLTA to such an extent that they relinquished their power to keep Althea Gibson out of the tournament.

Gibson's getting onto the courts at the West Side Tennis Club, first to play in the US Open in 1950 and then to win it in 1957, had been a breakthrough, but even her tournament victory would not have secured her membership in the club. In 1959, Ralph Bunche Jr., the fifteen-year-old son of Dr. Ralph Bunche—one of the most distinguished Black people in America, a Nobel Prize winner and United Nations Under-Secretary-General for Special Political Affairs—was denied membership. Bunche Jr. was taking lessons with George Agutter, a seventy-two-year-old pro who had been teaching at Forest Hills for forty-five years, and Agutter had urged him to apply for junior membership. Agutter had not realized that his pupil was a light-skinned Negro. After the error was recognized and Bunche Jr. was told it was out of the question, the elder Bunche telephoned the club president, Wildred Burglund, who said Forest Hills did not have Negroes or Jews as members. Burglund admitted to Bunche that Althea Gibson had twice won the woman's singles title there, but that was only because the tournament was under the auspices of the US Lawn Tennis Association. The USLTA could do as it wanted, but the West Side Tennis Club could still deny Gibson membership.

According to a newspaper account, "if the club admitted Negroes ... hundreds of its members would instantly resign."[157]

Bunche went public about the matter, which was rare for him.

> Neither I nor my son regard it as a hardship or humiliation. It is not, of course, in the category of ... segregation ... suffered by ... Negroes in the North as well as the South. But it flows from the same well of racial and religious bigotry. Rather, it is a discredit to the club itself.

Five US senators and New York's deputy mayor all publicly protested the heinous policy. The response from the leadership of the club was silence. The Supreme Court had made its landmark school integration decision five years earlier, but because the club had nothing in its written bylaws or constitution prohibiting Blacks and Jews and other unspecified minorities from joining, and the tradition of exclusivity was undocumented, no one had further recourse. The policy stayed in place.

Gibson would subsequently write that even though it was immensely significant for her to be allowed to play at Forest Hills, on the first occasion when she gained entry she was "discriminated against by the tournament committee when they assigned me to Court 14, which is the farthest removed from the clubhouse of all the courts on the club grounds and has the smallest capacity for accommodating spectators."[158] The well-known actor Ginger Rogers, who played mixed doubles in the tournament, was, on the other hand, put on the court directly in front of the clubhouse.

Even at her obscure location, though, Gibson was noticed, to the extent that she had to cope with the annoyance of flashbulbs constantly going off in her face and temporarily blinding her. The press was excited by her breakthrough presence, and her tennis was remarkable. Lean and muscular, she used her long arms gracefully, dazzling people especially with her powerful serve. It would only be a matter of time before she went from being the first African American, male or female, on those courts to making it to the center court and having even more of an impact as the first such winner of the entire tournament.

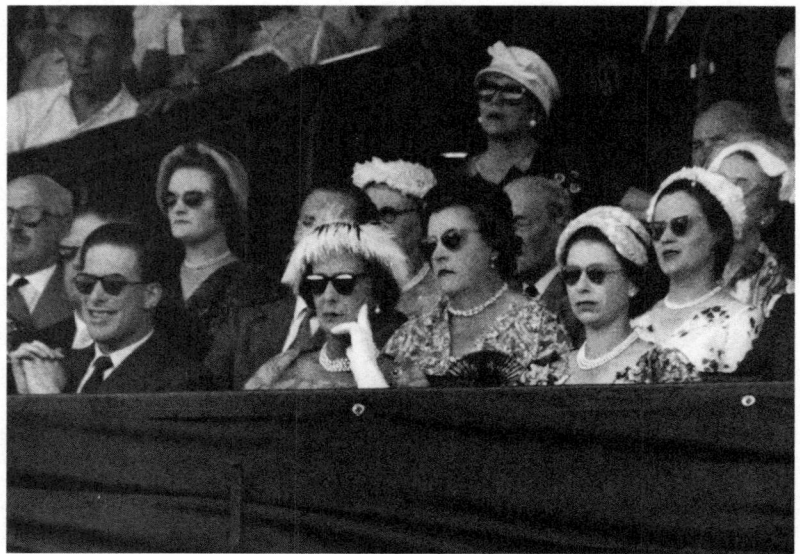

It was an unusually hot day, both for
watching tennis and for playing it.

◆

IN 1957, Althea Gibson was not only the first Black champion at Wimbledon; she was also the first champion to receive the trophy personally from Queen Elizabeth II. She wrote about this in her autobiography, *I Always Wanted to Be Somebody*, which is rare among athlete's memoirs because, although it is not great literature, it is fresh in tone and in its candor. Gibson validates the title when she describes herself getting ready for the match:

> Everyone in the dressing room was talking excitedly about the news that the Queen was going to be there. That made me feel extra good. I would have been terribly disappointed if she hadn't been.[159]

An hour before the match, when she was practicing on a side court, she "saw Queen Elizabeth eating lunch on the clubhouse porch. Instead of making me nervous, it made me feel more eager than ever to get out

there and play." As Gibson changed into a fresh shirt, she was counseled about how to curtsy to the Queen after the match. Then, just after Gibson won the finals with dashing tennis, the tournament officials asked her and the other finalist, Darlene Hard, to walk over to the umpire's chair. Hard, a gracious loser and very much the image of the all-American girl with her blond ponytail and large white hairbow, and Gibson, who towered over her, stood at attention with perfect smiles and waited as workmen unrolled a red carpet from the royal box.

> Queen Elizabeth, followed by three attendants, walked gracefully out on the court. She wore a pretty pink dress, a white hat and white gloves, and she was absolutely immaculate, even in all that heat. One of the officials called me to step forward and accept my award. I walked up to the Queen, made a deep curtsy, and shook the hand she held out to me. "My congratulations," she said, "it must have been terribly hot out there." I said, "Yes, your majesty, but I hope it wasn't as hot in your box. At least I was able to stir up a breeze." The Queen had a wonderful speaking voice and looked exactly as a Queen ought to look, except more beautiful than you would expect any real-life queen to look.[160]

Queen Elizabeth then presented the gold salver to Gibson. Gibson "curtsied again and backed away from her; . . . I remembered the backing away business from the movies."[161] The Queen then retreated, and the red carpet was rolled back up.

At a celebration ball that evening at the Dorchester Hotel, Gibson addressed the Duke of Devonshire, who was master of ceremonies, and said, "In the words of your distinguished Mr. Churchill, this is my finest hour." She thanked "the many good people in England and around the world whose written and spoken expressions of encouragement, faith, and hope I have tried to justify." She said that her win was "a total victory of many nations . . . created through the international language of tennis."[162] Then Gibson started the dancing by going out on the floor with the men's champion Lew Hoad. The two of them circled the ballroom to the song "April Showers," which Gibson had requested, and it was several minutes before others in the awestruck crowd followed them onto the dance floor.

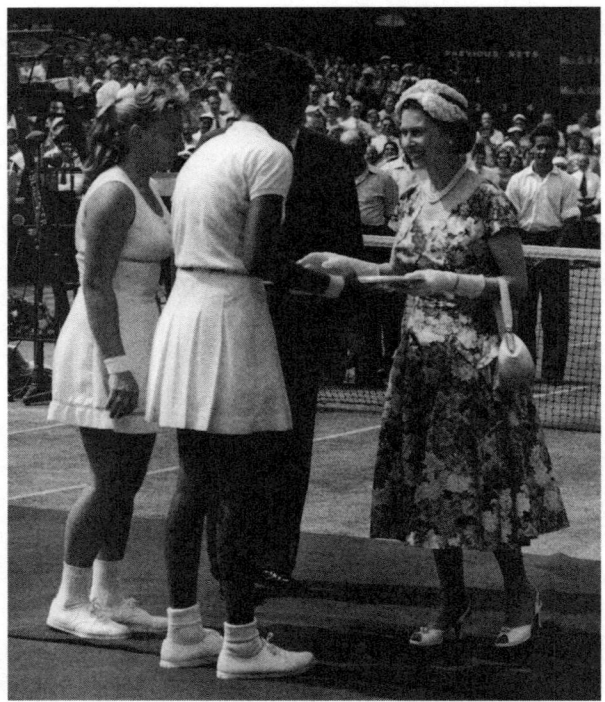

Two regal women: Althea Gibson meets Queen Elizabeth.

After her triumph in London, Gibson went back to the United States. In New York, she was the second African American—Jesse Owens, the track star who won four gold medals in the 1936 Olympics, had been the first—to be honored with a ticker-tape parade. President Dwight Eisenhower wrote to her:

> Recognizing the odds you faced, we have applauded your courage, persistence and application. Certainly it is not easy for anyone to stand in the center court at Wimbledon and, in the glare of world publicity, and under the critical gaze of thousands of spectators, do his or her very best. You met the challenge superbly.[163]

Gibson then won the US Open in the stadium where she had previously been forbidden entry. The following year, she glided her way to

victory yet again in both tournaments. The Associated Press, in both 1957 and 1958, declared her "Female Athlete of the Year."

Still, there was no getting away from prejudice. Playing doubles, Gibson and her partner Angela Buxton, who was Jewish, were turned down on the many occasions when they sought admission to the All England Lawn Tennis Club. And this was after Gibson had been publicly congratulated by the Queen.

◆

ALTHEA GIBSON loved performing, and not just on the tennis court. By her own admission, she "always wanted to be somebody" in more ways than as a sports champion. She was a talented singer and saxophonist; in 1943, she had been runner-up in an amateur contest at Harlem's renowned Apollo Theater. She was determined to make her way in the world of music.

In July 1957, just after she won Wimbledon, Gibson appeared on *The Ed Sullivan Show*. At the time, Sullivan was the best-known television host in the world, and his program was an American institution. Sullivan praised Gibson as "a great young champion who did it the hard way." She used the occasion to speak about tennis as a means for underprivileged children to elevate themselves in the world and referred to the marvel of someone from her humble beginnings having an audience with the Queen of England in front a large cheering public.

But being featured simply because of her tennis victory was not enough for her. In 1958, Gibson appeared periodically on the Sullivan show singing popular songs of the era, usually accompanied by a full orchestra. Her themes were invariably upbeat, as in "I Should Care." As she sang "Maybe I won't find someone as lovely as you, but I should care, I should care, I should care and I do," she inspired a round of applause from the audience. Nonetheless, to some of us, it is what we would call, at best, "a period piece"—a bit melodramatic and atonal. Gibson's performance of "We Have So Much to Live For" was another musical effort at optimism. When heard today, it does not make the grade for everybody, but if it was your sort of thing, there was no beating the earnestness with which Gibson sang the line "Though life is dreary

and blue, you know there's someone who cares for you." Gibson had an evangelical side. She put her heart and soul into it when she urged her audience to high spirits, singing, "So why not be happy, and thank God above, for all that He gave us, and make a world filled with love." The orchestra did not shy away from a style that now seems schmaltzy at best, but apparently it suited Sullivan's audience.

Fortunately, Gibson came more into her own musically when, a year later, on August 23, 1959, she appeared again on *The Ed Sullivan Show* and sang "Jelly Roll Blues" with the Turk Murphy Band. She now demonstrated more of the spirit and lightness with which she played tennis. This was also true when, in the year of her winning three Grand Slam tennis titles, she sang in public at the Waldorf Astoria Hotel at an eighty-fourth-birthday tribute to W. C. Handy, the songwriter who was considered "Father of the Blues."

It was an unusual idea of John Ford's when he put Gibson in *The Horse Soldiers*, and an odd decision on her part to take the role. On the screen, playing the part of a well-dressed slave, she is subservient and docile, the antithesis of the warrior she was in real life. She has mostly one look on her face—of wide-eyed astonishment. A general bloodbath, roaring with testosterone, *The Horse Soldiers* is not a great movie. Since Gibson gets shot dead well before the end, for most of us there is not much worth seeing from then on. But when she was on the screen, Gibson had a certain authenticity, in part because she refused to speak in the dialect that Ford initially expected of her. Ford as a director was known to insist on having the last word, but Gibson prevailed in her insistence that, despite the dictates of the film script, she not sound like a stereotype in a way that diminished Black people.

Regardless of her efforts on the screen and the stage, however, the only form of artistic performance at which Althea Gibson excelled was on the tennis court. For a while, that was enough to keep her flush. Even when she was no longer winning Grand Slam matches, in 1960 she managed to make $100,000 doing exhibition matches before Harlem Globetrotters basketball games.

◆

GIBSON'S NEXT foray was into the world of professional golf. In 1964, she joined the Ladies Professional Golf Association—the first African American to do so—at age thirty-seven. She was able to be a member but was still banned from tournaments not just in the South but also in the North, and often had to dress for matches in her car because she was not allowed in the clubhouse. Still, in 1976, Althea Gibson became Athletic Commissioner of New Jersey—and was the first woman to hold such a post anywhere in the United States. In taking that position, she again broke new ground. She had already demonstrated that an athlete could venture into the arts by singing so that all of America could hear her, appearing in movie theaters throughout the country, and writing a respectable book; now she showed that an athlete could play a role in public life.

Married and divorced twice, Gibson was essentially alone in the world toward the end of her life. After she turned sixty, her health started to decline. In the late 1980s, she had two cerebral hemorrhages, and in 1992 a stroke. Unable to pay her rent or for medical treatment, she asked for help from various tennis organizations, but never received it. Fortunately, Angela Buxton raised more than a million dollars from mutual acquaintances to assure her comfort until 2003, when Gibson died, at age seventy-five.

There is an art to living courageously when the odds are against you, and to using your own hardship to benefit the people who follow you. In 1999, Serena Williams, aged seventeen and already on the way to her first of six victories in the US Open, faxed Gibson questions to which the answers became a rich resource for both Serena and her sister Venus.[164] The Williams sisters felt a strong impact from Gibson's response: "'Play aggressively and with spirit. Since you'll be the underdog, you'll have nothing to lose. But most of all, be who you are and let your racquet do the talking.'" During Black History Month that year, the sisters published a newsletter with her on the cover of it. Serena and Venus Williams's titles at Wimbledon and the US Open were fabulous echoes of the achievement that made Althea Gibson in many ways their mentor.

◆

IN 1968, when Arthur Ashe was the first African American man ever to win a Grand Slam singles title, in the same stadium in Forest Hills where Althea Gibson had changed the course of history, Billy Jean King said it was thanks to this daughter of sharecroppers that it was "so easy for Arthur."[165] Tennis was how Althea Gibson made civilization advance.

15

TENNIS IN THE WORK OF EADWEARD MUYBRIDGE

Even before we know who Eadweard Muybridge was, or why he spelled "Edward" that way, or what exactly we are looking at here, or when it was done, the first question is why and how the photographer—in two rows of images, ten per row—made his subject the sequence of movements that constitute the serve in tennis. The second question is why this male tennis player is stark naked, as if it is the most normal thing in the world to have his genitals and thick pubic hair and the rest of his body in plain view while he swings a racquet.

Muybridge had started his depictions of living creatures in progressive motion with a horse. He wanted to show, exactly, which of the animal's hooved feet are elevated above the ground, the knees of its lithe legs crooked accordingly, in a correct trot and gallop. He was doing

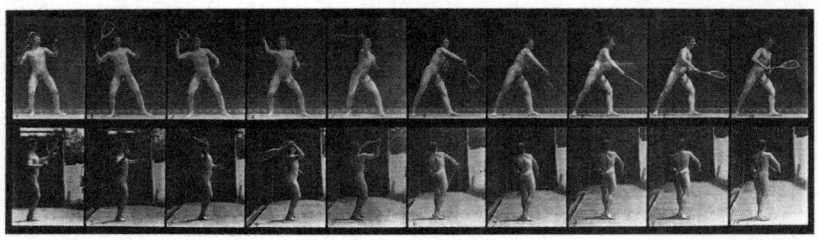

Muybridge's *Animal Locomotion* series effectively dissected the many elements of the serve.

this for a patron of his photography who owned racehorses as well as a collection of paintings of horses. The collector believed that neither the trot nor the gallop was evoked adequately in racetrack scenes, even the wonderful canvases and pastels by George Stubbs and Edgar Degas. Muybridge succeeded with a sequence of images that satisfied his client.

The photographer next chose a tennis player in the process of serving as a further example of coordinated motion. The tennis serve is a fantastic feat. It requires the synchronized action of the player's weaker arm tossing the ball upward to the ideal height and position while his stronger arm, the one that holds the racquet, goes down to the small of his back and then upward. Simultaneously, the player's legs go from being slightly bent at the knee to stretched to their ultimate height. The player must move his arm as if throwing a lance so that the strings and the ball contact the ball that he has tossed as his ammunition. The player then needs to hit at the correct trajectory to send the ball over the net with the area of the service court as his target. Wanting to dissect specific movements and freeze each element for observation, Muybridge could hardly have picked a better theme.

Still, why is he naked and why is Muybridge's female tennis player, of whom he did more series than the man, always dressed as primly as Whistler's mother? And what is she actually doing in coaxing the ball from the ground only to balance it on the racquet face, which she holds parallel to the surface of the court?

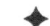

MUYBRIDGE'S LIFE had multiple facets. Like his horses and tennis players, he was always in the process of transformation. Born in England in 1830, he was named Edward James Muggeridge. His name twenty years later was Helios—the name of the Greek god known as the Titan of the sun. By then he had moved himself to San Francisco, then the capital of the Gold Rush in the Wild West. The city boasted forty bookstores and twelve photography studios, and Muggeridge had landed himself a job as a bookseller and decided he needed the new sobriquet for the position. His life and identity changed again a decade later after he decided to go back to London and travel on to Continental Europe. In

June 1860, at the Texas border, the horse pulling his stagecoach went wild, and the runaway vehicle had an accident that killed the driver and a fellow passenger; when Muggeridge woke up nine days later, in a hospital in Fort Smith, Arkansas, he had no memory of the period between a supper he had had in a wayside cabin, just before the accident, and the current moment. He had become deaf, lost his sense of smell, and was generally confused; fifteen years later, he would claim in an interview in the *Sacramento Daily Union* that the accident made his hair go from brown to gray.[166]

His next metamorphosis concerned his name. When he was living in San Francisco, he had become a photographer. As if to be in concord with the click of the camera shutter, Muggeridge had become Muybridge by the time he reached New York and was suing the stagecoach company. Eventually, after one of many trips to England, he replaced that humdrum "Edward" with Eadweard—which was the way the English kings spelled it—although for an exhibition of his work that went to Guatemala, he would be Eduardo Santiago Muybridge. The latter had the same ring as the name he had given to his son—Florado Helios Muybridge—who had been born in April of 1870. The following year, he married Florado's mother, Flora, after she got a divorce from her previous husband. Flora was twenty-one years old to Muybridge's forty-one.

When he was in New York settling his lawsuit, Muybridge applied for patents there and abroad for new devices for plate printing as well as clothes washing. It was the same period when Edward Clark, Isaac Singer, and others were taking out patents for variations of the sewing machine; the idea was to make the processes of daily labor more efficient and give people greater freedom in their everyday lives. Muybridge, meanwhile, was embarking in many directions at once. It has been hypothesized that the injury to his orbitofrontal cortex in the stagecoach debacle extended into the anterior temporal lobes, resulting in a lifelong impact on his behavior; he lost the social inhibitions he had before the accident, and at the same time became even more creative than he had been. During the 1860s, he traveled to Paris at least twice, became a director of a company in Austin, Texas, that owned silver mines, and served as a director of the Ottoman Company and the Bank

of Turkey. By the time he moved back to San Francisco, in 1867, the photographer who, before being thrown from the stagecoach, had been the image of a correct and conservative businessman, was a wild eccentric, forever canceling business arrangements and flying into rages. But he still managed to be successful. He transformed a horse-drawn carriage that only had two wheels into a portable darkroom he called Helios' Flying Studio. He began making stereographs: paired photomechanical prints or photographs positioned to stand side by side and viewed through a stereograph, a device resembling wide binoculars, in order to create a single three-dimensional image.

The stereographs Muybridge made as he took Helios' Flying Studio to Yosemite and then Alaska attracted the attention of Leland Stanford, a wealthy businessman, who commissioned Muybridge to do portraits of both his mansion and his racehorse Occident. Stanford told Muybridge that he was frustrated by the way paintings of horses either galloping or trotting were never accurate in how they depicted the positions of each of the horse's four feet. In 1878, Muybridge used twelve cameras to do a sequential series of photos of a horse in full action. He connected wires to an electromechanical circuit in such a way that when the horse's hooves tripped them, they automatically triggered the shutters of the cameras to which they were attached. Each exposure lasted 2/1000 of a second. The images of the horses in motion were published in magazines and became known worldwide. By 1879, he was making series with twenty-four cameras at once.

Muybridge's professional life zoomed forward; his personal life did the reverse. Shortly after Florado was born, the maternity nurse made sure Muybridge knew the extent of the love affair his wife was having with a family friend, Harry Larkin. The relationship was not new to Muybridge, but its details were. On the back of a picture he had taken of Florado, Flora had written "Harry." The boy's paternity became uncertain. Muybridge went straight to Calistoga, where Larkin worked in a mine. He showed Larkin a letter that Larkin had written to Flora, pulled out a pistol, and shot his wife's lover point blank.

Muybridge went to the Napa jail gleefully. Notably cheerful when incarcerated, he defended certain principles. Muybridge fought the racism directed at a fellow inmate, referred to as "a Chinaman,"[167] saying

the immigrant from Asia needed to be treated the same as everyone else. Meanwhile, Leland Stanford hired a defense attorney for him. Admitting in the courtroom that he had intended to murder his wife's lover, Muybridge mostly gave the impression that he had no idea of what was going on. On the rare occasions when he was more conscious of reality, he became enraged, bursting into incoherent cries and shouts. His lawyer pleaded insanity, and Muybridge was acquitted on the grounds of "justifiable homicide."[168]

By 1887, Muybridge had produced 781 plates of his *Animal Locomotion* series, from more than 100,000 images he had made. Plate 294 had the two rows of ten photos of the naked male tennis player, wiry and fit. The following plate was of a heavy-set woman dressed in the style in which ladies of the era played tennis. She is wearing a tam o'shanter—a Scottish bonnet normally worn by men—and sports a black jacket and a skirt of black and white vertical stripes that resembles a beach towel. After using her racquet to scoop up a ball from the ground—no mean feat, as anyone who has ever tried to do this knows—she remains stooped while balancing the ball on her racquet, which she holds with the face parallel to the ground, at knee height, like a serving tray. She then taps the ball into the air so that she can catch it and hold it ready to bounce as she pulls into her backswing and prepares to hit a forehand. Every tennis player knows that what she is doing is not easy to execute. Even a more athletic person in lightweight, breathable clothing would probably be awkward at it.

The top row shows the woman performing this act in right profile; the second has her facing left; the third has us seeing her from behind. In a way, it is the principle of Cubist painting, which would emerge some thirty years later, where we see the same subject from different vantage points simultaneously.

Next comes a plate with images of the same woman in the same cumbersome outfit, only this time she is wearing a wide-brimmed hat of white straw. Here Muybridge has her preparing to hit an underhand shot. Her form is that of a beginner, and a poor one at that. If she actually managed to make contact with the ball, were it to succeed miraculously in going over the net, it would do so in a high loop, like an underhand softball pitch.

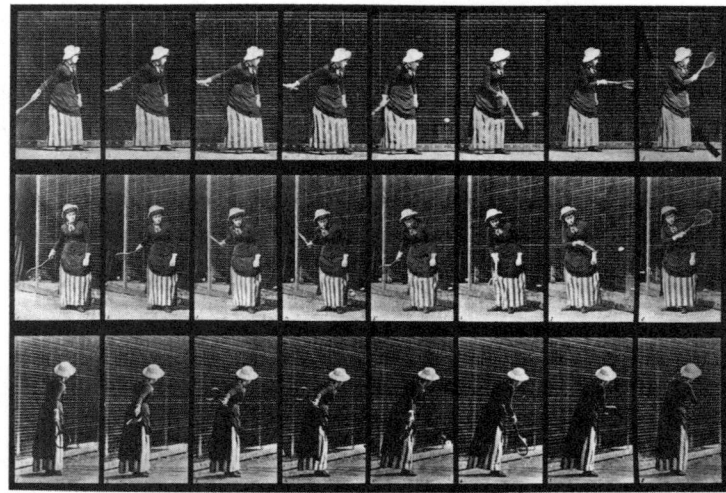

The well-dressed woman in Muybridge's first image of her playing tennis reveals the incremental motion of a well-executed forehand.

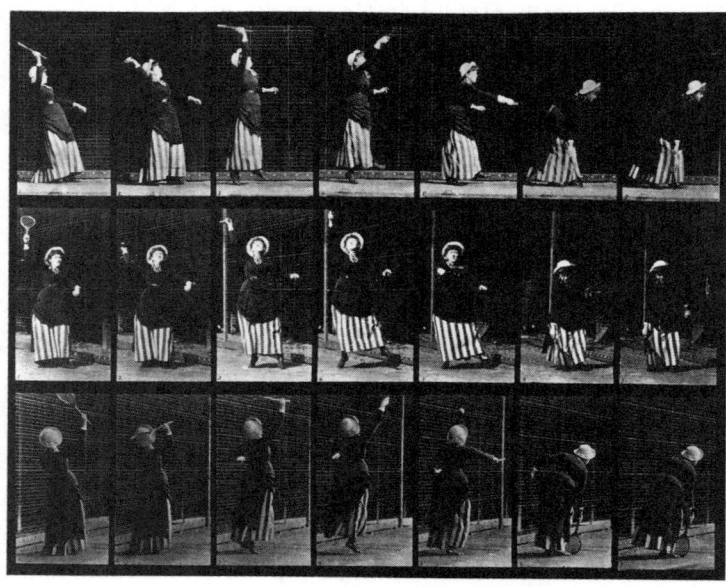

Muybridge's second image of the same woman has her going through the movements of a serve.

In the subsequent series by Muybridge, she is dressed as before, only this time she is serving. As with her groundstroke in the previous images, the woman shows herself to be an awkward beginner at the sport of tennis.

As for Plate 298, the last in Muybridge's tennis series, we have "tennis player as goddess." His graceful subject is in a toga. As in his first plate of a female player, she taps the ball to maneuver it up from the ground. She then balances it on her strings. After that, she appears to do an unusual dance. Why she is going through these motions is inexplicable—which is to say no more comprehensible than Muybridge's ranting when he was on trial for murdering his wife's lover.

Probably the greatest mystery about Muybridge remains his use of nudity. Not only did he show those men playing tennis with their private parts very public, but he also did a series of images of a voluptuous naked woman cavorting with a large dog, and as well as pairs of nude men wrestling or fencing. By putting two men on view at once, the photographer is able to fasten onto them with both a rear view and a front view in a single frame. People did not discuss homoeroticism when these images were made, but the issue has been explored since,

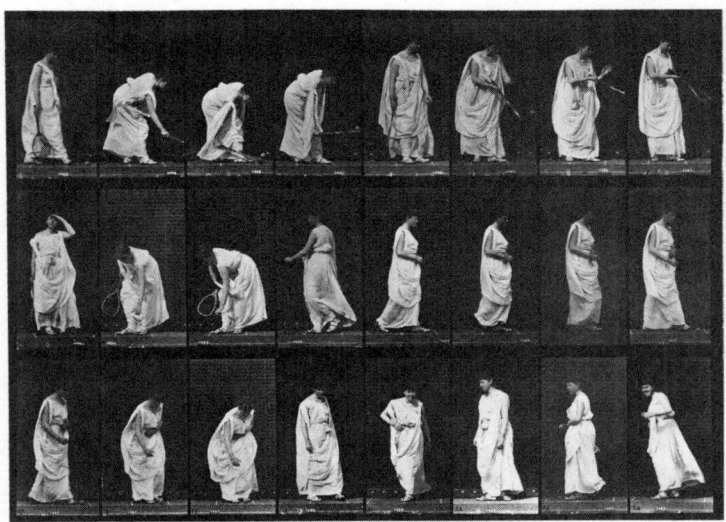

Here, Muybridge's tennis player is dressed as a Roman goddess.

especially in relationship to Muybridge's friendship with the painter Thomas Eakins and to the rumor that Eakins had an affair with one of Muybridge's lean male subjects. Muybridge offered his own explanation: "I strip away the clothes not to see the flesh, but to better see the motion. If I were able, I'd strip away the flesh as well in order to see the muscle, then strip the muscle to see the bone, and I'd even throw away the very skeleton if it could afford me the opportunity to see the unencumbered essence of action."[169] But although he cast it as such, he could not have been unaware of the provocative nature of his subjects. The nudity in the context of athletes stretched to their limits is, whatever the reasons for it, startling.

For all the mysteries, however, a lot is clear about Eadweard Muybridge. He was fascinated by the series of movements that people conduct with tennis racquet in hand. He had prodigious technical skill. He responded viscerally to the pleasure that occurs in different ways when the ball makes contact with the strings. A mixture of rational and irrational, Muybridge used his technical proficiency to create unlikely scenarios. But what is certain is that his rows of images, realized beautifully in a technical sense, evoke the simple miracle of hitting a tennis ball even when the body becomes contorted in the process of doing so. Muybridge's unique series reveal both how the striking of the ball is an art—with a good stroke it is a graceful and balletic act—and how at the same time the sport can inspire unique artistic renderings.

16

BUNNY AUSTIN

The image of well-being.

RENÉ LACOSTE was the first tennis player to wear a polo shirt on the court at Wimbledon; in 1933, Bunny Austin was the first to wear shorts. Those initial exposures of bare forearms and then of naked calves were well received largely because Lacoste and Austin were such stylish gentlemen to begin with.

Besides, Austin's tailor-made shorts fit perfectly. They were subtly pleated, narrow without being tight, and trimmed at Bermuda length. And whatever he wore, Austin was always dressed in subtle, understated style. The navy or white blazers and creamy cable-stitch V-neck tennis sweaters that he sported with those shorts were the finest, cut amply yet fitted impeccably to showcase his fine physique. The aesthetics of tennis—not just in the setting but also in the costume—are part of what makes the sport such an art in and of itself. The grace of the actors, the little refinements like the ritual handshake at the end of a match, are the frosting on the cake. Tennis is theater, the court a well-planned stage, that handshake like the actors' bows after the final curtain has gone down, and when the wardrobe has the panache of Bunny Austin's, and the leading man his charm, we are moved to applause.

Those shorts were pivotal both because of how dapper they looked and for the increased comfort they fostered. Fashion at its best, especially when it has true style and real elegance, is an artform. It is one of the means through which culture advances. Well-designed clothing flatters the body and pleases the viewer at the same time that it demarcates progress. It facilitates physical ease while it pleases the eye. Bunny Austin had the intrinsic good taste as well as the courage to be truly fashionable. He dressed with style, so different from the short-lived trends and the flaunting of brands that are often mistaken for fashionableness. Fashion at its best does not call attention to itself, and Austin had the flair to make his radical breakthrough in men's tennis attire in a way that made the change an instant classic.

Besides, he had the dash and manners that made him irresistible. Famously polite, when Austin had the Queen of Thailand as his doubles partner, he shouted, "Run, your majesty, run." Someone who addressed royalty so correctly knew how to show his bare legs without causing offence.

Austin had mettle about issues large and small; teased because of his nickname, he took it with aplomb. The sobriquet "Bunny" for Henry Wilfred Austin had been given to him by friends at school because of a comic strip—*Pip, Squeak, and Wilfred*—in which Wilfred was a rabbit. "Bunny" suited him; at five feet, nine inches and 132 pounds he was relatively small. Mercifully, he was thick-skinned. When a *New York*

Times correspondent wrote of him in those shorts at Wimbledon, "With his linen hat and his flannel shirt, the little tennis player looked like an A. A. Milne production"—implicitly comparing him to Rabbit in the company of Winnie-the-Pooh, Eeyore, and Christopher Robin—Austin laughed it off gracefully. He was equally amused when he was at Cambridge and the university magazine *The Granta* wrote that he was called "Bunny" due to "his quaint habit of consuming green food"![170]

Austin had little to worry about concerning his image even if his name was based on a little furry creature with four legs. As handsome as he was dapper, he was so dreamy to look at that Suzanne Lenglen insisted on him as her doubles partner. His features could have been drawn with a

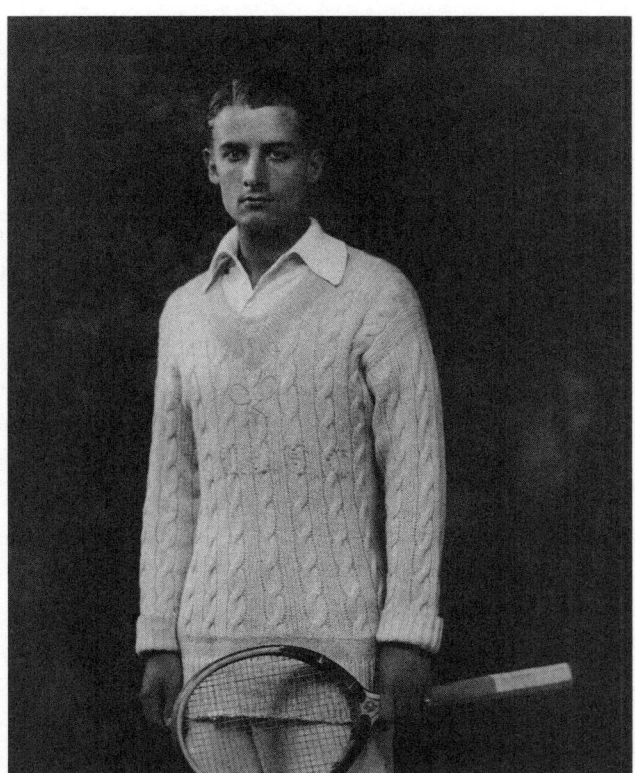

Bunny Austin's oversized sweater with its broad V-neck and subtle crossed tennis racquets embroidered on it would make a fashion statement today.

ruler; his straight nose, thin lips of perfect measure, and classical proportions were arresting to most everyone who encountered him.

Although Austin made it twice to the finals at Wimbledon and once at the French Championships, he never won. But, as his obituary said, "[h]is fluid strokes helped him to a world top 10 ranking for 11 consecutive years, starting in 1928. He was ranked second in the world in 1931 and 1938."[171] He may in effect have been "always a bridesmaid never a bride," but Bunny Austin was one of tennis's greatest charmers of all time. And his sporting of shorts in front of the royal enclosure on the most prestigious tennis court in the world made him a pioneer who changed the costume of tennis forever.

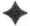

THE FANTASY of liberation from long pants—and, specifically, of wearing shorts at Wimbledon—had begun when Austin and Fred Perry were playing doubles at the Longwood Cricket Club, a haven of twenty-five grass and nine clay courts in Chestnut Hill, a wealthy suburb of Boston. Started as a cricket grounds, Longwood created its first tennis court in 1878, and has hosted major tournaments ever since. Its lovely clubhouse has the same sort of architecture—known as the Shingle style—as the houses in the neighborhood. Its uniquely American design appears to be more a continuous, taut envelope of flowing space than the massive, European-style mansions built in most other suburbs. Longwood is one of those theaters for tennis where time seems to have stopped at an idyllic moment when one has little to do except swing a racquet or enjoy iced tea on the veranda, like a capacious outdoor sitting room tucked in under its green-striped awning. But Austin had not yet reached the moment when he could go for a cold drink, and the heat was brutal that day.

Warm temperatures were Austin's nemesis:

> I had often debated in my mind the question of shorts for tennis. The idea first came to me when I was playing in Boston in 1928.... The day was extremely hot, 92° in the shade with high humidity. Trousers got soaked through and it seemed to me weighed a ton. Why, I asked myself, carry all that additional weight flapping round

your legs? Wasn't it ridiculous to play a strenuous, fast-moving game in trousers? I tried to visualize rugger, soccer and hockey being played in trousers. The thought was ridiculous. It seemed to me equally ridiculous to play tennis in trousers. It was simply an old tradition harking back to the less strenuous days when tennis was mainly a garden-party game.[172]

From that point forward, Austin contemplated wearing shorts. In 1932, four years after sweltering at Longwood, he took the big step and wore them at Forest Hills. The press had a field day, but he decided to stick to the habit. Meanwhile, he was told, "You are prepared to wear shorts in America, but you won't have the guts to wear them in Europe."

Austin decided to prove the naysayers wrong. In the South of France that winter, for tournaments in Beaulieu and Monte Carlo, he had his tailor make shorts for him that were based on what was worn for rugby. He got surprisingly little flak for it, although the public was not yet used to the idea. "As I was leaving my hotel one morning to play my match, wearing an overcoat with my bare legs protruding beneath, a young hotel porter came up to me anxiously. 'Excuse me, Mr. Austin,' he said, 'I think you've forgotten your trousers.'"[173]

The real challenge for Austin would be Wimbledon. The All-England Tennis Club was so strict about its stipulation that players dress in white that on one occasion, when an American appeared in striped trousers, he was firmly told never to show up in them again. On the other hand, Austin took heart in his knowledge that the club allowed women's dresses to be far shorter than previously had been expected with the added requirement of stockings. He summoned his courage and wore shorts. No one protested, and the general reaction was muted. It was the way in which he did so that clinched the matter; Austin's unarrogant self-confidence enabled him to leave this important legacy.

◆

IN 1935, two years after he introduced shorts at Wimbledon, Bunny Austin wrote a book called *Lawn Tennis Made Easy*, which was published in New York by the MacMillan Company. It is an in-depth volume of

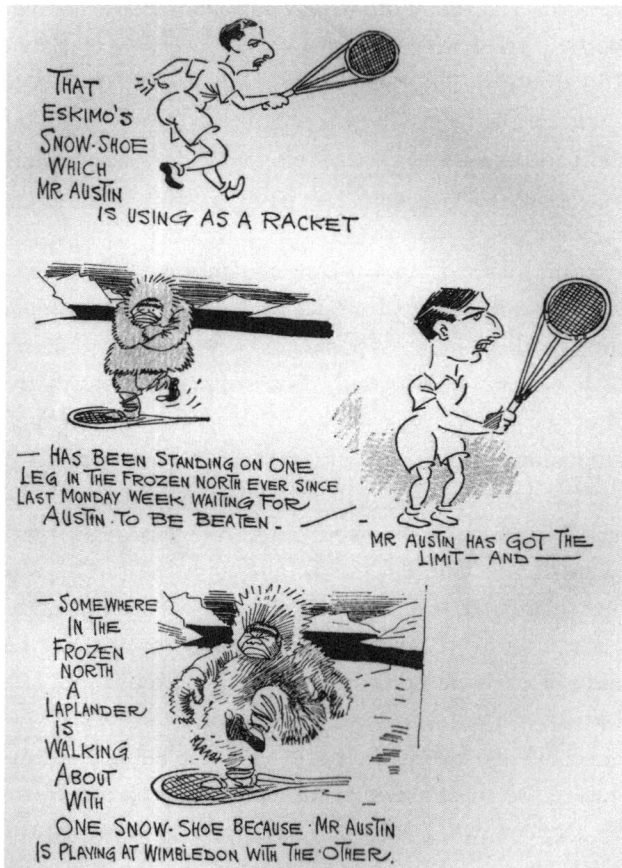

It is for his sartorial style that he will be best remembered, but Austin had already shown his willingness to risk ridicule when he introduced the three-armed racquet. He had a theory that it was stronger than the usual racquet; not only did he play with one himself, but he also encouraged others to use it. Its success was not on a par with that concerning shorts.

instruction, gracefully written, addressing every element of the game. The last chapter is entitled "Clothes and the Player." It is not, as one might expect, a guideline to appropriate style, which came to Austin naturally and was manifest in whatever he wore and the easy, unpretentious way with which he wore it. Rather, it was an explanation of

the reason for shorts, and an account of some of the controversy they initially inspired. It seems that they were a compromise, as the real goal was nudity.

> My belief is that the less you wear when playing tennis the better, while to wear nothing at all, as in the great days of ancient Greece, is the ideal. Athletes, by which I mean runners, jumpers, hurdlers, etc., have come nearest this ideal by wearing shorts and singlets of the lightest nature. As far as I know, no one had complained of indecency or stated that they would prefer athletics if athletes were more becomingly clad in heavier clothes. On the contrary, I feel that athletics afford us one of the most aesthetically satisfying pleasures of the eye—the perfect movement of the perfect body.

Austin charts his own history as a wearer of sensibly brief clothing. "I myself took two years to summon up enough courage to wear shorts, although for years I had known how much more healthy, comfortable and reasonable they were for tennis. I hovered in my bedroom in the south of France, I remember, putting them on, taking them off, putting them on again, wrestling with the problem of Hamlet—'To be or not to be.'" This was the occasion when the hotel doorman suggested that he had forgotten his pants; it was a story Austin would tell more than once. The opprobrium amused him:

> Old ladies will cease to pass such remarks as: "Oh, hasn't Austin got hairy legs?" running thereby the risk of being asked: "Well, madam, what did you expect—feathers?" And the players may well have the good fortune to overhear something in the nature of the following remark, heard at the Queen's Club: "Oh, yes, I like Borotra's beret, but I prefer Austin's legs."[174]

◆

IT'S NO surprise that Austin had been ready for a change in 1933, when he introduced shorts at Wimbledon. The previous year, he had been the first Englishman in a decade to make it to the finals there. But he lost to

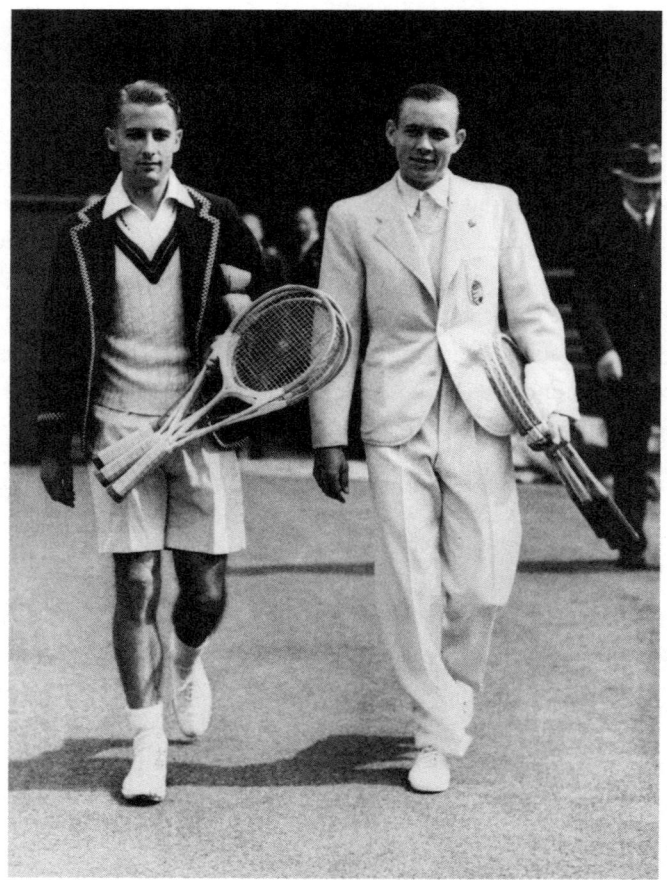

Austin with József Asbóth, as stylish a pair as
ever walked onto a court.

an American, Ellsworth Vines. In 2000, in the nursing home where he ended up, Austin told *The Guardian*, "Ellsworth wiped me off the court in 50 minutes. I was annihilated. It was 6–4, 6–2, 6–0 and he won the match with an ace."[175] Few players are that off-handed about defeat, but Austin was always disarmingly candid.

In 1979, Austin described that match in depth in *A Mixed Double*. Although he wrote it more than thirty-five years after the fact, it is a poignant firsthand account from a player's perspective of a Wimbledon's finals. He knew that because he was the first Englishman to reach the

finals after a long spate, people all over the country were rooting for him. He was primed to do his best, especially when his mother telephoned him that morning "with good news from the stars." An ardent astrologer, Mrs. Austin had just checked his horoscope and learned "that they were all in the ascendant."

Austin went to his osteopath to prepare himself for the match, and by the time he arrived at Wimbledon he was feeling on top of his game, although he considered himself the underdog:

> Ellsworth Vines, my opponent in the final, was a lean and lanky man with a huge serve, possibly as fine a serve as any man in lawn tennis has ever possessed. He was a quiet fellow, lacking the brash confidence so often—and often wrongly—associated with Americans. He was six foot four inches tall with extremely long arms, so his serve was delivered from a great height.
>
> Vines was a better player than I. I knew this, but I was in good condition and good form and I also knew that tennis was a game of upsets and it was often the underdog hitting an unaccustomed good streak who would win a match. On this particular day I was also fortified by the secret knowledge unknown to Vines that my stars were all in the ascendent and I was bound to win!

But he soon realized that something was just a tiny bit off:

> When we started, however, I found I was out of touch. This question of touch is a very important factor to a tennis player. Tennis, as the reader well knows, is a game of great accuracy. You can win or lose a match depending on whether your stroke just hits or just misses a line, just skims or just fails to skim the net. A whole match can turn on the error of a millimetre.

Fortunately for Austin, Vines also started badly. But in the ninth game, Austin lost his service. In tennis at Wimbledon level, the norm is that the players will win the games they serve; the moment they lose a game they have served, they are in trouble. After Vines broke Austin's serve, Austin lost the set. Still, he was not daunted: "But I did

not worry at all. I knew my stars were in the ascendent. I was bound to win in the end."

Even after losing the second set—in which Vines came on full force with his cannonball serve, while twice taking games served by Austin—he remained sure of himself: "My stars were in the ascendent. I knew I would win in the end!"

The third set, however, proved Austin's horoscope wrong:

> As the third set started it was like encountering one of those 150-mile-an-hour hurricanes you read about in the Caribbean that flatten everything before them. I was being flattened. I simply could not see Vines' services, nor could I see his returns to my services. The score mounted rapidly against me, 1–0, 2–0, 3–0, 4–0 and 5–0, and on his own service he reached 40–15, match point.
>
> Still I did not give up hope! I knew all my stars were in the ascendent and I was bound to win in the end!
>
> I waited for Vines to serve, watched the smooth, rhythmic and powerful swing! Boom! I did not move. I saw nothing, only a puff of dust on my service court, and then the sound of a ball hitting the stop-netting behind me. That was his service, I realized. The match was over. Vines had won! I have never been a believer in astrology since that day![176]

◆

BUNNY AUSTIN was courageous not only when it came to the issue of wearing shorts. While other people did not speak out about the Nazi ban of Jewish players on the German team for the Davis Cup, Austin and another tennis great, Fred Perry, protested in a letter to *The Times*. And that was only the beginning of his strong stance on matters of global politics. Austin used his renown as an athlete to advance world peace through the cause of Moral Re-Armament.

For that reason, Austin had to endure more than being teased about his nickname; he was rebuffed brutally for his devotion to a goal which was nothing less than world peace. In the fascinating dual autobiography he wrote in 1965 with his wife, the actress Phyllis Konstam, in

which they openly reveal their differing views about many subjects, he would write of this work to prevent the world from ever again going to war following the tragedies of WWI:

> From the first I knew it would be a battle. I went into it with my eyes open. I have not been disappointed. I have been accused of being a Fascist and a Communist, a pacifist and a warmonger, of running away from the war and of going on fighting it after others have stopped. I have been thrown out of the All-England Lawn Tennis Club at Wimbledon and have only once in the last twenty-five years been asked to a tennis occasion. Yet during these same years I have been the guest of Presidents and Prime Ministers and have felt the warmth of the affection of the so-called ordinary man on five continents.
>
> It has been a fascinating life, taking me to more countries than tennis ever did—and taking me far deeper into the real lives of their inhabitants. I have, through it all, been privileged to work with some of the most remarkable men in our generation. I marvel at my good fortune.[177]

Austin and Konstam were devoted to each other, but she considered his engagement with Moral Re-Armament ill-judged. Still, Bunny Austin knew how to stick up for his beliefs and defend himself against opprobrium, wherever it came from. Whether it was for his work for human salvation or his wearing shorts, he was resolute. The same year he lost to Vines at Wimbledon, Austin attended a celebration of Armistice Day that made him reflect on the futility of war. His feelings are what would lead him into the Moral Re-Armament movement:

> We cheered loudly and rejoiced for we had won the war. Although hundreds of thousands of human beings had been sacrificed for that end; although mothers had lost their sons, children their fathers and sisters their brothers; although budding poets, authors, scientists, industrialists and sportsmen, who carry overseas friendship and goodwill, had laid down their lives for that end we cheered loudly and rejoiced for we had won the war.

But now we no longer rejoice for although we won the war we know that not one single belligerent country has benefited by the result and that all today are facing an economic crisis worse than any living man can remember. We know that the chaos has thrown into unemployment millions of those who were told that they were fighting for a better world in which to live.

Austin was convinced that the futility of war was reason for people to cease celebrating military victory and instead do only what was necessary to prevent the debacle from recurring. "The lesson we have learnt is bitter; the price that we have paid for it is bitterer still and lest we forget that lesson, let the wounded who are with us still be our constant reminders and prevent us ever again from plunging into another welter of human sacrifice and carnage."[178]

Austin's beliefs led him to the Oxford Group, a movement founded by an American minister, Frank Buchman, who in 1938, as Europe began to rearm its military forces, declared that it was more important to "re-arm morally.... Moral recovery creates not crisis but confidence and unity in every phase of life."[179]

In December of that same year, Austin wrote a book elaborating on the idea—*Moral Rearmament (The Battle for Peace)*. With its new spelling for "Re-Armament," it sold more than half a million copies. He concluded his introduction, "Crisis is not past, will not pass, but will inevitably be followed by catastrophe, unless we fight individual and national selfishness, rearm ourselves morally and spiritually against the forces of destruction, and bring into being a new spirit and a new quality of life."[180] He lectured to a large public about the need for "Honesty, faith, and Love"[181] in every sector of human existence and make it his full-time job to promulgate his beliefs. He enjoyed public support from fellow athletes, among them Babe Ruth, Joe DiMaggio, Bobby Jones, and Gene Tunney. But he always encountered strong resistance at home.

Phyllis Konstam, meanwhile, would have nothing to do with the Oxford Group. She was a force to reckon with. She had been in three Alfred Hitchcock films—*Champagne*, which was silent, in 1928; and *The Skin Game* and *Murder*, both talkies, in 1930—and performed on the stage as well. She and Austin had met on a Cunard liner in 1929 when he was going to America for the US Open, and they had a lavish wedding

in 1931. They were a worldly couple—friends of Daphne du Maurier, Ronald Coleman, Charlie Chaplin, and Michael, King of Romania. A play about them, called *Love All*, was staged at MRA's Westminster Theatre. Being in the public eye brought attention to their fundamental disagreement about the cause that was Austin's raison d'être.

In *A Mixed Double*, Konstam makes clear that she disliked the Oxford Group from the start and that she assiduously wanted Austin to avoid it. On first meeting her husband's new associates, Konstam thought,

> I don't like those people, I don't like the look on their faces. The more I think of them, the more I feel they are dangerous. Don't let's have anything more to do with them.[182]

Subsequently, she became even more opposed. She was unabashed about her antipathy to the movement that had become so vital for her husband:

> Realising that Bunny's interest in the Oxford Group was serious, I became very concerned. As the days went by, my feelings against his new friends grew and grew. I hated them. I was overjoyed to pick up all kinds of unpleasant gossip which I passed on with relish to my husband and friends without ever checking the sources from which they came or knowing whether they were true or not.
>
> The fact was, I was afraid of being shown up. I led a selfish and indulgent life smeared over with a tiny layer of idealism and occasional good works. I felt I either had to admit that Bunny's friends were right and do something about it, which I had no intention of doing, or I had to prove that they were wrong to everyone I met, but most especially to myself.
>
> When Bunny's interest increased every day, it made me very angry indeed. "For heaven's sake," I said, "I don't want to be married to a bloody saint."

Konstam was the first to admit that she was shattered by what she saw as the end of her "chosen way of life" and "fought like a demon." Her candor about herself and her values was in its way as radical a departure from the norm as Austin's wearing shorts at Wimbledon. But

it had a very different spirit behind it. She describes herself not only as temperamental and hypocritical, but as manipulative as well:

> At parties I could turn on gobs of charm, but once the guests had gone and as soon as the front door was closed, oh brother! . . . I did not give a damn about the kind of world we lived in. That thousands of men were unemployed, that millions were hungry, that whole families lived in one room, even in our own country, did not really bother me. "Why don't you leave me alone," I said to Bunny. "I am perfectly happy as I am."
>
> "Yes, I know," he replied, "but you are the only one who is!"
>
> Finally I used a woman's best weapon, tears! Bunny, being tender-hearted, could not bear to see me sobbing. So once more I got my own way.
>
> It was very nearly the end of our marriage.[183]

One of the issues was the religious one. Austin's new faith had a doctrinaire, evangelical side. At the beginning of their marriage, Konstam, who was Jewish, and Austin, who was Protestant, shared an essential agnosticism. But now Austin became something of a born-again Christian. Austin describes his faith, "I began to take Christ's absolute standards of honesty, purity, unselfishness and love seriously. I decided that I would turn to God for direction in everything." He felt that he heard God talking and wrote down the messages.

Still, what attracted Austin to Moral Re-Armament was its values and impact independent of the faith in Christ's teachings and in God's guidance. He was convinced that he had discovered the solution for world peace. The meeting in 1938 in Munich at which Hitler, Chamberlain, Mussolini, and Daladier claimed to have assured an end of war by ceding part of Czechoslovakia to Germany was deemed a triumph:

> Moral Re-Armament has advanced the programme of England's military preparedness on the non-military side. . . . Since Munich, British morale has improved at least as fast as Britain's fighting machine.
>
> My immediate part in this campaign was to mobilise the backing of the world of sport. Thirty-five of Britain's best-known sportsmen

joined with me in a call for Moral Re-Armament through sport. We followed up this appeal by speaking to large sporting crowds.[184]

Although many people shared Austin's belief that the Munich accord was a good thing for England and the world, it would become, of course, vilified for its short-sightedness.

◆

AUSTIN'S INTERNATIONAL fame as a tennis champion played a major role in his ability to advance the cause of Moral Re-Armament in the United States as well as England. Because of the skill with which he wielded a racquet, a speech he gave at the exclusive boys school Groton, in Massachusetts, led to his meeting President Franklin Roosevelt.

> Afterwards the headmaster, Mr. Endicott Peabody, told us that he wanted to inform a former pupil of his of "the great healing that Moral Re-Armament was bringing to the nations."
>
> We went to the Mayflower Hotel to await word from the President. We waited all through the day and through the following morning. In the afternoon I went to the telephone and called the White House. I asked to speak to the President.
>
> A feminine voice came over the phone. It was Missy LeHand, the President's secretary. She asked me to hold the line. A moment later she was back again. The President would be pleased to see us. Would we go round immediately to the White House? We jumped into a taxi and were soon being ushered into the famous oval room.

Austin was mightily impressed by the way that Roosevelt, whose legs were paralyzed from polio and was consequently unable to stand, "gave every impression that he was rising from his chair. 'Why,' he said to me, 'I would have recognized you anywhere from your photographs.' Here was the famous Roosevelt charm in action."

The president agreed to Austin's request that he send a message to a meeting of the Moral Re-Armament organization coming up at Constitution Hall, in Washington.

"The underlying strength of the world," ran the President's message, "must consist in the moral fibre of her citizens. A programme of moral re-armament for the world cannot fail, therefore, to lessen the danger of armed conflict. Such moral re-armament to be most highly effective must receive support on a world-wide basis."[185]

Austin closes his part of his and Konstam's memoir with the hope that what President Roosevelt perceived in the Moral Re-Armament movement would be realized. "We can, if we will, shift our country and our civilization above the tragic divisions of race and tribe, class and creed and demonstrate how life is meant to be lived—how through a God-led unity all hands can be filled with work, all stomachs with food and all hearts with an idea that really satisfies."[186] Bunny Austin was not just a charmer in shorts.

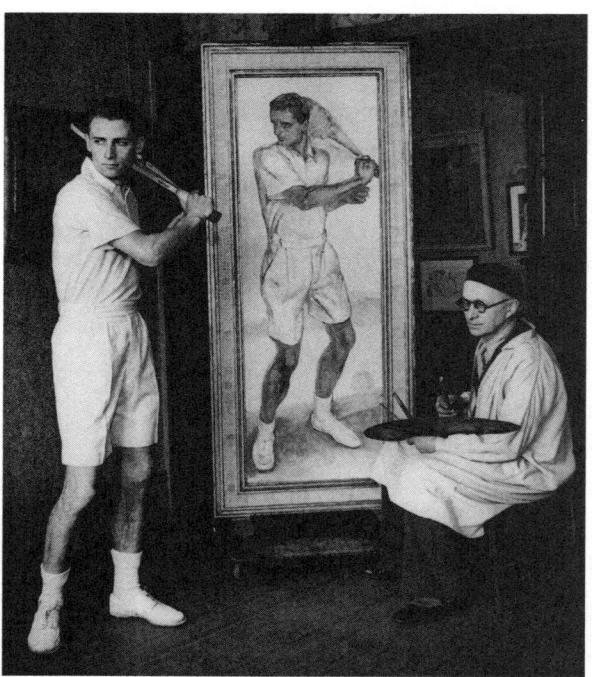

The man who broke the shorts barrier at Wimbledon made it into London's National Portrait Gallery with this painting by Alfred Wolmark.

17

A FABERGÉ TENNIS TROPHY

I T WAS in a shop window on St. James's Street in London, on display alongside splendid enamel boxes and miniature bibelots and lavish pieces of jewelry. I had often gazed at this window not far from Piccadilly to enjoy the finery of czarist Russia and imagine life at a time when royalty exchanged sumptuous gifts and the standards of craftsmanship were such that glistening gold and sparkling emeralds and diamonds were worked with unequaled skill. My pleasure in escaping into the fantasy realm offered by the lives of Russian aristocracy went back to my college years when I was reading Tolstoy and Turgenev for the first time and often stared into the vitrines at a landmark New York store, itself a little jewel of a place, called A La Vieille Russie, on Fifth Avenue not far from Tiffany's and other emporia of luxury. In those days I knew two very different ways of life—for most of the year, that of an undergraduate at Columbia University in the era when everyone studied the vicissitudes of Western civilization in an atmosphere of broiling intensity, and in the summers, that of a counselor at Tamarack Tennis Camp in Franconia, New Hampshire, the rural paradise where happy teenagers, clad in regulation whites, developed their tennis games while enjoying idyllic living conditions in clear mountain air. Walking on St. James's Street, looking in the display that always reminded me of A La Vieille Russie, I never imagined that anything on view would link the two worlds and, amid the

finery evoked by those nineteenth-century novelists, conjure a hard-fought game of tennis.

The object that took me by surprise is essentially a cut-glass vase, rhomboid in form: visually light and impeccably executed. Its simple silver top bears the inscription that explains its purpose: A PRIZE, MIXED DOUBLES, ST PETERSBURG, 1912. The carved lettering, in flowing script, bands the whole and so can only be seen one part at a time, but a handsome card identifying the piece provides the full text in translation. It also gives the name of the maker, Peter Carl Fabergé.

Peter Carl Gustavus Fabergé, who was born in 1846 and died in 1920, was a goldsmith and jeweler whose father, Gustave Fabergé, had

Fabergé's tennis trophy, a little-known masterpiece,
was awarded for victory in a mixed doubles held in
St. Petersburg in 1912.

founded the business that supplied the Russian court with the objects that added luster to their existence. Before the Revolution brought an end to the era when the last czar and czarina ruled their country with a taste for finery and frivolity rivaled only by that of the last French kings and their wives and mistresses, Peter Fabergé had made designs, especially jeweled Easter eggs, that had a style unto themselves.

What more could be known about that object that could be admired through glass in London's most upmarket shopping district? After seeing it on numerous occasions—the shop, Wartski Ltd., established in 1865, was just around the corner from my favorite small hotel in London—I mustered my courage and walked in to inquire about it. I did not pretend to be a potential purchaser, only an admirer. Its purveyors could not have been kinder. They took the splendid exemplar of delicately carved crystal out of the window and placed it on a velvet-covered table so I could study it from every angle. The piece was accompanied by a description of rare precision and elegance: "The striking glass body engraved on each of its four sides with a stylized floral and foliate motif flanked by beaded borders, beneath which hangs beaded garlands and foliate branches, the silver collar decorated with acanthus leaves, the plain silver top inscribed in Cyrillic 'St Petersburg, 1912,' 'A Prize, Mixed Doubles,' 'St Petersburg.'" The Wartski salespeople made no claim of additional information: the precise tennis match for which this was the trophy, who the woman and man were who took it home, whether it was for a daylong event at a small private club or family court or for an international tournament.

But in an additional text about this small masterpiece, the shop on St. James's Street provided some vital facts:

> An All Russian Lawn Tennis Championship as well as the first Russian Open Championship, hosting players from Europe and the USA took place in St Petersburg in 1912. The same year also saw Russia's first participation in tennis at the Olympics, which were held in Stockholm.

And then they invited a wonderful fantasy: "It may also be possible that the trophy was awarded as part of a private tournament, played among visitors at a palace or house."

It is a fine idea. A private tournament, nice friends only, on that grass court with a garden alongside it. What would people drink while watching? Dark Russian tea from delicate porcelain cups? Chilled vodka in Fabergé silver goblets? More important, how would they play? Would their strokes have flourishes? What would they wear? What would their banter be?

Photographs taken in those days when the privileged class in St. Petersburg lived so luxuriously, before anyone had a whiff of the revolution to come, show that for mixed doubles, the women tended to wear frilly, white, long-sleeved blouses. Their black skirts were so long that you could not see their footwear. The men were all in white long-sleeved shirts buttoned at the neck and baggy white trousers with cummerbund-like sashes across their middles.

Dressed as such, they took their sport seriously. In a diary entry from June 1913, Grand Duchess Olga, the oldest daughter of Czar Nicholas II and his wife, Alexandra, writes, "In the afternoon [we] rode in motors to play tennis. I played four sets with Zelenetzky against Anya and Kira N., also played one set with him against Kira and Arseniev, [we] won all five sets."[187] For a member of a family known for its fondness for leisure, Olga was tireless. On another summer afternoon, she and another Olga—her aunt—played "against A and Baron von Noalde and lost miserably."

The baron sounds like great fun. After the match, he taught Olga to walk on stilts and had her doing giant steps in no time. Meanwhile, the tennis court was not left empty: "Papa played with Anya, Khvoskinsky, and Rodionov." Papa was, of course, the czar. But he had none of the autocratic grandeur the title implies. Nicholas in his photos is lean, smiling with his white moustache, always affable-looking: John Newcombe as the doyen of the Winter Palace. Olga seems to have had only good times with her devoted dad. "Played tennis with Papa against Pavl. Al. and Poups (Potovsky). We won one set, they won two. Everyone went swimming, but we returned to the yacht."[188]

◆

LIFE WAS not easy for the royal family, however. In 1904, Czarina Alexandra had given birth to Alexei Nikolaevitch, who, as the first son

after four sisters, was to inherit the throne. As a baby, he was discovered to suffer from hemophilia. The genetic disease inherited from the maternal side not only made him always at risk of excessive bleeding, difficult to control at best, but also often put him in poor health. Maybe the czar and Poups Potovsky—have you ever heard a better name?—had fun rallying across the net and going for a dip in the Baltic before relaxing on the yacht, but long before they knew the Bolsheviks would end their idyll, they experienced horrendous personal struggle.

Still, tennis provided the czar and his family some of what it gives to many of us: a reprieve from life's difficulties. Perhaps the Fabergé trophy was the coup de grace after a nice day of playful competition among the ever-fascinating Romanovs.

◆

TENNIS TROPHIES are never like this one by Fabergé. They tend to be hideous affairs. It is rare that they have any of the beauty of the sport itself.

After all, good tennis depends on efficiency, lightness, grace. The shimmering gold-colored vessels handed to tournament winners are the opposite of the strokes they have executed and the footwork with which they have glided as swiftly and effortlessly as Fred Astaire. Their form has no relation to their function; are they miniature funeral urns, Renaissance banqueting objects, receptacles for odiferous socks? These trophies are heavy, visually and physically, and the amount of gratuitous ornament is overwhelming. They use weighty drumrolls to congratulate lyrical lightness.

It is the same everywhere. From Roland Garros and Wimbledon to small tennis clubs in America's loveliest summer watering holes, trophy design is over the top. You would expect better at those resorts on the coast of Maine with a half-dozen red clay courts and a small clubhouse covered in white clapboards from which the paint is slightly peeling because of the sea spray, but the trophies counteract the reigning naturalism. This is equally true at rustic camps deep in pine forests where a single court in old macadam is the scene of the annual competitions; the lily is invariably gilded.

Why are the trophies awarded for the meticulousness and Zen-like resolve required to winning a tennis match those hodgepodges of gold-plated handles and garlands and wreaths these objects almost always are? In a well-executed serve, everything has a reason. The toss is launched to rise elegantly to a target, at which point it should hover like a hummingbird for a micro-moment while the sweet spot of the racquet strings makes contact to send it on the correct trajectory to the spot in the opponent's service box where, ideally, it can escape easy response. This is perfect engineering, lean and efficient. In art, it would be Brancusi's *Bird in Space*, not a rococo altarpiece with filigree and cherubs making it impossible to rest the eye. Why is the reward not understated and proportioned to echo the purity and weightlessness that are the imperatives of good tennis?

Even at the fanciest of clubs, there is an incongruity when the players who fight their way through match after match and win the tournament are awarded these garish extravaganzas. The victors stand there, soaked in sweat, their well-trained bodies pushed to exhaustion, while the Duke and Duchess of Fancy-on-Costly, in their navy blue blazers and flowered dresses, reward inner strength with something that boasts only the gloss of its surface. And the bigger the piece of hardware, the better. The more hideous, the more glorious. So it has always seemed.

I write this with the perspective of a groomsman, the guy on the sidelines looking on with envy. Any trophies I earned were, at best, little cups for victories along the lines of "runner-up for member-guest mixed doubles." Maybe if I had been a young buck given the gold for winning championships or were now a Senior champion at a minor tennis club, I would look at those overstated trophies awarded to the victors as things of beauty. But I never admired a trophy until I discovered that unique object in the shop window on St. James's Street.

Peter Carl Fabergé's creation was something else. The Russian court designer had the ability to be luxuriant and tasteful at the same time, and to execute splendid objects not just with phenomenal technical skill but with unprecedented imagination as well. Fabergé's artistry was such that he not only served the goals of the Romanovs and their court, but also did so with a style irresistible to those of us whose ancestors came from shtetls. The last czars and czarinas lived in a world of material plenitude

that was above all exquisite. The serving trays and Easter eggs and sword handles that Fabergé and his workshop provided for their daily existence embody genuine skill and flair. They are not ostentatious. The picture frames and delicate small boxes with their tiny bows composed of emeralds and diamonds on glistening enamel surfaces are lovely to see and touch. His tennis trophy—the only one he is known to have made—is, however different in function and scale, consistent in the quality of its craftsmanship and its ability to please.

◆

THERE IS another possibility that the Fabergé could have been given to a couple of happy tennis victors.

In 1907, when he was eight years old, Vladimir Nabokov had started to take tennis lessons in St. Petersburg. His coach was also the coach of the French national champion.

Maybe *this* was the court where a Fabergé crystal vase was the trophy: the place where the future author of *Lolita* worked on his groundstrokes and acquired the skill to get back in the right position swiftly.

Better yet, maybe it was the "vividly green grass court" at which Nabokov sets his breathtaking "La Veneziana." Yes, this is where the Fabergé trophy is to be presented. Its luminous crystal will receive and enhance the red of the castle and the green of the trees and the grass. Fabergé made a sort of prism; the yellow of the flowers will also appear in it, like tiny stars.

Who will receive the trophy? Let it be young Nabokov himself, please. Or else let it be Frank, the hero of the 1920 story Nabokov set in the grounds of the red castle with its superb tennis lawn.

Consider his style as a player: "Frank, who was serving, tossed the ball high with his left hand, leaned far back as if he were about to fall over, then immediately lunched forward with a broad arching motion, his glossy racquet giving a glancing blow to the ball, which shot across the net and bounced like white lightning at Simpson, who gave it a helpless sidewise look."

Perfect! The Fabergé trophy belongs in the hands of the master of that flawless ace. It has the tautness and stretch with which this fine

player leans back. It has the smooth finish of the racquet that strikes across the ball with such zip. Light within the vase also bounces "like white lightning."

At last. The trophy and the game for which it is a reward have the same merits. An object exists that celebrates victory at tennis with the same finesse as the sport.

Let Fabergé and Nabokov call the shots. When they do, tennis shows itself to be the essence of art. And the game and its reward are in perfect sync.

18

ANYONE FOR TENNIS?

IT'S A dire situation, every suggestion makes matters worse, but the speaker is so oblivious that he blithely asks, "Tennis, anybody?" The idea of picking up a racquet and heading onto the court becomes a mark of upper-class indifference to the harsh realities of life. Tennis belongs to the domain of the sort of people who sit around in drawing rooms and have nothing better to do than don foppish white clothing and saunter onto a tennis lawn where they will swing their silly woven wands at a fuzzy ball and shout "Jolly good!" or "*Merde, alors!*" as the occasion demands. You must be in a fugue state even to contemplate the idea of such a meaningless diversion.

When did the question become tongue-in-cheek? When did it start to signify "Let's while away our time doing something completely useless"? And is the saying, at its origin, "Tennis, anyone?" or is it "Tennis, anybody?" or could it be "Anyone for tennis?" Are we really meant to disparage the foolish characters who ask the question? Or to take a certain comfort in their imperviousness to life's hardships? Legend has it, meanwhile, that the escapism implicit in the question was thanks to Humphrey Bogart.

He is said to have uttered a version of the line in an early stage of his acting career, before he was a formidable tough guy and the hero of *Casablanca*. In the 1920s, Bogart was a stage actor. In 1948, in an interview with the Hollywood gossip columnist Erskine Johnson, whose

syndicated accounts of the stars of the silver screen were read all over America, Bogart said,

> I used to play juveniles on Broadway and came bouncing into drawing rooms with a tennis racket under my arm and the line: "Tennis anybody?" It was a stage trick to get some of the characters off the set so the plot could continue. Now when they want some characters out of the way I come in with a gun and bump 'em off.[189]

Bogart subsequently put the memory in context, when he was interviewed by the linguist William Safire three years later in *The New York Herald Tribune*:

> "People forget how I used to look on Broadway," the actor reminisced. "There would be a crowd of charming and witty young blue bloods gathered in the drawing-room set, having tea, while the hero and the heroine get into a petty squabble. The writer couldn't think of any other way of getting excess characters off the stage, so the leads could be alone—and that's where I would appear in the doorway, in my flannels, hair slicked back, sweater knotted jauntily about my neck, four tennis racquets under my arm, breathing hard as I said my line: 'It's 40–love out there. Anyone care to come out and watch?'"

But when Safire asked Bogart if he ever actually said "Tennis, anyone?" or "Anyone for tennis?" he replied, "The lines I had were corny enough, but I swear to you, never once did I have to say 'Tennis, anyone?'"[190]

Did he? One of the most reliable cultural commentators of the last century was the British news announcer Alistair Cooke. In 1957, Cooke wrote that Bogart had indeed said it. Bogart's denial that he ever used the line may have been a matter of wanting to rewrite history to prevent people from associating him with the sort of toffs who would blithely ask "Tennis, anyone?" Cooke's column explores the question in some depth:

> Thirty years ago, towards the end of the first act of one of those footling country house comedies that passed in the 1920s for social satire, a juvenile in an Ascot and a blue blazer loped through the

French windows and tossed off the immortal invitation: "Tennis anyone?" Possibly he did not coin the phrase but he glorified the type, if wooden young men with brown eyes and no discoverable occupation can ever be said to go to glory, on stage or off.

This young man, whose performance the late Alexander Woolcott wrote "could be mercifully described as inadequate," seemed to be cast by fortune for the role of a Riviera fixture.[191]

Cooke goes on to characterize Bogart as a bit of an upper-class twit until, in the course of twenty years, he evolved into a "cryptic Hemingway tough" who had made "the leap from the "make-believe represented by "'Tennis, anyone?'" to the machismo of "'Drop the gun, Louie.'" Cooke says that Bogart felt compelled to deny having said "Tennis, anyone?" to begin with.

In 1975, Nathaniel Benchley, a close friend of Bogart's, wrote his biography, in which he supports Alistair Cooke's claim:

> Richard Watts, Jr., recently retired critic for the *Post*, swears that he heard Humphrey, wearing a blue blazer and carrying a tennis racket, come onstage and speak the immortal line, "Tennis, anyone?" as the playwright's device for getting unwanted characters off the stage, but he cannot now remember the name of the play. Others tend to doubt that the words were ever spoken; they maintain they were symptomatic of the kinds of part rather than any one part itself, and Humphrey gave a different version every time the subject came up. Once he said his line was, "It's forty-love outside—anyone care to watch?"[192]

What is it about the line that would make Humphrey Bogart insist that he never said it and others take a strong stance for or against his having done so? Tough guy that he was, was Bogie afraid of ever having seemed quite that effete? Is "Anyone for tennis?" really such a sin?

In *Bogart: In Search of My Father*, Bogart and Lauren Bacall's son, Stephen Humphrey Bogart, takes up the question with a different slant on it:

> Though [Bogart's] early parts were as juveniles, he sometimes called them 'Tennis, anyone?' parts and that is why he is given credit for

bringing that phrase into the language. He explained juveniles this way: "The playwright gets five or six characters into a scene and doesn't know how to get them offstage. So what does he do? He drags in the juvenile, who has been waiting in the wings for just such a chance. He comes in, tennis racquet under his arm, and says, 'Tennis, anyone?' That, of course, solves the playwright's problem. The player whom the author wants to get rid of for the time being accepts the suggestion. The leading lady, who is due for a love scene with the leading man, declines. So the others exit and all is ready for the love scene between the leading lady and man. It doesn't always have to be tennis. Sometimes it's golf or riding, but tennis is better because it gives the young man a chance to look attractive in spotless white flannels."[193]

◆

THE BOGART question boils down to whether "How about a game of tennis?" is a witty rejoinder to be taken lightly or a callous disregard for the harsh realities of life.

We go back in time to determine how Bogart felt about the quip when he was younger, as opposed to how he felt about it in retrospect. In 1936, there was an interview with Bogart in *Screen & Radio Weekly,* an obscure publication of *The Detroit Free Press,* with the telling title "Fugitive from a Racquet: Humphrey Bogart Escapes from Tennis-Playing Juvenile Roles."[194] Carlisle Jones writes that for Bogart, the tennis racquet became a "perennial prop for leading juveniles" and as such symbolized the sort of role he came to consider "an actor's lowest estate." Jones quotes Bogart: "'Tennis is a playwright's idea of the proper game for the juvenile to play.'" He adds, "'He wears clean white flannels, sneakers and has a chance to show the hair on his chest. It's supposed to be good theater.'" Bogart ends the interview ironically using the sport for his exit line:

"Let's finish this tomorrow," he suggested. "How about a game of tennis?"

[...]

"That damned line still haunts me," he said. "Hope you don't mind."

Why did it haunt him? What was so bad about a bit of caustic wit? For some of us, a larky "Anyone for tennis?" has charm. It is the opposite of seeing a game as a grueling combat with its players putting up their dukes in an all-out battle. Is tennis a real sport in which players prove their mettle—like boxers in the ring—or is it an effete pastime? In fact, its ability to stand up to a bit of tongue-and-cheek irony reflects nuance and the wonderful artfulness that surrounds the art of tennis.

In 1968, the English musician Eric Clapton wrote "Anyone for Tennis" as part of the soundtrack for the movie *The Savage Seven*. The music is practically monotone, sung with very few notes of limited range, accompanied by harmonica and guitar. Although the line "Anyone for tennis, wouldn't that be nice?" gets repeated four times in the short composition, the song has no real connection to sport; rather, it serves as a non sequitur, bespeaking a certain indifference to the truth. Does that tickle us as the essence of wit or does it put us off as irrelevancy? Does the perception of disconnectedness delight us or repel us? Clapton describes calamity after calamity in verses that always end with the same refrain:

> *And the ice creams are all melting on the streets of bloody beer*
> *While beggars stain the pavement with fluorescent Christmas cheer*
> *And the Bentley driving guru is putting up his price.*
> *Anyone for tennis, wouldn't that be nice? . . .*
> *The yellow Buddhist monk is burning brightly at the zoo*
> *You can bring a bowl of rice and a glass of water too*
> *And fate is setting up the chessboard while death rolls out the dice.*
> *Anyone for tennis, wouldn't that be nice?*

Facing matters of life and death, if we resort to "Anyone for tennis, wouldn't that be nice," the issues are resolved.

◆

VARIATIONS ON "Tennis, anyone?" such as "Anyone for tennis?" and "How about a game of tennis?" occur in a large body of English literature.

The line, of which the first iteration was "Anybody on for a game of tennis?" seemed to have originated with George Bernard Shaw, that most

urbane and witty of playwrights, in *Misalliance*, which he wrote in 1909–10 and set in an English country house. The main character is Johnny Tarleton. He is the son of the very rich owner of Tarleton's Underwear and a bit of a toff. The play opens with Johnny in a swinging chair that has an awning over it, in a pavilion in the garden. There is, in sight, an "umbrella stand in which tennis rackets, white parasols, caps, Panama hats, and other summery articles are bestowed." Thus we know from the moment the curtain rises that the characters whose house we are in are stylish tennis players. As amusing women and men move on and off the stage in various degrees of snippiness, the dialogue is full of Shavian repartee, a sequence of clever one-line putdowns and brilliant summings-up. One character says, "Paradoxes are the only truths"; another follows a surprising pronouncement with "Put that in your pipe and smoke it." The redoubtable Lord Summerhays, a fount of wisdom about many topics, sums up a lot of his beliefs when he advises the Tarletons:

> Here everything has to be done the wrong way, to suit governors who understand nothing but partridge shooting (our English native princes, in fact) and voters who don't know what they're voting about. I don't understand these democratic games; and I'm afraid I'm too old to learn. What can I do but sit in the window of my club?

The fatuous dialogue is a perfect lead in to "Anyone for tennis?" Lord Summerhays disparages all reading, asking, "How can you dare teach a man to read until you've taught him everything else first?" This is the perfect moment for the only line that can properly conclude the scene:

> JOHNNY [intercepting his father's reply by coming out of the swing and taking the floor]: Leave it at that. That's good sense. Anybody on for a game of tennis?

Later on in *Misalliance*, another ridiculous discussion is similarly brought to an end with a summons to tennis:

> JOHNNY: Has it ever occurred to you that a man with an open mind must be a bit of a scoundrel? . . . If a member of my club wants to

steal my umbrella, he knows where to find it. If a man put up for the club had an open mind on the subject of property in umbrellas, I should blackball him. An open mind is all very well in clever talky-talky; but in conduct and in business give me solid ground.

Their banter continues until the female protagonist can no longer tolerate it.

> HYPATIA [suddenly, as if she could bear no more of it]: Bentley, do go and play tennis with Johnny. You must take exercise.
> LORD SUMMERHAYS: Do, my boy, do. [*To Johnny*] Take him out and make him skip about.[195]

Even if this notion of putting a stop to things with a game of tennis is derisive, it comes as a relief. Shaw intends us to think that tennis is a silly diversion from higher truths, but he also gives the game enormous charm as the cure for all woes.

◆

BUT IT then became apparent that the idea of tennis as a form of escapism pre-dates Shaw by two years, albeit in an obscure source. "The Magic Photograph," a short story that appeared in a New Orleans publication, the illustrated magazine of the *Daily Picayune*, in 1908, contains a scene in which tennis is a cure-all.

> Ralph Wyatt [spoke] from the porch railing, where he sat idly swinging his tennis racquet. [...]
> [...]
> "I confess myself handicapped," said Ralph Wyatt, lifting his angularity from the rail as he passed the photograph to Tommy Farwell, "and I want to forget my sorrows. Who's for tennis?"
> As he held out his hand to assist Nellie Taggart from her rocking chair, that young lady was obviously elected for tennis also.[196]

Tennis, it seems, is a great cure for sadness.

◆

ELSEWHERE, SKIPPING off for tennis has a suggestion of decadence.

Somerset Maugham's 1921 play *The Circle* has the sardonic bite that often underlies that great writer's stories and theater pieces. The proposal of a game of tennis after we are told "the action takes place at Ashton-Adey, Arnold Champion-Cheney's house in Dorset," is as silly as those double-barreled names, especially because it comes during a serious conversation. The characters earnestly debate the merits of using the word *damn* in polite conversation and the importance of politicians speaking truthfully until a young man dressed for tennis appears:

[EDWARD LUTON *shows himself at the window. He is an attractive youth in flannels.*]
TEDDIE: I say, what about this tennis?
ELIZABETH. Come in. We're having a scene.
TEDDIE [*Entering*]: How splendid! What about?
ELIZABETH: The English language.
TEDDIE: Don't tell me you've been splitting your infinitives.
ARNOLD [*with the shadow of a frown*]: I wish you'd be serious, Elizabeth. The situation is none too pleasant.
ANNA: I think Teddie and I had better make ourselves scarce.
ELIZABETH: Nonsense! You're both in it. If there's going to be any unpleasantness we want your moral support. That's why we asked you to come.
TEDDIE: And I thought I'd been asked for my blue eyes.
ELIZABETH: Vain beast! And they happen to be brown.[197]

These, of course, are just the sort of people who resolve matters by repairing to the tennis court.

◆

THE OXFORD English Dictionary provides a fine example of "Tennis anyone?" with its definition of those two words as "a typical entrance or exit line given to a young man in a superficial drawing-room comedy."[198] The

Anyone for Tennis? • 237

OED also quotes the playwright/director John van Druten, author of *I Am a Camera* and *Bell, Book, and Candle*, as saying, of generic theater characters:

> There is no average Mr. and Mrs. Blank, at all. An attempt to draw one—for example, the ordinary middle-class husband or wife—will lead you into the pit of emptiness, and you will emerge with something as unreal as the juveniles in plays who come in impertinently swinging tennis rackets, and when the time for their exit arrives, make it with the remark: "Tennis, anyone?"[199]

THE ENGLISH are particularly attuned to variations of the line. The following cartoon appeared in *Time Out!*, a daily comic strip which was SYNDICATED TO several American newspapers in the summer of 1951.

This installment of the cartoon series "Time Out" appeared in the *Daily Intelligencer Journal* published in Lancaster, Pennsylvania.

◆

AND THEN there is Monty Python's skit "Sam Peckinpah's 'Salad Days.'" It is Python humor at its best. The quintessential English dandy opens the scene. He is dressed in white flannels; a loud, vertically striped jacket with an equally loud diagonally striped tie; and a white straw boater. "What a simply super day! I say, anyone for tennis?" There is uproarious laughter, and then someone throws a tennis ball that hits him on the head, with a lot of Peckinpah-style violence following.

◆

THE 1934 play *Ain't Love Grand?*, by Pauline Peterson, opens with a variation of the line.

>ACT I
>
>*Scene I*
>
>PLACE: Front room of the Lane home in Rawsley, a fairly large city. The room is furnished tastefully with the usual furniture—small table, deep chairs, lamps, piano, rugs, etc.
>
>[...]
>
>DONA: Everything's a mystery to me! Peggy is supposed to be kidnapped and she walks in! Judy's acting queer! And Peggy's just as queer! I wonder what's next?
>
>CLAUDE: Oh, well, let's not trouble our minds about it! How about a game of tennis?
>
>DONA: All right—anything to pass the time away. [Exit Dona and Claude.][200]

By putting that so near the beginning of *Ain't Love Grand?*—the very title suggests flippancy—Peterson implies that in the story about to unfold, there will be as much escapism and not looking at things realistically as there will be actual events. The idea of a tennis game is the ultimate "devil-may-care" approach to life.

This is why it was said of the splendidly high-spirited actress Rosalind Russell, "She fell into second leads almost immediately—the sort of stilted society roles she tabs as the 'Who's for tennis?' or 'Jack looks peaked today' variety."[201]

WHEN THE comedian Bob Hope wrote—surprisingly—a newspaper article about a labor dispute at the Metropolitan Opera, he observed, "The guys I would feel sorry for are all those spear-carriers who'd have to get dramatic parts in other shows. Picture 40 of them running on the stage at one time and yelling in unison, 'Anyone for tennis?'"[202]

IN 1949, to suggest the profundity of the novelist William Saroyan, a newspaper article reported, "No trivial fables of the 'Tennis, anybody?' type came from him."[203] That same year, the gossip columnist Hedda Hopper quoted Errol Flynn saying, "I used to play broken old fellows with bald wigs, who came on stage and said, 'Your carriage, sir.' The only thing I missed was running on stage wearing a beret and blazer, and shouting, 'Tennis, anybody?'"[204] In the wonderful original movie *Sabrina*, directed by Billy Wilder in 1954, the character played by William Holden opens a scene by inquiring "Tennis, anyone?" There is no better line to represent a happy-go-lucky, pleasure-seeking rich boy.

♦

IN THE English television series *Anyone for Denis?*, which is about the domestic life of Margaret Thatcher and her husband, the title was both a pun and a suggestion that compared to his wife, Denis Thatcher was a lightweight. But so be it: "Anyone for tennis?" and its variations have become among the most telling expressions in the English language. When said by Humphrey Bogart, a Shavian hero, Errol Flynn, or William Holden, its utterance has a wonderful spark to it, for it is both bold and self-deprecating. The capacity to mix insouciance with

profundity is, in its way, a form of magic. Art in its many guises comes from the ability to transform everyday reality into something with qualities all its own. What is evoked by the simple question "Anyone for tennis?" is another example of the versatility of the sport as the basis for a range of artistic possibilities.

19

GUILLERMO VILAS

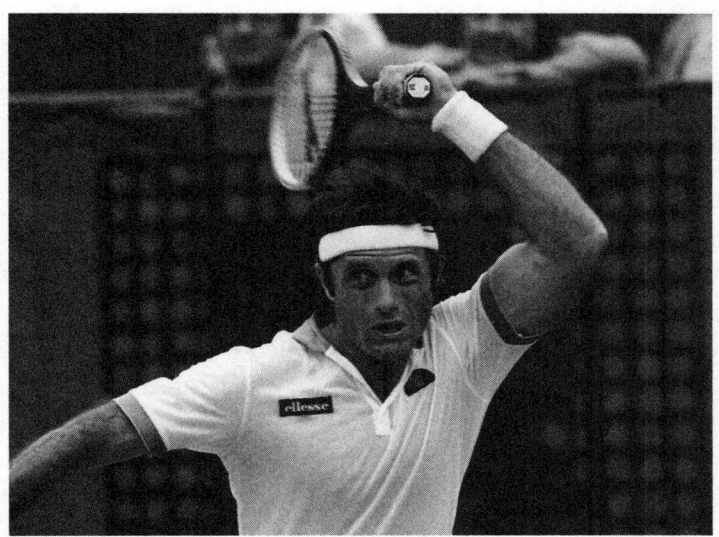

Guillermo Vilas hits a topspin forehand with picture-perfect form.

WAS GUILLERMO Vilas—for just one season, maybe only for a brief moment—ever "the No. 1 tennis player in the world"?

That question became the obsession of someone who never met him. It loomed so large that there were legal hearings to determine the answer.

"One" is the ne plus ultra; you can go no higher, the Academy Award whereby a film or an actor is the best of the year. "No. 1" reflects standards of excellence that pertain to the way we regard art. The notion

of a single master who leads the pack is intrinsic to the way artists are considered—whether or not they invite a comparison that elevates one above another. Verdi or Puccini? Shakespeare or Marlowe? Picasso or Matisse? Leonardo or Michelangelo? Of course, the need to name a No. 1, the very idea that an individual is the best of the best, is a practice of debatable worth, but the idea of the Gold Medal winner in an art show, the Nobel for a novelist, a First Prize in a musical competition, has taken hold. This is why the tennis world had so much invested—perhaps still does—as to whether Guillermo Vilas warranted the title. There is some instinct that makes a person want to know he is at the top of what he does.

"Being No. 1 is very important," said Mats Wilander, the Swedish player who was World No. 1 in the mid-1980s, during his heyday. "The conversation you have in a taxicab or a conversation you have with somebody who asks what you do for a living. 'I'm a tennis player.' 'Oh, you good?' 'Yes, I was world No. 1', and they go 'wow!'"

Nothing else gives you the same buzz, according to Wilander. "If you say I was the French Open champion, it's not the same; it's not as heavy."

A documentary with the deft title *Guillermo Villas: Settling the Score*, released on Netflix in 2020, charts not just Vilas's efforts to get his ranking retroactively, but also the drive of a tennis journalist to obtain what he considers justice for this great player. In 2007, Eduardo Puppo, a fellow Argentinian who greatly admired Vilas, decided the Association of Tennis Professionals should declare Vilas No 1. Puppo had discovered that the Women's Tennis Association had just changed its rankings such that in 1976, Evonne Goolagong had been No. 1 for two weeks. It was a retroactive victory, but one worth the fight for his compatriot, Vilas, who had been dubbed "The Eternal Two" by Argentina's national news media. How could he elevate Vilas from the position of being "always a bridesmaid, never a bride"?

Puppo learned from an online communication with Marian Ciulpan, a Romanian mathematician, that at the end of 1975 and going into 1976, the ATP should have ranked Vilas No. 1 but did not publish the information. Over a period of twelve years, Puppo tried on three occasions to get the ATP to change its record, but he failed each time. The numbers should have made it a straightforward matter, but the calculations

are complicated and involve many elements. The ranking is based on the number of points a player has won in the four Grand Slam tournaments and in other qualifying ATP Masters tournaments, of which there are as many as fifteen. The average is calculated on a weekly basis, and the player with the highest average in any given week is No. 1. However, the calculations were not made accurately in the period when Vilas merited the ranking.

In recent times, Novak Djokovic has been No. 1 in more weeks than any other player, but Federer holds the record for the number of consecutive weeks in which he has held the ranking and the youngest player ever to have been No. 1 is Carlos Alcaraz. There have been players who held the position only briefly—in 1999, five different players were No. 1—and other players who have held it continuously for an entire year. In 1975 and '76, Jimmy Connors was No. 1 without interruption. But when, at Puppo's behest, Ciulpan used computer technology to examine the calculations, he was able to confirm that Vilas should have had it for a window of time at the end of 1975.

Ciulpan reconstructed 280 weeks of rankings, from August 1973 to December 1978. At the time, according to the ATP database, only 128 rankings out of the 280 were officially ratified. The remaining 152 weeks had never been calculated, and no one should have been named No. 1 for them. In 1975, only thirteen weeks were calculated and published by the ATP. Yet Jimmy Connors, despite the absence of data, was declared No. 1 for the remaining thirty-nine weeks as well. When Ciulpan reviewed the numbers, he learned that starting on September 22, 1975, Vilas should have been No. 1 for the first time in his life for five consecutive weeks and that the same was true for two weeks in January 1976. But the weeks for which no results had been calculated were given to Connors.

Puppo sent the evidence to the ATP in December 2014. Ciulpan had armed him with 1,232 files concerning a range of matches that proved, without doubt, that Vilas had won a sufficient number of matches of the right sort in those seven weeks at the end of 1975 and the start of '76 to be No. 1. There was no doubt, but the ATP refused to change its allocation of the position retroactively. The ATP said that if it did so, "it could open the flood gates for others to launch claims." It said it was "impossible to rewrite history," regardless of the evidence.

Guillermo Vilas was shattered. Retired to Monte Carlo and suffering from advanced Alzheimer's disease, he had hoped justice would be served. The dynamic Italian player Gabriela Sabatini was among the many people who lamented the ATP's decision, saying, "We all know his fight on court, so being acknowledged as No. 1, I imagine it would be something very nice."

The central issue of *Settling the Score* is why this happened and why Puppo cared so much. When we watch the film, we certainly want Vilas to have had the highest honor, even if for only a single week. The Argentinian player mesmerizes us; we feel that he had a "No. 1-ness" about him. It is a thrill to watch him; he is in a class of his own. It is a crying shame that Guillermo Vilas was denied the No. 1 status, which elevates those who hold it to the pantheon of elite players from all of time. When we see him play, we know he warranted it.

◆

IF YOU start in the earliest years of tennis tournaments, the No. 1's never had names like "Guillermo Vilas." They sound rather as if they could have been on the roster at Eton. Spencer Gore and William Renshaw and Ernest Renshaw were the first of the gang. After that the requirement seems to have been having "Wil" in your name; those ranked at No. 1 between 1886 and 1897 included not only William Renshaw but also Willoughby Hamilton, Wilfred Baddeley, and Wilberforce Eaves. In the following years, William Larred and Anthony Wilding were often atop the list. In the 1920s, we get to names most of us are more familiar with: Bill Tilden, René Lacoste, and Henri Cochet. Then come the players whose names make them feel like old friends to most tennis aficionados: Fred Perry and Don Budge and Bobby Riggs and Jack Kramer.

Enter the first of the No. 1 rankings from a Latin country: Pancho Segura. And then, time and again, a tennis player whose name came to signify excellence: Pancho Gonzales. What tennis player would not want his name associated with this band of greats? And add to the list the recognized superstars: Rod Laver, Ken Rosewall, John Newcombe, Arthur Ashe, Jimmy Connors, Ilie Nastase, Novak Djokovic, Pete Sampras, Roger Federer, Rafael Nadal, Bjorn Borg, John McEnroe, Ivan

Lendl. No wonder it would mean so much if Vilas had been No. 1, retroactively, for a few weeks almost half a century ago.

Watching the film, we want Vilas to have been No. 1 because he is so likable. He developed his amazing skill as an old-fashioned rich kid—clean-cut, in immaculate whites, holding the best wooden racquets of the era—and remained just as sympathetic after his transition to rock-musician looks. He played in a band and wrote poetry when he had very long and thick hair, which was unusual for a pro. He then started working with Ion Tiriac, a famously tough and demanding coach. It was under Tiriac's command that he won all those matches that, as was later realized, should have given him the title.

Puppo and Vilas finally met when the ATP, the Supreme Court of tennis, determined that even if Vilas should have been declared No. 1 had the calculations been made correctly, he would not be considered ever to have won the crown.

Regardless of the lack of the title, Guillermo Vilas always had that extra force, mental as much as physical, that certain players exude. He was possessed of the charisma that is unaffected by numeric calculation. Tennis is, after all, an art, and art in the truest sense cannot be measured in metrics. We bemoan the injustice, but there is an element to the story that brings us to truth, which is more important than a statistic. This was hardly the first time in history that consummate artistry did not garner the accolades it merited. It is a reminder to all of us that the indefinable and the incalculable are key elements of the sport of tennis.

20

OLEG CASSINI

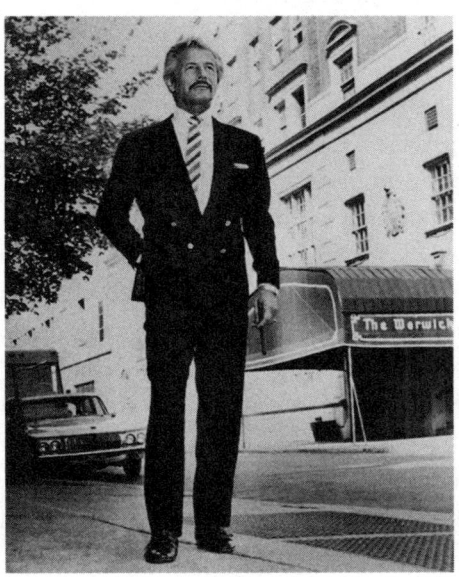

If his off-kilter necktie makes him look somewhat nonchalant,
Oleg Cassini was the essence of urbane style.

I F YOUR name is Oleg Cassini, you had better look the part. Be a mix of Russian nobleman and Italian playboy. Dress with flair and carry yourself like a military captain.

The man who had that stylish name had not only the verve and energy it summoned, but some flamboyance to boot. With his shock of wavy silver hair, Clark Gable moustache, broad shoulders, and trim physique, he cut a fantastic figure.

A clothing designer, Cassini was a bon vivant who lived to the hilt. He was once engaged to Grace Kelly. He made the dresses and hats that

helped define Jackie Kennedy's style when she was in the White House. He was a man about town. He was also a champion tennis player.

Moreover, in the 1970s, Cassini created a line of tennis wear that used the bold colors of the avant-garde painting of the time. In 2004, when he was ninety-one, during an interview for *New York Magazine*, his answer to a question as to why, with his reputation for pillbox hats and "red-carpet gold" evening gowns, he had once launched a line of clothing called Oleg Cassini Sport, included the beloved rubric, "Tennis, anyone?"[205] Witty and insouciant, he lived his fantasies.

◆

CASSINI WAS an artist in whatever he did. He created, perhaps above all else, an image for himself of a hardworking dandy whose very presence had so much theater to it that one expected him to bow before he walked off stage, whether the stage of the moment was a tennis court, a fashion runway, or a sitting room where his costar included at least one beautiful woman. He made the movements of tennis itself a ballet in which he cavorted like a dancer from the Ballets Russes. He used appearance and gesture and costume—at times meaning the clothes in which he or his patrons played sports—to give the impression that Cyrano de Bergerac was about to leap before your eyes. He never missed the chance, whether at net preparing to volley deftly or in society fixing his eyes on his interlocutor in conversation, to hold you in his thrall.

His name and that of his younger brother, Igor, were among the many conscious constructions with which he created his persona. The older Cassini was born in 1913, in Paris, Oleg Aleksandrovich Loiewski; Igor, born in Sebastopol in 1915, was Igor Aleksandrovich Loiewski. Their father was Count Alexander Loiewski; it was only when they were teenagers that the boys took their mother's name as their surname. The change added to the flair that was already intrinsic to them both. Until she married, their mother had been Countess Marguerite Cassini.

Wrote Oleg, "The doctor arrived in a carriage after midnight. He wore a top hat, white tie and tails, white gloves, and spats . . . I arrived . . . at 2:00 a.m., an hour that became one of my favorites in later life."[206] In his lively memoirs, Oleg makes it sound as if he remembered the

details from having witnessed it and not because he was told about it later. Oleg's confidence in his right to amusement was genetic. The reason for being in Paris was that his father was "employed, at the time, in the pursuit of pleasure; that was his occupation." The count "practically lived at Charvet"—the elegant Parisian shirtmaker—and "owned several hundred shirts, all of them silk in various colors ... He would send these shirts, fifty at a time, to London for laundering. He also claimed to own 552 ties."[207] The colors of the count's silk shirts would have an impact on Oleg's designs for tennis clothes; the passion for excess permeated all he did.

In 1917, the Russian Revolution forced the Loiewski family to flee the country and leave their lavish homes and substantial fortune behind. Oleg saw his cousin Uri shot in the Kronstadt Revolt just before his family escaped. They went first to Denmark, then Switzerland. Next, they headed to Athens at the invitation of its royal family, but just before they were scheduled to arrive, a revolution started in Greece as well, forcing the Loiewskis to get off the train in Florence. There they settled, which is why the boys Italianized their name.

Marguerite Cassini started a successful fashion house in Florence and had a roster of international clients, among them many Americans. Having had their lavish way of life fall apart in Russia, the boys again began to experience easy circumstances. Oleg proved himself to be a natural athlete; he was a gifted horseman from the moment he first got into the saddle. At age fourteen, he also proved himself a talented costume designer. He won prizes for the traditional Russian garb executed for him by a seamstress and worn by him and his brother, and sketched dresses that his mother included in her latest collection. "She said that I had the ability to understand a dress in one glance," he would remember.[208]

Still, Oleg Cassini had certain struggles. He was skinny and short for his age, with a big nose that made strangers call him Pinocchio. He struggled in his efforts to appeal to women. "I realized that I was starting with certain physical disadvantages and would have to work harder than other boys to succeed. My fantasy was to do this through athletics, to be a champion tennis player."[209] Watching his first match on a summer holiday in Deauville, he was moved "by the innate elegance of the

sport, the formal dress, the graceful movements."[210] This eventually led to "a frantic program of tennis practice."[211]

At sixteen, Oleg watched his American girlfriend, Baby Chalmers, play tennis on a court in a pine forest in Forte dei Marmi. The couple subsequently went to see a tournament in Viareggio: "I remembered the feelings I'd had about tennis at Deauville; it was simply the most elegant sport. I *had* to be a tennis player."[212] He told his mother this was his ambition. She bought her sons tennis racquets and hired a German instructor for them, but, he wrote, "in truth, we taught ourselves. We played every day for hours. We threw ourselves into it, and were playing tournaments within a year. Mother was very pleased. She'd say, 'With a tennis racquet and a dinner jacket, you'll be able to go anywhere in life.'"

Oleg held a ranking at the club, and before long he was an Italian junior champion.

But the Cassinis' way of life again began to disintegrate. Following the stock market crash, Countess Cassini's business started to fail. It then collapsed completely. "We continued to appear to be rich, and to appear so for all the world," Oleg observed, but the family was forced to sell its villas, and Countess Cassini told her sons they would have to manage without her support.

Their mother, nonetheless, continued to instill optimism in the boys. Oleg admired her spirit: "We were still gentlemen, she insisted. Still Cassinis. The absence of money was only a temporary inconvenience."[213]

Oleg and Igor carried on as before, and "playing tennis was very important in that respect." Oleg continued to practice the sport, and to flourish at it. Tennis was becoming an anchor in his adolescence. He would say with hindsight, "My ability with a tennis racquet opened many doors throughout my life. Wherever I traveled, all I had to do was find the best club, introduce myself as a ranked player, and then prove it on the court, and I'd be welcomed as an equal."[214]

Even though Oleg was on the Italian junior Davis Cup team and "ranked among the top ten in Italy"—immodest about his skills in his memoirs, he does not specify whether this was on a junior level or for players of all ages—he was inconsistent on the court. He tended to do badly in morning matches, which he attributed to his "social proclivities."[215] He would, however, be surprisingly victorious against difficult

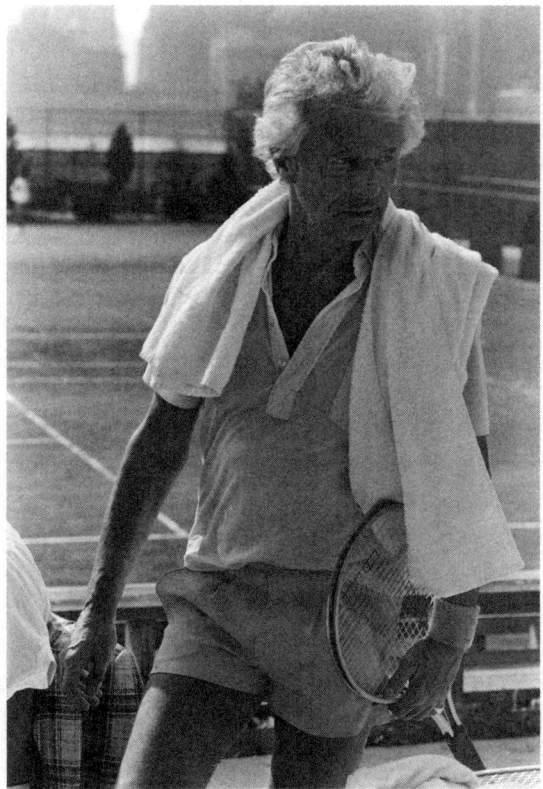

Oleg Cassini was always a striking sight on the tennis court.

competition. He "won thirteen major tournaments," in many of which he was considered the underdog. Referring to the way he played not just as a teenager but from then on as well, Oleg would analyze his own game: "My strengths as a player were speed and guile, willpower more than strength. I played tennis in fact as I lived; I ran and ran. I ran my opponents silly. I ran *myself* silly."[216]

He believed that the way he moved on the tennis court was akin to the speed with which he did everything else.

Cassini had studied political science while skiing, riding, and playing soccer for teams at the University of Florence until he changed course and went to the Accademia di Belle Arti Firenze, where he studied under the great metaphysical painter Giorgio de Chirico. He next went

to Paris to study fashion under Jean Patou, the French couturier who had designed tennis clothing for Suzanne Lenglen and Helen Wills. Cassini made a painting on silver foil of a vibrantly colored evening dress and won a prize for it. He was sufficiently encouraged to return to Italy and start a boutique in Rome, where his clients included the cream of the crop of Roman society and the film industry.

He also got himself into a duel over a young inamorata. He won it simply by nicking his opponent, and was delighted to gain renown as a womanizer with the courage of a knight. "News of this duel spread through Italy overnight, and it did *wonders* for my reputation. So I was known to the young women of Italy. I was a curiosity: a gentleman who fought duels and played tournaments tennis."[217] His fiery temper caused people to refer to him as "the matchstick." The nickname did not stick, but even if it referred to his thinness as well as his inflammatory personality, he would be proud of it for many years.

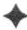

OLEG CASSINI sailed for America in the winter of 1936. When he arrived in New York, the possessions he had with him adhered to his mother's advice; they were "limited to a tuxedo, two tennis rackets, a title, and talent." He did not, however, have instant success and was soon short of funds. Failing to get work as a designer, he lived in a YMCA. Then his brother appeared. Igor had with him a jeweled miniature of Nicholas II that the czar himself had given to their maternal grandfather, who had been Russia's ambassador to the United States. It had originally been encrusted with diamonds, but their mother had had to remove and sell most of them in Europe to manage after her business collapsed. Still, there were enough jewels remaining on the miniature for the Cassini brothers to be able to sell it for five hundred dollars. For a while, it was enough to live on without working.

When spring came, Oleg and Igor went to the West Side Tennis Club in Forest Hills, and introduced themselves as ranking Italian players. They did so well in their first doubles match that they were invited to become junior members. "This was our only link to the glamorous world we assumed was our natural habitat. Given our dreary reality

at that point, there was an almost dreamlike quality to our immediate acceptance on a tennis court."[218] That summer, Oleg did well in small tournaments all over New England; room and board were provided to the players. In the autumn, he began having greater success as a clothing designer as well as a man about town, frequenting the Stork Club and El Morocco and starting a firm he called Oleg, Inc. The next step was Hollywood. He wanted to make clothing for the stars.

Once Oleg was in California, Wendy Barrie, an attractive actress who was the girlfriend of the gangster Bugsy Siegel, invited him to his second West Side Tennis Club, this one in Cheviot Hills, near the 20th Century Fox Studios on the west side of Los Angeles. Tennis again gave Oleg entrée into a milieu that he would not have known otherwise. Film directors, actors, and agents all played at this West Side Tennis Club. One of his first times there, Oleg spotted Errol Flynn and Gilbert Roland on the courts and felt that he was getting closer to having his skills with his racquet get him into the film world.

He knew, nonetheless, that he was not yet in the top echelon of Hollywood society. Oleg was allowed to use the courts on Saturdays and Sundays, when they were open to players who were not club members, but the other people hanging out at the club on weekends were mostly unemployed, the way he was. He was convinced that he would only gain real status when he was invited to a private court, like Jack Warner's. Then luck came his way. One of the other weekend players without a job was the up-and-coming agent Ray Stark. "A very energetic tennis player," Stark "was called 'Rabbit' because he scurried about."[219] Stark and Oleg were quickly spotted as talented players, and soon Oleg "was welcomed as an equal"[220] and invited for a month of free membership. Not having to pay was a good thing; by then, he was so broke that he had to sell his car. He knew he would not survive in Hollywood without one—"it was like being lost in the desert without a camel"[221]—but none of his efforts to make it as a clothing or costume designer succeeded. Adding to the problems was his unwillingness to take an ordinary job that would prevent him from getting out on the tennis court whenever he wanted.

The day he sold his car, Oleg was asked into a round robin tournament. He was forced "to play with real hackers," which he knew was not

good for his game, but he had nothing better to do. He was paired with "a gray-haired, distinguished-looking gentleman, a nice fellow and a fair weekend player." Cassini was so good that they got into the finals and won.

His partner was thrilled beyond belief. This man about whom Cassini knew nothing except his first name had never won in a tournament, and so he invited Cassini home for a celebratory drink and to meet his wife. He had a high position at Paramount, where they happened to be looking for someone in their costume department, in which the only other designer was the renowned Edith Head. To have a chance of getting the job, it would be necessary to produce sketches for a Claudette Colbert movie before the following day at 10 a.m., and his doubles partner knew, even then, that Oleg's chances were slim. He nonetheless encouraged Oleg to try for the job with the same spirit and acuity that he demonstrated when volleying at net.

It was a Sunday afternoon. Oleg Cassini and Ray Stark rushed to Paramount hoping to learn more about the vacancy. There Oleg was told that the job was to replace Omar Khayam, a well-known costume designer, and that not only were thirteen designs required before the deadline, but also that there were many other submissions already. Cassini worked through the night on dresses and suits for the French-born star who had already won an Academy Award for her role in *It Happened One Night* and who with her beguiling smile and aristocratic demeanor was the highest-paid actress in Hollywood.

Ray Stark delivered the drawings for him on time the following morning, and Oleg got the job, for $250 a week. He was told to report to work immediately, and his life changed forever. Oleg was soon doing the clothing for Veronica Lake, Gene Tierney, and Rita Hayworth. He credited his success to the round robin.

Oleg's work at Paramount did not last long, though. He designed prolifically in 1941 and into 1942, but following the outbreak of World War II, he volunteered for military service. He ended up as a first lieutenant in the US Cavalry until the war ended. He was then welcomed back to Hollywood, where he was quickly asked to do the costumes for *The Razor's Edge*, which was to come out in 1946. In creating costumes for this movie, based on Somerset Maugham's brilliant novel, Oleg

returned to civilian life at its most cosmopolitan. He outfitted Anne Baxter and men as dashing as Herbert Marshall and Clifton Webb. Webb played the role of Maugham's Elliot Templeton, a character who was incredibly like Cassini himself, a mix of frivolous socialite and penetrating intelligence who redefined the meaning of *urbanity*. Soon the roster of women who wore Cassini's clothes included Marilyn Monroe, Audrey Hepburn, Joan Crawford, Anita Ekberg, and Gina Lollobrigida. And it had all started thanks to tennis.

◆

IN 1952, Oleg Cassini set up a fashion house in Hollywood. His eponymous collection flourished immediately, and it helped that Igor had become a prominent gossip columnist, the second one to write under the name Cholly Knickerbocker.

In 1947, using that pseudonym, Igor had named Jacqueline Bouvier "deb of the year." He introduced Oleg to her in 1953, just before she married John Kennedy. In 1961, soon after she became first lady, Mrs. Kennedy made him her official couturier; he became "Secretary of Style." As he began to fashion "the Jackie look," Oleg said, "We are on the threshold of a new American elegance thanks to Mrs. Kennedy's beauty, naturalness, understatement, exposure and symbolism." Consciously dressing her as both a film star and a queen, he put her in designs of timeless simplicity, very much in the style of French haute couture. Mrs. Kennedy's brother-in-law Senator Edward Kennedy eventually said, "Oleg Cassini's remarkable talent helped Jackie and the New Frontier get off to a magnificent start. Their historic collaboration gave us memorable changes in fashion, and style classics that remain timeless to this day."[222]

Meanwhile, Oleg Cassini had been getting married or engaged at the same remarkable pace with which he did everything else. After he divorced his first wife, Merry Fahrney, he married Gene Tierney. They divorced but then reconciled and got together again. His next liaison was with Grace Kelly. He said she "dressed like a schoolteacher" before they met, and he encouraged her "to put a little sex into her clothes." Oleg pursued her romantically even after she turned him down because she

Cassini's designs made the first lady more beautiful than ever.

was involved with Ray Milland. Unwilling to accept defeat, he went on a seduction campaign that began with sending her a dozen red roses every day with a card saying "from your friendly florist"; after seven days of this, he presented himself as "her friendly florist." His humor attracted her, and it was not long until they were engaged. Kelly's mother quickly voiced her disapproval: Oleg's track record of two divorces made him too much of a risk. But it was really Kelly's racist father, who disapproved of the Cassinis' Russian and Italian bloodlines, who crushed the relationship. Grace Kelly later said that if her parents had not forced her to break her engagement to Oleg Cassini, she would have had a very different life from what she had with the Prince of Monaco.

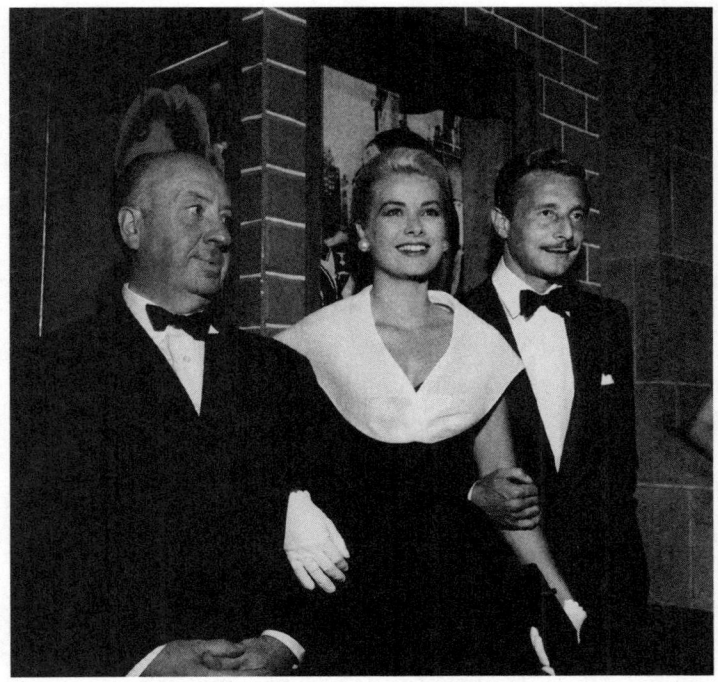

Alfred Hitchcock's greatest star, Grace Kelly, engaged to marry Cassini, was radiant on the arms of both men.

In 1971, Oleg married Marianne Nestor, a model whose face was known from the covers of magazines. She worked for his fashion house, which may be the reason they kept the marriage secret; it came out only after Oleg died, age ninety-three, in 2006. The legal battle over his estate, with Nestor disputing Oleg's will, in which he left almost everything to Christina, his daughter with Gene Tierney, would be the subject of considerable attention in the international press.

In 2004, at age ninety-one, Oleg Cassini was asked, in a *New York Magazine* interview, if he ever considered being a professional athlete instead of a designer. He replied:

At the very beginning of my career, when I opened my business in Italy, I was also a ranked tennis player. I had won many tournaments. To be an athlete was my first choice. Second choice: designer.

However! There was more money in being a designer at that time. The athletes were not making the money they make today. I'm talking about 1933.[223]

Nonetheless, he had combined sports and fashion successfully. Oleg had launched, in the early 1970s, the Competitors Collection of menswear. His advertising featured Ted Turner in his sailing clothes, Bob Hope in his golf wear, Michael Jordan for basketball, Mario Andretti or racing, and, in his tennis wear, Charlton Heston, Regis Philbin, and Kenny Rogers. The clothing became immensely popular in each domain. Among other projects, Cassini outfitted the entire Davis Cup team.

His tennis clothes were unlike anyone else's, a declaration of flash and modernity. The colors jump out at you; the emerald green, Coca-Cola red, and royal blue could not be stronger. In style, they were the antithesis of the elegant whites worn in the pre-Revolutionary Russia Oleg came from, but they establish a new form of flamboyance. The warm-up jackets resemble the costumes of drum majorettes; the trousers, especially those with bold stripes up the sides, would suit soldiers guarding the palace. There are also polka dot tennis dresses as well as a plain white dress with red and green stripes on it. One jacket has a motif clearly reflecting Oleg's fondness for Native American designs.

Oleg Cassini's tennis clothes may not be to everyone's taste—they lack the subtlety and classicism of Chanel's and Jean Patou's—but they took the art of sports fashion in unprecedented directions. Those dresses and track suits utilize the colors of Pop Art. With their unexpected references to Native American designs, they were not merely about dressing. They showed the power of design to alter dramatically one's sense of the nature of the sport they enhanced. The permutations of tennis clothes, in this instance in the hands of a competent player who was also a charming gadfly, were yet another means through which the theater of the game had an impact on culture worldwide.

21

HENRY MCBRIDE

THE BEST-KNOWN portrait of Henry McBride, the art critic who did more than any other writer to open America to modern painting and sculpture, shows him pressed against the picture plane (see Color Plate 23). He is disconcertingly close to us while looming over a distant tennis court. The meandering perspective and scale of things are deliberately distorted. The court is so far away that the players on it—stick figures in action—are not quite as tall as McBride's feet are long. The omnipresent McBride, meanwhile, is a consummate dandy. He wears a formal dark jacket that is something between a blazer and a topcoat, a white foulard, white ducks, and white shoes that are tapered toward the toe like women's ballet slippers. He is holding a scorecard of some sort. He is the authority and judge, just as he was in the realm of contemporary art.

 The artist, Florine Stettheimer, provides a lot of information visually. Her style is light-hearted, her purpose serious. On the distant tennis court, we spot McBride a second time, miniaturized, from behind, in the same outfit and pose, seated at net in the traditional, stepladder-style chair of a tennis umpire. Behind all this, we see representations, in Stettheimer's cartoon-like rendering, of work by some of the artists McBride helped to establish: John Marin, Gaston Lachaise, Charles Demuth, Stettheimer herself, and, from an earlier time, Winslow Homer. He determined artistic quality with the same

astuteness with which an eagle-eyed umpire announces the score and makes line calls.

McBride was a seer. Hilton Kramer, one of the most influential art critics of the second half of the twentieth century, called him the "premier critic of the modernist movement" in America. "What so many others at the time found shocking and even repulsive in modernist art, McBride had the wit—and the artistic intelligence—to see as the classics of the future, and he had the good fortune to live long enough to see his judgment vindicated."[224]

McBride, who was born in 1867, was intellectually modest and wrote in an easy, conversational tone. His unpretentious style was well suited to the popular press, which was where he made his mark—primarily in *The New York Sun*, a daily newspaper with a large readership. He wrote with decisiveness and pizazz about the art that was shown in New York, and because of his bravery as well as his authorial grace, influenced artistic taste not just during his own lifetime, but ever since as well. "Cézanne is a great painter," he declared in 1913; that view, eloquently supported, counter to the tide of opinion, changed art history. The same year, he gave a firsthand report from Matisse's studio, and the following year provided an account of a visit to Gertrude Stein in Paris with Picasso present. In 1916, he again wrote about Cézanne, with the wisdom to zero in on the watercolors. He did not hesitate to voice skepticism about the artists whose quality he questioned—he struggled with the Cubists and declared George Bellows "uneven"—but he was never nasty or vindictive. Above all, he brought to public attention most of the great modernists who were little known until he discovered them: the sculptors Gaston Lachaise, Elie Nadelman, Constantin Brancusi, Jean Arp, Alberto Giacometti, and Jacob Epstein; the photographer Alfred Stieglitz; the painters John Marin, Charles Burchfield, Georgia O'Keeffe, Charles Sheeler, Charles Demuth, Joan Miró, and Ferdinand Léger. He also had a superb eye for work by artists no longer alive but currently being given exhibitions in New York: Thomas Eakins, Georges Seurat, Albert Pinkham Ryder, Henri Rousseau, and El Greco among them. In 1951, he was already writing about Jackson Pollock.

McBride never hesitated to take risks with his viewpoint. He said that between Jacques Prévert and Jean-Paul Sartre, Prévert "may turn

out in the end, to be the greater genius of the two."[225] He backed up the claim: "Jacques Prévert has no inclination whatever to carry weight upon his shoulders. . . . Jean-Paul Sartre, on the other hand, never disguises the weight of any enterprise he undertakes."

It makes perfect sense that Henry McBride was a tennis junkie.

The requisites of tennis were the qualities McBride evinces in his art criticism. One needs to be decisive and strong while having a gentle touch, powerful with finesse. Control is essential; so is a certain leisurely pace. You need to be highly responsive, to notice what is coming your way, and to calibrate your response to it. It is vital to be steady and level-headed, but equally important to be able to deliver the occasional zinger.

Lincoln Kirstein, another influential cultural commentator as well a ballet impresario, wrote glowingly about McBride and about the Stettheimer portrait. He tells us, very specifically, that what we see in the background is not just a tennis court but is "the international tennis matches at Seabright, New Jersey, since McBride was passionately interested in the game and particularly admired the *trois mousquetaires,* Cochet, Borotra, and Lacoste." McBride loved to watch tournament tennis and wrote about it with the enthusiasm and discernment that inform his art criticism. On September 21, 1923, he wrote to his friend Malcolm MacAdam, whom he addressed as "Cher Malc":

> I went to the tennis championships at Manheim the day before the semi-finals, and saw four grand matches. The Tilden-Alonso match was wonderful—at least Tilden's part in it. He is the greatest I have ever seen and he was greater that day, than I have ever seen him. He is a genius and people glue their eyes to his every movement the way they used to glue their ears to Caruso. Billy Johnson who is almost as strong lacks genius, and is not really exciting to watch.[226]

McBride loved watching good tennis, and MacAdam was generally the person to whom he wrote about it. On June 23, 1930, he informed his friend that he was "motoring back to London this afternoon (for I want to see some Wimbledon tennis)."[227] It seems he never missed Wimbledon unless he had to. Three years later, it was the great photographer Alfred Stieglitz to whom he wrote, "It's not just the news

of the London conference that keeps me going, so much as the tennis news from that city. I enjoyed the Wimbledon tournament so much that even at this late date I actually think of writing a tennis article to tell some of these boys where to get off."[228] But Wimbledon was not the only tournament he went to; he would let his friends know about matches elsewhere, and he was invariably excited about them.

McBride was a great admirer of the composer Virgil Thomson. He had attended—on May 20, 1929—the first audition of the opera *Four Saints in Three Acts*, for which Gertrude Stein had written the libretto and Thomson the music, in Stettheimer's studio. Following that performance, he wrote about how much he admired Thomson's resilience as well as his musical gifts:

> But young Virgil Thomson really is a wonder. I never saw such self-possession in an American before. He is absolutely unbeatable by circumstance. When singing some of the opera to me he was constantly interrupted but never to his dis-ease. He would stop, shout some directions to the servant, and then resume, absolutely in pitch and on time.[229]

Each man was highly aware of the personality of the other, and what McBride expressed with words, Thomson did with music. Thomson did a number of "musical portraits." A friend would sit in front of him, and then he would make a short musical composition that was supposed to reveal his subject. On May 9, 1935, Thomson did one of McBride. McBride posed for it in a comfortable chair in Mrs. Kirk Askew's large living room on Manhattan's Upper East Side. McBride would describe the portrait in a letter to Malcolm MacAdam, in which he explained that Thomson gave him a detective story to read during the sitting and that Thomson

> scribbled notes and in an hour and a half it was finished. I think it's pretty good. Virgil cribbed the idea from Florine's portrait and the last part of the composition—this will slay you—he has me on a tennis court dashing hither and yon, but winding up with a big smash. Evidently I won the game . . . When Virgil explained about

the tennis match, I said it sounded as if I were being chased by an angry artist. Virgil laughed and said, "Well, it could be that, too."[230]

Thomson called the portrait "Tennis." When it is performed on the piano, it has the flow and continuity of tennis rallies. By being playful and intelligent, "Tennis" is a remarkable evocation of one of the great critical voices of the twentieth century. There is a sense of lively exchange back and forth. And toward the end it speeds up, as if the ball is flying over the net. The conclusion suggests a victory for the bright, energetic, fair-minded, clearheaded writer. Thomson wrote down the significance of the notes and tempo: "Point, set, match."

McBride, who died in 1962, liked calling things as they were.

22

CARAVAGGIO

No one ever tells us if Caravaggio's groundstrokes were as deft as his brushstrokes, or whether he could serve half as well as he could paint a boy's eyes. But it was a tennis match that led to his exile and his early death. He competed with the ferocity of the assailants in his *The Flagellation of Christ*.

Michelangelo Merisi da Caravaggio was known to be a belligerent character, described in 1604 by the artist Karel van Mander as roaming about Rome "with a sword at his side, and with a servant following him, going from one tennis court to the next, ever ready to engage in a fight or an argument." Rome was the center of Christendom, but it was known for brawls and swindling, with the danger of violence around every corner. Caravaggio was ready to defend himself, and in any case he was not one for polite society; he liked debauchery and enjoyed the company of courtesans. He was also an extraordinarily good painter, who could animate angels' wings to rare effect, give young men faces of uncommon beauty and vivacity, and orchestrate the blacks and whites of his scenes of ecstasy so that the emotions soar. There was no element of his life that was not dramatic.

When he was still in his twenties, Caravaggio was one of the most sought-after painters in the world, receiving more commissions for altarpieces than he could accommodate. But his success failed to satisfy him. On May 28, 1606, by which time he was thirty-five, he and Ranuccio

Tomassini had an argument during a tennis match; Caravaggio was an old hand at the game and had been playing ever since he was a young man. The court was on what is now the Via di Pallacorda—Street of the Tennis Court—in Rome. This building for tennis was attached to the Palazzo Firenze, home and office of Caravaggio's main patron, Cardinal del Monte, who worked for the Medicis. There are at least two versions of what happened. In one, Caravaggio confronted the mild-mannered Tomassoni; an argument turned into a fight; Caravaggio wounded Tomassoni in the thigh (we do not know exactly how); and when Tomassoni was lying there helpless, Caravaggio dealt a blow that killed him. Another account had Tomassoni and Caravaggio hitting each other with their racquets until Caravaggio killed him with his sword.

The law court record provides some certainties. This was a form of tennis we might call double doubles, with four players to a side. Tomassini was the captain of one team, Caravaggio of the other. The teams battled. Tomassini was killed, and even though Caravaggio escaped without a scratch, one of his teammates was wounded. Caravaggio, if found guilty of the murder, could have been put to death for the crime; rather than risk a trial, he fled Rome forever—never again to see the great churches where he had painted masterpieces. When he did try to return, in 1610, he died en route. Accounts differ as to the cause, whether it was a fever or lead poisoning or murder, possibly revenge for Tomassini's death.

Following Caravaggio's death, Francesco Buoneri, a younger painter who had been employed by Caravaggio and worked in a Caravaggesque manner, depicted the tennis racquet as a lethal weapon. It became a tool of death in Francesco's illustration of the story of Hyacinth and Apollo from Book X of Ovid's *Metamorphoses*. In this mythic poem, written in Latin in about 8 CE, Apollo and Hyacinth are the best of buddies, sporting and galivanting together. But disaster awaits them in their punishment for the crime of love between a male god and a male mortal. The tragic end to their romance occurs when Apollo throws a discus that hits Hyacinth in the leg, causing him to fall and die. In his illustration of Hyacinth's death, Francesco, also known as Cecco del Caravaggio, replaced discus throwing with the more contemporary sport of tennis. In this way it more closely resembled Caravaggio's killing of Tomassini.

Francesco showed a moment of the scenario of his own invention: the murder victim being cradled by his killer. These muscular men are

nearly naked. The tennis racquet of the victim has fallen underneath him; the victor grips his own racquet, with a broken string wrapped around his finger.

The intertwining of their bodies has a strong homosexual element, as did Francesco's relationship to Caravaggio. Francesco was a *garzone*—a young man working for Caravaggio (he shows up in a parish census from 1605). But he was not just a helper who lived in the spare room. Francesco is the lad who, in 1602, age fourteen, posed nude as Cupid for Caravaggio's *Love Conquers All*. In 1649, the Englishman Richard Symonds, a lover of Italian art, traveled to Rome to immerse himself in Caravaggio and saw this canvas, which was initially in the palace of the Giustiniani family. Symonds was told by one of the Giustinianis that Francesco did more than let Caravaggio study his naked body. Besides modeling as both secular and biblical figures—he was Caravaggio's "servant that laid with him." This comes as no surprise; as *St. John the Baptist*, Francesco, posing naked on a lambskin while clinging to a ram's horns, looked more erotic than saintly.

When, following Caravaggio's death, Francesco painted *The Death of Hyacinth*, he gave the very handsome Apollo a strong resemblance to Caravaggio, as we know him from his self-portraits. Although the attribution to Buoneri has recently been questioned, we believe the compelling work shown on Color Plate 24 to be by him. Hyacinth, sprawling across one of Apollo's athletic thighs, is less easily identifiable, but this representation of Hyacinth's tennis opponent resembles Francesco as we know him from what is thought to be a self-portrait—his only one—as a musician. In his illustration of Ovid's homoerotic poem, Caravaggio's boyfriend thus cast himself as the victim mourned by the man who was both his lover and his murderer.

The tenderness with which Apollo/Caravaggio holds and looks at Hyacinth/Francesco suggests that the killing was inadvertent—not intentional like the fatal blow that forced Caravaggio to leave town as quickly as he could. Hyacinth's left hand has fallen onto Apollo's left foot tenderly.

These burly men sport amazing footwear. Apollo wears gold and silver sandals; Hyacinth sports strappy pink numbers. The flowers between the left feet of both men, named for the victim, represent the way that he lives on, immortalized, even following his killing.

This painting, from the 1620s, done in such a Caravaggesque style, the dramatic brushwork and thunderous colors all accentuating the drama, was the first illustration of the notorious tennis court murder. Others would follow. In a fresco painted c. 1635 in the Ducal Palace of Savigliano, near Turin, the unnamed artist has Apollo, anxiously checking out the condition of the fallen Hyacinth, still holding his tennis racquet. The scene takes place on a proper court, the details quite realistic except for the larger spiderweb in the center of the net, a sort of horror-movie element in the elegant space complete with spectators filling the gallery.

In c. 1752, Caravaggio's fatal tennis match was again transposed into the death of Hyacinth, this time by Giambattista Tiepolo (see Color Plate 25). The rendition is a tour de force of high Baroque painting. Tiepolo's carefully composed, majestic depiction of the scene has three tennis balls and a racquet on the ground. Precisely why they are there, with the racquet lying next to some blossoming hyacinths—the flowers again serving to immortalize the dead man for whom they were named—is not easy to explain but Giambattista, even more than his son Giovanni, was a master of narrative detail. Apollo and Hyacinth are both shirtless and each has shoulders and a chest large enough to be a those of a weightlifter. Hyacinth is fully exsanguinated. Whereas Apollo is suntanned bronze, the dead man's pasty, bloodless hue is the same white

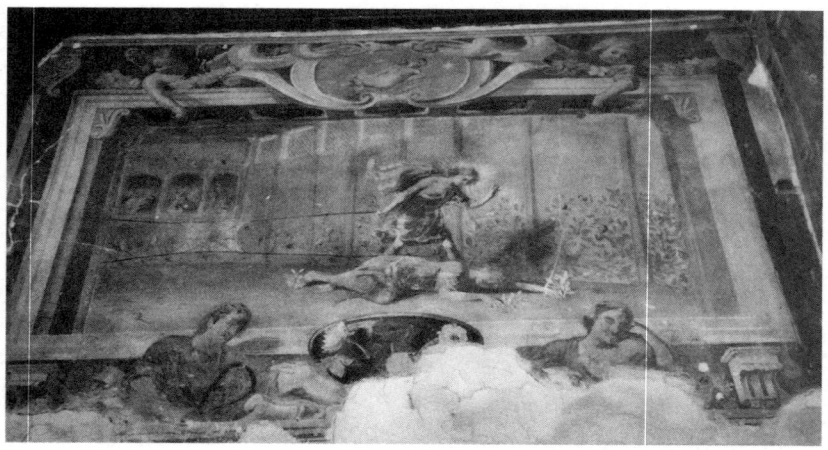

Death of Hyacinth. Fresco, Palazzo Taffini, Savigliano.

as the marble statue of a horned Bacchus figure who looks at the scene devilishly. The onlookers—a helmeted nobleman in robes, some soldiers, children, and, we feel, that demonic marble statue—are all clearly fascinated to see the fatal results of a male god and a male mortal loving each other. There is, in the background, a net for tennis and suggestions of a walled court.

The German count Wilhelm Zu Schaumburg-Lippe (1724–1777), who asked Tiepolo to execute that painting in 1752, was a dedicated tennis player. He commissioned it as a portrait of an opponent he favored above all others: a musician friend who died in 1751. The count's father wrote to him referring to the subject of the painting as "your friend Apollo." In portraying Apollo and Hyacinth, Tiepolo had thus honored the count and his friend while continuing the tradition of the gods as stand-ins for Caravaggio and his rival at tennis.

It's no surprise that as great an artist as Caravaggio inspired painters to such an extent that their work begat the adjective "Caravaggesque." The word came to signify his art: an emotional pitch, ferocious action, the sexual allure of men for men. The allegorical renditions of the event on the tennis court that led to Caravaggio's demise have a tragic beauty that would survive the test of time.

23

MANTUA

Once upon a time, Mantua was paradise. In *Romeo and Juliet*, it is the place to which Shakespeare dispatches the besotted Romeo in the hope that he could eventually be reunited with Juliet. Once they are at a safe remove from their native Verona, the nearby city where their families' animosity has put them in peril, Mantua is supposed to offer salvation. In Verdi's *Rigoletto*, it is where, in the sixteenth century, the local duke gives grand parties in his lavish apartments and his court jester, Rigoletto, sings magnificently. In 1608, an English travel writer, Thomas Coryate, wrote of it, "This is the citie which of all other places in the world I would wish to make my habitation"; Aldous Huxley declared it "the most romantic city in the world." Its cobbled streets and passageways belong to a fairy tale and its palaces are unique in their artistry. Its Palazzo Te provides amusement park–style thrills in the context of serious architecture. And its Palazzo Ducale is home to a fresco cycle by Andrea Mantegna that is a triumph of verisimilitude and equipoise. The Italian Renaissance had peaks of glory here.

To learn that Mantua was once a tennis center, that in the sixteenth century there were three substantial courts in town, is a gigantic taunt. We know where the tennis spaces were; we have descriptions of matches; we can conjure the sound of the ball bouncing; but the actual courts, nets and lines, and so on, are no more. Today those courts exist

only in old etchings, descriptions of matches played between the royals, entirely reconfigured spaces, and our imagination. They are the stuff of dreams.

This was tennis in the form that was the ancestor of the lawn tennis we play today. Now called "Real Tennis" or "Court Tennis," it had originated in France in the early fourteenth century, if not before. It spread to England, where in 1365 statutes were enacted restricting servants and laborers from playing, thus making it the domain of the upper classes. Its courts, which were indoors and retained elements of medieval cloisters and of cowsheds, had high walls and a ceiling. There were two sides with a net in the middle; you had to hit the ball over it, but, as in squash, you played against the walls, with the ball sometimes running down the roof of one of the side structures. The court size often ran as large as thirty-five meters by twelve; there was no symmetry, which is to say that neither the ends nor the sides matched; and the game was played with irregular, very heavy balls, and bent, wobbly racquets. But in the rules and objectives of the game, the sport had a lot in common with the modern version.

We do not know precisely when this form of tennis spread to Italy, but we do know that in Mantua the original players were the Gonzagas, and that is saying a lot. The Gonzagas were one of the most powerful dynasties in Renaissance Italy, and Mantua was their seat of government from 1328 to 1708. Although the Gonzagas did not make the grade of the highest-ranking nobles in all of Europe, they married those who did: members of the Medici, Hohenzollern, Habsburg, Este, and Montefeltro dynasties. They possessed a chalice that contained drops of Christ's blood, and ten family members became cardinals. And they entertained lavishly—which meant inviting their stylish neighbors like the Estes of Ferrara over for a good game of tennis.

If you have ever walked through the Palazzo Ducale to get to the room with Mantegna's masterpiece, you know just how big the building complex is. Under the Gonzagas' rule, its size grew to more than thirty-five thousand square feet. Not only could dignitaries be treated with the highest caliber of hospitality here, but in one vast *sala*, initially the biggest room of the palace, Pisanello had, in 1447 and '48, painted enchanting frescoes depicting chivalry in the court of King Arthur.

The elegant comportment and graciousness shown in the paintings served as a model for the lavish treatment visitors received with the Gonzagas as hosts.

A few years after those frescoes were made, the even larger Sala Grande was built in the adjacent space. It measured fifteen by sixty-five meters, which provided space, in 1463, for eight hundred people to be seated at twenty-seven tables for a banquet celebrating Federico I Gonzaga's marriage to the Bavarian Margaret von Wittelsbach. And when the tables were cleared away, it accommodated ballgames. Periodically transformed into a tennis court, it was a spectacular setting for the sport.

◆

I HAVE fantasies about how it happened that a banquet hall could be converted into a tennis court. I imagine the dinner guests—well stuffed with roasted game and inebriated from quantities of hearty red wine poured from silver and crystal flasks—deciding that the time had come for fun and games. What could be better than tennis to add to the festive atmosphere while working off some of the excess of dinner? One element of the art of tennis consists of the flights of the imagination the sport invites. Tennis is a great amusement, and as such it stimulates imagined visions of it played in a range of circumstances.

The idea of the Sala Grande becoming a makeshift tennis court after a sumptuous repast in the fifteenth century has an echo for me. During one of the most amusing evenings of my life, a game of round-robin table tennis was played on the wooden deck behind my parents' house after a particularly good summertime dinner. At about midnight, my friends and I brought the ping pong table up from the basement recreation room, where it usually lived, and set it up under the stars. We scraped together adequate lighting. Round robin ping pong has many people playing; you hit your shot, drop the paddle, and run; your opponent hits the return; by then, on your side of the table the next player has picked up the paddle to hit the shot that follows; you are out of the game when you lose a point. The sport has marvelous style when played by women in short black dresses who have the competitiveness

as well as the glamour of Jordan Baker in F. Scott Fitzgerald's *Great Gatsby* while eager young men covet them. The cheerful shouts gild the lily. For me, the late-night tennis games in Mantua had the same frippery transformed into a different culture.

But I also have a less felicitous memory brought on by the thought of that Real Tennis court in Mantua. The year was 2004. I had been the guest on a radio talk show to discuss my biography of the painter Balthus, and the recording studio was in the 5th arrondisement of Paris. After the show, I went outside and was unlocking my bicycle when one of the people who had interviewed me commented on my squash racquet in the carrier on the back of the bike. He asked me if I had ever played Real Tennis. I said that once after lunch at the Racquet Club in New York a friend and I had knocked the ball around briefly on the court there, but we never even changed from suit and tie and it had only been a chance to learn the parameters of this unusual sport.

My new acquaintance invited me to play with him on the one Real Tennis court in Paris, not far from the Arc de Triomphe. We met there at the appointed time so that I could give the sport a try. Naturally I put on my most elegant whites, complete with a white cable-stitch sweater, but nothing helped me be any good. The bounce of the woolen ball and the twisted form of the racquet threw me completely; despite my decent level of skill at tennis and squash and even paddle tennis, I could rarely make full contact to hit the ball back over the net. I struggled to get to the ball after it rolled down the roof of the shed that was part of the court. More than once, I actually whiffed it.

My host was gracious, hit the ball to me as best he could, and assured me that my apologies were not warranted and that I was giving him a decent game. But I was pathetic. On a few occasions I hit a shot squarely in the right direction, but mostly I flubbed everything.

Afterward, we went back to the locker room. It had not occurred to me to bring my own towel; I had obsessed over the correctness of my whites but packed nothing else. As we headed into the showers, I saw the other man lay out, on a wooden bench, his immaculate Hermès towel, a color-coordinated washcloth, and a row of matched bath products, shampoo and conditioner and shower gel, from a fancy French cosmetics company. I had nothing whatsoever with me. After the shower, I

François Olislaeger's drawing of an imagined tennis match between the architect Le Corbusier, in the small house where he spent his final summers, and me, captures the disorienting feeling of playing on an old-fashioned "real tennis" court with its shed-like structure that figures in the game.

told him I had not realized I needed to have my own towel. He assured me that this was no problem and pointed to the dryer next to the sink, which blew out hot air for people who had just washed their hands. The most athletic thing I did that day was to blow-dry myself by jumping and turning in every possible position.

This was all a far cry from anything to do with tennis on that royal court in Mantua, except that the sport was the same. And that is part of the wonder of tennis: What is consistent in its rules and physical layout invites diverse human experiences.

◆

IN JULY of 1493, Giovanni Gonzaga—the youngest son of Federico I, the Marquess of Mantua, and Margaret of Bavaria, the Marchioness—wrote to his sister-in-law Isabelle d'Este about a tennis game played there between his brother Francesco and the Turkish ambassadors. The clothing in which they played reflected their rank; the waistcoats were of splendid brocade, the breeches, sometimes tight, sometimes ballooning, were high style. But however elegantly dressed they were, the ballplayers in the Palazzo Ducale were not always well mannered.

On August 28, 1522, such a ferocious dispute erupted during a casual game in the Sala Grande between the court painter Domenico Fetti and a priest from a local church that their supporters began attacking one another with weapons. We know this from an apologetic letter that Fetti wrote two weeks later to Duke Ferdinando Gonzaga; Fetti ended up fleeing to Venice. Even though he was wanted back in Mantua, he never returned; a battle on the tennis court cost the city one of its finest artists.

The Sala Grande was not far from the Camera degli Sposi—bridal chamber—in the northeast tower of the palazzo. There we find the masterful fresco cycle that Andrea Mantegna painted between 1465 and 1474. It is mind-boggling that tennis was once played in the same building as this dazzling group of paintings, which required nine intense years to complete. Multiple vantage points and illusionistic marble architecture, theatrical curtains, and rolling landscapes bring to life these scenes of the Gonzagas holding court in their splendid costumes.

Some of the people in those paintings were the very ones who played tennis nearby in the Sala Grande. In one large fresco, the imperious-looking fellow in his purple robes is Ludovico Gonzaga, who would habitually come into the room and seat himself below his portrait in the same position in which Mantegna painted him. The portrait was warts and all; presenting himself with this image that was not especially flattering was Ludovico's way of saying that he could be counted on as trustworthy and up front about all subjects. Surely someone who allowed himself to be seen with such candor and humility—and holiness—would never cheat on a line call. In another fresco, Ludovico speaks with his son Francesco at a moment after he had been anointed a cardinal. It was thought that having a high position in the Church further assured his virtuousness.

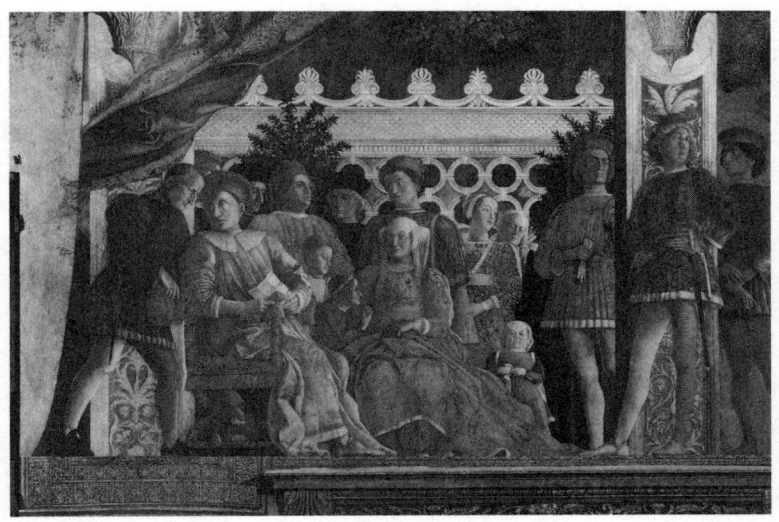

Andrea Mantegna, *The Court Scene* (1465–74).
Fresco, Ducal Palace, Mantua.

Above these frescos is one of the most alluring ceilings ever made. What look like relief carvings are paintings depicting the lives of Hercules and Orpheus, with, toward the top, medallions that portray the first eight Roman emperors, held above us by putti that seem entirely real. Higher than that, more putti and courtiers looking down have astounding physical reality. The realism of these powerfully animated figures makes us believe the Gonzagas were in the presence of gods, angels, Roman emperors, and the elite of their own era—all at once. Rarely has the art of painting been executed with such enormous skill.

FEDERICO II of Gonzaga, the Fifth Marquis of Mantua and Captain of the Papal Forces, was the biggest tennis enthusiast in this family. He probably learned the sport from Pope Julius II; it was the pope's favorite ball game. He was already a decent player in 1515, when he went to France to meet the new king, François Premier, shortly after François's investiture. There Federico discovered that he and the king had a lot

in common: a fondness for hunting, gambling, women, and tennis. But François outdid him by having his own tennis courts in two of his palaces, Gaillon and Blois. Federico decided that he too had to have a tennis court at home. After he returned to Mantua and moved into the Palazzo di San Sebastiano to be with his parents, he built courts adjacent to the palace both for tennis and for the ball game called *Pallone*. With this second tennis court in the royal compound, it was no longer necessary to walk over to the Palazzo Ducale for a game.

This space that served as a spectacular tennis court in the Palazzo di San Sebastiano is where Mantegna painted his *Triumph of Julius Caesar* fresco cycle; today these nine large canvases can be seen at Hampton Court in London, and they are marvels. The complex scenes painted between 1484 and 1492 are paeans to victory. If we allow ourselves the fantasy that the third in the group of nine—*The Trophy Bearers*—represents a tournament winner having his prizes carried home for him, the sense of success and the trophies for it are magnificent. It is difficult to look at the victor—in shorts, no less—without smiling; his codpiece and the sword and the staff he is carrying are more than a little phallic, and with his angelic curls, he resembles a modern teenager from a wealthy suburb. Playing tennis while surrounded by art of this caliber must have enhanced the feeling of energy evoked by Mantegna. His painting bespeaks decisiveness and faultless execution, qualities guaranteed to improve one's performance on the tennis court. His colors convey judiciousness, a grasp of the importance of placement. There has never been a space since then that had anything approaching the quality of this tennis court in which nine Mantegna canvases were the backdrop for the game.

Mantegna's canvases that once loomed over a tennis court reveal an energetic painterly style that succeeds in articulating dense subject matter with vivacity and clarity. In scene 4, *The Vase Bearers*, the representation of the trumpeters with their instruments raised high is a visual Gloria. Here the hardware carried by two of the men in the triumphant procession are extravagant spoils of victory, with the fanfare of the music one imagines the perfect accompaniment.

Subsequently, Federico, the playboy of the Gonzagas as well as the family tennis star, had yet another palace constructed—this one for

him and his mistress, Isabella Boschetta. Federico got Raphael's student, the painter and architect Giulio Romano, to come from Rome to Mantua to be both the architect and the decorator of the new extravaganza, called Palazzo Te, which he created between 1525 and 1527. Of course, it had to have a tennis court, not just so that Federico and his courtiers had another place to play, but also so that he could accommodate the wishes of the Holy Roman Emperor, Charles V, with whom Federico now sided in his rivalry against François Premier. Charles V was another of the imperials who played tennis. He and Federico were both eager to outshine François in the competition to see who could build the better tennis court. The one François Premier constructed set the standard that the court at the Palazzo Te had to beat when it was added on a couple of years after the core building was completed.

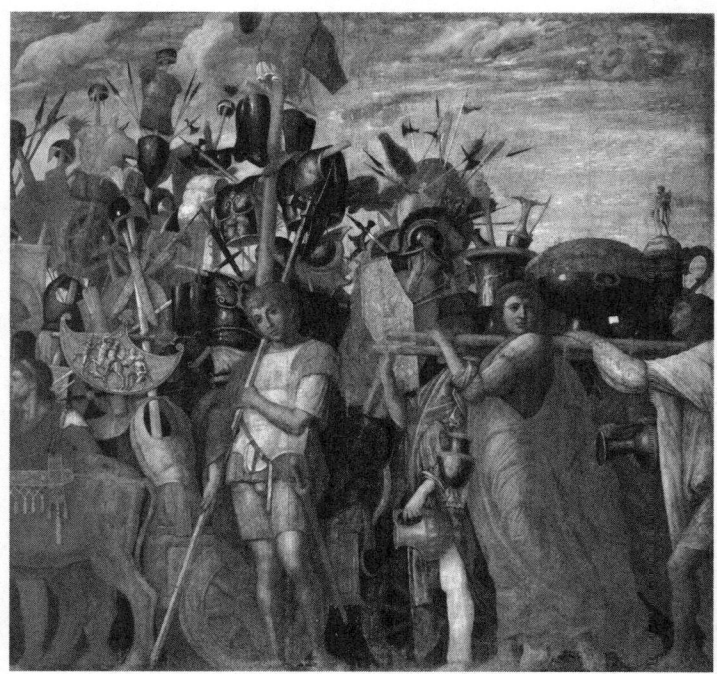

Andrea Mantegna, *The Triumphs of Ceasar: 3, The Tropy Bearers*, 1484–1492. Royal Collection, Hampton Court Palace.

The Palazzo Te is all about illusion—or, one might say, deception. Federico Gonzaga built this pleasure dome at a safe distance from the palace where his wife lived, and he and Giulio Romano had planned its frescoes, based on a new Italian version, done in 1522, of Ovid's *Metamorphoses*, to be an ode to the potential of transformation. The translation by Niccolò degli Agostini modernized Ovid and provided subject matter that enabled him to create an atmosphere of muscular energy and high-speed motion. Were you to walk through those capacious chambers full of lively frescoes on your way to the tennis court, you would be charged by their force.

You enter the palazzo through the Camera del Sole e delle Luna. The elegant plasterwork ushers your vision upward, to a ceiling fresco of a chariot driver; seeing him in a side view, from below, you realize that he is not wearing underwear and is mooning you with his fleshy buttocks, his dangling testicles plain to see.

Some people will dwell on the sight, others may avert their eyes, but whether you want to move on quickly or loiter, you need to pass through invisible doors disguised as parts of the wall. There are also false doors that appear real, so the process of going from room to room presents its delightful challenges.

As you continue the progression, you are in for treats. From that first space focused on the sun and the moon, you reach the Sala dei Cavalli, which shows you the impressive horses from the Gonzagas' stud farm. These sleek and muscular animals stand in front of a background with false marble pilasters that seem real but are in fact painted in trompe l'oeil on the flat walls. The walls have what appear to be windows but are not. The window frames appear to be relief sculpture but are not. They open to halcyon landscapes—which are, of course, also deceptions. These are not the rolling fields they appear to be but instead further displays of Giulio Romano's craft. The painting of those windows and landscapes and the horses in front of them is magical. The scenes with the steeds transfix the viewer.

And then you enter the Sala dei Amore et Psyche. A large fresco shows a banquet that has turned into an orgy, with naked creatures, male and female, young and old, large and slender, all cavorting. Once you have reached these bawdy scenes, you could well have heard

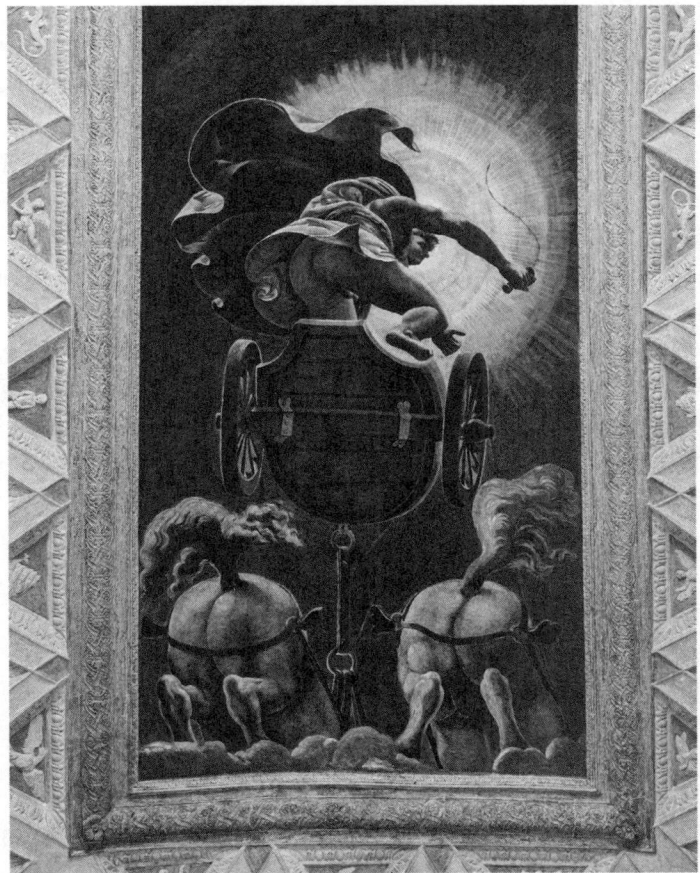

Giulio Romano, *Apollo Driving the Chariot of the Sun*, 1527. Fresco, Pallazo del Te, Mantua.

tennis being played, as the court was nearby. Imagine the combination! The heavy woolen balls of court tennis would be thumping while you look at a river god urinating gallons, Mars and Venus bathing, Jupiter (he is shown as part serpent) approaching Olympia with violent lust, and Pasiphae in the guise of a cow seducing a bull while Polyphemus, who holds the pipes of Pan with which he serenaded Galatea before he murdered her lover, looks on from over the fireplace. There is a plethora of other scenes of human coupling blanketing the walls and ceilings.

Next comes the Sala dei Giganti, which had the tennis court directly adjacent to it—with a concealed door connecting the two. The frescoes here depict battles between the Olympians and the giants in which enormous human beings, based by Agostini on monstrous serpents in Ovid's text, battle the Olympic gods, further renditions of the powerful Jupiter among them. The grotesque giants attacking the gods of Mount Olympus are crushed by marble columns that break over them with violent force. Everyone is oversized, which means being overly muscled and so ridiculously strong that they can tear down buildings with abandon.

Looking at this tumultuous scene in the sixteenth century, you would have heard the woolen tennis balls bouncing and rolling down the sloping roofs of the little structures within the court. The Salla dei Giganti was designed so that someone whispering at one end of the room could be heard with the whisper amplified on the far side; the noises from the adjacent tennis court were also magnified. This meant that while Mount Aetna erupted and the giants loomed above, you heard the sounds unique to a tennis match.

In the Salla dei Giganti, Jupiter launches a thunderbolt to destroy the giants trying to climb Mount Olympus; his triumph represents the ultimate victory of the Gonzagas in all endeavors. Presumably that meant that they won at tennis, too.

The action on the tennis court was, we presume, tame compared to what the giants were doing, but a lot of what we see in Giulio Romano's frescoes is related to the sport. Energy is at a peak; there is craft, skill, and—sometimes—deliberate deception. And there is an element of fun that comes from a multitude of surprises.

Federico had made sure the tennis court was ready so that Charles V could play with him when he visited Palazzo Te to admire its splendor. This took place, and we know that it was a game of doubles. The court was in optimal condition, there was a generous supply of racquets and balls, there was a lot of ceremony before the match, and they played for four hours. Charles's partner was M di Balasone; Federico's was M de la Cueva, the emperor's chamberlain, for whom it was a proud occasion as, for the first time, he was treated as the equal of his employer. For a doubles team to be effective, there can be no hierarchy. The open-minded approach worked well, and Charles lost sixty scudi.

The tennis court at Palazzo Te is visible in an engraving by Gabrielle Bertazzolo from 1596, but it was destroyed sometime between then and when illustrations were next made of the Palazzo Te at the start of the nineteenth century. Still, the foundations of the court remain—they measure 24 by 9.5. meters—and when the palazzo was restored, more recently, three tennis balls, each about five centimeters in diameter, were found. Because of holes made by mice on the surface of the balls, we can see the fibrous stuffing that was used inside. We also know that the original racquets were strung with silk strings rather than the usual sheep's gut.

Tennis was taken seriously in all three courts in Mantua, and generations of Gonzagas, following those who built them, enjoyed having pros visit Guglielmo Gonzaga, who ruled the dynasty in the second half of the sixteenth century, employed a pro named Gian Antonio Neapolitan, who was considered a great authority on the sport. Guglielmo's successor, his son Duke Vincenzo I, who ruled from 1587 to 1612, employed numerous professionals. The account books show one occasion when a first-rate French player, formerly in the employ of the Duke de Nemours, was hired. The good training enabled Vincenzo to perform in public; court records describe one occasion in 1585 when Vincenzo played to entertain a visiting delegation of Japanese princes.

There is a wonderful portrait of young Luigi Gonzaga di Santo, Vincenzo's cousin, about to hit a tennis ball. Luigi's father, the Marquis Ferrante of Castiglione, had wanted Luigi to become a great military leader. At age four, the boy had been sent to a military camp, but he resented the training, and at age seven he decided both to become a priest and to take up tennis. Luigi would die at age twenty-three, nursing plague victims in Rome, for which reason in the eighteenth century he was canonized.

When we see Luigi as a youth with his tennis racquet gripped in his right hand, a tennis ball in the palm of his left, he has a wonderful look on his face. In his dainty shoes, immaculate outfit with pearl buttons and a lace ruff, and tights, he seems angelic. But in his eyes and slightest hint of a smile, he seems to be anticipating victory—maybe a serve that will be an ace, or steely groundstrokes that bring his opponent to his knees.

The Gonzagas were good at all sorts of things, and tennis was another splendid realm in which they could demonstrate their excellence. In its costume, architecture, and, we presume, the way they played the sport itself, they elevated the game to the level of an art well practiced. Anyone whose family had commissioned Andrea Mantegna to paint frescoes in their sleep chamber wanted the best of the best. Even as a child, Luigi demonstrates finesse; he exudes the quiet sense of self evident in the Renaissance masterpieces with which the Gonzagas enhanced their lives. His little wooden racquet and ball for tennis are sure to be the tools of an aesthetically pleasing game played with style and charm.

Portrait of Luigi Gonzaga, unknown artist.

24

HENRY V

Royal Shakespeare Company

IN SHAKESPEARE'S *Henry V*, victory at tennis represents victory at war, and with it the kingship of an entire nation. At the same time, the sport embodies frivolity, escapism from more serious matters—the significance it has when someone asks "Anyone for tennis?"

Shakespeare gives it both meanings in this masterpiece of 1599, which was considered his finest "war play." It is because in the eyes of some people the game of tennis was irrelevant compared to matters

of life and death that it is the basis of a life-altering insult. That its essential tools of play—tennis balls—represent cannon fodder and its fundamental device, the racquet, assumes the role of weapon only adds to its significance.

The audience for this Shakespearian tragedy was already familiar with King Henry from *Henry IV Parts I* and *II*. Only a prince in the earlier plays, Henry was a bit of a lightweight, more interested in fun and games than in the affairs of state. At the start of *Henry V*, the Dauphin of France—the son of King Charles VI and therefore the heir apparent—adheres to the tradition whereby one country's royalty makes a gift to that of another country by sending England's new king a chest full of tennis balls. It is a swipe at his being too much of a pleasure-seeker in the past. In effect, the gift is scornful and infuriates Henry.

The Dauphin has sent those tennis balls, in the hands of his ambassadors, because Henry, now that he has become the king of England,

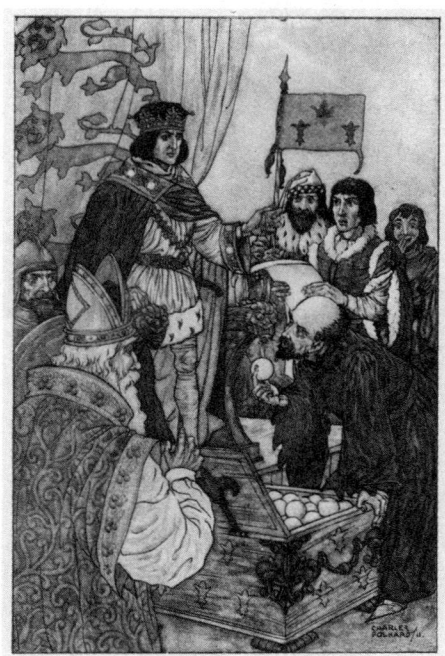

Rarely has a tennis ball been endowed with such power as in Shakespeare's *Henry V*.

considers himself entitled to be king of France as well. The ambassadors are there to dissuade Henry from his grandiose dreams. The delegation also challenges Henry for having already taken "certain dukedoms" after claiming that they are part of his rightful heritage. Imparting the message to Henry that he is acting in an unbecoming fashion, the "tun of treasure" serves to mock his foolishness. It is a significant quantity of tennis balls, the size of the gift a warning to the English king that he is thinking too big. The stage directions do not specify how many balls or in what vessel they are carried, but whatever the production details, the message is the same.

Henry's response is widely considered one of the most brilliant speeches in all of Shakespeare's plays. He uses the snidely intended gift as the starting point for an extended metaphor in which he and his minions will treat those tennis balls like "gun-stones" with which to defeat the Dauphin. Henry tells the ambassadors,

> *We are glad the Dauphin is so pleasant with us;*
> *His present and your pains we thank you for:*
> *When we have matched our rackets to these balls,*
> *We will, in France, by God's grace, play a set*
> *Shall strike his father's crown into the hazard.*
> *Tell him he hath made a match with such a wrangler*
> *That all the courts of France will be disturb'd*
> *With chaces.*

Henry wants the ambassadors to inform the Dauphin that he will indeed assume the French throne. Moreover, the gift of those tennis balls will turn against the Dauphin:

> *And tell the pleasant prince this mock of his*
> *Hath turn'd his balls to gun-stones; and his soul*
> *Shall stand sore charged for the wasteful vengeance*
> *That shall fly with them: for many a thousand widows*
> *Shall this his mock mock out of their dear husbands;*
> *Mock mothers from their sons, mock castles down;*
> *And some are yet ungotten and unborn*

That shall have cause to curse the Dauphin's scorn. [. . .]
His jest will savour but of shallow wit,
When thousands weep more than did laugh at it.
Convey them with safe conduct. Fare you well.

Henry is confident that not only will the Dauphin see France vanquished by England, but it will also pay a hefty price for using tennis balls as a symbol of his youthful foolishness. In the rest of the play, Henry and his troops try to validate his claim that France should be part of England.

Films of *Henry V* have related its story to the events of their epoch. Laurence Olivier, who directed and starred in the 1944 version, presents Henry as the embodiment of English patriotism. Kenneth Branagh, directing and starring in the 1989 movie, portrays the acts of war more as an example of man's inhumanity to man. Regardless, the balls are a vital prop. The object that is central to the sport of tennis is presented with a significance only Shakespeare could have conceived for it. The reason tennis itself is such a natural source of transmutation in theater and film as in ballet and music is because of the many analogies it and its tools establish.

The next time you look at a basket of tennis balls to be used for lessons or practice sessions, imagine their symbolic role as a form of mockery in the pivotal opening scene in one of Shakespeare's most riveting histories. Their use is the purview of royalty changing history.

25

NICK OHLY

Like John Newcombe, my friend Nick Ohly smiled with his eyes. As my daughter Charlotte said when she saw him at the airport when we were all leaving for Senegal in March 2007, he had "movie-actor good looks." The smile, which came from deep within, and the sky blue of those eyes, were magnetic.

Charlotte had known Nick since she was a very little girl, but in 2007 she had not seen him for several years, and now that she was twenty-three, she was more susceptible to his form of handsomeness than she had been when growing up. His were very old-fashioned good looks: natural, absent any vanity. Charlotte was referring not to the current, narcissistic sort of movie stars, but more to the William Holden or Gary Cooper type. I recently asked her what adjective she would use to describe him, and she replied, "Craggy-patrician." With his well-proportioned, rugged face, Nick looked like a mix of a New England farmer and a Greek warrior chiseled in marble. But although he played hockey, lacrosse, and soccer, all with great skill, he was ineffably gentle, without an aggressive bone in his body. I regularly played tennis and squash with him, and we skied together with our children; he was graceful without conceit. He was so coordinated that he could ice-skate backwards, fast, while avoiding the obstacles in the less-than-perfect frozen lily pad roots and other ice of our pond.

He was, quite simply, one of the kindest, most thoughtful, most genuine people I have ever met. When on one occasion he was a few minutes late for our Monday midday tennis game and said this was because he had been held up giving blood at the Red Cross, I was not surprised to learn that he did this as often as the system allowed. Not that he volunteered the information; I got it out of him only with questioning. Any form of self-aggrandizement would have been anathema to him.

Nick and his wife, Sara, a striking beauty with wide-set eyes and a generous smile, were the devoted parents of two sons, Derek and Jack, and they were a dream of a family. The four of them enjoyed good fortune—healthy bodies, easy circumstances, great intelligence—but they never flaunted what they had. And Nick was by no means blind to the reality of problems when they occurred. He was deeply concerned about Sara's migraines and was forever investigating the causes and solutions for that mysterious malady; I felt that he would have done anything to enable his beloved wife to stop suffering. I know other people who seem to enjoy life with little strife in the way that Nick did, but part of the way they do it is by not looking adversity in the face; Nick was different and was very real about difficulties (for others, anyway; less so for himself), although he was a perennial optimist.

We offered each other a level of support that for me is the essence of true friendship. We were there for each other, consoling as our parents became ill, Nick attending my mother's funeral and me at his father's. In 1989, when I was critically ill from an allergic reaction to the medication Bactrim—I was told that if I had ingested it for one more day I would have diead—and in enforced isolation at Yale New Haven Hospital, I said that only two friends could visit, and Nick was one of them; he was of course smiling and uplifting, and I could talk to him freely about was going on with me, which is rare in the milieu I come from, one in which people are not supposed to acknowledge difficulties.

Ever since we met, we would play squash or tennis twice a week, sometimes more, unless one of us was traveling. From the moment we saw each other on the way into the locker room until we said goodbye in the parking lot, we went from subject to subject, animatedly catching up on one another's lives, recounting travels and talking about what we were reading, sometimes delving into our pasts, as when Nick recalled

marvelous details about his summer on Samothrace. But we never chatted when we were actually playing the sport, except that each would praise the other copiously for a shot well hit. I marveled when Nick showed himself to be ambidextrous by suddenly putting his squash racquet into his left hand to get a shot coming straight down the left wall of the court, and he was visibly delighted on the rare occasion at tennis when I would ace him by hitting a serve just inside the line and out of his reach. (I would not mind being able to hit such serves today; this seventy-seven-year-old body is just not the same as it was half a lifetime ago.)

It was not only before and after racquet sports that Nick and I talked. But we were both leading full and hurried lives when our children were little, so we had to avail ourselves of every opportunity to exchange ideas. There was a certain electricity between us. Particularly during the 1980s and '90s, I suffered from horrendous bouts of depression—painful to discuss—and Nick was the one friend with whom I could address this. He did not experience the same ailment, at least not in the same form, but he was empathic. In my everyday life, I successfully masked the agonizing darkness; the luxury of having a friend who was so responsive and

Nick Ohly, March 2007.

kind was of incredible meaning. With his trenchant observations and good advice, his only goal was to make my life better, never to compete the way most people do by rushing into their own stories.

◆

ABOUT THE only disagreement—*argument* would be too strong a word—Nick and I ever had occurred when I told him I wanted to construct a tennis court in Senegal in the rural village where we supported a medical center and were building a kindergarten. He could not understand why we would spend money in that way when there were so many priorities for the local population, where people were living in conditions of poverty and had neither electricity nor plumbing. I told him I could not help wanting them to have some of the same pleasures I had had growing up, when I would walk to the local park to play tennis, and that if no one had built those public courts, I would have missed out on what I consider to be one of my life's essential pleasures. I also suggested to him that tennis was potentially the means through which someone born to poverty in the village could transform his or her life by achieving a level of excellence that became a conduit to success in the larger world. Nick said that the chance to play tennis was just not as important as the necessities of existence; I agreed with that but maintained that we all have the right to different aspects of existence beyond the imperatives.

I restrained myself by not reminding Nick that he had grown up with a court at his family's country house in Vermont and was so accustomed to such luxuries that he did not recognize their rarity. Anyway, we let the matter drop, but I wish he could see that court in Senegal now, the way that it is also used for basketball and serves people of all ages from other villages as well, bringing untold pleasure to individuals who have so little. The presence of the court caused us to create a soccer field. The regional meets not only bring people together, but also give the local doctor a chance to discuss issues like birth control with the crowds that would otherwise not be in the same place at the same time. The dissemination of vital advice is thus a by-product of the presence of that tennis court.

On the trip to Senegal, Nick and Charlotte and I and others who were part of Le Kinkeliba—the organization that set up the rural medical

The two Nicks with Madame Sidibé, of the
Wassadou Medical Center, March 2007.

centers we helped support—were staying in the small hospital in the village of Wassadou. One day there was time to spare, and Nick asked if they had a bicycle he could use. They did—a single-gear bike with a large box attached to the back so that it functioned like a wheelbarrow, with the cyclist able to transport ample quantities of vegetables or firewood or whatever needed to be moved between locations. Nick was invited to use the bike—the box was empty—and he took off, going over a bridge that crosses the Gambia River at a location inhabited by baboons.

I have no idea how far Nick went in the blistering heat, but in the village of Niminecke, he encountered a hitchhiker hoping to find a lift to Wassadou. Nick told the hitchhiker, a boy of about sixteen with a wool knit hat that seemed implausible on such a hot day, to get into the vegetable box. The boy must have weighed at least 130 pounds, but this did not prevent Nick from cycling back with apparent ease.

When Nick turned into the driveway of Wassadou, the boy was grinning from ear to ear and leaning back like a prince in a sedan chair.

Nick Ohly at a Senegalese school.

But he showed no sign of getting out. Nick, who had had his own teenage sons, politely but firmly indicated that it was time for the boy to give up his position in the vegetable box. I am sure that part of the experience for the boy was the feeling that he was being chauffeured by someone of exceptional kindness and whose inability to speak the local language made no difference.

ON NOVEMBER 12, 2007, about nine months after we returned from Senegal, Nick and I met for one of our usual midday-Monday tennis matches at the New Haven Lawn Club.

Our schedule depended on his office hours, and we both arrived at the parking lot at precisely 12:40. We had one of our animated conversations while walking in and changing into the requisite whites and heading to the court. I cannot remember what we talked about when getting ready, which we both did very quickly so as to waste as little of our precious tennis time as possible, but it could have been anything from the latest column by Maureen Dowd—whose writing we both liked—to an

update on what we had done over the weekend or the latest about one of our kids, then in their twenties and thirties.

We played a terrific set with long rallies and reached a score of six to six. Nick did not punch a time clock at his office, but he never wanted to stay away for too long during his lunch break—he would eat his usual peanut butter and jelly sandwich while driving back to his architectural firm—and I asked whether we should call it a day or play a tiebreaker.

"Oh, let's keep on playing. It's such a beautiful day and the game is so much fun."

Our tennis was very evenly matched, and we reached a moment when Nick was leading seven to six in the tiebreaker. I went to the back of the court to pick up a ball that had rolled against the fence. When I turned back, I saw that Nick was lying down in front of the net, on his side of the court, right near the bench and the water cooler. I called out "Nick!" thinking he must have fallen and possibly sprained his ankle. He did not answer.

I raced up to him and was standing next to him when he made what sounded like loud snoring sounds. I thought he was joking and pretending to be asleep because he was lying on the ground. Then I realized that he was no longer breathing, not an iota. What I had heard was the sound of the last bit of air leaving his lungs, the death rattle.

I bent over and tried artificial resuscitation, trying to reanimate Nick with mouth-to-mouth breathing. I imagined his coming to and saying "I knew we were good friends, but I didn't know it was like this" while regaining consciousness. I pushed on his chest. He remained inert.

There was no one on the adjacent tennis courts. I looked desperately for another human being to summon a doctor. I did not want to leave Nick lying there alone, but finally I ran as fast as I could until I found a very nice maintenance man and asked him to call for emergency help. Within about five minutes I heard sirens. A group of men—I cannot tell you whether they were firemen or medics or where exactly they had come from—arrived. One told me to stand some distance away and while they tried what I would call emergency clappers. Then, with a forlorn look on his face, one of the men said to me, "Fatal cardiac arrest."

I almost immediately found my phone and called Sara. Fortunately, she was home and answered. "Hi, Sara, it's Nick *Weber*. Nick has had

cardiac arrest. We are on Court 4 at the Lawn Club, the court nearest to the parking lot. The emergency services are here." Sara said she would be there right away.

I will never forget the look on Sara's face as she came rushing onto the tennis court. One of the medics told her how sorry he was that her husband was dead. Still, we agreed that we must get him to the hospital immediately in an ambulance. Sara wanted to be with him in the back, and I followed them in my car. I remember that I called Kathy—my wife—and said to her, "Hi, Nick Ohly has dropped dead on the tennis court. Sara is with him in the ambulance, and they are on their way to Yale New Haven." It was Kathy's birthday, and I apologized for giving her such bad news on that of all days.

Sara and I spent the rest of the afternoon together in "the bereavement room" with Nick's body next to us, separated only by a white curtain of the type they have around hospital beds. Nick was lying there on his back, still wearing his whites (as was I). Sara was amazing. She told me that in the ambulance she thought about how whenever there was a crisis Nick would be the optimistic one, saying things might work out in a positive way, whereas she always fretted and feared the worse. "This time, I thought, 'I'll channel Nick. I'll be the optimist. Maybe they can do something at the hospital.'"

We called Derek and Jack and then Nick's two brothers. I called Nick's office and spoke with Kevin Roche, the renowned architect for whom Nick worked, who quickly offered to organize cars to pick up Derek in Boston and Jack in New York. Sara and I talked about how Nick wanted to be an organ donor, and we mentioned this to one of the doctors, whom we both knew. He said Nick was too old for his eyes or kidneys or any other organ to be considered viable for a transplant.

A lot of the rest of that day is a blur. But I do remember calling David Melchinger, who had become my doctor because Nick had recommended him to me when I was looking for a general practitioner a few years earlier. Ironically, I had gone to him that same morning for a checkup and had had an EKG. Dr. Melchinger told me that he already had the news of Nick's death from his colleagues at the hospital.

Then he said, "The way Nick died, if he had been on an operating table with thirty doctors around him, they would not have been able

to save him." Dr. Melchinger explained that with that form of cardiac arrest, the patient is instantly dead, with no chance of reviving. He also told me—and I wish I did not remember this—that Nick knew he had a health condition of some sort "and might have done something about it." As I say, I wish that were not part of my memory.

AT THE end of that afternoon, there was a lot to do with cars. I drove Sara to hers, which was in the Lawn Club parking lot, and followed her home. She gave me Nick's spare set of car keys and I drove to my house, half an hour away, and then Kathy drove me back to the Lawn Club so I could get Nick's car from the parking lot and drive it to his house—it was painful to picture him at the wheel driving to the court cheerfully earlier in the day—with Kathy following me. It felt very strange to deal with these logistical issues.

We went into the Ohlys' house. Sara now had family members and friends with her, and I was introduced to the minister from the nearby church, who would be doing Nick's funeral. Sara said, in her usual breathy voice, warm and animated, "Reverend. This is another Nick, Nick Weber. He was with my husband playing tennis when my Nick died. They were best friends." The minister, a gray-haired Black man with a radiant smile, said, "What an honor, to be with your wonderful friend when he died." I have rarely been more grateful for anyone's words.

The day after Nick died, I asked a mutual friend of ours if he would play tennis with me on a public park court in a town near where we lived. I did not want to return to the Lawn Club so quickly, but I felt that if I did not quickly start playing tennis once more, I would never again go onto a court. Among other things, Nick would have disapproved of my stopping the sport that was such an agreeable part of both of our lives.

I SAW a lot of Sara during the following week. At some point she told me the boys had requested an autopsy and it had been discovered that Nick had 90 percent coronary blockage.

On Saturday, Kathy and I were seated near the front of the church for the funeral. There were a number of speakers, including Nick's beloved sons. In different ways, most everyone invoked his charisma, although one speaker annoyed me by saying that Nick was known to be indifferent to the clothes he wore. I thought this was not the case—Nick simply dressed in his own style, generally wearing a blue shirt and khaki trousers. He always looked handsome, even if a shirt collar was frayed. Besides, he had a particularly nice navy blue wool overcoat that he had bought in The Hague and wore on cold winter days. I do not remember the context of the silly and inaccurate remark, only that I bristled. He dressed with the same artistry with which he lived, in a quiet style that did not call attention to itself. Everything was in proportion, careful without being fussy. And although he would never know it, on the tennis court he had managed to achieve the rarest of feats: to die with grace, falling like a golden warrior.

Giving my short eulogy, I told everyone about Nick and me visiting the Dessau Bauhaus together and his eating *metts*—chopped raw pork—and about the boy in the vegetable box in Senegal. I also told them Nick's last words, which he had said with a smile on his face:

Oh, let's keep on playing. It's such a beautiful day and the game is so much fun.

EPILOGUE

The Magic of It All

TENNIS IS a great mnemonic. At age seventy-seven, having played since I was eight, I have certain memories that come back reliably in response to their cues on court. Most have come to represent far more than a simple story and are the source of lessons I apply in many non-tennis situations.

Anytime I'm up 5–3, I'm sure to remember a moment from the summer of 1960, when I was twelve years old. I was at Camp Killooleet, a progressive co-ed summer camp in Vermont. There was an alleged intention to downplay competitiveness—no camp teams, no money that might mean one camper had more than other. But nothing kept me from wanting to be number one on the tennis ladder. I was number three, and I knew I had no chance of beating Nico Elmaleh, who was number two, but I thought I might have a crack at beating Johnny Evarts, who was number one. If so, I would be king. (It was a kid's version of the dream that would haunt Guillermo Vilas.)

Johnny was everything I wasn't: cool, naturally athletic, Protestant, square-jawed, blond, with a button of a nose. He had a handsome older brother who was a counselor; I'd have loved the same. It was as if were I to beat him at tennis, I'd achieve all I envied. I challenged him to a ladder match, a single set, one Sunday afternoon, and we went out onto the red clay court. I was playing unusually well and was up 5–3 when the dinner bell rang.

An hour later, we were back on the court. Full of macaroni and cheese (with a crust of buttery breadcrumbs), I proceeded to lose the next four games and was defeated 7–5. To this day, I have a fear of counting my chickens before they've hatched. What happened on the tennis court became a metaphor for one of the essentials of my psychological makeup. It's not just that I become phobic if I'm ahead 5–3 in a set of tennis and start to struggle so much with self-doubt that I end up in defeat. I'm also on guard if I feel at the edge of success in any other endeavor. I become determined not to have "another Johnny Evarts moment" and push myself to concentrate and give my all. (I also avoid mac and cheese.) Especially when there's a prospect of victory if I just keep going as I have been, I remind myself that complacency is tantamount to suicide.

NET IS my most uncertain place on the court. Standing there conjures memories of prep school matches in those awkward years when confidence and self-doubt alternated in equal measure. But since adolescence, I've learned to accept the reality that volleying is the weakest part of my game and not to berate myself for my ineptitude. If I've failed to master the twelve- to eighteen-inch punch in front of me that would assure success, so be it. I can't claim to be entirely past the embarrassment and discomfort I felt as a teenager and tried to conceal, but I've come to see that an inadequate net game, or any equivalent shortcoming, won't kill me.

Beyond the recollections of feeling like a lesser player than I wanted to be, I also have moments on the court that bring happy memories of my own sense of power. Sometimes when I hit a strong forehand that flies by my opponent, I think about a day when I visited Trish Troup, a tennis camp friend whose family had a house at Squam Lake, a beautiful New Hampshire resort where wood-shingled houses are surrounded by pine trees. Trish's mother was discussing colleges and said of Barnard (the women's college at Columbia University, where I went) that she had been "warned there are a lot of Jews there." Why the hell did I not immediately tell her I'm Jewish? The remark was burning inside

me when I was coerced into playing a few sets of singles with someone named Chuck, deemed the top player at Squam. A nice guy, but when I played, I took out my rage on him, assuming that he was Mrs. Troup's dream WASP. The moment we got on the court, I started the familiar mental process whereby I'm a Jew fleeing the Nazis; if I have a prayer of survival, I have to crush my opponent. Mrs. Troup had been so smug when she made the remark; I began to play better and better because I had to vanquish the enemy. I have no doubt that Chuck was the superior player, but I handily won four sets in a row. One powerful forehand hit at a wide angle, and I relive that summer afternoon more than half a century ago on Squam Lake. There are periodically occasions in life when I manage to motivate myself to get through difficult situations and prevail by imagining that Chuck is on the other side of the net.

Hitting a down-the-line backhand can make me remember games with my friend Ricky when we were teenagers, playing in the public park. All we really wanted to do was listen to and look at the older girls who also played there, especially the one with beautiful black hair and a glorious figure who would say "Your ad" in a way that sounded like "You're odd." I knew her name was Myra—no other facts—but I can still hear that voice and picture the sullen way she stood when receiving.

If I play on macadam in the baking sun, I repair mentally to the courts alongside the Hudson River when I was at Columbia and periodically lost a ball to the traffic on the West Side Highway. The intensity of those years of immersing myself in Shakespeare and Freud and medieval art comes back to me. On red clay, I often recall the nicer courts at Yale when I was getting a master's degree in art history. Next to the football stadium, called the Bowl, those courts on the outskirts of New Haven made tennis feel like a gentleman's pastime compared to the gridiron on which footballers crashed into one another in their bulky gear. It was a time in my life when afternoon tennis and evening movies made up a very pleasant routine with which I diverted myself while avoiding going into the army during the Vietnam War. The nostalgia is bittersweet—those two years were fraught with anxiety—but it was one of the few periods when my days were not scheduled, and the way that clay dust can spread over white taped lines often brings me back.

With its guidelines and regulations, always consistent even when the court surfaces are not, tennis has the power to summon so much. On the rare occasions when I get to play on grass, each irregular bounce conjures the cucumber sandwiches and tart lemon squares served following the ringing of the bell for afternoon tea at Argideen Lawn Tennis Club, near the ruins of Timoleague Abbey in West Cork, Ireland. Of course, lots of things conjure lots of memories, but there's a special quality to tennis that makes it such a rich inspiration.

Clay courts in Italy are redder than in other places, or so it seems to me. Perhaps it's because of the bright sunlight or the blood oranges that grow nearby, but they seem to be the rich color of that delicious fruit. Whenever I play on Italian clay—and I've been lucky enough to do so at the Hotel des Bains in Venice and at a club surrounded by pine trees in Genoa and in Siena not far from the marvelous Duccios—I'm brought back to the summer of 1976, when I was teaching my beautiful fiancée how to play at a club in a suburb of Rome. Her sharp-tongued aunt told her how good she looked in white and then added, "I normally hate white: It reminds me of snow and virginity and other useless things." Katharine in a tennis dress was *une merveille*.

When I play in the rural Senegalese village where we support a medical center and a school, my mind backtracks to the opposite experience of games at the expensive country club in suburban Connecticut when I was a teenager. Whether it's in a world of donkey carts or of BMWs, it's always the same game, but the dynamics in a milieu of wealth and privilege have caused far more angst than do games full of laughs in a remote corner of Africa. Tennis can be a reminder that joy comes in unexpected places.

TENNIS CAN also have a direct impact on our most important relationships. Brief events on the court can have lasting significance. This is a consequence of what I would call their "artfulness." I'm thinking of a minor yet major occurrence on the last day of May 2020. It was at a time when most everything inside me was falling apart. For some of us, that happens periodically, whatever masks we wear.

I was playing tennis with my son-in-law, Robbie Smith, the husband of my daughter, Charlotte, and the father of my grandsons, Wilder and Beau. (You've already encountered Robbie as an admirer of Andre Agassi.) We're different types of men and with a thirty-year age gap, but we're good friends. Some people forget all their problems when they play tennis; they're lucky. Regrettably, on that sunny spring day, my anxieties were surfacing. The running and hitting had blown away my inner safety valve.

The COVID-19 pandemic was raging; we had all abandoned our former ways of life. Everybody was full of questions and doubts about the impact of the disease then and in the future. The situation exacerbated my usual fears of death. And all sorts of worries that I normally have under control were emerging even as I ran to get back to the midpoint on the court. I was asking why about a plethora of problems and agonizing at the lack of answers.

Sometimes this inner hell emerges during a tennis match the way it does during meditation. You're trying to concentrate on the game, but a myriad of unhappy thoughts come, unbidden, to the surface.

I was not conscious as I hit a strong crosscourt backhand that I was doing anything special. Rather, I was acting on instinct. There were more than sixty years of history in that shot. On some level, previous backhands were present, hit ever since I was a little kid (I had started loving the game at age eight). I never played tennis particularly well, but it's always just been there, part of me. Certain reflexes occur, whether I'm on asphalt, clay, grass, synthetic grass, or rubberized macadam, even if I'm hitting with the high-tech materials of today rather than the wood and sheep gut of my childhood, and all the experiences were somehow present as I laced the ball to the most distant corner on Robbie's side. I'm not a topspin player, so it was low rather than looping; it cleared the white band bordering the top of the net by no more than a few inches. It then bounced near the spot where the back line of the service box meets the sideline, at an angle and with a speed that made it untouchable. My son-in-law shouted, with enthusiasm, "Cracking!"

It was a golden moment that cut through everything else. First, to be complimented by my daughter's husband, given all the complexities of such a relationship, was agreeable. The spontaneity and warmth of his

shout showed Robbie as he is: a person capable of being happy for someone else (an unusual quality, I think.) At age seventy-two, I had never heard the exclamation "Cracking!" before, but Robbie is Irish and lives in England, where it's a more vivid way of saying "Excellent!" The shot, which seemed to have nothing to do with me personally, had charisma. Charisma is a force that can exist in acts and objects as well as in people. It's present in Giotto's frescoes, paintings by Mondrian, the Brahms string octet, and Le Corbusier's chapel at Ronchamp. It was there in that lovely word *cracking*. Everything in the world was right again.

NOTES

CHAPTER 1 / *Charisma*

1 René Lacoste, "The Quest of the Davis Cup," in *The Fireside Book of Tennis*, ed. Allison Danzig and Peter Schwed. (Simon and Schuster, 1972), 29.
2 Max Weber, *Economy and Society: An Outline of Interpretive Sociology* (University of California Press, 1978), 241.
3 Cindy Shmerler, "50 Years Later, A Finals to Remember," *New York Times International Edition*, January 11–12, 2025.
4 Ibid.
5 Ibid.
6 Frank Deford, "John Newcombe," in Danzig, *The Fireside Book of Tennis*, 455–57.
7 Richard Evans, "Stolle, Unseeded, Wins U.S. Championship," in Danzig, *The Fireside Book of Tennis*, 828.
8 Walter Bingham, "It Almost Came Up Roses for Rosewall at Wimbledon," *Sports Illustrated*, July 13, 1970, quoted in Danzig, *The Fireside Book of Tennis*, 893–94.
9 Fred J. Podesta, "Rod Laver's Incredible Streak and $160,000," in Danzig, *The Fireside Book of Tennis*, 905.
10 Herbert Warren Wind, "First U.S. Open Championships," in Danzig, *The Fireside Book of Tennis*, 869.
11 Joe Jares, "Love Conquers All," *Sports Illustrated*, April 14, 1975, https://vault.si.com/vault/1975/04/14/love-conquers-all
12 Julie M. Heldman, "Virginia Wade," in Danzig, *The Fireside Book of Tennis*, 442–444.

CHAPTER 2 / *Tennis in the Art of Bonnard and Vuillard*

13 Claude Anet, *Suzanne Lenglen* (Simon Kra, 1927).
14 Claude Anet, *Adolescence* (À la Cité des Livres, 1925), 1.
15 Ibid., 2.
16 Ibid., 18.

17 Gloria Groom, *Édouard Vuillard: Painter-Decorator: Patrons and Projects, 1892–1912* (Yale University Press, 1993), 100.
18 John Russell, *Vuillard* (Thames and Hudson, 1971), 53.
19 Letter from Jean Schopfer to Édouard Vuillard, dated May 22, 1895, Salomon Archives, Paris, quoted in Beaulieu, Annette Leduc, "An Art Nouveau Experiment: Édouard Vuillard's Porcelain Wedding Service for Jean Schopfer, 1895," *Studies in the Decorative Arts* 13, no. 1 (2005): 72–93.
20 Antoine Terrasse, ed., *Bonnard/Vuillard: Correspondance* (Gallimard, 2001), 34.
21 Russell, *Vuillard*, 57.
22 Ibid., 59.
23 André Gide, "Promenade au Salon d'Automne," *Gazette des Beaux Arts* (December 1905).
24 "[V]ais déjeuner chez Claude Anet [. . .] bonne impression des tableaux de Roussel . . . mauvais effect de mon panneau [à côte] du portrait de Bonnard; mon ignorance du dessin.'" Vuillard, *Journal*, 5398 (1), entry dated Tuesday 2 June 1908, quoted in *National Gallery Technical Bulletin* Vol. 33, 2012, p. 111, n. 141.
25 Claude Anet, *Through the Russian Revolution* (Alpha Edition, 2019), 46.
26 Ibid., 54.
27 Ibid., 56.
28 Ibid., 76.
29 Ibid., 78.
30 Ibid., 94.
31 Ibid., 95.
32 Claude Anet, *Love in the Afternoon* (Classica Libris, 2021), 138.
33 Ibid., 138.

CHAPTER 4 / *Alice Marble*

34 Althea Gibson, *I Always Wanted to Be Somebody* (HarperCollins, 1958), 63–65.
35 L. Rodney, "On the Scoreboard: Miss Gibson Plays at Forest Hills," *The Daily Worker*, August 24, 1950.
36 Alice Marble, *The Road to Wimbledon* (W.H. Allen, 1947), 102; quoted in David L. Porter, *Their Greatest Victory: 24 Athletes Who Overcame Disease, Disability and Injury* (McFarland, 2013), 69.
37 Ibid., quoted in Porter, 69.
38 In *The Road to Wimbledon*, she says twelve; in *Courting Danger*, she says fourteen.
39 Al Laney, *Covering the Court: A 50-Year Love Affair with the Game of Tennis* (Simon and Schuster, 1968), 203.
40 Alice Marble, *Courting Danger. My Adventures in World-Class Tennis, Golden-Age Hollywood, and High-Stakes Spying* (St. Martins Press, 1991), 2.
41 Ibid., 20.
42 Billie Jean King in "Alice Marble, 77, Top U.S. Tennis Star of 1930s," *New York Times*, December 14, 1990.
43 Laney, *Covering the Court*, 200–201.

44 Marble, *Courting Danger*, 40.
45 Ibid., 40.
46 Ibid., 41.
47 Ibid., 43.
48 Ibid., 47.
49 Ibid., 48.
50 Quoted in Marble, *Courting Danger*, 50.
51 Ibid., 50.
52 Ibid., 85.
53 Ibid.
54 Ibid., 99.
55 Ibid., 105.
56 Ibid., 115.
57 William T. Tilden, *My Story: A Champion's Memoirs* (Hellman, Williams & Company, 1948), 206.
58 Ibid., 162.
59 Ibid., 163.
60 Ibid.

CHAPTER 5 / Bill Tilden

61 *Irish Times*, July 14, 1939.
62 Laney, *Covering the Court*, 73.
63 Ibid., 62.
64 Ibid., 60.
65 Ibid., 73.
66 Ibid., 73.
67 Ibid., 75.
68 Allen M. Hornblum, *American Colossus: Big Bill Tilden and the Creation of Modern Tennis* (University of Nebraska Press, 2018), 16.
69 Laney, *Covering the Court*, 70; quoted in Hornblum, *American Colossus*, 137.
70 Hornblum, *American Colossus*, 237.
71 René Lacoste, *Lacoste on Tennis* (William Morrow, 1928), 217, quoted in Hornblum, *American Colossus*, 255.
72 H. W. Austin, *Lawn Tennis Made Easy. By the Austin-Caulfeild System* (The MacMillan Company, 1935), 211.
73 Laney, *Covering the Court*, 41–42.
74 Ibid., 70–71.
75 Hornblum, *American Colossus*, 17.
76 Tilden, *My Story*, 140.
77 Ibid.
78 Ibid., 151.
79 Ibid., 151–52.
80 Ibid., 67.

81 Ibid.
82 William T. Tilden, *It's All in the Game: And Other Tennis Tales* (Methuen, 1922), 20, quoted in Hornblum, *American Colossus*, 148.
83 Hornblum, *American Colossus*, 148.
84 Tilden, *My Story*, 11.
85 *New York Times*, January 28, 1926, quoted in Hornblum, *American Colossus*, 239.
86 *Variety*, January 6, 1926, quoted in Hornblum, *American Colossus*, 239.
87 Laney, *Covering the Court*, 136.
88 Tilden, *My Story*, 231.
89 Ibid., 262.
90 Ibid., 270.
91 Ibid., 285.
92 Ibid., 288.
93 Karen Crouse, "Bill Tilden: A Tennis Star Defeated Only by Himself," *New York Times*, August 30, 2009.
94 Tilden, *My Story*, 307.
95 Ibid.
96 Ibid., 308.
97 Hornblum, *American Colossus*, 383.
98 Ibid., 384.
99 Tilden, *My Story*, 310.
100 Ibid., 311.
101 "Judge Refuses to Set Bail for Tilden, Named by Boy," *Los Angeles Times*, February 2, 1949, quoted in Hornblum, *American Colossus*, 390.
102 Hornblum, *American Colossus*, 395.

CHAPTER 7 / *Suzanne Lenglen*

103 Claude Anet, "Un match historique: Suzanne Lengle contre Helen Wills," *Revue de France* 7, no. 2 (January 15, 1927): 253–75.
104 Claude Anet, *Suzanne Lenglen* (Simon Kra, 1927).
105 Ibid., 58–60.
106 Ibid., 88–89.
107 Joshua Shifrin, *101 Incredible Moments in Tennis: The Good, the Bad and the Infamous* (Jr Books Ltd, 2010), 101.

CHAPTER 9 / *The Song and Dance of Tennis*

108 Carl Van Vechten, quoted in "Controversial ballet 'Le Sacre du printemps'—['The Rite of Spring']—performed in Paris," accessed January 31, 2025, https://www.history.com/this-day-in-history/controversial-ballet-le-sacre-du-printemps-performed-in-paris
109 Christopher Dingle, "The Story of Debussy's 'Jeux,'" *BBC Music Magazine*,

accessed April 19, 2019, https://www.classical-music.com/features/articles/story-debussy-s-jeux/
110 Ibid.
111 Ibid.
112 Robert Orledge, *Satie the Composer* (Cambridge University Press, 2008), 19.
113 Alan M. Gillmor, *Erik Satie* (W. W. Norton, 1992), 20.

CHAPTER 11 / *Helen Wills*

114 Julie Cart, "Tennis Legend Helen Wills Moody Dies," *Los Angeles Times*, January 3, 1998, https://www.latimes.com/archives/la-xpm-1998-jan-03-mn-4570-story.html
115 H. W. Austin, *Lawn Tennis: Bits and Pieces* (Sampson Low, Marston and Co., 1930), 195.
116 Laney, *Covering the Court*, 185.
117 Ibid., 106.
118 Anonymous, "The American Girl and the Mexican Muralist: Helen Wills and Diego Rivera," June 29, 2014; published on the internet without further information.
119 Helena Huntington Smith, "Another Glorified Girl," *The New Yorker*, August 27, 1927.
120 Allison Danzig, "Helen Wills Is Queen of Her Tennis World," *New York Times*, September 9, 1928, excerpted in the August 25, 2013, magazine: https://www.nytimes.com/2013/08/25/magazine/helen-wills-is-queen-of-her-tennis-world.html
121 Ibid.
122 Smith, "Another Glorified Girl."
123 Smith, "Another Glorified Girl."
124 Ibid.
125 Cart, "Tennis Legend Helen Wills Moody Dies," *Los Angeles Times*, January 3, 1998.
126 Smith, "Another Glorified Girl."
127 Ibid.
128 From an anonymous blog.
129 Steve Flink, "Obituary: Helen Wills Moody," *The Independent*, January 3, 1998.
130 Phelan, quoted in an anonymous blog.
131 Quoted in an anonymous blog.
132 Diego Rivera, *My Art, My Life: An Autobiography* (Dover Publications, 1991), 107.

CHAPTER 12 / *Vladimir Nabokov*

133 Quoted in Tim Harte, "Athletic Inspiration: Vladimir Nabokov and the Aesthetic Thrill of Sports," *Nabokov Studies* 12.1 (2009): 147–66.

134 Vladimir Nabokov, *Speak, Memory* (Vintage International, 1989).
135 Ibid., 40.
136 Ibid., 41–42.
137 Ibid., 257.
138 Ibid., 258.
139 Vladimir Nabokov, *La Veneziana* (Penguin, 1995), 1.
140 Ibid.
141 Ibid., 2–3.
142 Ibid., 4.
143 Vladimir Nabokov, *Glory* (McGraw-Hill Book Company, 1971), 45.
144 Ibid., 46–47.
145 Ibid.
146 Ibid., 47–48.
147 Ibid., 175.
148 Ibid.
149 Vladimir Nabokov, *Lolita* (Penguin Books, 2015), 162.
150 Ibid., 230-231.
151 Ibid., 232.

CHAPTER 13 / *Tennis Chic: Jean Patou*

152 Hannah Jane Parkinson, "Court Couture: Why Tennis Fashion Owes It All to Suzanne Lenglen," *The Guardian*, June 11, 2023, https://www.theguardian.com/fashion/2023/jun/11/court-couture-why-tennis-fashion-owes-it-all-the-suzanne-lenglen
153 In "Impression de Melle Suzanne Lenglen au cours de son voyage actuel en Amérique," in *Tennis et Golf*, October 13, 1926, p. 527, quoted in Emmanuelle Polle, *Jean Patou*, Paris; Flammarion, 200.
154 From an article in *United Press*, 1926, no further information given, quoted in Polle, *Jean Patou*, 200.
155 Jean Patou in *San Jose News*, June 28, 1928, quoted in Pauline Miele, "La Silhouette sportive c'est le chic absolu. Jean Patou et la jupette de tennis," published August 1, 2014, at https://strabic.fr/La-silhouette-sportive-c-est-le-chic
156 Ariele Elia in the catalogue *Elegance in an Age of Crisis: Fashions of the 1930s* (New Haven: Yale University Press, 2014), quoted on the Museum at FIT website: https://exhibitions.fitnyc.edu/1930s-fashion-blog/tag/tennis/

CHAPTER 14 / *Althea Gibson*

157 "Segregation: West Side Story," anonymous article dated July 20, 1959, in the Ralph Bunche papers of the University of California, UCLA Special Collections.
158 Althea Gibson, *I Always Wanted to Be Somebody* (New Chapter Press, 2022), 71.
159 Ibid., 132.
160 Ibid., 134.

161 Ibid., 134.
162 Ibid., 138.
163 Ibid., 140.
164 Gavin Newsham, "Tennis Legend Althea Gibson was a champion ahead of her time: 'Nothing to Lose,'" *New York Post*, July 29, 2023.
165 Larry Schwartz, "Althea Gibson Broke Barriers," *ESPN.com*, https://www.espn.com/sportscentury/features/00014035.html

CHAPTER 15 / *Tennis in the Work of Eadweard Muybridge*

166 "The Larkysn-Muybridge Tragedy," *Sacramento Daily Union*, February 5, 1875.
167 Ibid., https://cdnc.ucr.edu/?a=d&d=SDU18750205.2.26.2&srpos=70&e=-------en--20--61-byDA-txt-txIN-muybridge-------
168 "The Killing of a Seducer Legally Justified," *Chicago Daily Tribune*, February 18, 1875, https://chroniclingamerica.loc.gov/lccn/sn84031492/1875-02-18/ed-1/seq-2/
169 Muybridge, as quoted in "Remember That Time the Motion Picture Was Invented (and Everyone Was Naked)?," *Messynessy*, https://www.messynessychic.com/2019/05/09/remember-that-time-the-motion-picture-was-invented-and-everyone-was-naked/

CHAPTER 16 / *Bunny Austin*

170 H. W. Austin and Phyllis Konstam, *A Mixed Double* (Chatto & Windus, 1969), 31.
171 Frank Litsky, "Bunny Austin, 94, a Pioneer in Tennis Shorts," *New York Times*, August 28, 2000.
172 Austin, *A Mixed Double*, 95–97.
173 Ibid.
174 "Bunny" Austin, *Lawn Tennis Made Easy* (MacMillan Company, 1935), 104–109.
175 Michael Gray, "Bunny Austin," *The Guardian*, August 28, 2000.
176 Austin, *A Mixed Double*, 66–68.
177 Ibid., 11.
178 Ibid., 68-69.
179 Frank Buchman, *Remaking the World* (Blandford Press, 1955), 46.
180 H. W. Austin, *Moral Re-Armament: The Battle for Peace* (William Heinemann, 1938), 8.
181 Ibid., 7.
182 Austin, *A Mixed Double*, 81.
183 Ibid., 86–87.
184 Ibid., 102.
185 Ibid., 107–108.

CHAPTER 17 / *A Fabergé Tennis Trophy*

186 Ibid., 258.
187 Helen Azar, *Journal of a Russian Grand Duchess: Complete Annotated 1913 Diary of Olga Romanov, Eldest Daughter of the Last Tsar* (Createspace Independent

Publishing Platform, 2015), as cited on https://www.theromanovfamily.com/tennis-and-the-romanov-family/
188 Ibid.

CHAPTER 18 / *Anyone for Tennis?*

189 Erskine Johnson, "In Hollywood," *Portsmouth Herald,* September 16, 1948.
190 William Safire, "On Language: Drop the Gun, Louie," *New York Times Magazine,* July 1, 1990.
191 Alistair Cooke, "Art and the Age of Violence," *Guardian,* January 16, 1957.
192 Nathaniel Benchley, *Humphrey Bogart* (Little, Brown and Company, 1975), 30.
193 Stephen Humphrey Bogart, *Bogart. In Search of My Father* (Dutton, 1995), 87.
194 Interview with Humphrey Bogart by Carlisle Jones, *Screen & Radio Weekly,* in *The Detroit Free Press,* Sunday, May 24, 1936.
195 George Bernard Shaw, *Misalliance* (Project Gutenberg, 2008), https://www.gutenberg.org/files/943/943-h/943-h.htm
196 George Randolph Chester, "The Magic Photograph," *Illustrated Magazine of the Daily Picayune,* May 17, 1908.
197 Somerset Maugham, *The Circle: A Comedy in Three Acts* (George H. Doran Company, 1921), 11–12.
198 Oxford English Dictionary, 2nd edition, 1989.
199 Ibid.
200 Pauline Peterson, "Ain't Love Grand?," *The Leader-Post* (Regina, Saskatchewan, Canada), December 8, 1934.
201 From *Hollywood Sights and Sounds,* by Robbin Coons, about the actress Rosalind Russell (1907–1976), published in several American newspapers in October 1940—for example, in the *Big Spring (Texas) Daily Herald* of Tuesday, October 15.
202 Bob Hope article published in the *Chicago Daily Sun-Times* of Friday, September 10, 1948.
203 John Rosenfield's portrait of the American novelist William Saroyan, published in *The Dallas Morning News* of Sunday, January 30, 1949.
204 From an interview with Errol Flynn by Hedda Hopper, in several American newspapers in May 1949—for example, in the *Chicago Daily Tribune* of Sunday, May 29.

CHAPTER 20 / *Oleg Cassini*

205 Amy Larocca, "The Sporting Life," *New York Magazine,* May 28, 2004, https://nymag.com/nymetro/news/people/columns/intelligencer/9231/
206 Oleg Cassini, *In My Own Fashion* (Simon and Schuster, 1987), 16.
207 Ibid.
208 Ibid., 35.
209 Ibid.
210 Ibid., 35–36.

211 Ibid., 36.
212 Ibid., 45.
213 Ibid., 46.
214 Ibid.
215 Ibid.
216 Ibid., 46–47.
217 Ibid., 54.
218 Ibid., 77.
219 Ibid., 104.
220 Ibid.
221 Ibid., 105.
222 Oleg Cassini, *A Thousand Days of Magic* (Rizzoli, 1995), 224.
223 Amy Larocca, "The Sporting Life," *New York Magazine*, May 28, 2004.

CHAPTER 21 / *Henry McBride*

224 Hilton Kramer, "Foreword: A Note on Henry McBride," in Henry McBride, *The Flow of Art: Essays and Criticisms*, ed. Daniel Catton Rich (Yale University Press, 1997), 11.
225 Henry McBride, *An Eye on the Modern Century: Selected Letters of Henry McBride*, eds. Steven Watson and Catherine J. Morris (Yale University Press, 2000), 416.
226 McBride, *Letters,* 146.
227 Ibid., 200.
228 Ibid., 240.
229 McBride, *The Flow of Art*, 15.
230 McBride, *Letters*, 271.

CREDITS

The Tennis Song. Written by Cy Coleman and David Zippel. Published by Notable Music Co. Inc. (ASCAP). Used with permission.

Excerpt from "The University Poem" from *Selected Poems of Vladimir Nabokov* by Vladimir Nabokov, copyright © 2012 by The Estate of Vladimir Nabokov. Used by permission of Alfred A. Knopf, an imprint of the Knopf Doubleday Publishing Group, a division of Penguin Random House LLC. All rights reserved.

IMAGE CREDITS

Page 10: Ed Lacey/Popperfoto via Getty Images.Page 14: © National Portrait Gallery, London.
Page 24: History and Art Collection / Alamy Stock Photo
Page 30: © RMN-Grand Palais / Art Resource, NY.
Page 35: © National Gallery, London / Art Resource, NY.
Page 38: Sueddeutsche Zeitung Photo / Alamy Stock Photo
Page 41: Courtesy and copyright © Lawrence Schiller / Originally published in World Tennis Magazine (November 1956). Hardcopy at the Museum Archive at the International Tennis Hall of Fame, Newport, RI.
Page 47: Bettmann via Getty Images.
Page 50: Gjon Mili/The LIFE Picture Collection/Shutterstock.
Page 53: Masheter Movie Archive / Alamy Stock Photo.
Page 59: Hulton Archive via Getty Images.
Page 61: Rapp Halour / Alamy Stock Photo.
Page 63: IanDagnall Computing / Alamy Stock Photo.
Page 68: Glasshouse Images / Alamy Stock Photo.
Page 80: Cinematic / Alamy Stock Photo.
Page 85: PA Images / Alamy Stock Photo.
Page 87: MGM / RGR Collection / Alamy Stock Photo.
Page 93: Bettmann via Getty Images.

Page 95: Smith Archive / Alamy Stock Photo.
Page 101: Heritage Image Partnership Ltd / Alamy Stock Photo.
Page 105: Matthias Person. Courtesy Josef and Anni Albers Foundation.
Page 117: Matthias Person. Courtesy Josef and Anni Albers Foundation.
Page 119: Pierre Otolo. Courtesy Josef and Anni Albers Foundation.
Page 120: Pierre Otolo. Courtesy Josef and Anni Albers Foundation.
Page 141: Photo courtesy of Calder Foundation, New York / Art Resource, New York. Artwork © 2025 Calder Foundation, New York / Artists Rights Society (ARS), New York.
Page 143: © Helen Wills Moody / Victoria and Albert Museum, London.
Page 150: Chronicle / Alamy Stock Photo.
Page 156: © 2025 Banco de México Diego Rivera Frida Kahlo Museums Trust, Mexico, D.F. / Artists Rights Society (ARS), New York.
Page 159: Photograph of Dmitri Nabokov. Copyright © Vladimir Nabokov Literary Foundation, Inc., used by permission of The Wylie Agency LLC.
Page 179: GRANGER - Historical Picture Archive / Alamy Stock Photo.
Page 181: Historical / Contributor via Getty Images.
Page 185: Alpha Stock / Alamy Stock Photo.
Page 187: Alpha Stock / Alamy Stock Photo.
Page 190: PA Images / Alamy Stock Photo.
Page 192: PA Images / Alamy Stock Photo.
Page 205: © National Portrait Gallery, London.
Page 207: © National Portrait Gallery, London.
Page 210: Cartoon by Tom Webster; published in Austin & Konstam, A Mixed Double, Chatto & Windus, 1969.
Page 212: Hulton Archive via Getty Images.
Page 220: © National Portrait Gallery, London.
Page 222: © Wartski & Company.
Page 241: Dom Slike / Alamy Stock Photo.
Page 247: Archive Photos via Getty Images.
Page 251: Penske Media via Getty Images.
Page 256: Smith Archive / Alamy Stock Photo.
Page 257: Moviepix via Getty Images.
Page 275: Courtesy and copyright © François Olislaeger.
Page 277: © Palazzo Ducale/HIP/Art Resource, NY.
Page 281: © Ghigo G. Roli / Art Resource, NY.
Page 285: Photo by Keith Pattison © RSC.
Page 286: Chronicle / Alamy Stock Photo.
Page 291: Courtesy Le Korsa.
Page 293: Courtesy Le Korsa.
Page 294: Courtesy Le Korsa.

COLOR PLATES

COLOR PLATE 1: Image copyright © The Metropolitan Museum of Art. Image source: Art Resource, NY

COLOR PLATE 2: Norton Simon Art Foundation.

COLOR PLATES 4–5: JJs / Alamy Stock Photo. (both images)

COLOR PLATE 6: Retro AdArchives / Alamy Stock Photo.

COLOR PLATE 7: © Laurent de Brunhoff; from *Babar's Adventures*, Stewart, Tabori & Chang (New York, 1989), with the permission of Phyllis Rose de Brunhoff.

COLOR PLATE 8: Digital image © Whitney Museum of American Art / Licensed by Scala/ Art Resource, NY. Artwork © 2025 Heirs of Josephine N. Hopper / Licensed by Artists Rights Society (ARS), NY.

COLOR PLATE 9: Courtesy and copyright © François Olislaeger.

COLOR PLATE 10: Sir John Lavery, Played, 1885. Oil on panel. 14 × 11¾ in. (35.5 × 30 cm.) Private collection.

COLOR PLATES 12–16: Courtesy and copyright © 2025 The Josef and Anni Albers Foundation/Artists Rights Society (ARS), New York. (all images)

COLOR PLATE 17: © Helen Wills Moody / Victoria and Albert Museum, London.

COLOR PLATE 18: GRANGER – Historical Picture Archive / Alamy Stock Photo.

COLOR PLATE 23: Gift of Ettie Stettheimer, the artist's sister. (lower left)

COLOR PLATE 25: © Thyssen-Bornemisza Museum, Madrid.

ACKNOWLEDGMENTS

THE DEDICATEE of this book is one of the most loving, generous, amusing, warm, and astute human beings on this earth. Her gifts of perception and kindness are of the same caliber as her splendid groundstrokes. And she is style itself—in her way of interacting with others as in her tennis outfits are. This marvelous individual has encouraged this book from the start, in a way that has meant the world to me. What a joy it is to have Lucy Swift Lemonides as my daughter.

Saul Weber, my father, taught me tennis, and was invariably patient with me always wanting to hit a few more shots. *His* father was equally patient when he would come to repair the windows I broke when using our garage doors as my backboard. Caroline Fox Weber, my mother said that, as her doubles partner, I was never to say that I was sorry if I missed a shot; she knew that I tried my hardest and said that no apologies were needed in life if you give your utmost. Nancy Weber, my sister, was a great sport always willing to keep hitting with me even when it was too dark outside to see and has remained as kind ever since our marvelous childhoods.

My wife, Katharine Weber, whether in her preparations for the ritual teas at the Argideen Lawn Tennis Association with its lovely grass courts in Ireland, or in our partnerships at mixed doubles at The New Haven Lawn Club, has been the brightest and most entertaining of companions. My daughter Charlotte Fox Weber, who as a child had an uncanny ability to hit a backhand well after the moment when you thought that the ball had passed by her, has been, always, utterly

extraordinary in more ways than I can enumerate. She leads her life with the magic of those shots. And how I love going onto the tennis court with her two sensational sons, Wilder Fox Smith and Beau Fox Smith. Wilder, so ineffably kind and spirited and brilliant, and Beau, so independent and funny, give my life its main purpose. Their energy and vitality and flare for living are a perpetual inspiration for me. Their father, Robbie Smith, graces the pages of this book with his marvelous energy and spirit of fun. He has been there at times of need, with companionship and heart. Charles Lemonides, my other son-in-law, gives advice thoughtfully and offers inestimable friendship. Forthright and strong, Charles has provided emotional support and a sense of connectedness of rare richness.

In 1978, I gave a lecture at a fancy dinner at a museum where the Board Chairman, introducing me, totally in his cups, took one look at my lengthy c.v. and said, as his entire speech, that I "worked in the summers at Tamarack Tennis Camp." Forget the better-known institutions; he could have picked no better one to feature. Jack Kenney, the philosopher who founded that wonderful haven of clay courts cradled in the mountains of New Hampshire, imbued the game with his personal magic. This was not a tennis camp that stressed competition; rather, having attracted its first campers with a small classified ad in *The Saturday Review of Literature*, a magazine with progressive values, it treated the sport as a chance for balance in life. At Tamarack, in 1967, I met George Gibson, an absolute dream of a friend, good as gold, who from then until now has enriched my life with his kindness and spark through thick and thin. Hallie Thorne Rintel—bright, beautiful, warm-hearted—and Didi Bush—so full of laughter and heart—also added tremendous joy to those summers and have continued to do so ever since. Kathy Agoos, who was also there as a counselor, is a fabulous friend, always as dependable as she is full of laughter, and she changed my life by introducing me to her mother and father, Ruthie and Herb Agoos, who in turn introduced me to Anni and Josef Albers. A connoisseur of art and design who also had a particularly beautiful forehand, Herb's life was enhanced by art and tennis at their apogees. And Julie Agoos, Peter Agoos, and Ted Agoos, each for different reasons, are wonderful beyond words.

Hugh O'Donnell and Catherine Hegarty are splendid tennis companions, always gracious and fun, the essence of camaraderie. Tom Doyle, as charming and bright as he is adept on the court; erudite and generous, he gave me a copy of the rare Nabokov text which became so vital to this book, for which I am forever grateful. Maurice Moore, with his rare ability to coach as well as simply to enjoy the game, has always been a fantastic friend. Ray Coppinger, whose speed on the court and will to get to the ball are equaled by no one, has been an exceptionally supportive and understanding companion. Shane O'Neill, whose down-the-line backhand is as good as his baking, has provided many enjoyable games. Joel Cadiz is a true gentleman as well as a master of the sport when we play in all sorts of weather conditions in Ireland. I will be forever grateful to John Eastman, a friend whom I miss mightily, for taking me out on a "Real Tennis" court, and also for his unique spirit and alertness to the wonders of life and art. Daphne Warburg Astor, whom I also greatly miss, was not only a delight when playing tennis so gracefully, but was also a marvelous friend with whom to discuss the demeanor of Sinner or the spirit of Graff as if we were at courtside together, and to celebrate so much else in earthly existence. Fiona Kearney, with her infectious enthusiasm, greatly enhances the pleasures of the game as well as the joys of looking at art; she has been exceptionally insightful as well as supportive in a myriad of ways. It is not only when he has a racquet in hand that Romain Langlois, one of the world's great enjoyers, is a splendid, uplifting friend. John Doyle is as companionable a person as one could imagine at the other side of the net, his positive energy as powerful as his serve. For furthering the pleasures of being on a tennis court, I also want to thank John Ryden, Lisa Sornberger, Leland de la Durantaye, Alexander Guillaumin, Andrea Warburg Kaufman, Robert Devereux, Thomas Clotteau, Hannah Starman, Édouard Detaille, Dario Jucker, Ricky Johnson, Pierre Otolo, Moustapha Diouf, Olivia Howe, Rupert Taylor, Micky Astor, Dave Smith, Kathryn Reiger, Laurent Van Reepinghen, Buz Kohn, Samuel Gaube, Kyle Goldbach, Sam Childs, Elsie Childs, Jane Grossman, Fritz Horstman, Lamine Keita, Arthur André, Tom Nash, Andy Seguin, David Leiber, Mickey Cartin, Alan Riding, Saliou Seck, Sophie Hunter, Toby Dewey, Judy Duncan, Jack Duncan, Pamela Druckerman, Fabrice Hergott, Mareta

Doyle, Simon Kuper, Willy Carey, Mike Adler, Henry Singer, Joan Warburg, Willard Greenwald, Robert Campagna, Sandy Schwartz, Sophie Dumas, Pierre-Alexis Dumas, Michel Navarra, Jon Newman, Nick Ohly, Charlie Kingsley, Chris Morrin, Chris Liu, and Ulysse Massey.

Willem Van Roij's energy and skill at dealing with the illustrations for this book, and his attention to the issues of permissions, reflect the same tenacity with which he wields a tennis racquet. Josh Slocum, as always, has been a marvel of energy, intelligence, creativity, and diligence in accomplishing multiple tasks with the deftness of one of those people who can stand at the net and cover a lot of territory demonstrating the reflexes and capability to execute one put-away volley after another. His kindness and understanding match his brightness in a rare combination of attributes. Philippe Corfa showed fantastic skill and patience in helping incorporate my handwritten editing into the electron version of the text. Anne Sisco has been an angel.

William Clark pursued the idea of publishing this book with the energy and courage requisite for a Grand Slam victory. His tenacity and patience led to David Godine being its publisher, which has been felicitous in spades.

Celia Johnson has been more than the editor of this book. She has an advisor with acumen as well as a cheering squad; a source of vital encouragement, Celia has contributed unstintingly to the making of this book. Her responsiveness, grace, and supportiveness have been boundless. David Allender, the Director of David Godine, has been enthusiastic from the start, a team captain with rare energy and knowledge. Will Thorndike, its publisher, has been engaged with a commitment and sense of excellence beyond all expectations. Virginia Downes, Brooke Koven, and Katherine Gaudet have helped make *The Art of Tennis* itself an artwork. Thanks to their eye for design and impeccable standards of execution, they are crackerjack professionals who have mastered all the shots.

NFW, Paris, 10 May 2025

A NOTE ON THE TYPE

The Art of Tennis has been set in Janson. Our text face owes its revival to Chauncey H. Griffith of Merganthaler Linotype, 1937. It's been discovered that this type is originally the work of Nicholas Kis (1650-1702), a Hungarian, who most probably learned his trade from the master Dutch type founder Dirk Hoskens. Janson is held in high regard for being both readable and handsome.

Book design by Brooke Koven
Composition by Vicki Rowland